Adobe Photoshop Elements 5.0

A visual introduction to digital photography

Philip Andrews

Focal Press is an imprint of Elsevier Linacre House, Jordan Hill, Oxford OX2 8DP, UK 30 Corporate Drive, Suite 400, Burlington, MA 01803, USA

First edition 2007

Copyright © 2007, Philip Andrews. Published by Elsevier Ltd. All rights reserved

The right of Philip Andrews to be identified as the author of this work has been asserted in accordance with the Copyright, Designs and Patents Act 1988

No part of this publication may be reproduced, stored in a retrieval system or transmitted in any form or by any means electronic, mechanical, photocopying, recording or otherwise without the prior written permission of the publisher

Permissions may be sought directly from Elsevier's Science & Technology Rights Department in Oxford, UK: phone (+44) (0) 1865 843830; fax (+44) (0) 1865 853333; email: permissions@elsevier.com. Alternatively you can submit your request online by visiting the Elsevier web site at http://elsevier.com/locate/permissions, and selecting Obtaining permission to use Elsevier material

Notice

No responsibility is assumed by the publisher for any injury and/or damage to persons or property as a matter of products liability, negligence or otherwise, or from any use or operation of any methods, products, instructions or ideas contained in the material herein. Because of rapid advances in the medical sciences, in particular, independent verification of diagnoses and drug dosages should be made

British Library Cataloguing in Publication Data A catalogue record for this book is available from the British Library

Library of Congress Cataloging-in-Publication Data A catalog record for this book is available from the Library of Congress

ISBN-13: 978-0-240-52049-0 ISBN-10: 0-240-52049-1

For information on all Focal Press publications visit our website at www.focalpress.com

Printed and bound in Canada

07 08 09 10 11 11 10 9 8 7 6 5 4 3 2 1

Layout and design by Karen and Philip Andrews in Adobe InDesign CS2

Picture credits

With thanks to the great guys at www.ablestock.com for their generous support in supplying the cover picture and the tutorial images for this text. Copyright © 2006 Hamera and its licensors. All rights reserved. All other images and illustrations by Karen and Philip Andrews © 2006. All rights reserved.

Working together to grow libraries in developing countries

www.elsevier.com | www.bookaid.org | www.sabre.org

ELSEVIER

BOOK AID

Sabre Foundation

April 1		- 4
10	nto	DTC
\sim	IIIC	nts

0011101110			
Foreword	vii	Editor: View > Zoom In and Zoom Out	59
Introduction	ix	Editor: Window > Navigator	60
Acknowledgements	Х	Step 3: Image rotating	61
4		Step 4: Cropping and straightening	62 62
The Buzz of Digital Photography	1	Cropping New rotation controls	64
The beginning – the digital photograph	3		65
Making the digital image	5	Step 5: Automatic corrections	65
Quality factors in a digital image	5	First some background Organizer: Edit > Auto Smart Fix and Auto Red Eye Fix	66
The steps in the digital process	8	Version Sets	66
Where does Photoshop Elements fit into the process?	9	Undo, Revert and Undo History	67
Photoshop Elements 5.0	10	Step 6: Printing	68
Thotoshop Elefficitis 5.0	10	Step 7: Saving	71
		Editor: File > Save	71
Introducing Photoshop Elements 5.0	11	Editor: File > Save	72
	NAME OF TAXABLE PARTY.	'The formats I use'	72
Adobe Photoshop Elements 5.0 – new tools and features	12	Step 8: Organizing your pictures	74
The Photoshop Elements 5.0 workflow	13		74
The interface	18	Tags Collections	74
The change continues	19	Stacks and Auto Stacks	75
New tools and features	19	Step 9: Backing up your files	76
Revamped favorites	21	Organizer: File > Backup	76
Menus	22	Multi Disk Backups	76
Tools	24	Mutti Disk Backups	70
Tool types	24	400	
The Quick Fix editor	28	4 Simple Image Changes	77
The Organizer workspace (Photo Browser or Date View)	30	Simple Image Changes	77
The Photo Creations feature	32	Three levels of editing	78
		Setting up your screen for Elements	80
Fire	25	Popularity can be a problem	81
First Steps	35	Before you start	81
The Welcome screen	37	Brightness and contrast changes	83
Step 1: Getting your pictures into Elements	38	Editor: Enhance > Adjust Lighting > Brightness/Contras	
Organizer: File > Get Photos > From Camera or Card		Editor: Enhance > Auto Contrast	85
Reader	38	Editor: Enhance > Auto Levels	86
Organizer: File > Get Photos > From Scanner	41	Editor: Enhance > Auto Smart Fix	86
Ensuring enough pixels for the job	43	Editor: Enhance > Adjust Smart Fix	87
Editor: Image > Divide Scanned Photos	44	The Quick Fix editor – 'quick change central'	87
Organizer: File > Get Photos > From Files and Folders	46	Altering a few tones only	88
How to multi-select the files to import	47	Editor: Enhance > Adjust Lighting > Shadows/Highlight	
Organizer: File > Get Photos > From Mobile Phone	47	Dodge and Burn tools	90
Organizer: File > Get Photos > From Online Sharing Serv	rice	Color corrections	93
	48	Editor: Enhance > Auto Color Correction	94
Organizer: File > Get Photos > By Searching	49	Editor: Enhance > Adjust Color > Remove Color Cast	94
Other options for getting your photos into Elements	50	Editor: Enhance > Adjust Color > Color Variations	95
Creating new documents	52	The Red Eye Removal tool	97
Editor: File > New > Blank File	52	Editor: Enhance > Adjust Color > Adjust Skin Tone	98
Editor: File > New > Image from Clipboard	53	Using filters and effects	98
Editor: File > Create or Organizer: File > Create	54	Editor: Filters menu	98
Editor/Organizer: File > New > Photomerge Panorama	55	Editor: Filter > Filter Gallery	99
Editor: File > Import > Frame From Video	56	Editor: Window > Artwork and Effects	100
Step 2: Viewing your pictures	57	Editor: Filter > Blur > Motion Blur	104
Organizer: View > View Photos in Full Screen	58	Editor: Filter > Sketch > Chalk & Charcoal	105
First stop – View Photos in Full Screen	58	Editor: Filter > Distort > Liquify	106
Organizer: View > Compare Photos Side by Side	58	Editor: Filter > Sketch > Graphic Pen	107
Comparing apples with apples	59	Editor: Filter > Stylize > Emboss	108

Third party filters	109	Color selection tools	176
Getting help with Elements	110	Modifying drawn and color-based selections	177
Hints	110	The new Magic Selection Brush	179
The How To feature	110	The Magic Extractor feature	181
Help	111	Selections in action	183
		Advanced dodging and burning	183
par .		Artificial depth of field	185
Hands on Techniques	113	Filtering a selection	186
Better digital capture	114	Selective saturation changes	186
So what is in a RAW file?	115	Layers and their origins	188
Elements raw processing Step-by-step	117	The Layers palette	189
Opening the Raw file	117	Layer types	190
Rotate	118	Frame Layers	192
Adjusting white balance	118	Layer transparency	194
Tonal control	120	Layer blend modes	195
Color strength adjustments	121	Layer Styles	197
Sharpness/Smoothness and Noise Reduction	122	Organizing layers	199
Output options	123	Quick guide to Layer shortcuts	200
Save, Open or Done	123		
Color depth or 'What do you mean 8 bits per channel?			
Manual tonal control	130	Combining Text with Your Images	201
Editor: Window > Histogram	131	Creating simple type	204
Editor: Enhance > Adjust Lighting > Levels	132	Creating Paragraph Text	204
Specialized color control	135	Basic text changes	205
Editor: Enhance > Auto Color Correction	136	Creating and using type masks	205
Editor: Enhance > Adjust Color > Adjust Hue/Saturation		Reducing the 'jaggies'	206
Editor: Enhance > Adjust Color > Color Variations	139	Warping type	207
Editor: Enhance > Adjust Color > Adjust Color Curves	140	Applying styles to type layers	207
Sponge	142	New text alternatives in version 5.0	211
Editor: Filter > Adjustments > Posterize	142	Debunking some type terms	213
Editor: Filter > Adjustments > Invert	143	Font size	213
Editor: Filter > Adjustments > Photo Filter	144	Font family and style	213
High quality sharpening techniques	145	Alignment and justification	214
Editor: Enhance > Auto Sharpen	145	Leading	214
Editor: Enhance > Unsharp Mask	146		
Editor: Enhance > Adjust Sharpness	148		
Elements' sharpening tools	149	Using Elements' Painting	
Retouching techniques	150		215
Editor: Filter > Noise > Dust & Scratches	151	and Drawing Tools	215
Clone Stamp	152	Cookie Cutter tool	217
Spot Healing Brush	153	Painting tools	217
Healing Brush	154	Paint Brush	217
Editor: Filter > Noise > Reduce Noise	155	The More Options palette	218
Adding texture to an image	157	Airbrush	219
Editor: Filter > Noise > Add Noise	157	Pencil	220
Editor: Filter > Texture > Grain	159	Paint Bucket	220
Editor: Filter > Texture > Texturizer	161	Choosing my paint colors	222
Changing the size of your images	164	Painting tools summary	222
Editor: Image > Resize > Image Size	164	The Impressionist Brush tool	222
Editor: Image > Resize > Canvas Size	167	Color Replacement tool	223
Increasing the canvas size with the Crop tool	168	Erasing	224
		Smart erasing	226
Using Selections and Layers	169	Better with a tablet	226
Selection basics	170	Painting tools in action	227
Drawing selection tools	170	Hand coloring black and white	227
Drawing selection tools Drawing selection tool summaries	175	Drawing tools	228
Drawing selection tool summaries	1/3	Even more shapes	229

Cookie Cutter tool	230	Sending images as e-mail attachments	281
Shapes and graphics in the new Artwork and Effects		Attach Selected Items to E-mail dialog	281
palette	231	Making simple web animations with Elements	283
		Traditional animation	283
	anni anni anni anni anni anni anni anni	Animation – the Elements method	284
Photo Layouts	233	Animation advice	285
Four steps to Photo Layout creation	236	Flipbooks – a new way to animate	285
	238	Creating your own slide shows	286
Editing existing Photo Layout designs	240	Creating slide shows	286
Adding, removing and replacing photos		Version 5.0 slide shows in action	287
Adding, moving and deleting pages	242	Editing the slide photos	290
The Artwork and Effects palette	245		
Artwork and Effects > Artwork	246	45	
Artwork and Effects > Themes	246	Preparing Images for Printing	291
Artwork and Effects > Special Effects	247		NAME OF TAXABLE PARTY OF TAXABLE PARTY.
Artwork and Effects > Text	248	Printing the Elements way	293
Artwork and Effects > Favorites	248	Printing from the Organizer workspace	295
		The link between paper type and quality prints	295
40		Making your first print	296
I U Creating Great Panoramas	249	Printing a section of a full image	298
Taking Photomerge images	252	Making multiple prints	298
Image overlap	252	Contact sheets	299
Keep the camera level	252	Picture packages	301
Maintain focal length	253	Picture labels	303
3	253	Individual Prints	304
Pivot around the lens		Balancing image size and picture quality	306
Maintain exposure	254	Aiming for the best prints	306
Keep white balance consistent	255	Getting to know your printer	306
Watch the edges	255	Typical printing problems and their solutions	310
Editing your panorama	256	Web-Based Printing	311
Editor: File > New > Photomerge Panorama	257	Making your first online prints	312
Photomerge from the Photo Browser	259	Options for web printing	313
Photo Browser: File > New > Photomerge Panorama	259	4.5	
Photomerge in action	260	Photo Creations	315
Vertical stitches	260		
Document stitches	260	The Photo Creation projects	316
Making panoramas that spin	262	Photo Book Pages, Photo Layout and Album Pages	318
Fixing panorama problems	263	Greeting Card	320
Top tips from panoramic professionals	264	CD and DVD Jackets	322
		CD/DVD Label	324
44		Slide shows on your computer or TV	326
Preparing Images for the Web		VCD/DVD with Menu	328
	265	Photo Gallery	330
or E-mail	265	Flipbook	332
Images and the Net	267	Photo Calendar	334
GIF	267	Photo Stamps	336
JPEG	268	4 4	
JPEG 2000	268	14 Managing Your Files	337
PNG	268		
Flash	269	Organizing your photos with Photoshop Elements 5.0	338
		It starts in-camera	338
Getting the balance right	269	And continues when downloading	338
Web compression formats side by side	271	Organizing and searching features	340
Making your own web gallery	273	Tagging your photos	341
Multi-select pictures to include	275	Creating new tags	341
Built for speed	276	New Face Tagging technology	342
Going live	276	Collections – the Elements way to group like photos	343
Step-by-step Photo Galleries creation	277	Adding photos to a group	343
Sharing online – the Web Photo Galleries alternative	280	Using Collection Groups	344

Collection and Tagging strategies:	344
Locating files	344
Finding tagged photos or those contained in a collecti	on
	345
Find by details or metadata	346
Attaching a Map Reference	347
Protecting your assets	347
Making your first backup	348
Multi-disk Backup	349
Multi-session Backup	349
Online Backup	349
Backup glossary	350
Backup hardware	350
Back up regularly	350
Store the duplicates securely	350
Versioning your edits	351
Versions and Photoshop Elements	351
Elements' image stacks	352
Auto Stacking	353
Automating editing tasks	355
Multi-selection editing	356

Appendices	391
Jargon buster	392
Keyboard shortcuts	403
Elements/Photoshop feature equivalents	406
Index	407

15 Theory into Practice:	
Real Life Elements Projects	357
Project 1: Slide shows from your home videos	358
Project 2: Stitching big paintings together	359
Project 3: Professional folio of images on CD-ROM	361
Project 4: The school newsletter	362
Project 5: Real estates go digital	364
Project 6: Photographic print display	366
Project 7: Business manager presentation	368
Project 8: Restoration of a family heirloom	370
Project 9: Menu for restaurant	371
Project 10: Advertisement optimized for black and white	373
Project 11: Company logo, letterhead, business card	375
Project 12: Holiday paporamic posters	377

16 Where to From Here?	381
The differences between Elements and Photoshop	383
Offset printing	383
Web-based production	384
Color management	385
Automated functions	386
Paths	387
Curves	388
Color Balance	388
16-bit support	389
High Dynamic Range photos	390
Vanishing Point	390
Who can guide me further?	390

Foreword

In the mid-eighties a group of professional photographers, including myself, were invited to attend an early demonstration of the Quantel Graphics Paintbox system in action at a digital retouching house in Covent Garden, London. We all sat spellbound as we saw our scanned images instantly transformed by the magic of this new computer system. This was my first glimpse of the future of photography in a digital age. From that day forward I had always wanted to have my own computer retouching system and take control of the magic pen myself. However, I was soon brought back down to earth when I was told how much one of these systems would have cost. Back in those days digital retouching services were the preserve of an elite number of businesses such as advertising agency clients, as these were the only people who could afford to pay the equivalent of a good week's salary for an hour of electronic retouching time.

A few years later, Photoshop made its first appearance — an image-editing program that was designed to run on a desktop computer. From these humble beginnings Adobe Photoshop has grown to become the leading image-editing computer program used by graphic designers, artists, web designers and photographers from all around the world. Millions of people are now able to scan, capture and retouch their own photographs on desktop computers both at home and at work — in fact, I have heard all sorts of people from the bank manager to my hairdresser describe the amazing things they have been able to do to their pictures using a computer.

Whenever I present seminars on Photoshop techniques, I am always pleased to note the mixed age range and makeup of the audiences who attend these events. Digital image editing has been truly democratized now that everyone can afford to play. I use the word play deliberately, because even after all the years I have been using Photoshop, I still get a buzz whenever I am sitting at the computer transforming my pictures.

Photoshop Elements is essentially a cut-down version of Photoshop, yet it contains nearly all the image manipulation power of the parent program, but in an easy-to-use interface. Although Adobe have limited the range of some of the more advanced Photoshop features and functions, they have included a host of cool features such as the File Browser in the Organizer workspace and the Photomerge feature. Adobe Photoshop Elements is therefore an exciting program in its own right and it's going to be fun to use as well, but it is also a powerful tool, capable of handling a number of professional tasks.

Philip Andrews is a skilled and enthusiastic teacher and here he has produced a very well-written book that will help you, the reader, to quickly get to grips with all aspects of the program. The book is clearly illustrated throughout and you will find that Philip has thoughtfully included a number of practical tips on how to capture better photographs. On top of this, he shows you more than how to operate the program – he also demonstrates how to use Photoshop Elements with examples of practical assignments, such as the production of a school newsletter or an illustrated restaurant menu. In my experience I have found that readers always find it much easier to understand a program when they are provided with project examples that have a logical purpose to them. Philip's book is in every respect refreshingly direct and easy to understand.

Whatever your interest, I am sure that you are going to get a lot of interesting use out of Photoshop Elements. Whether you are into manipulating photographs, wishing to build better websites or producing better looking prints, this book will help you to master all the necessary tools contained in the program.

The learning curve has just got shallower!

Martin Evening

www.martinevening.com, www.photoshopforphotographers.com

Introduction

Here at Adobe, we believe that we make great software but just as a car manufacturer would never consider publishing a street index, we rely on gifted authors to provide our users with directions and guidelines on how to make the most of our products.

This task is not a simple one. It requires a good understanding of the product, the digital imaging environment and, most of all, the user. Philip Andrews is unique in that he is an author who possesses all these qualities. He has an ongoing professional photographic practice, lectures at universities and colleges, holds a position as an Adobe Ambassador in Australia and has authored over 200 articles and 20 books worldwide.

With these credentials you would imagine that his texts are informative but a little stuffy and academic – not true! In this, the fifth edition of his best selling Photoshop[®] Elements book, he again uses a very comfortable and easy to understand style that leads the reader carefully through the basics and then onto the more advanced techniques needed to edit and enhance their digital images. He not only provides 'must have' information about Photoshop Elements and how to use it, but also introduces the reader to important general digital concepts that puts the package firmly in the context of current imaging technology.

The book is dotted with great illustrations and pictures and, via the download section of the associated website, readers have the opportunity to follow the step-by-step techniques using many of these same images that are featured in the text. In addition, a whole chapter of real life projects shows how you can use Photoshop Elements to enhance your digital photography projects at home, at work, on vacation or at school.

I believe that with Philip providing you with such a good 'street index' to our Photoshop Elements 5.0 software you will be creating fantastic digital images in next to no time at all.

Good luck and have fun with your image making.

Jane Brady

Marketing Manager, Creative Solutions, Adobe Systems

Acknowledgements

Always for Kassy-Lee, but with special thanks to Adrian and Ellena for putting up with a 'would-be author' for a father for the last few months. Yes it is over...till next time at least!

Thanks also to the enthusiastic and very supportive staff at Focal Press whose belief in quality book production has given life to my humble ideas – yet again! Special thanks to Marie Hooper, Margaret Denley, Georgia Kennedy and Stephanie Barrett for as everyone knows, but doesn't acknowledge nearly enough, 'good book production is definitely a team effort'.

My appreciation goes to Jane Brady for her support and kind introduction, and cheers also to Martin Evening, the 'Guru of GUI', Don Day and Richard Coencas for their technical and 'pixelbased' guidance and to all the image makers who gave so freely of their time and pictures to provide practical examples of 'Real Life Digital Imaging'.

And thanks once more to Adobe for bringing image enhancement and editing to us all through their innovative and industry-leading products, and the other hardware and software manufacturers whose help is an essential part of writing any book of this nature. In particular I wish to thank technical and marketing staff at Adobe, Microsoft, Canon, Nikon and Epson.

And finally my thanks to all the readers who continue to inspire and encourage me with their generous praise and great images. Keep e-mailing me to let me know how your imaging is going.

Philip Andrews

The Buzz of Digital Photography

The beginning – the digital photograph

Making the digital image

Quality factors in a digital image

The steps in the digital process

Where does Photoshop Elements fit into the process?

Photoshop Elements 5.0

part from the initial years of the invention of photography, I can't think of a more exciting time to be involved in making pictures. In fact, I believe that Fox Talbot, as one of the fathers of the medium, would have little difficulty in agreeing that over the last few years the world of imaging has changed forever. Digital photography has become the two buzz-words on everyone's lips. Increasing levels of technology coupled with comparatively affordable equipment have meant that sophisticated imaging jobs that were once the closely guarded domain of industry professionals are now being handled daily by home and business users.

This book introduces you to the techniques of the professionals and, more importantly, shows you how to use these skills to produce high quality images for yourself and your business. With the text centered on Adobe's Photoshop Elements package and completely revised to cover the new features in version 5.0 as well as the tools common to the previous versions of the program, you will learn the basics of good digital production from the point of capturing the picture, through simple manipulation techniques to outputting your images for print and web. To help reinforce your understanding, you can practice with the same images that I have used in the step-by-step demonstrations by downloading them from the book's website (www. guide2elements.com). See Figure 1.1. Also, you will find real life examples in Chapter 15 showing you how to use your new-found skills to enhance your own images or create professional graphics for your business applications. Source files and instructions for these projects can also be found on the website, giving you the opportunity to practice your skills on real world tasks. See Figure 1.2.

Figure 1.1 The book's associated website contains practice images as well as downloadable projects designed to build your skills and knowledge.

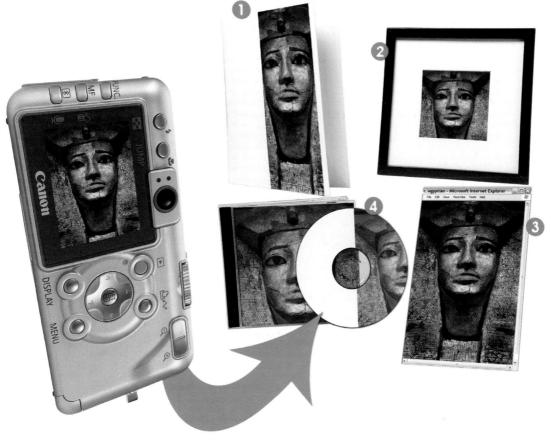

Figure 1.2 Digital imaging skills can be used to manipulate and enhance images so that they can be used in a variety of personal and business publications and products. (1) Presentation folder. (2) Framed print. (3) Web page. (4) CD artwork.

The beginning – the digital photograph

Computers are amazing machines. Their strength is in being able to perform millions of mathematical calculations per second. To apply this ability to working with images, we must start with a description of pictures that the computer can understand. This means that the images must be in a digital form. This is quite different from the way our eye, or any film-based camera, sees the world. With film, for example, we record pictures as a series of 'continuous tones' that blend seamlessly with each other. To make a version of the image the computer can use, these tones need to be converted to a digital form. The process involves sampling the image at regular intervals and assigning a specific color and brightness to each sample. In this way, a grid of colors and tones is created which, when viewed from a distance, will appear like the original image or scene. Each individual grid section is called a picture element, or pixel. See Figures 1.3 and 1.4.

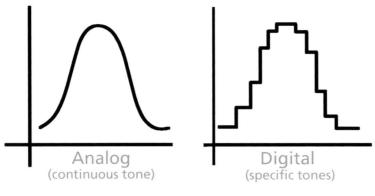

Figure 1.3 Continuous tone images have to be converted to digital form before they can be manipulated by computers.

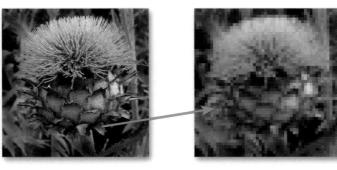

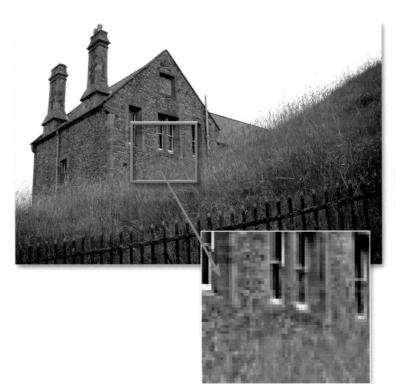

Figure 1.4 A digital picture is made up of a grid of picture elements or pixels.

Making the digital image

Digital files can be created by taking pictures with a digital camera or by using a scanner to convert existing prints or negatives into pixel form. Most digital cameras have a grid of sensors, called charge-coupled devices (CCDs), in the place where traditional cameras would have film. Each sensor measures the brightness and color of the light that hits it. When the values from all sensors are collected and collated, a digital picture results. See Figure 1.5.

Figure 1.5 The CCD or CMOS sensor takes the place of film in digital cameras.

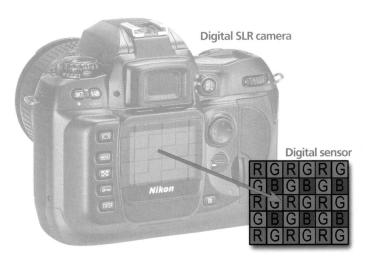

Scanners work in a similar way, except that these devices use rows of CCD sensors that move slowly over the original, sampling the picture as they go. Generally, different scanners are needed for converting film and print originals; however, some companies are now making products that can be used for both. See Figure 1.6.

Quality factors in a digital image

The quality of the digital file is largely determined by two factors – the numbers of pixels and the number and accuracy of the colors that make up the image. The number of pixels in a picture is represented in two ways – the dimensions, i.e. 'the image is 900×1200 pixels', or the total pixels contained in the image, i.e. 'it is a 3.4 megapixel picture'.

Generally, a file with a large number of pixels will produce a better quality image overall and provide the basis for making larger prints than a picture that contains few pixels. See Figure 1.7. The second quality consideration is the total number of colors that can be recorded in the file. This value is usually referred to as the 'color or bit depth' of the image. The current standard is known as 24-bit color or 8 bits per red, green and blue channel. A picture with this depth is made up of a selection of a possible 16.7 million colors. In practice this is the minimum number

of colors needed for an image to appear photographic. In the early years of digital imaging, 256 colors (8 bits of color per channel) were considered the standard. Though good for the time, the color quality of this type of image is generally unacceptable nowadays. In fact, new camera and scanner models are now capable of 12 bits per channel (36-bit color all together) or even 16 bits per channel (48-bit color all together). This larger bit depth helps to ensure greater color and tonal accuracy. See Figure 1.8.

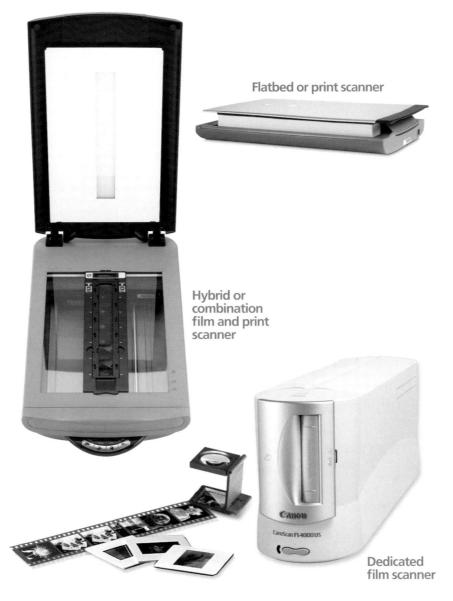

Figure 1.6 Photographs and negatives, or slides, are converted to digital pictures using either film or flatbed scanners.

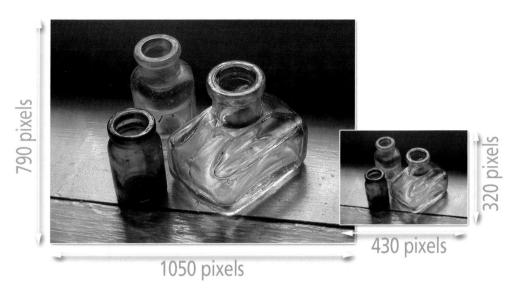

Figure 1.7 The size of a digital image is measured in pixels. Images with large pixel dimensions are capable of producing big prints and are generally better quality.

Figure 1.8 Color or bit depth determines the number of colors possible in a digital file. Confusingly the number of colors is often referred to as 'bits per color channel' with most files being made up of three channels – Red, Green and Blue. This gives a total of three times the bits per channel. (1) 8 bits per color channel or 24-bit total color (16.7 million colors). (2) 8-bit total color (256 colors). (3) 4-bit total color (16 colors). (4) 1-bit total color (two colors).

The steps in the digital process

The digital imaging process contains three separate steps – capture, manipulate and output. See Figure 1.9. Capturing the image in a digital form is the first step. It is at this point that the color, quality and detail of your image will be determined. Careful manipulation of either the camera or scanner settings will help ensure that your images contain as much of the original's information as possible. In particular, you should ensure that delicate highlight and shadow details are evident in the final image.

If you notice that some 'clipping', or loss of detail, is occurring in your scans, try reducing the contrast settings. If your camera pictures are too dark, or light, adjust the exposure manually to compensate. It is easier to capture the information accurately at this point in the process than try to recreate it later.

Manipulation is where the true power of the digital process becomes evident. It is here that you can enhance and change your images in ways that are far easier than ever before. Altering the color, contrast or brightness of an image is as simple as a couple of button clicks. Changing the size or shape of a picture can be achieved in a few seconds and complex manipulations like combining two or more images together can be completed in minutes rather than the hours, or even days, needed with traditional techniques. See Figure 1.10. Manipulation gives digital illustrators the power to take a base image and alter it many times so that it can be used in a variety of situations and settings. Once changed, it is possible to output this same image in many ways. It can be printed, used as an illustration in a business report, become part of a website, be sent to friends on the other side of the world as an e-mail attachment or projected onto a large screen as a segment in a professional presentation.

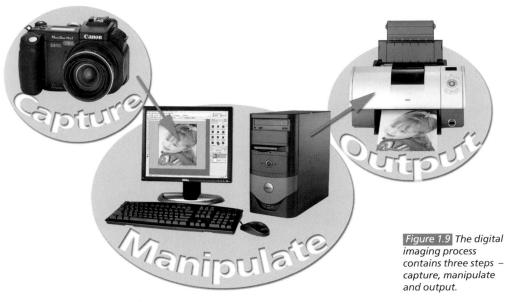

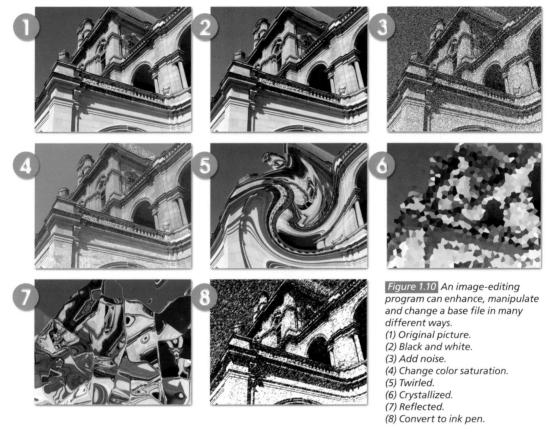

Where does Photoshop Elements fit into the process?

Photoshop Elements is a program that can be used for enhancing, manipulating, printing and organizing your digital photographs. Put simply, this means that it is the pivot point for the whole digital imaging process. See Figure 1.11. Its main job is to provide the tools, filters and functions that you need to manage, change and alter your pictures. Elements is well suited for this role as it is built upon the same core structure as Adobe's famous professional-level program Photoshop. Many of the functions found in this industry-leading package are also present in Elements, but unlike Photoshop, Adobe has made Elements easier to learn and, more importantly, easier to use than its professional cousin. In this way, Adobe has thankfully taken into account that although a lot of users need to produce professional images as part of their daily jobs, not all of these users are, or want to be, imaging professionals. See Figure 1.12. In addition, Elements contains features designed to download digital pictures from your camera, or scanner, directly into the program, as well as functions that allow you to output easily your finished images to web or print. When used in conjunction with other programs, like desktop publishing packages, it is also possible to include Elements' enhanced images in professionally prepared brochures, advertisements and reports.

Figure 1.11 Photoshop Elements is built on the same editing engine as its professional cousin Photoshop.

Photoshop Elements 5.0

Rather than sitting back and basking in the reflected glory of the success of the first few releases of Elements (versions 1.0, 2.0, 3.0 and 4.0). Adobe has been hard at work improving what was already a great product. Version 5.0, just like the releases before it, is a state-of-the-art image-editing program full of the features and functions that digital photographers and desktop image makers desire the most. Far from being overshadowed by the power and dominance of its bigger brother Photoshop CS2, Elements has quickly become the editing and enhancement 'weapon of choice' by many who count picture making as their passion. Completely revised to cover all versions of the program, this book will help you learn about the core technology and functions that are shared by Photoshop and Elements, and will also introduce you to the great range of features that are unique to Elements.

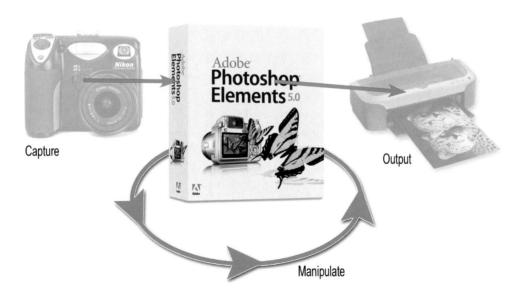

Figure 1.12 Elements is the center of the imaging process, providing the ability to import, manipulate and output digital pictures.

Introducing Photoshop Elements 5.0

Adobe Photoshop Elements 5.0 – new tools and features

The Photoshop Elements 5.0 workflow

The interface

hotoshop Elements is the type of software tool that photographers, designers and illustrators use daily to enhance and change their photos. There are many companies who make programs designed for this purpose and in this field Adobe has a substantial advantage over most of its competitors because it also produces the flagship for the industry – Photoshop. Now in its ninth version, this product, more than any other, has forged the direction for image-editing and enhancement software worldwide. In fact, the tools, functions and interface that are now standard to graphics packages everywhere owe a lot to earlier versions of Photoshop.

With the release of Elements, Adobe recognized that not all digital imaging consumers are the same. Professionals do require a vast array of tools and functions to facilitate almost any type of image manipulation, but there is a significant and growing number of users that want the robustness of Photoshop but don't require all the 'bells and whistles'. This makes Elements sound like a cut-down version of Photoshop, and to some extent it is, but there is a lot more to this package than a mere subset of Photoshop's features. Adobe has taken the time to listen to its customers, and has designed and included in Elements a host of extra tools and features that are not available in Photoshop. It's this combination of proven strength and new functions that makes Elements the perfect imaging tool for digital camera and scanner owners who need to produce professional-level graphics economically.

Adobe Photoshop Elements 5.0 – new tools and features

The release of version 5.0 of the program builds upon the firm foundation and user following that the previous editions secured. The revision contains a variety of new tools and features that I predict will fast become regularly used favorites. In addition, this Windows-only version builds on the extra organization and management features that were added in 3.0 and 4.0 and were originally part of the Photoshop Album package. Some of the new or upgraded features can also be found in Photoshop CS2, others are only available in Elements. Table 2.1 details some of the changes that are 'New for 5.0' and compares them with features found in previous versions of Photoshop and Elements.

The new or revised features are also highlighted throughout the book with the 'New for 5.0' symbol. Unlike previous versions of the program, version 5.0 is a Windows-only release and so this text contains no Macintosh equivalents.

Apart from the inclusion of a host of new features like Adjust Color Curves, a dedicated Convert to Black and White filter, a new Adjust Sharpness control, Auto Stacking of your Organizer images and an easy-to-use Correct Camera Distortion filter, the program continues to improve the picture management features that have made Elements a favorite with digital shooters. Right from version 3.0 of the program, Adobe has been gradually increasing the power of Elements to catalog, tag, rate, backup and search your photos. In version 5.0 this work continues and is

coupled with brand new ways of editing, enhancing and using your pictures. For the first time Elements includes an Artwork and Effects palette that houses graphics, layer styles, shapes, frames and even matched graphical elements broken into project themes. The new Photo Creation feature provides a free form workspace for arranging and presenting your pictures, giving the user more control over the final results than ever before. See Figure 2.1.

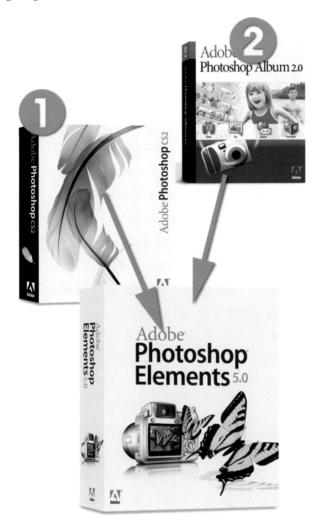

Figure 2.1 Photoshop Elements 5.0 combines many of the advanced editing features contained in Photoshop CS2 (1) along with many of the management tools that started life with Photoshop Album (2).

The Photoshop Elements 5.0 workflow

Elements 5.0 provides a workflow solution from the moment you download your files from camera, scanner or the net, through organization and manipulation phases and then onto printing (photos, books, calendars) or sharing the pictures electronically (online gallery, slide shows, e-mail attachments). Understanding how the various components in the system fit together will help you make the most of the software and its powerful new features. See Figure 2.2.

<u>Table 2.1</u> Summary of features of different versions of Adobe Photoshop Elements and Adobe Photoshop.

	PHOTOSHOP ELEMENTS						PHOTOSHOP				
	Photoshap Bemerits Budge	Photoshop Elements to	Photoshop	Address Baseline Base	Address Reasons	T contrader		Address (Salarian Salarian Sal	Address Honosilement Lamina (I).		
Feature	v5.0	v4.0	v3.0	v2.0	v1.0	CS2	CS	v7.0	v6.0		
 Artwork and Effects Palette 	-	×	×	×	×	×	×	×	×		
• Free Form Photo Creations	✓	×	×	×	×	×	×	×	×		
• Flipbooks	\checkmark	×	×	×	×	×	×	×	×		
 Correct Camera Distortion 	\checkmark	×	×	×	×	✓	×	×	×		
 Convert to Black and White 	V	×	×	×	×	×	×	×	×		
 Multi-session DVD/CD Rom writing 	✓	×	×	×	×	×	×	×	×		
 Expanded Version Sets 	\checkmark	×	×	×	×	×	×	×	×		
 Arrange and Distribute objects 	✓	×	×	×	×	✓	✓	✓	✓		
 Photo Creations – Auto Fill 	\checkmark	×	×	×	×	×	×	×	×		
 Multi-page documents 	\checkmark	×	×	×	×	×	×	×	×		
 Video format support in Organizer 	V	×	×	×	×	×	×	×	×		
• Yahoo Photo Map	\checkmark	×	×	×	×	×	×	×	×		
 Auto Stacking 	\checkmark	×	×	×	×	×	×	×	×		
 Multi-disk backup 	V	×	×	×	×	×	×	×	×		
 Online backups 	\checkmark	×	×	×	×	×	×	×	×		
• Flash galleries	\	×	×	×	×	×	×	×	×		
 Adjust sharpening control 	\checkmark	×	×	×	×		×	×	×		
 Advanced photo downloader utility 	✓	×	×	×	×	×	×	×	×		
 Shared media collections with Viiv technology 	✓	×	×	×	×	×	×	×	×		
 Color Curves 	\checkmark	×	×	×	×	\checkmark	\checkmark	\checkmark	\checkmark		
 Automatic Red Eye Fix 	\checkmark	✓	×	×	×	×	×	×	×		
 Magic Selection Brush 	\checkmark	\checkmark	×	×	×	×	×	×	×		
 Automatic Face Tagging 	\checkmark	\checkmark	×	×	×	×	×	×	×		
Magic Extractor	\checkmark	✓	×	×	×	\checkmark	\checkmark	\checkmark	×		
• Straighten tool	\sim	✓	×	×	×	×	×	×	×		
• Order Prints pane	✓	✓	×	×	×	×	×	×	×		
Create Desktop wallpaper from photos	√	V	×	×	×	×	×	×	×		
 Convert or remove ICC profiles 	✓	✓	×	×	×	√	. 🗸	✓	✓		
 View slide shows from inside Elements on TV via Windows XP Media Center 	✓	✓	×	×	×	×	×	×	×		
 Add captions to multiple files 	\checkmark	\checkmark	×	×	×	\checkmark	\checkmark	\checkmark	×		
 Adjust Skin Tone feature 	\checkmark	\checkmark	×	×	×	×	×	×	×		
• Remove JPEG artifacts	\checkmark	\checkmark	×	×	×	\checkmark	×	×	×		
• Create Paragraph text	\checkmark	\checkmark	×	×	×	\checkmark	\checkmark	\checkmark	\checkmark		
 Multi-select layers 	\checkmark	\checkmark	×	×	×	\checkmark	×	×	×		
 Defringe command 	\checkmark	\checkmark	×	×	×	\checkmark	\checkmark	\checkmark	\checkmark		
 WYSIWYG font previews 	\checkmark	\	×	×	×	\checkmark	×	×	×		
• Revised File Info dialog	√	\checkmark	×	×	×	\checkmark	×	×	×		

		PHOTOS	HOP EL	EMENT:	5		РНОТО	оѕнор	on the second
	Protecting Beneath of the Control of	Protoshop Bernents to	Photoshop	Address of the second of the s	AAAby Basolog Beron 2	12 Contraction		Panelage Panelage Co	Therefore
Feature	v5.0	v4.0	v3.0	v2.0	v1.0	CS2	CS	v7.0	v6.0
 Revamped Slide Show editor Find by metadata or Version 	✓	✓	x x	x x	×	x ✓	×	×	×
Set		•	Α	~	~	•	. .	^	
 Preview pictures in Full Screen mode 	✓	✓	×	×	×	√	✓	√	×
 Macintosh and Windows version 	×	√	√	√	√	\checkmark	\checkmark	\checkmark	√
 Import Outlook or vCard contacts 	✓	✓	×	×	×	×	×	×	×
 Camera Raw file support 	\checkmark	\checkmark	\checkmark	×	×	\checkmark	\sim	×	×
 16 bit per channel file support 	✓	✓	✓	×	×	\	V	✓	✓
 Shadow/Highlights control 	\checkmark	\checkmark	\checkmark	×	×	\checkmark	\sim	×	×
 Cookie Cutter cropping tool 	\checkmark	\checkmark	\checkmark	×	×	×	×	×	×
 Quick Fix editor 	\checkmark	\checkmark	\checkmark	×	×	×	×	×	×
 Auto Smart fix enhance feature 	✓	✓	✓	×	×	×	×	×	×
 Spot Healing Brush 	\checkmark	\checkmark	\checkmark	×	×	\checkmark	×	×	×
 Photo Browser with Date View 	\checkmark	√ WIN	√ win	×	×	×	×	×	×
 Photo/Palette/Organize Bin 	\checkmark	\checkmark	\checkmark	×	×	×	×	×	×
 Color Variations 	✓	\checkmark	\checkmark	\checkmark	\checkmark	\checkmark	✓	\checkmark	✓
 Hints palette 	\checkmark	\checkmark	\checkmark	\sim	\checkmark	×	×	×	×
 PDF slide show 	\checkmark	✓	✓	\checkmark	×	\checkmark	\checkmark	×	×
 Save for Web option 	\checkmark	\sim	\sim	\checkmark	\checkmark	\sim	\checkmark	\sim	\checkmark
 Recipes (How to) palette 	\checkmark	✓	\checkmark	✓	\checkmark	×	×	×	×
 Photomerge panoramic stitching tool 	\	\	✓	√	\	√	✓	×	×
 Get Photos from mobile phone 	✓	√	√win	×	×	×	x	×	x
 Adjustment layers 	\checkmark	\sim	\checkmark	\checkmark	\checkmark	\checkmark	\sim	√	
• Filter browser	\checkmark	✓	✓	✓	\checkmark	✓	\checkmark	×	×
 Picture Package for multiple prints 	✓	\	V	\	\	V	\checkmark	V	√
 Web Photo Gallery wizard 	\checkmark	✓	\checkmark	√	\checkmark	\checkmark	√	√	×
 Tag and Collection creation 	\sim	\checkmark	\sim	×	×	\sim	×	×	×
Effects browser	V	\checkmark	V	· 🗸	/	×	×	x	×
• Red Eye Brush	\checkmark	\checkmark	\checkmark	\checkmark	\sim	\checkmark	\checkmark	×	×
Painting tools	\sim	\	1	\	\	\checkmark	\checkmark	✓	√
 Web-based photo printing 	\checkmark	\		\sim	√	V	\sim	×	×
• Save as JPEG 2000	✓	~	√	√	×	√	√	×	×
 Photo Creations project wizard 	V	√win	√ WIN	×	×	×	×	x	×
 Selection/Mask Brush 	✓	\	\	\checkmark	×	×	×	×	×
 Attach to E-mail feature 	✓	-	√		*	×	×	×	×

Organize

1. START-UP

The **Welcome screen** is the first dialog box that the users sees when opening Element 5.0. From this screen you can choose to overview the program, organize, fix, edit or make a new Photo Creation from your pictures. There is also a link for connecting to online tutorials in the top right of the window.

Editor or Organizer workspaces rather than at the Welcome screen.

2. GET PHOTOS

The **Get Photos** feature allows you to preview, select and transfer files from a range of sources. Version 5.0 includes a sophisticated photo download utility for use with card readers and connected cameras.

Figure 2.2 The Photoshop Elements workflow moves from download through editing and enhancing to output.

Book resources at: www.guide2elements.com

3. VIEW/ORGANIZE

The **Organizer** workspace of Elements 5.0 works like a 'super' file browser, allowing you to manage, search, tag and backup all the photos in your picture catalog. You can view the photographs via the Photo Browser window or using the Date View. Pictures can be grouped into collections and you can find specific images via the unique 'keyword tags' that you attach to the files.

In Date View images are grouped and displayed based on the date they were taken.

Keyword tags can be added to any image. You can even create your own tags. You can also form subsets of picture based around a Collection heading. Both these features make finding your favorite pictures much easier.

4. EDIT/ENHANCE

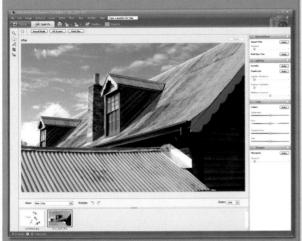

The **Quick Fix** editor provides a series of one-click or semi-automatic fixes for common problems with lighting, contrast, color and sharpness. All the controls are contained in the one screen for speed.

The **Standard** editor contains all the familiar editing and enhancement tools that Elements users have come to expect. It is here that you can take full control over the manipulation and fine-tuning of your pictures. You can also add text, play with layers, create multi-picture composites and combine all manner of special effects with your original photo.

In version 5.0 the two editing workspaces become part of the same screen. Switching between the edit modes is as simple as clicking the tab in the top left of the workspace.

5. PRINT/SHARE

The **Photo Creations** options have been completely revised for 5.0. Via these features Elements provides a multitude of output choices, both traditional, such as prints, and digital only, like the new Flash Galleries feature. Rather than being a completely separate workspace, as was the case in the previous version, users can make a variety of creations directly from either the Editing or Organizer spaces.

All the creation choices have been revised and now use standard step-by-step wizards that take the hard work out of using your photos to make items like DVDICD labels, album pages, flipbooks, slide shows, flash galleries, greetings cards and photo layouts.

As well as being able to output to a desktop printer, you can print online or even create wall calendars or Photostamps.

The interface

The program interface is the link between the user and the software. Most graphics packages work with a system that includes a series of menus, tools, palettes and dialog boxes. These devices give the user access to the features of the program. The images themselves are contained in windows that can be sized and zoomed. In this regard Elements is no different. Version 5.0 of the program sees a new look and feel to the workspace with a darker gray surround to most windows. See Figure 2.3.

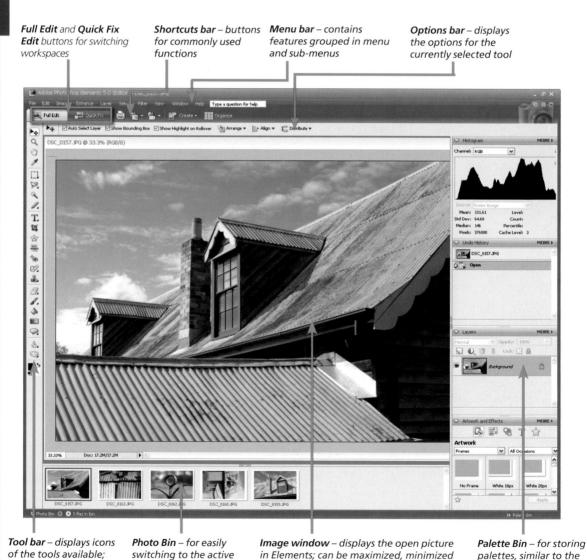

and cancelled using the corner buttons

Palette Well in v1.0, 2.0

Book resources at: www.quide2elements.com

document from those

Figure 2.3 The interface for the Windows-only release of Elements 5.0 Standard Editor.

open in the Editor workspace

can also be displayed in

two-column view

For most editing and enhancement functions you will be using the Full Editor component of Photoshop Elements, so over the next few pages we will look at the various parts of this screen and how they are used to allow you to interact with and change your pictures. Later on in the chapter we will also examine the interface of other parts of the Elements system such as the Organizer, Quick Fix editor and the Photo Creations wizard.

Photoshop Elements 5.0 is now supplied as a Windows-only package, whereas previous editions of the program have been released in two forms to suit both the Macintosh and Windows platforms.

The change continues

One of the most striking and immediately obvious changes to Elements 5.0 is the look for the interface. Adobe has been hard at work since version 3.0 redesigning and then refining the interface of the workspaces. Now the overall look is more modern complete with dark gray surrounds and colorful 3-D icons. Popular features like the **Photo** and **Organize Bins** that neatly retract to the side or bottom of the screen when they are not in use have been retained and added to. In particular, the new **Artwork and Effects** palette fits snuggly into the design and will quickly become a pivot point for all your layout activities. So for most of us who are migrating from 4.0, you will feel right at home in the 5.0 workspace.

New tools and features

As well as reinforcing the existing cosmetic changes initiated in previous versions Adobe has also chosen to include a range of new tools and features in release 5.0. These include great new productivity tools such as:

- the **Adjust Color Curves** control which provides finer levels of enhancement over the shadows, highlights and midtones in your photo (see Figure 2.4).
- the Adjust Sharpness filter provides even better control over the quality of sharpening applied to your images,
- a **Correct Camera Distortion** feature that removes the perspective and distortion effects that result from using wide or ultra wide angle lenses,
- new ways to search for stacked files in the catalog with the Find All Stacks command,
- a revised web gallery building feature, called Flash Galleries, that makes use of the multimedia abilities of the Flash format to professional looking photo

Figure 2.4 You can now manipulate the tones in the shadows, highlights and midtones of your picture independently using the new Adjust Color Curves feature.

- websites complete with self running slide shows and smooth transitions,
- the new Convert to Black and White feature
 which finally gives digital photographers the ability
 to customize their color to grayscale conversions (see
 Figure 2.5),
- the new **Flipbook** option creates small animations from multiple images, simulating the flipbooks of old, and then outputting the completed results to a video file (see Figure 2.6),
- a new way to arrange and present your images, called **Photo Layouts**, it includes options for adding predesigned frames, backgrounds, graphics, shapes, text and layer styles and even whole themes (matched sets of frames and backgrounds) to multi-page projects (see Figure 2.7),
- a **Backup Online** function that provides an easy way to keep a copy of your pictures on a secure web server ready to restore lost files in the case of a disaster,
- the ability to create true **multi-page documents** such as albums or scrapbooks where all the image, style and graphics components are stored together in the one file,
- a revised Photo Downloader utility which provides more options and easier pathways for downloading your files from camera or memory card to Elements,
- the ability to **Automatically Stack** photos with similar content or taken at the same time,
- more options for tweaking layer styles,
- extra creation and output projects including CD and DVD labels, CD and DVD jackets, scrapbook pages,
- write backups of your catalog over Multiple Disks and Multiple Sessions,
- Version Sets now are contained in a dark gray 'capsule' with a Collapse/Expand button for easy viewing,
- You can drag-select **multiple thumbnails**; use Shift and Ctrl keys to augment the selection. Selected thumbs are highlighted dark gray, and
- the ability to map your memories by viewing your photos displayed on a Yahoo Map in the precise location where your photographed them.

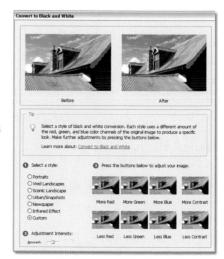

Figure 2.5 Control how the colors in your photos get translated to gray with the new Convert to Black and White feature.

Figure 2.6 Create simple animations from multiple photos with the Flipbook function.

Figure 2.7 Arrange and present your photos with professional results with Photo Layout.

Revamped favorites

In addition to these new features version 5.0 also showcases improved versions of many of the program's existing tools and functions that have proven to be firm favorites with image makers worldwide.

Revamped features include:

- the ability to scroll through the photos in your
 Organizer catalog faster than in previous versions, even if your picture collection grows to exceed
 50,000 images,
- added sophisticated options in the Photo
 Downloader such as the ability, in the Advanced mode, to automatically stack alike images and add group tags to sets of photos (see Figure 2.8),
- the added ability to set the Photo Downloader utility to automatically transfer photos from camera or memory card the moment either is connected,
- being able to write the tags you apply to photos as standard **IPTC keywords** allowing others to see and use these tags when you share the photos (see Figure 2.9).
- better sharing of content such as slideshows with **Premiere Elements**, and
- improved selection abilities in both Magic Selection Brush and Magic Extractor tools (see Figure 2.10).

Figure 2.8 New options in the Photo Downloader utility allow for automatic photo stacking and group tagging.

Figure 2.9 Now you can write the tags, which you apply so carefully to your photos, to their EXIF data. This allows others, who don't have Elements, the ability to view, sort and search your pictures based on these tags.

Figure 2.10 The Magic Selection Brush (1) and Magic Extractor tool (2) that were first introduced in Elements 4.0 have both been revised so that they now produce more predictable and more accurate results.

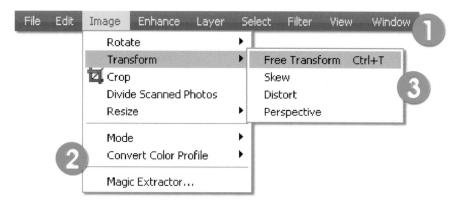

Figure 2.11 The menu bar provides access to the major features and commands in the program. (1) Main menu bar. (2) Menu. (3) Sub-menu.

Menus

Most image-editing programs contain a menu bar with a range of choices for program activities. In addition to the standard File, Edit, View, Window and Help menus, Elements contains five other specialist headings designed specifically for working with digital pictures. See Figure 2.11.

The *Image* menu contains features that change the shape, size, mode and orientation of the picture. Grouped under the *Enhance* heading is a range of options for altering the color, contrast and brightness of images, as well as the new Auto Sharpen, Adjust Sharpness and Convert to Black and White features. All functions concerning image layers and selections are contained under the *Layer* and *Select* menus. Version 5.0 also introduces a new option to the Enhance > Adjust Color menu in the form of the Adjust Color Curves control. The special effects that can be applied to images and layers are listed under the *Filter* menu and in this latest release the Unsharp Mask filter has been moved to the Enhance menu.

Selecting a menu item is as simple as moving your mouse over the menu, clicking to show the list of items and then moving the mouse pointer over the heading you wish to use. With some selections a second menu (sub-menu) appears, from which you can make further selections. See Figure 2.11.

Some menu items can also be selected using a combination of keyboard strokes called shortcuts. The key combinations for these features are also listed next to the item in the menu list. For example, the Free Transform can be selected using the menu selections Image > Transform > Free Transform or with the key combination of Ctrl + T (the Control key and the letter 'T').

Because Photoshop Elements 5.0 has several different workspaces that you can work within, I will indicate the workspace first before the menu sequence required to select a feature. For instance, to select the Free Transform feature (as pictured in Figure 2.11) from inside the Standard Editor space the notation would be **Editor: Image > Transform > Free Transform**.

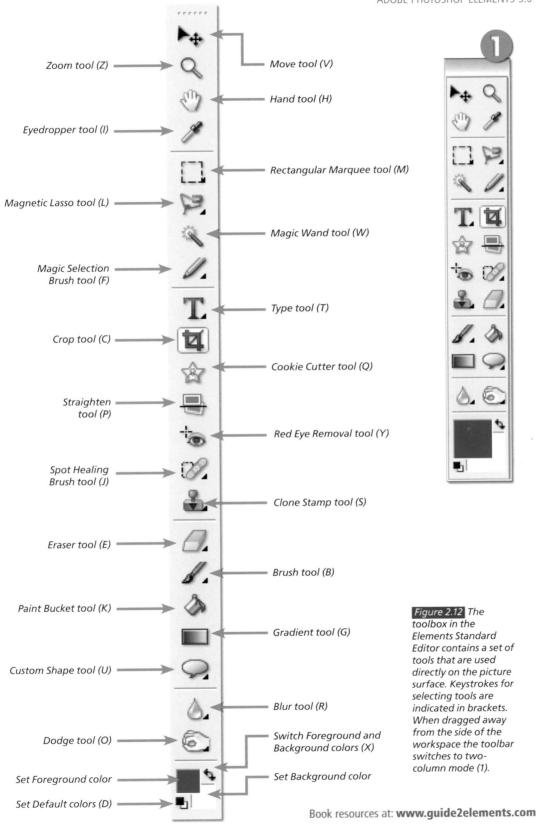

Tools

Unlike menu items, tools interact directly with the image and require the user to manipulate the mouse to define the area or extent of the tools' effect. Over the years the number and types of tools found in digital photography packages have been distilled to a common few that find their way into the toolbox of most programs. Amongst these familiar items are the Magnifying Glass or Zoom tool, the Brush, the Magic Wand, the Lasso and the Cropping tool. See Figure 2.12 on page 23. In addition to these few, each company produces a specialized set of customized tools that are designed to make particular jobs easier. Of these, Elements users will find the Red Eye Removal tool, Custom Shape, the Selection Brush, Cookie Cutter, Straighten, Healing Brush and the Magic Selection Brush tools particularly useful.

Some tools contain extra or hidden options which can be viewed by clicking and holding the mouse key over the small triangle in the bottom right-hand corner of the Tool button. Alternatively the sub-menu may list a variety of tools related to the one currently selected. Selecting a new option from those listed will replace the current icon in the toolbox with your new choice. To switch back simply reselect the original tool or repeatedly press the tool's hotkey. See Figure 2.13.

Figure 2.13 Click and hold the triangle in the bottom right of the tool icon to reveal the tool's other options or related tool choices.

Tool types

The many tools available in Photoshop Elements can be broken into several different groups based on their function or the task that they perform.

Selection tools

Selection tools are designed to highlight or isolate parts of an image. This can be achieved by drawing around a section of the picture using either the Marquee or Lasso tools or by using the Magic Wand tool to define an area by its color. The Selection Brush tool allows the user to select an area by painting the selection with a special brush tool. Careful selection is one of the key skills of the digital imaging worker. Often, the difference between good quality enhancement and a job that is coarse

Figure 2.14 Selection tools are used to isolate a specific area in a picture. This can be achieved by drawing around the picture part or you can create the selection based on color.

Book resources at: www.guide2elements.com

and obvious is based on the skill taken at the selection stage. Also included in this group is the Magic Selection Brush, that selects picture parts based on quick scribbles. See Figure 2.14.

Painting/drawing tools

Although many photographers and designers will employ Elements to enhance images captured using a digital camera or scanner, some users make pictures from scratch using the program's drawing tools. Illustrators, in particular, generate their images with the aid of tools such as the Paint Bucket. Airbrush and Pencil. This is not to say that it is not possible to use drawing or painting tools on digital photographs. In fact, the judicious use of tools like the Brush can enhance detail and provide a sense of drama in your images. Also included in this grouping are the Eraser tool, which comes in handy for cleaning up drawn illustrations and photographs alike, the Gradient tool used for filling areas with a blend from one color to another and the Custom Shape tool. Unlike the other tools in this group the Custom Shape tool creates vector-based or sharp-edged graphics. This tool is especially good for producing regularly shaped areas of color that can be used as backgrounds for text. See Figure 2.15.

Enhancement tools

These tools are designed specifically for use on existing pictures. Areas of the image can be sharpened or blurred, darkened or lightened and smudged using features like the Burn or Dodge tool. The Red Eye Brush is great for removing the 'devil'-like eyes from flash photographs and the Clone Stamp tool is essential for removing dust marks, as well as any other unwanted picture details. The Spot Healing tool works like an advanced version of the Clone Stamp. See Figure 2.16.

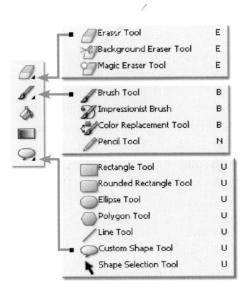

Figure 2.15 Painting and drawing tools are used to add details to existing images or even create whole pictures from scratch.

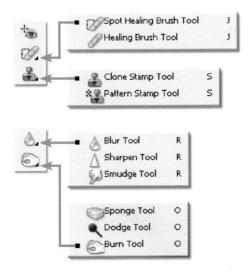

Figure 2.16 Enhancement tools are used to alter existing images to improve their overall appearance.

Move and view tools

The Hand tool helps users navigate their way around images. This is especially helpful when the image has been 'zoomed' beyond the confines of the screen. When a picture is enlarged to this extent it is not possible to view the whole image at one time; using the Hand tool the user can drag the photograph around within the window frame. The Zoom tool allows you to get closer to, or further away from, the picture you are working on and the Move tool is used to select, and move, individual picture parts within the picture itself. See Figure 2.17.

Figure 2.17 The Hand tool is used to navigate around enlarged pictures, whereas the Zoom tool alters the magnification of the image on screen.

Text tools

Combining text with images is an activity that is used a lot in business applications. Elements provides the option to apply text horizontally across the page, or vertically down the page. In addition, since version 2.0, two special text masking options have been included that can be used in conjunction with images to produce spectacular effects. See Figure 2.18.

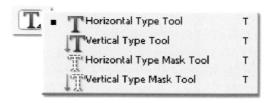

Figure 2.18 The Text tool is used to add type and type masks to images.

Cropping and straightening tools

The final group of tools is designed for removing unwanted sections of the image and straightening crooked pictures. Using the standard and familiar Crop tool we can drag a marquee around the part of the picture that we wish to keep and then double-click inside the frame to remove the image areas outside the selection. The Cookie Cutter tool, first introduced in version 3.0, takes the idea further by providing the ability to crop your picture to a specific shape on the rectangular canvas.

Figure 2.19 The Crop and Cookie Cutter tools are used for changing the shape of your pictures and removing unwanted edge sections.

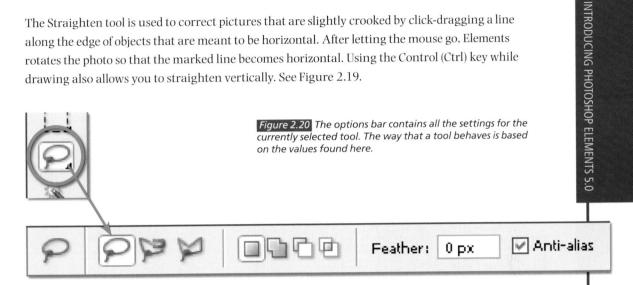

Options bar

Each tool and its use can be customized by changing the values in the options bar. See Figure 2.20. It is located below the shortcuts bar at the top of the screen. The default settings are displayed automatically when you select the tool. Changing these values will alter the way that the tool interacts with your image. For complex tools like the Brush, more settings can be found by selecting the More button located to the extreme right of the bar.

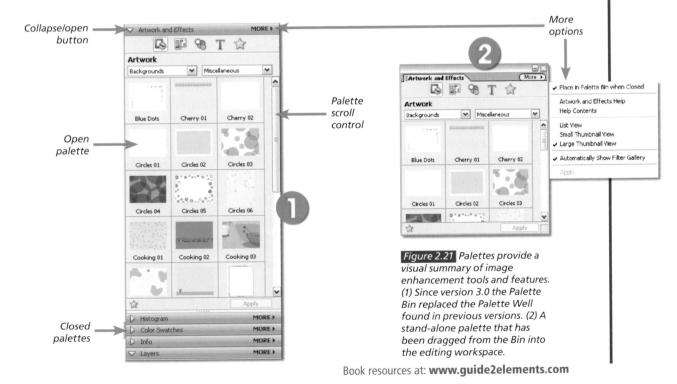

Palettes

Palettes are small windows that help the user enhance their pictures by providing extra information about images or by listing a variety of modification options. See Figure 2.21. Palettes can be docked in the Palette Bin (Palette Well for versions 1.0 and 2.0) or dragged and dropped onto the main editing area. Commonly used functions can be grouped by dragging each palette by their tab onto a single palette window. To save space only have open those palettes that you need for the editing or enhancing job at hand. Close the remaining palettes by clicking the Close button in the top of the palette window or drag them to the retractable Palette Bin so that they are out of the way.

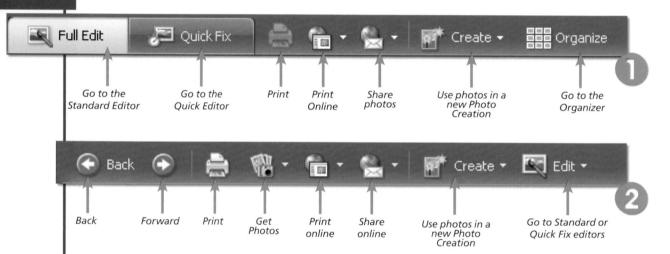

Figure 2.22 Shortcuts are button versions of commonly used menu items. (1) The shortcuts bar for the Quick Fix and Standard editor workspaces. (2) The shortcuts bar for the Organizer workspace.

Shortcuts bar

The shortcuts bar in the Standard and Quick Fix editors along with the one found in the Organizer workspace contain button versions of commonly used commands. See Figure 2.22. The same commands can also be accessed via the menu bar. In the Editor workspaces there are two buttons to the left that allow you to switch between Quick Fix and Standard modes. This spot was occupied by the Palette Well in previous versions of the program. The Palette Bin now performs the same function as the Palette Well, allowing the open palettes to be stored away from the main editing space providing more screen area for image windows.

The Quick Fix editor

The Quick Fix tool (Enhance > Quick Fix), which was introduced in version 2.0 of Elements, cleverly combined a variety of commonly used enhancement and correction tools into a single image control center. With this feature the user no longer needed to access each individual

tool or menu item in turn, rather all the options are available in one place. The feature proved so popular that in Elements 3.0 a completely new editing option, called the Quick Fix editor, was introduced. The component is accessed from the Welcome or start-up screen, or via the Quick Fix shortcut button in the Standard editor workspace or the Edit shortcut key and menu in the Organizer. The Quick Fix workspace has the same before and after layout as the original Elements 2.0 dialogue and contains a reduced tool and feature set designed to facilitate the fast application of the most frequent of all enhancement activities undertaken by the digital photographer. See Figure 2.23.

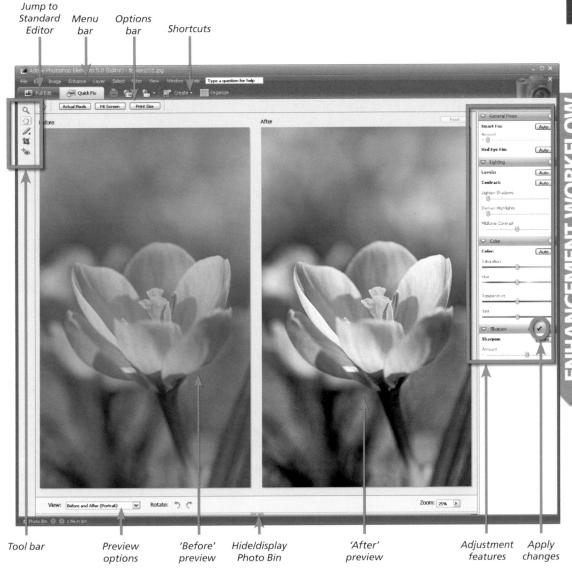

Figure 2.23 The Quick Fix editor brings together all your most commonly used tools and adjustment features into one easy- and quick-to-use workspace.

The Zoom, Hand, Crop, Magic Selection Brush (and the nested Selection Brush) and Red Eye Removal tools located in a small tool bar to the left of the screen are available for standard image-editing changes and the fixed Palette Bin, to the right, contains the necessary features to alter and correct the lighting, color, orientation (Rotate), red eye (automatically) and the sharpness of your pictures.

One of the best aspects of the Quick Fix editing option is the fact that the user can choose to apply each image change automatically, via the Auto button, or manually using the supplied sliders. This approach provides both convenience and speed when needed, with the option of a manual override for those difficult editing tasks. The adjustment features are arranged in a fashion that provides a model enhancement workflow to follow – simply move from the top to the bottom of the tools starting with picture rotation, working through lighting and color alterations and, lastly, applying sharpening.

The Organizer workspace (Photo Browser or Date View)

Along with the Quick Fix editor, Elements 3.0 also introduced a new sophisticated file browsing and management workspace called the Organizer. Previous to this Elements incorporated an older style File Browser feature which provided a quick way to visually locate your images but didn't contain the range of search, tag and display options that the Organizer workspace boasts. See Figures 2.24 and 2.25.

Once the picture files have been imported (Organizer: File > Get Photos) into Elements they can be viewed by date taken, their associated tags and even their folder location. Pairs of pictures can be viewed side by side with the Organizer: View > Compare Photos Side by Side feature to help choose the best shot from a series of images taken of the same subject. Instant slide shows of whole

Figure 2.25 The Organizer or Photo Browser workspace adds extra search, management and viewing options to your collections of images. Simple 'Auto Fixes' (Auto Smart Fix and Auto Red Eye Fix) can be applied directly from the thumbnail display without having to enter the main editing application window.

collections, or just those pictures selected from the browser, can be created and displayed using the Organizer: View > View Photos in Full Screen feature.

Simple editing tasks, such as the automatic adjustment of levels, contrast and/ or sharpness along with simple orientation and crop changes can be performed directly from inside the browser with the Auto Fix feature. Finding your favorite pictures has never been easier as you can search by date, caption, filename, history, media type, tag and color similarity (to already selected photos).

Different icons in the top right corner of the Photo Browser thumbnail represent different file types.

- (1) Multi-page .PSE. (2) Photo gallery.
- (3) Slide Show.
- (4) Video.

The Photo Creations feature

In version 3.0 Adobe added a separate Photo Creations workspace to Elements. The feature used a wizard approach to create great projects with your pictures. It is these sets of guided projects that have helped set Elements apart from other image-editing programs. Much of the program's popularity is based on the ease with which users can convert a group of their photos into a finished project.

In version 5.0 the Photo Creations area has been completely revised. The step-by-step wizard approach remains but the separate workspace is gone. Now you can commence the creation process from either the Organizer or Edit workspaces using the options listed under the Shortcut button or the File > Create menu. See Figure 2.26.

Figure 2.26 The Photo Browser or Organizer shortcuts bar provides button-based access to a range of organizing, editing and sharing options for selected thumbnail images.

The Create menu is the starting point for the production of slide shows, greeting and postcards, calendars, online galleries, album pages and Video CD (VCD) presentations. Whole collections, several individually selected files from the Organizer or images open in the Editor, can be used as a basis for the projects. The steps involved in creating the project are clear and precise, with sophisticated and professional results being available in minutes rather than hours, which would be the case if manually produced.

Version 5.0 Creations

As well as changing the way that you access creations, version 5.0 contains a modified mix of creation offerings. The major addition is the Photo Layout project. This new entry is a free form multi-page offering and the new wizard, introduced here, flows through to the other creation options (Album Pages, CD/DVD Jacket, Greeting Card, CD/DVD Label, Kodak Photo Book pages). The wizard contains three basic steps — choose project page size, select the layout design and then nominate the style of the layout. Next you click OK and Photoshop Elements

Figure 2.27 The Photo Creations option provide step-by-step guides to creating projects such as album pages, greeting cards, slide shows and online galleries. (1) Photo Creations are accessed via the File > Create menu or the Create shortcut button. (2) Most Create options now use a common wizard to select the size, layout and style for the project. (3) After clicking OK the projects are created as a multi-page document in the Standard editor workspace. The pages are stored in a special stack in the Photo Bin. Extra frames, photos, shapes, text and graphics can be added at this point. (4) The finished creation can then be printed on a desktop printer or via the online options (5). The multi-page document is saved in the new .PSE or Photoshop Elements format (6).

creates multiple pages and automatically inserts the photos in the layouts on these pages. At this stage the project becomes a standard multi-page document, a format that is also new to version 5.0. See Figure 2.27. Whilst the project is in the Standard Editor space you can adjust the style settings (drop shadows etc.), add extra pictures, surround them with frames, add text and other graphics or shapes, or even change each page's theme. When complete you save projects in the .PSE or new Photo Creations Format. See Figure 2.28.

Multi-page documents can be printed directly on your desktop printer or sent to an online print or book service, such as the one offered by Kodak's EasyShare gallery.

Figure 2.28 To coincide with the introduction of new multi-page creation documents in Photoshop Elements 5.0 Adobe has created a new file format called the Photoshop Elements format; it has a .PSE extension. Multipage documents and projects can be identified in the Organizer by the new PSE icon in the top right of the thumbnail.

s a simple introduction to the program, this chapter will take you through the first basic steps involved in digital photography from downloading your pictures from your camera to the computer to holding an enhanced print in your hand.

We won't get involved in any manual or complex editing or enhancement techniques – there will be plenty of time for these in the next couple of chapters – instead, we will look at the various ways that you can get your images from your camera or scanner into the program, and see how you can manage the pictures once they are there. Then we will select an individual photograph, rotate and crop the image, save the changed file and finally print the picture. So let's get started.

Figure 3.1 The Elements Welcome screen appears as the user opens the program. The screen can also be displayed by selecting Window > Welcome from the menu bar of the Standard and Quick Fix editor workspaces and the Organizer.

The Welcome screen

When Elements is first opened, the user is presented with a Welcome screen containing several options. See Figure 3.1. The selections are broken into different types of imaging activities and, depending on where you are in the workflow, will determine your entry point into the program.

So to start let's overview the options in the Welcome screen.

Product Overview – This selection provides you with a description of how Photoshop Elements can be used to enhance and improve your digital photographs. It also contains an introductory movie and details of the differences between this and other versions of Photoshop Elements.

View and Organize Photos – Designed as the first port of call for downloading your pictures from cameras, scanners and mobile phones, this selection takes you to the Organizer component of the Elements system. Start here when first introducing your pictures into Elements.

Quickly Fix Photos – This selection takes you directly to the Quick Fix component of the Photoshop Elements system. This editing mode provides more manual control than is available with the Auto Fix feature but less than that found in the more sophisticated Full Edit.

Edit and Enhance Photos – Click here to take you to the Full Edit. This mode provides you with the most powerful enhancement and editing tools and features available in Elements. Users undertaking complex, multi-step alterations to their photographs should proceed directly to this workspace.

Make Photo Creations – This button takes you to the step-by-step interface that guides you through the production of items such as slide shows, album pages, greetings cards, web galleries and wall calenders.

Tutorials – Select this option if you want to access the online Photoshop Elements tutorials and video resources. This includes the How To techniques and Help topics.

Start From Scratch (not included in 5.0) – This option was a part of the Welcome screen from previous releases of the software. It provided an alternative to commencing the editing process with an existing image. In version 5.0 to create a new blank document go to the Full Edit workspace (choose Edit and Enhance Photos in the Welcome screen) and then select File > New > Blank File. This action achieves the same result and is the place to start if you want to construct a picture from several other images or if you need to create a document of a specific size and format.

Step 1: Getting your pictures into Elements

Over the history of the development of Photoshop Elements one of the most significant additions to the program has been the Organizer or Photo Browser/Date View workspace. This feature provides a visual index of your pictures and can be customized to display the images in Browser mode, Date mode or sorted by keyword tags or collection. Unlike the standard file browsers of previous editions, which created the thumbnails of your pictures the first time that the folder was browsed, the Photo Browser, or Organizer as it is also called, creates the thumbnail during the process of adding your photographs to a collection.

To start your first collection simply select the View and Organize option from the Welcome screen and then proceed to the Organizer: File > Get Photos menu option. Select one of the listed sources of pictures provided and follow the steps and prompts in the dialogs that follow.

Organizer: File > Get Photos > From Camera or Card Reader

To start we will download photographs from a memory card or camera. This will probably be the most frequently used route for your images to enter the Elements program. Select the From Camera or Card Reader option from the File > Get Photos menu or from the list that pops up when you click the Get Photos button in the shortcuts bar. Next you will see the Adobe Photo Downloader dialog. This feature has been completely overhauled for version 5.0. It now contains the option of either a Standard or Advanced dialog. See Figure 3.2. The Advanced option not only provides thumbnail previews of the images stored on the camera or card but the dialog also contains several new features for sorting and managing files as they are downloaded. But let's start simply, with the options in the Standard dialog.

Standard Mode Workflow

After finding and selecting the source of the pictures (the card reader or camera) you will then see a thumbnail of the first file stored on the camera or memory card. By default all pictures on the card will be selected ready for downloading and cataloging.

Next set the Import Settings. Browse for the folder where you want the photographs to be stored and if you want to use a subfolder select the way that this folder will be named from the Create Subfolder drop-down menu. To help with finding your pictures later it may be helpful to add a meaningful name, not the labels that are attached by the camera, to the beginning of each of the images. You can do this by selecting an option from the Rename File drop-down menu and adding any custom text if needed. It is at this point that you can choose what action Elements will take after downloading the files via the Delete Options menu.

It is a good idea to choose the Verify and Delete option as this makes sure that your valuable pictures have been downloaded successfully before they are removed from the card. Clicking the Get Photos will transfer your pictures to your hard drive – you can then catalog the pictures in

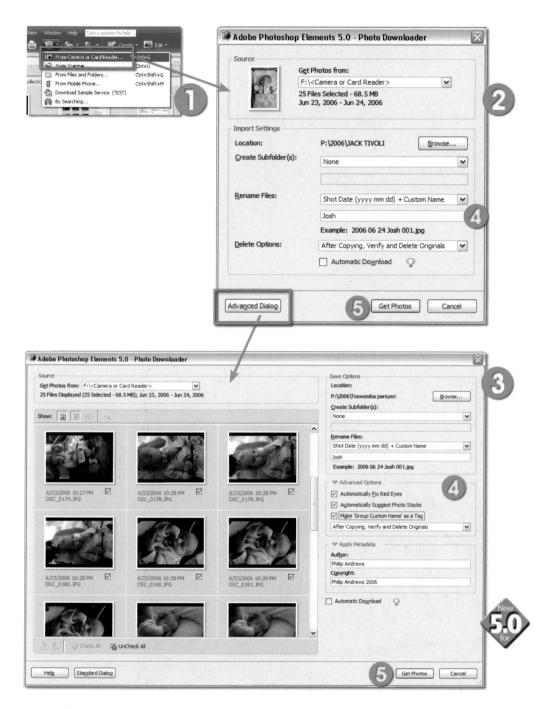

Figure 3.2 To download the pictures from your camera's memory card whilst in Organizer workspace:

- (1) select Get Photos > From Camera or Card Reader.
- (2) locate the card reader in the drop-down menu.
- (3) browse for the folder to store the pictures.
- (4) elect to Rename or Auto Fix Red Eye, and then
- (5) click the Get Photos button.

the Organizer workspace. For more choices during the download process you will need to switch to the Advanced mode. See Figure 3.2.

Advanced Mode Workflow

Selecting the Advanced Dialog button at the bottom left of the Standard mode window will display a larger Photo Downloader dialog with more options and a preview area showing a complete set of preview thumbnails of the photos stored on the camera or memory card. If for some reason you do not want to download all the images, then you will need to deselect the files to remain by unchecking the tick box at the bottom right-hand of the thumbnail.

Note: Only files that are selected in Adobe Photo Downloader can be deleted from the camera. This means they have to be downloaded and added to the catalog (even if they're already there from a previous download) before they are deleted.

This version of the Photo Downloader contains the same Location for saving transferred files, Rename and Delete after importing options that are in the Standard dialog. In addition, this mode contains the following options (see Figure 3.3 and Figure 3.4):

Automatically Fix Red Eyes – First introduced in Elements 4.0, this feature searches for and corrects any red eye effects in photos taken with flash.

Automatically Suggest Photo Stacks – Select this option to get the downloader utility to display groups of photos that are similar in either content or time taken. The user can then opt to convert these groups into image stacks or keep them as individual thumbnails in the Organizer.

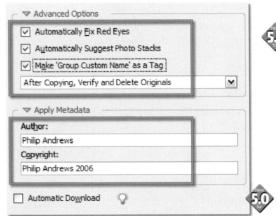

Figure 3.3 The Photo Downloader utility's Advanced mode contains several new options including auto stacking, auto tagging and adding metadata on the fly. This is in addition to the great Auto Red Eye Fix feature that was introduced in version 4.0.

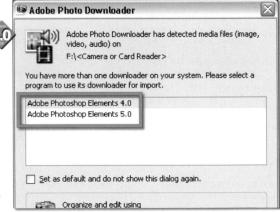

Figure 3.4 If you are upgrading from Elements 4.0 and have retained that version of the program alongside the new version, then selecting the Get Photos > From Camera or Card Reader option will display the warning seen here. Use this dialog to select the downloader version that you wish to use. To make this a permanent choice tick the 'Set as default and do not show this dialog again' option.

Make 'Group Custom Name' as a Tag — To aid with finding your pictures once they become part of the larger collection of images in your Elements' catalog, you can group tag the photos as you download them. Adding tags is the Elements equivalent of including searchable keywords with your pictures. This task is normally handled once the photos are in the Organizer workspace but version 5.0 introduces a new automated way to add the same tag to all the photos downloaded in a single session. The tag name used is the same as the title added in the Rename section of the Photo Downloader utility.

Apply Metadata (Author and Copyright) – With this option you can add both author name and copyright details to the metadata that is stored with the photo. Metadata, or EXIF data as it is sometimes called, is saved as part of the file and can be displayed at any time with the File Info (Editor) or Properties (Organizer) options in Elements or with a similar feature in other imaging programs.

Automatic Downloads

Both the Standard and Advanced dialogs contain the option to use automatic downloading the next time a camera or card reader is attached to the computer. The settings used for the auto download, as well as default values for features in the advanced mode of the Photo Downloader, can be adjusted in the Organizer: Edit > Preferences > Camera or Card Reader dialog.

Organizer: File > Get Photos > From Scanner

The Organizer: Get Photos > From Scanner option enables users to obtain images directly from the scanners they have connected to their computers. A dialog asking the user to 'Select an input source' may appear if your scanner is not automatically detected. To continue, select the device from the list and click OK. Next, the driver window that was supplied with the scanner will be displayed. In this dialog you can preview the picture and adjust the settings that will govern the scanning process. See Figure 3.5.

Start by performing a Preview scan (some scanners handle this step automatically). This will produce a quick low-resolution picture of the print or negative. Using this image as a guide, select the area to be scanned with the Marquee or Cropping tool. Next, adjust the brightness, contrast and color of the image to ensure that you are capturing the greatest amount of detail possible. Now input your scan sizes, concentrating on ensuring that the final dimensions and resolution are equal to your needs. As a rough guide, remember that if your original print or film frame is small you will need to scan at a high resolution in order to produce a reasonable file size. Large print originals, on the other hand, can be scanned at lower resolutions to achieve the same file size. Sound a little confusing? It can be, but most scanner software is designed to help you through the maze.

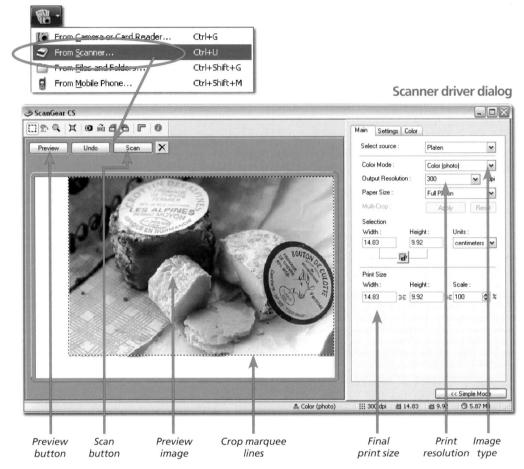

Figure 3.5 Scanner driver software contains settings to vary the output size and resolution of your images as well as controls for changing the brightness, contrast and color of your scans.

The scanner driver dialog is designed and supplied by the same company that manufactures the scanner itself. When the Organizer: File > Get Photos > From Scanner option is selected the Elements program goes in search of this driver software and displays it in a separate window on screen. When you alter settings you are controlling the scanning process only. All of this process happens outside

of Elements and, once completed, the scanned file is then passed to the Elements program. This is the reason why after scanning you sometimes need to close the control dialog to see the finished image waiting in the Elements workspace behind.

The driver dialog detailed above is supplied with Canon scanners. Your own scanner control may appear different from this one but all but the most basic machines will have options for changing size, resolution, contrast, brightness and color. Look to your manual or the online help option for your model to locate the controls.

Ensuring enough pixels for the job

When you capture an image using a print or film scanner you are creating a digital file. Unlike the situation with most digital cameras, where the largest pixel dimensions of the file are fixed by the size of the sensor, images made via a scanner can vary in size depending on the settings used to create them. To make sure that you have enough pixels for your requirements, it is important to remember that the quality of the image, and the size that it can be printed, are determined, in part, by its pixel dimensions. It is therefore good practice to choose the pixel dimensions for your image based on what that picture will be used for. An image that is destined to become a poster will need to have substantially more pixels than one needed for a postage stamp. 'Just how many more pixels are needed?' is a good question. The answer can be found in the numbers you input in the scanner dialog.

The final dimensions of your digital picture should be input directly into the Width and Height boxes of the control. Next, the output resolution that you will use when printing your picture is placed in the Resolution box. The scanner driver will usually handle the rest, working out the exact file size needed to suit your requirements.

If you are unsure what resolution to input, use the settings in the following table as a starting point. See Table 3.1. If your picture is to be printed at a variety of sizes, scan your image for the largest size first and then use the tools in Elements (Editor: Image > Resize > Image Size) to downsize the digital file when necessary. Making large images smaller preserves much of the quality of the original but the reverse is not true. Enlarging small files to create the correct resolution needed for a big print job will always produce a poor quality file, especially when it is compared to one that was scanned at the right size in the first place. See Figure 3.6.

How the image will be used	The final output resolution to select
Screen or web use only	72 dots per inch (dpi)
Draft quality inkjet prints	150 dpi
Large posters (that will be viewed from a distance)	150 dpi
Photographic quality inkjet printing	200–300 dpi
Magazine printing	300 dpi

Table 3.1 Different image outcomes require different levels of output resolution. Use the values in this table as a guide when sizing your photo.

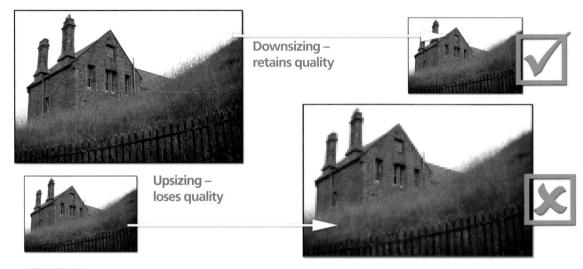

Figure 3.6 Downsizing images is acceptable but enlarging always produces a final picture that is poor in quality. It is better to rescan the original if you need to print it bigger. Only enlarge a small picture as a last resort.

Editor: Image > Divide Scanned Photos

For those readers with many pictures to scan, the Divide Scanned Photos feature will prove a godsend. With this feature you can scan several prints at once on a flatbed scanner and then allow Elements to separate each of the individual pictures and place them in a new document.

To ensure accurate division of photos place a colored backing sheet on top of the prints to be scanned. This helps the program distinguish where one picture starts and the other ends. See Figure 3.7.

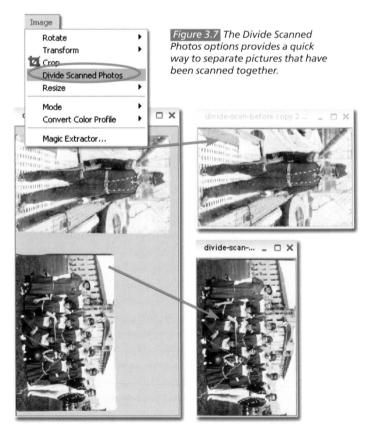

Scanning summary

Making a scan is a four-step process that starts with previewing the image (1). Next, the area to be scanned is selected (2), the brightness, contrast and color changed (if needed) (3), and finally the output dimensions and resolution set (4).

FIRST STEPS

Organizer: File > Get Photos > From Files and Folders

Acting much like the File > Open option common to most programs this selection provides you with the familiar window that allows you to browse for and open pictures that you have already saved to your computer. Though slightly different on Windows and Macintosh machines, you generally have the option to view your files in a variety of ways. Windows users can choose between Thumbnails, Tiles, Icons, List and Detail Views using the drop-down menu from the top of the window. See Figure 3.8. The Thumbnail option provides a simplified File Browser View of the pictures on your disk and it is this way of working that will prove to be most useful for digital photographers. After selecting the image, or images, you wish to import into the Photo Browser or Organizer, select the Get Photos button.

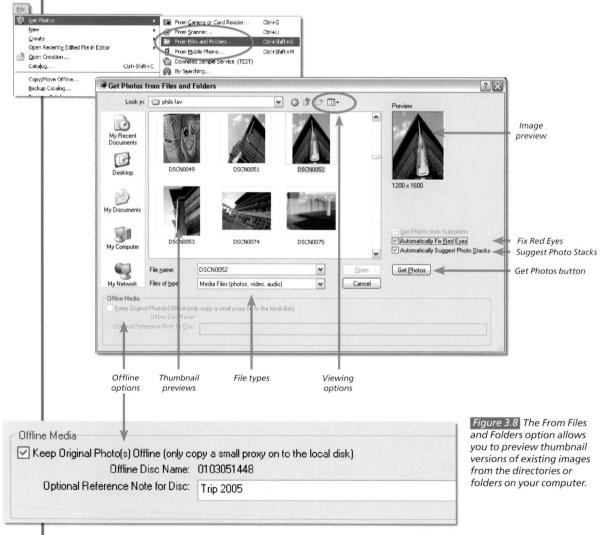

The Offline Media options allow you to import small thumbnail versions of the pictures that you have stored on CD-ROMs, DVDs or other media that can be disconnected from your computer. Elements catalogs these pictures and allows you to search and organize the thumbnails just like any other picture.

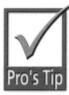

How to multi-select the files to import

To select several images or files at once hold down the Ctrl key whilst clicking onto the pictures of your choice. To select a complete list of files without having to pick each file in turn click on the first picture and then whilst holding down the Shift key click on the last file in the group.

Organizer: File > Get Photos > From Mobile Phone

With the rise in specifications of the digital cameras built into the modern mobile phones, many photographers are finding that these cross-over devices are great for the odd snapshot, or for the time when you don't have your full kit handy. It is no surprise then that Adobe includes a Get Photos > From Mobile Phone option in the Organizer of Elements. The option does not link your computer directly to your mobile phone, (you will need the software that came with the unit for that), but rather watches the default folder where your phone pictures are downloaded. When new pictures are added to the folder, Elements either adds them to your catalog automatically or notifies you of the new files and asks permission to add them. See Figure 3.9.

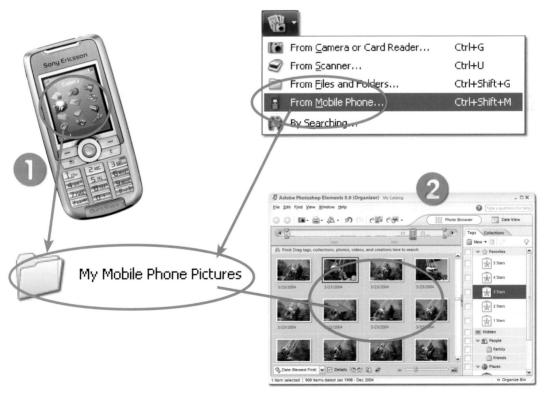

Figure 3.9 Getting pictures from your mobile phone is a two-part process. Firstly the pictures are downloaded from the phone to your computer (1) and then Elements imports them from this folder into the Photo Browser (2).

Figure 3.10 Setting up the Photo Browser so that it watches for new files in specific folders is a good way to automatically keep your catalogs up to date. Simply add the specific folders to those listed in the Organizer: File > Watch Folders window.

To make sure that you can import your mobile phone pictures directly into Elements add the default download folder to the watch list first before selecting the File > Get Photos > From Mobile Phone option. Simply select File > Watch Folders and use the Add button to browse for the folder that you use to store your mobile phone pictures. At the bottom of the window you can also choose whether Elements notifies you of new files added to the watched folders or automatically imports them into the Photo Browser. See Figure 3.10.

Organizer: File > Get Photos > From Online Sharing Service

Elements users living in supported areas of the world can take advantage of the online printing and sharing opportunities provided by www.kodakgallery.com. After a simple, and free, sign-up procedure is completed you will be able to upload web-friendly copies of your pictures directly to the service. Once stored online you can request for the files to be printed using the Kodak Gallery print service or you can choose to share the files. This Get Photos option is designed to access files that have been earmarked for sharing using services like those provided by www.kodakgallery.com. See Figure 3.11.

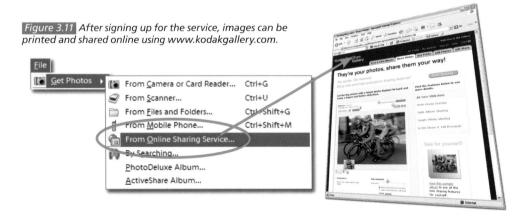

Organizer: File > Get Photos > By Searching

The Get Photos > By Searching option provides a speedy way to locate all the folders connected to your computer that contain pictures that you may want to add to your Organizer catalogs. After you set the search options and click the search button Elements will weave its way through your computer hunting down folders that contain candidate picture files. By default the program will not locate files in the GIF or PNG formats (both of which are almost exclusively used for web pages). If you are looking for these file types then you will need to use the Get Photos > From Files and Folders option. You can also choose to exclude small pictures and those images contained in system or program folders. Both these options should be selected to speed up the search process.

Once the folder list has been compiled, which usually only takes a few seconds, you can select (or multi-select) the folders whose images you wish to import. Clicking the Import Folders button will then add the pictures contained into the catalog of the Photo Browser. See Figure 3.12.

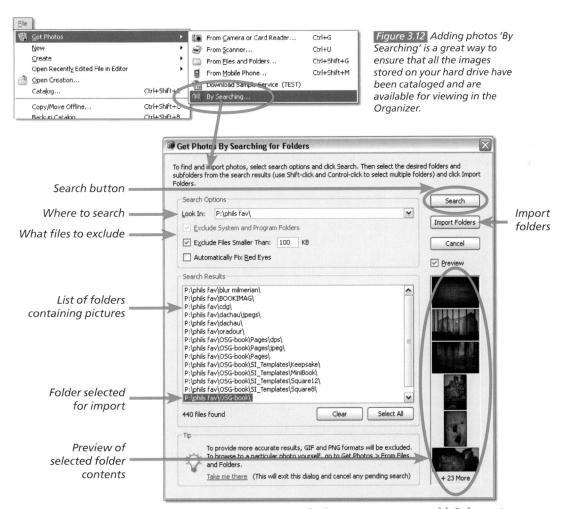

Book resources at: www.guide2elements.com

Other options for getting your photos into Elements

Though my recommendation is that you always import and organize your pictures via the Organizer and Get Photos features there will be times when you need to access existing files, or even newly photographed images, whilst in one of the Elements editor modes – Quick Fix or Standard Edit. The follow options give you just this type of access.

Editor: File > Open

Working in much the same way as the Get Photos > From Files and Folders option, selecting File > Open presents you with the standard Windows file browser. From here you can navigate from drive to drive on your machine before locating and opening the folder that contains your pictures. You can refine the display options by selecting the specific file type (file ending) to be displayed and as we have already noted you can also choose the way to view the files. In Figure 3.13 the thumbnail view was selected so that it is possible to quickly flick through a folder full of pictures to locate the specific image you are after.

Editor: File > Open As

On the odd occasion that a specific file won't open using the File > Open command you can try to open the file in a different format. Do this by selecting the File > Open As option and then choosing the file you want to open. After making this selection pick the desired format from the Open As pop-up menu, and click the Open button. This action forces the program to ignore the file format it has assumed the picture is saved in and treat the image as if it is saved as the file type you have selected. If the picture still refuses to open, then you may have selected a format that does not match the file's true format, or the file itself may have been damaged when being saved. See Figure 3.14.

This feature is also used for open files where the extension is unknown. This is particularly useful if a picture is saved on a Macintosh machine without a file extension and then transferred to a computer running the Windows operating system which requires a file extension to open it.

Editor: File > Open Recently Edited File

As you browse, open and edit various pictures from your folders Elements keeps track of the last few files and lists them under the File > Open Recently Edited Files menu item. This is a very handy feature as it means that you can return quickly to pictures that you are working on without having to navigate back to the specific folder where they are stored.

By default Photoshop Elements lists the last 10 files edited. You can change the number of files kept on this menu via the Recent File List setting in the Editor: Edit > Preferences > Saving Files window. Don't be tempted to list too many files as each additional listing uses more memory. See Figure 3.15.

Editor: File > Organize Open Files

This option adds files that are currently open in the Editor workspace to the Organizer catalog, if they're not already there and they don't need resaving. It is important to note that some formats that you can open in the Full Edit workspace are not supported in the Organizer. These include: PICT, EPS, Photoshop Raw and SCT.

Book resources at: www.guide2elements.com

Figure 3.15 The Open Recently Edited File list displays the last few pictures that you have opened in the Editor workspace. The number of files that are included on this list is determined by the Recent file list contains option in the Saving Files preferences.

Creating new documents

Editor: File > New > Blank File

The File > New > Blank File option creates an Elements picture from the settings selected in the New dialog box. The box has sections for the image's name, width, height, resolution and mode. The background content of the image can be chosen from the list at the bottom of the box and you can also choose an existing template from a range of document types from the drop-down Preset menu. See Figure 3.16.

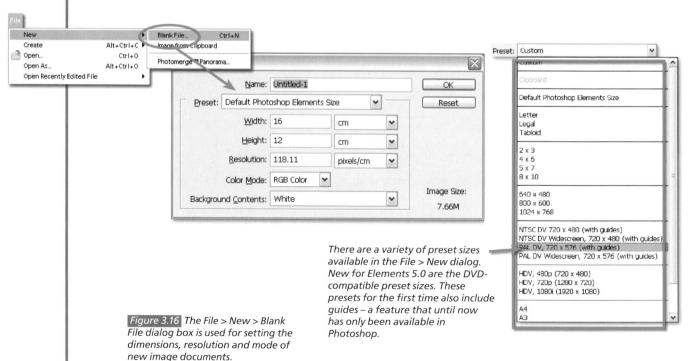

At this stage it is important to remember that the quality of the image, and the size that it can be printed, are determined, in part, by its pixel dimensions. As we saw in the scanner section earlier in the chapter, you should choose your image's pixel dimensions based on what you intend to use the picture for. Small prints need fewer total pixels than those images intended for large posters. To ensure that your document will suit your end purpose, input the final dimensions of your product directly into the Width and Height boxes. Next, add the resolution that you will use when outputting your image in the 'Resolution' box. Be sure to check that the resolution unit is set to 'pixels/inch' not 'pixels/cm'; inadvertently picking the wrong option here will have you creating huge images needlessly. If you are unsure what print resolution to input, use the guide in Table 3.1 (see p. 43).

Editor: File > New > Image from Clipboard

Many programs contain the options to copy (Edit > Copy) and paste (Edit > Paste) information. For the most part, these functions occur within a single piece of software, but occasionally the process can also be used to copy an image, or some text, from one program and place it in another. Previous versions of Elements provided different pathways for making a new file from pictures stored in the computer's memory, but since versions 3.0 a specialist Image from Clipboard item can be found under the File > New menu. See Figure 3.17.

Once a picture has been copied to memory, selecting the New > Image from Clipboard option automatically creates a new document of the correct size to accommodate the copied content and pastes the picture in as a new layer. There is no need to guess the size of the copied picture as Elements automatically determines this when it creates the new document.

It is worth noting that if there is no image stored in memory then this option will be 'grayed out' (unavailable) in the menu list.

Figure 3.17 The New > Image from Clipboard dialog box is used for pasting already copied pictures as a layer in a new Elements document.

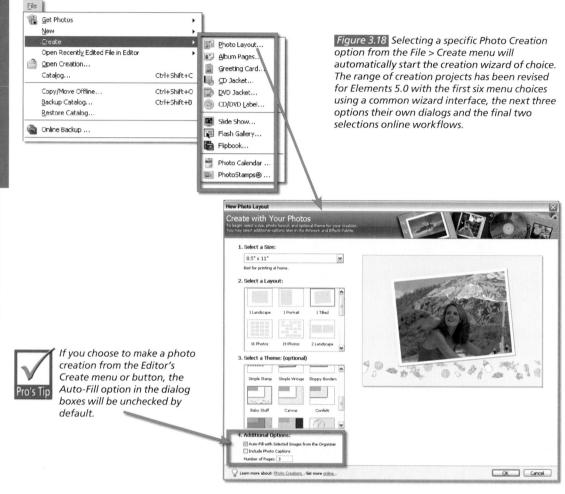

Editor: File > Create or Organizer: File > Create

Including the Create menu under the File heading means that you can jump from either the Editor or Organizer workspaces directly into the Photo Creation process. As most of the creations products (slide shows, web gallery, album pages) use several images as a basis for their projects many users start the creation process by selecting the photos first inside Organizer before choosing the project. See Figure 3.18.

In previous releases of the program creations were produced in their own workspace.

In version 5.0 the separate workspace has gone and users can now go directly to the specific dialog of the creation project of choice from either the Editor or Organizer workspaces. Also new for Elements 5.0 is a variety of new free form creation projects based around a common interface. For example the new Photo Layout option allows you to create multi-page projects complete with customized backgrounds, resizable frames and added graphics, shapes and text. The finished creations can be printed online or at the desktop.

Editor/Organizer: File > New > Photomerge Panorama

One of the most popular features of all those included in Elements is the special panoramic stitching tool called Photomerge. In fact the tool was valued so highly by digital photographers the world over that many who already owned Photoshop purchased its smaller brother just so that they could use it. Now that Photomerge is included in Photoshop there is no need for the Photoshop users to lust any more. Selecting the File > New > Photomerge Panorama option takes you directly to the Photomerge Add Files dialog. Use the Browse button to locate the pictures that you want to include in the stitched panorama and then click OK. The selected images are transferred to the Photomerge workspace and the program attempts to sequence, arrange and blend the individual images to form a single wide-angle photograph. See Figure 3.19. For more details on how to use the Photomerge feature see Chapter 9, Creating Great Panoramas.

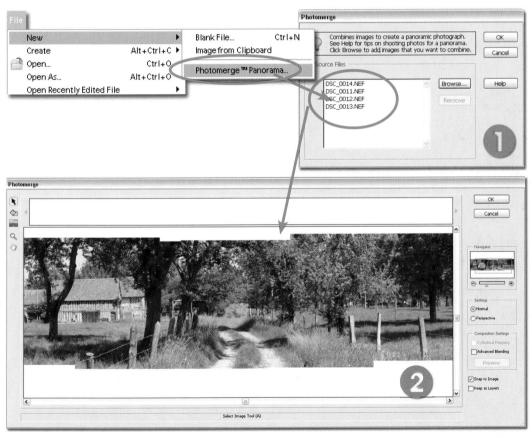

Figure 3.19 Choosing the File > New > Photomerge Panorama option starts the panorama stitching process by displaying the Add Files dialog first (1). After browsing for and locating the pictures to include in the composition you click OK to proceed to the main Photomerge workspace (2). From here you can fine-tune the stitching process and produce the final panoramic photograph.

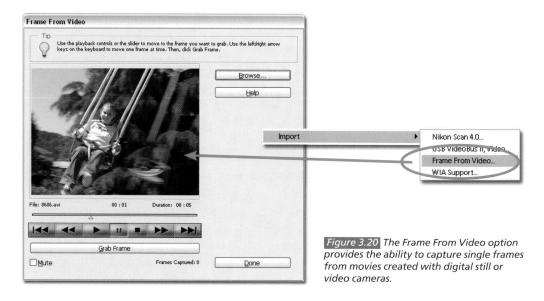

Editor: File > Import > Frame From Video

Almost hidden from view in a new position on the File > Import menu is the Frame From Video option. With the increase in popularity of digital video, it was a great move on Adobe's part to include this feature in version 2.0 of the program. The option gives the users the opportunity to capture still frames from a variety of stored video formats. The Frame From Video dialog employs familiar video player buttons to play, rewind and fast forward the selected footage. The Grab button snatches still frames from the playing video and places them into Elements ready for editing. Though images captured in this fashion are rarely of equal quality to those sourced from a dedicated stills camera or scanner, there are occasions when a feature such as this fits the bill. See Figure 3.20.

Figure 3.21 You can view cataloged pictures in the Organizer workspace in two different ways.

(1) Photo Browser View – based on a thumbnail view with an associated time line at the top.

(2) Date View - photos organized according to the date they were shot.

Step 2: Viewing your pictures

After importing your pictures into the Photo Browser users can then choose to display them in Photo Browser or Date mode. Files can be tagged with appropriate keywords, to help when searching for specific pictures later, or grouped into collections of images with similar subjects. Although this is not the place to undertake major editing tasks you can apply simple enhancements (mostly automatic) using the Auto Smart Fix and Auto Red Eye Fix functions. We will look at these in step 5 of this First Steps introduction.

To apply more complex changes to your photographs you can jump from the browser directly to either the Quick Fix or Full Edit windows. In the same way you can also use selected pictures or collections as the basis for producing one of the many Photo Creations options available. But don't think that Photo Browser's prowess ends there, the images you select can also be printed, e-mailed to your friends, shared online and even sent to a mobile phone all from this one window. See Figure 3.21.

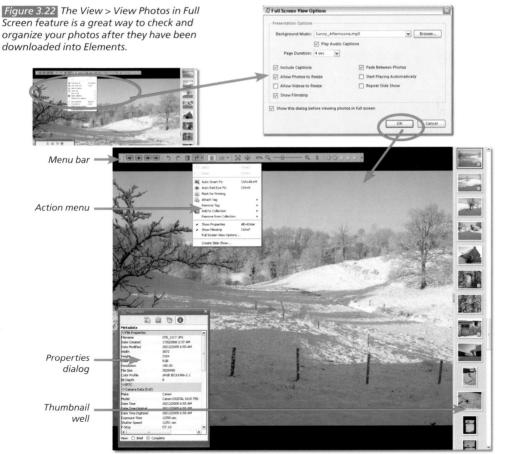

View Photos in Full Screen display

Organizer: View > View Photos in Full Screen

Starting life as the Photo Review feature in version 3.0, the View Photos in Full Screen option provides an instant slide show of the files that you have currently displayed in the Photo Browser. Seeing the photos full size on your machine is a good way to edit the shots you want to keep from those that should be placed in the 'I will remember not to do that next time' bin. With the provided menu you can play, pause or advance to next or last photos using the VCR-like controls. You can enlarge or reduce the size that the picture appears on screen with the Magnification slider (Zoom Level control). For quick magnification changes there are also Fit to Window and Actual Pixels buttons. But the real bonus of the feature is the list of actions that you can perform to pictures you review. You can automatically enhance, add and remove tags, mark the file for printing and add the file to a chosen collection using the choices listed under the Action menu. Specific picture properties such as tag, history and metadata are available by hitting the Alt + Enter keys to display the Properties window. See Figure 3.22 on page 57.

As well as showing all the photos currently in the browser you can also multi-select the images to include in the review session before starting the feature, or even limit those pictures displayed to a particular collection. The Full Screen View options can be set when the feature is first opened or accessed via the last item on the Action menu.

First stop – View Photos in Full Screen

All together, the options available in the Photo Review feature make this a great place to check the results of a day's shooting. You can flick through the images that you have recorded, sorting the good ones into a newly created collection and deleting the not so good examples of your photographic prowess. If you prefer to keep all the images together and just add keyword tags to selected files then this is easily achieved here as well.

Organizer: View > Compare Photos Side by Side

Closely linked to the View Photos in Full Screen feature detailed above is the Compare Photos Side by Side option, which allows users to display two similar pictures side by side. This is a great way to choose between several images taken at the same time to ensure that the best one is used for printing or passed on to the editor for enhancement. See Figure 3.23. To select the images to display click onto one of the compare workspaces (left or right in the example) and then click on a thumbnail. Now select the other workspace and click the comparison image thumbnail. All the same Full Screen adjustment and organizational controls are available in the Compare Photos feature, including the Zoom control, which provides the ability to examine candidate files more closely.

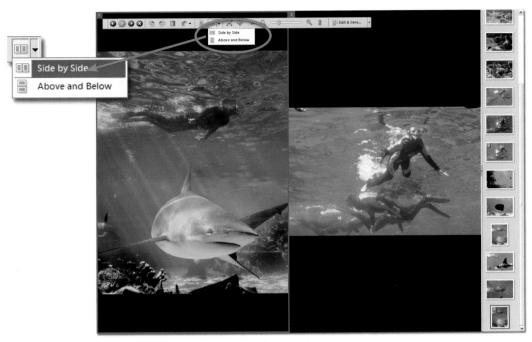

Figure 3.23 The Compare Photos Side by Side feature provides the opportunity for you to review the quality of similar photos in Full Screen mode.

By pressing the 'X' key you can switch the pictures from left to right. This technique can be very useful when sorting similar shots. For example, when editing bracketed photos you can keep moving the better shot to the left (whilst flicking through the alternative options on the right) until you find the perfect exposure and then flag that one for printing.

Comparing apples with apples

Clicking the Sync Pan and Zoom button (chain icon) will magnify both pictures to the same zoom level when either picture is changed. The feature also scrolls both pictures in unison, allowing the same specific areas of a photograph to be examined without the need to independently move each image.

Editor: View > Zoom In and Zoom Out

Images displayed in the Editor workspace can be viewed at a variety of different magnifications. To alter the size of the picture on screen, use either the menu option View > Zoom In or Zoom Out, or the Zoom tool. Clicking on a photo with the tool selected will enlarge the picture and clicking with the Alt key (Windows) or Option key (Macintosh) held down will reduce the size. Clicking and dragging will draw a marquee, which will then enlarge the selected part to fill your window. Double-clicking the Zoom tool automatically displays the image at 100%. Double-clicking the Hand tool fits to screen. See Figure 3.24.

Figure 3.24 Images can be enlarged or reduced on screen by using either the Zoom In or Out feature (View > Zoom In or Out) or the Zoom tool.

Editor: Window > Navigator

When the picture is enlarged beyond the boundaries of the window, you will only be able to see a small section of the image at one time. To navigate around the picture, use the Hand tool to click and drag the picture within the box. Alternatively, Elements contains a special Navigator window, where you can interactively enlarge and reduce image size, as well as move anywhere around the image boundaries. See Figure 3.25.

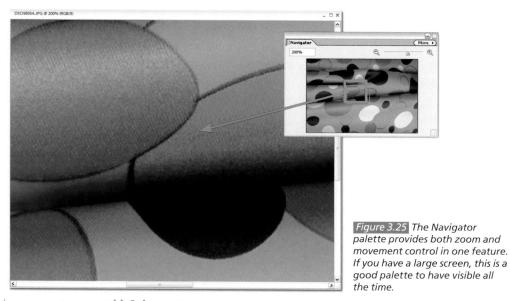

Book resources at: www.guide2elements.com

Step 3: Image rotating

One of the first tasks to undertake on pictures that you have downloaded from your camera or scanner is to correct their orientation. This, of course, is only true for those images that were taken with the camera on the side, or prints that were inadvertently scanned the wrong way up. You can rotate your pictures back to their rightful orientation in the Photo Browser or Photo Review features or in any of the Elements Editor workspaces. Use the steps below to reorientate your photos depending on the workspace you have open.

Photo Browser: Select the thumbnail of the picture that needs rotating and then select Rotate 90° Left or Right from either the Edit menu or the right-click menu. See Figure 3.26.

Full Screen Photo: Either wait until the image you need to rotate is displayed on the main screen, or select it from the Thumbnail well on the left of the window, and then click one of the Rotate buttons located in the tool bar.

Full Edit: To rotate the whole picture using the Image > Rotate $> 90^{\circ}$ Left or Right options. Rotating the photo 180° will turn the picture upside down. Flipping the canvas provides a mirror image of the original. The other options in the Rotate menu are for rotating separate layers in an image. For more information on layers see Chapter 6.

Quick Fix Editor: As well as using the same menu commands detailed for the Full Edit above, you can also click on the rotate buttons displayed in the General Fixes > Rotate section of the editor's Palette Well.

Adobe Photo Downloader: You can also rotate photos in Advanced section of the Photo Downloader utility. Just click on the thumbnail and then select the appropriate rotate button.

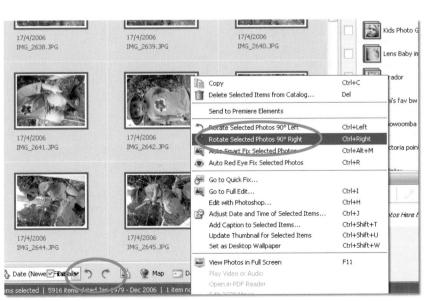

Step 4: Cropping and straightening

Cropping

Cropping a picture can help add drama to an image by eliminating unneeded or unwanted detail. It can also be a good method for altering the orientation of a crooked scan. Again there are several different ways of cropping your pictures depending on which Elements workspace you are using, but all are dependent on selecting the portion of the image you wish to retain, using either the Marquee or Crop tools.

Quick Fix and Full Edit: With the first approach you need to select the Marquee tool and then click and drag the tool over the image to define a selection (of the area you wish to keep). Then, to apply the crop, choose Image > Crop from the menu bar. See Figure 3.27.

If you want a little more control then try using the specialist Crop tool. Looking like a set of darkroom easel arms, it is present in both editors' tool bars. Once the tool is selected click and drag on the image surface. You will see a marquee-like box appear. The box can be resized at any time by dragging the handles positioned at the corners or sides. When you are satisfied with the changes, crop the image by either clicking the green tick button at the bottom of the crop marquee or by double-clicking inside the crop marquee. See Figure 3.28.

Auto Straightening

The crop marquee, in the Editor workspaces, can also be rotated to suit an image that is slightly askew. You can rotate the selection box by clicking and dragging the mouse pointer outside the edges. Now when you click the OK button the image will be cropped and straightened. See Figure 3.29. If this all seems a little too complex, Elements also supplies automatic Straighten Image and Straighten and Crop Image functions. Designed especially for people like me, who always seems to get their print scans slightly crooked, these features can be found at the bottom of the Image > Rotate menu.

The Straighten tool

A new tool was added in Elements 4.0 to help you straighten the horizon lines in your photos. Called the Straighten tool, you can automatically rotate your pictures so that any line is aligned horizontally. Start by selecting the tool from the toolbar and then click-drag the cursor to draw a line parallel to the picture part that should be horizontal. Once you release the mouse button Elements automatically rotates the photo to ensure that the drawn line (and the associated picture part) is horizontal in the photo. See Figure 3.30. But don't stop there. The tool also has the ability to straighten vertically as well. Hold down the Ctrl key while you drag the Straighten tool along a vertical line and then release the mouse button.

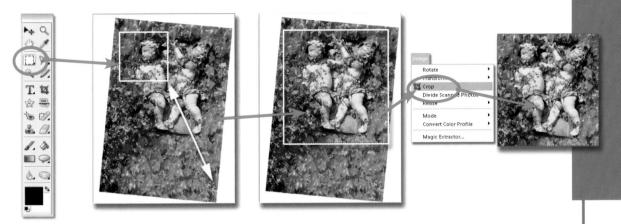

Figure 3.27 The Marquee tool is used to select an area that is then cropped using the menu option Image > Crop.

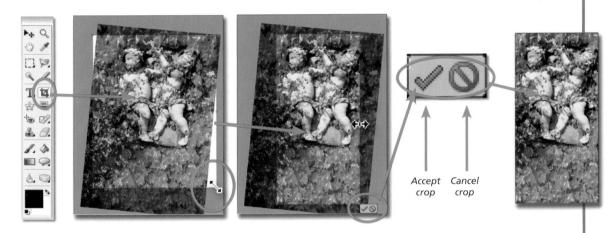

Figure 3.28 The Crop tool allows adjustment of the selection via the handles positioned at the corners and sides of the Bounding box.

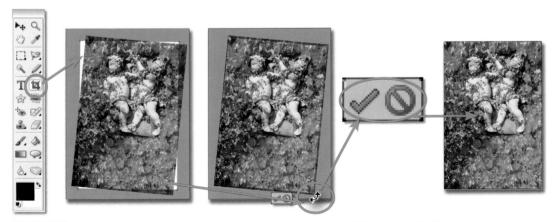

Figure 3.29 Rotating the Crop tool's selection provides the option for straightening crooked images.

T M

1.3

When rotating the image, Elements can handle the resulting crooked edges of the photo in three different ways. The three approaches are listed in the drop-down menu in the options bar. They are:

Grow Canvas to Fit – The canvas size is increased to accommodate the rotated picture. With this option you will need to manually remove the crooked edges of the photo with the Crop tool.

Crop to Remove Background – After rotating Elements automatically removes the picture's crooked edges. This results in a photo with smaller dimensions than the original.

Crop to Original Size – The photo is rotated within a canvas that is the size of the original picture. This option creates a photo which contains some edges that are cropped and others that are filled with the canvas color.

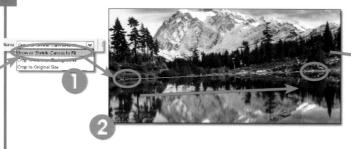

Figure 3.30 To use the Straighten tool in Elements 5.0, select it from the tool bar, choose the Canvas option (1), click-drag a reference line on the picture that aligns with the horizon (2) and release the mouse button to complete (3).

New rotation controls

Along with the new frames options contained in the Artwork and Effects palette comes a new way to rotate layer content in Elements. Like the corner handles that appear on the edges of the layers when using the Free Transform feature, the new rotate handle provides a click and drag pivoting option. In addition to their use with frame, the Rotate handles are also available with the Image > Transform > Free Transform and Image > Rotate > Free Rotate Layer commands. By default the layer content pivots around the center but you can also pivot from the corner or edges of the layer. Just select another Reference Point location in the features options bar. See Figure 3.31.

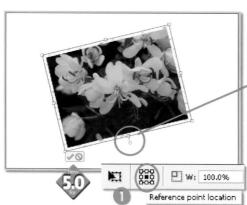

Figure 3.31 In addition to the resizing handles that are normally found on the edges of layer content, Elements 5.0 introduces a Rotate handle in the middle of the bottom edge. Click and drag to pivot the image around a central reference point. To pivot around an edge or corner click on a new reference in the feature's options bar to establish a new pivot point (1).

Step 5: Automatic corrections

First some background

One of the real strengths of the Elements program is that the editing and enhancement capabilities of the software are built upon the industry standard Photoshop platform. But as most people who have had a play with Photoshop will tell you, this 'killer' application is not an easy beast to tame, let alone master. This is where Elements steps in. It combines the majority of the editing abilities of Photoshop with an easier interface and therefore a much simpler learning curve. Version 5.0 continues this tradition by providing a variety of enhancement and editing options for the digital photographer. They are skillfully arranged from the automatic 'press this button now' type tools that provide quick and accurate results for the majority of pictures, through to the more sophisticated and user-controlled features required for completion of more complex, professional-level, correction tasks. See Figure 3.32.

In this First Steps section of the book, we will take a look at the quick and automatic correction tools that are part of the Organizer workspace only. These tools will provide a good starting point for the majority of changes that you will want to make to your digital photographs and, somewhat more importantly, they will give you good results quickly without having to understand too much about the underlying theory of how the tool works and how best to use it.

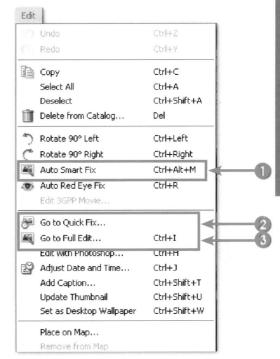

Figure 3.32 Photoshop Elements 5.0 contains a range of editing and enhancement features grouped according to complexity and degree of user control. These editing options are available from the Organizer either through the menu structure or by right-clicking a selected image thumbnail.

- (1) The Auto Fix option provides automatic corrections from within the Organizer workspace.
- (2) The image is sent to Elements' Quick Fix editor workspace.
- (3) The image is sent to the Elements' Full Edit workspace to be edited.

As your skills develop, however, you will probably want to take a little more control over the editing and enhancement process and for this reason Chapters 4 and 5 of the book will introduce you to the range of more sophisticated tools and features that are part of the Quick Fix and Full Edit workspaces. The editing and enhancement options presented in the later chapters are capable of results that rival the professionals. But that's coming up; for the moment let's look at the changes we can make using the tools available in the Photo Browser.

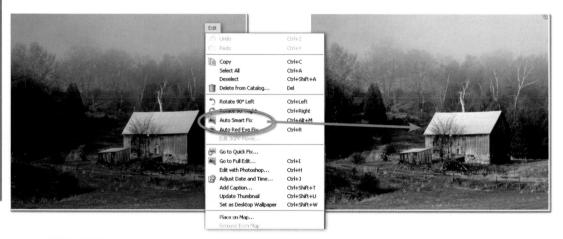

Figure 3.33 Photoshop Elements 5.0 contains two different auto fix options that can be accessed from within the Organizer workspace – Auto Smart Fix adjusts the color, brightness and contrast of the picture and Auto Red Eye Fix overpaints the red in the eyes of flash portraits.

Organizer: Edit > Auto Smart Fix and Auto Red Eye Fix

The Auto Smart Fix and Auto Red Eye Fix features can be applied to individually selected or multi-selected pictures in the Organizer workspace by selecting the options either from the Edit menu or via the right-click pop-up menu.

The **Auto Smart Fix** option analyzes the colors and tones in the picture before automatically adjusting the brightness, contrast and color cast in the photo. For general images this auto-only solution produces good results but if you are unhappy with the changes simply select the Edit > Undo option to return the picture to its original state. See Figure 3.33.

The **Auto Red Eye Fix** feature is part of the new red eye correction technology that has been added into all levels of the Elements program. You can now automatically remove the dreaded red eye effect at the time of downloading your pictures from a memory card or camera, when importing files from a folder or from inside the Photo Browser. For the last option simply right-click the offending photo and select the Auto Red Eye Fix option from the displayed menu. If the automatic function doesn't eliminate the problem you can manually remove red eye in the Full Edit or Quick Fix editor workspace using the Red Eye Removal tool. See Chapter 4 for more details.

Version Sets

The changed file that results from these auto adjustments is not saved over the top of the original; instead a new version of the image is saved with a file name that is appended with the suffix '_edited' attached to the original name. This way you will always be able to identify the original and edited files. The two files are 'stacked' together in the Photo Browser with the latest file displayed on top. The stack of photos representing different editing stages in the picture's

history is called a Version Set and is identified with an icon in the top right of the picture showing a pile of photos. To see the other images in the version stack simply click the Expand button to see the images in the version set . Alternatively you can right-click the thumbnail image and select Version Set > Reveal Photos in Version Set. See Figure 3.34.

Using the other options available in this pop-up menu the sets can be expanded or collapsed, the current version reverted back to its original form or all versions flattened into one picture. Version Set options are also available via the Photo Browser Edit menu.

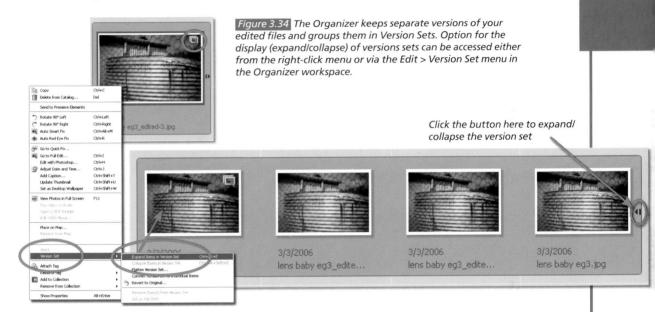

Undo, Revert and Undo History

With so many options available for changing images, it's almost inevitable that occasionally you will want to reverse a change that you have made. One way to step back through your changes is to select an earlier permutation of your picture via the Version Sets feature as detailed above, but Elements also provides several other methods to achieve this.

The Undo control, Edit > Undo, will successfully take your image back to the way it was before the last change. The Undo command is available in all Elements' workspaces. If you are unhappy with all the alterations you have made since opening the file, you can use the Revert feature, Edit > Revert (previously File > Revert), to exchange the saved version of your file with the one currently on screen. Revert options are available in the editing workspaces in Elements. See Figure 3.35.

The Undo History palette (Window > Undo History) provides complete control over the alterations made to your image. Each action is recorded as a separate step in the palette. Reversing any change is a simple matter of selecting the previous step in the list. See Figure 3.36.

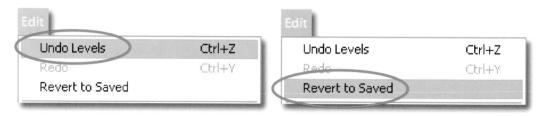

Figure 3.35 Image changes can be reversed by using either the Undo (Edit > Undo) feature or Revert options (File > Revert).

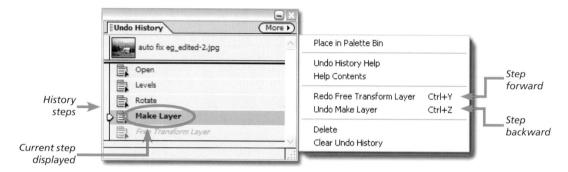

Figure 3.36 The Undo History palette provides the facility to step backwards through the most recent image changes.

Step 6: Printing

The falling price of quality inkjet printers means that more and more people are now able to output photographic quality prints right at their desktop. To get you started quickly we will look at the print options available from the Photo Browser but keep in mind that these features are also available from the editing workspaces as well. For more details on printing see Chapter 11.

The Print Selected Photos feature (see Figure 3.37) provides users with a common place to start the print process. This feature largely replaces the Print Preview option found in earlier versions of the program. To display the feature you can select the Print item from the File menu or select the same option from the pop-up menu displayed when you click the Print shortcut button. See Figure 3.38.

Before accessing the feature select the image or images that you want to print. Don't worry if you need to add more pictures when you are in the dialog as the great guys at Adobe have kindly added an Add photos button at the bottom left of the screen. The process for creating a print project is as easy as setting the options in sections 1, 2 and 3 of the dialog.

Section 1: Start by selecting the printer that will output the image from those listed for your computer. At this stage you should also check that the actual settings for the printer match the type of image you are printing and the media (paper) you are using. Do this by adjusting the settings in the Printer Preferences window which can be displayed by clicking the button next to the printer drop-down menu.

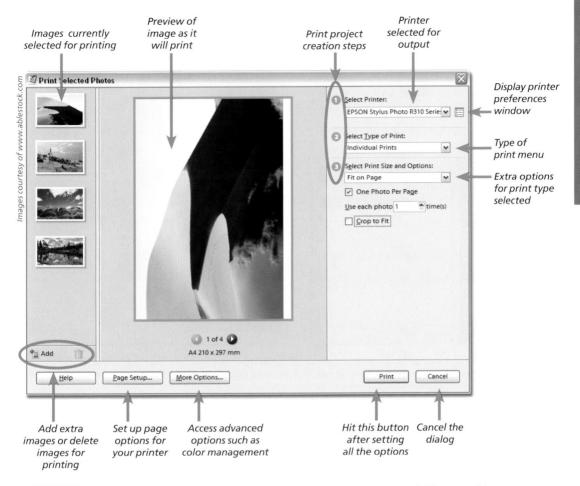

Figure 3.37 The Print Selected Photos dialog is the pivot point for all your printing activities. From this one spot you can output individual photos, contact sheets, picture packages and label sets. See Chapter 11 for more details on advanced printing tasks.

Figure 3.38 After selecting files in the Organizer workspace, or opening images into the Editor, the Elements Print option can be accessed via the File menu or one of the print icons on the shortcut bar. (1) Print using a desktop printer. (2) Print using an online service.

Section 2: Next choose the type of print you wish to create. See Figure 3.39. There are four options to select from:

- Individual Prints designed for printing a single photograph per page,
- Contact Sheets used for creating a sheet of small thumbnails of a group of selected pictures.
- Picture Packages ideal for putting several larger photos on a single page using templates, and
- Labels creates a page of label-sized pictures that match commercially available label sheets.

Figure 3.39 You can select a range of different print types from the Print Selected Photos dialog. The options include (1) Individual Prints, (2) Contact Sheets, (3) Picture Packages with a variety of images per page templates and (4) Labels to suit standard sheet label sizes and shapes.

Section 3: The options available in this section change according to the print type that you selected in the previous step. For instance, when you select Individual Prints you can then choose the size that you want the image to be on the page, the number of times the same picture will be repeated, the number of photos to print on each page and whether to allow the program to crop the picture in order to fill the full page. See Figure 3.40.

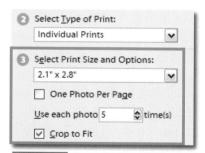

Figure 3.40 The options available in section 3 are determined by the Print type in section 2.

After adjusting the settings in each of the sections of the Print Selected Photos dialog click the Print button to output your photograph. Now sit back and enjoy your first digital photograph.

More printing options

See Chapter 11 for fuller details on the array of print options available to Windows Photoshop Elements users.

Step 7: Saving

Whilst you are making changes to your photos, the picture is stored in the memory (RAM) of the computer. With the alterations complete, the file should then be saved to a hard drive or disk.

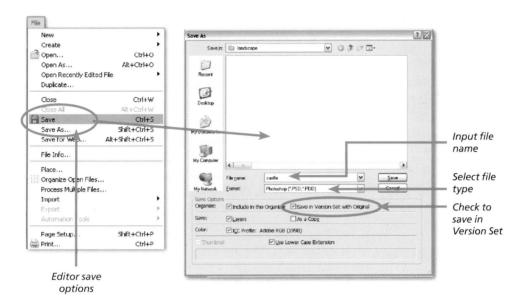

Figure 3.41 Saving images is an important part of the imaging process, as it is this step that commits all changes permanently to memory. For most users the Photoshop or PSD format should be used. Other file types have characteristics, like compression, that make them a better choice when sharing files, especially across the Internet. Use the File > Save As option to save your picture in other formats.

In previous versions of Elements the user needed to perform this saving step habitually after completing editing, and this still remains the case for images edited in the Standard and Quick Fix editor workspaces. But as we have already seen, for the changes made directly from the Photo Browser, Elements automatically saves the edited file and the original together in a Version Set. These auto save actions are terrific for the new user as they reduce the chance of overwriting the original file or losing changes that have taken valuable time to complete.

Editor: File > Save

Saving images edited in either the Quick Fix or Full Edit is a three-step process that starts by choosing File > Save from the menu bar. With the Save dialog open, navigate through your hard drive to find the directory or folder you wish to save your images in. Next, type in the name for the file and select the file format you wish to use. To include the edited file in a Version Set with the original, click-check the Save in Version Set with Original box at the bottom of the dialog. See Figure 3.41.

Editor: File > Save As

For most images you should use the Photoshop or PSD format. This option gives you a file that maintains all of the specialized features available in Elements. This means that when you next open your image you will be able to continue to use items like layers and editable text. If, on the other hand, you want to share your images with others, either via the web or over a network, then you can choose to save your files in other formats, like JPEG or TIFF. Each of these options can provide more compact files than PSD, but doesn't support all of Elements' advanced features.

To save a file in a format other than the PSD file type select the File > Save As option, selecting a different option from the drop-down format menu.

To coincide with the introduction of the new multi-page creations in Photoshop Elements 5.0, Adobe released a new file format that was capable of storing the individual pages, their content and settings. Called the Photoshop Elements format, or .PSE, it contains all of the characteristics of the PSD file type but with the added ability of being able to save multiple pages (documents) in the one file.

'The formats I use'

Elements, like its industry-leading brother Photoshop, can open and save files in a multitude of different file formats. It's great to have such a choice, but the big question that most new digital photographers ask is 'What format should I use?'

And like most of the big questions in life there is no single answer to this query. The best way to decide is to be clear about what you intend to use the image for. Knowing the 'end use' will help determine what file format is best for your purposes. Until we look more closely at format characteristics like compression, use the way I work as a starting point. My approach is outlined below.

At the *scanning* or *image capture* stage, I tend to favor keeping my files in a TIFF or RAW format. The save options in most scanning software will usually give you the option to save as a TIFF straight after capture and many digital cameras offer the option to store pictures as either RAW or TIFF files. If I need to use JPEG with my camera to increase the number of shots I can fit on my compact flash cards, I change the format to TIFF or PSD after downloading. This way, I don't have to be concerned about any further loss of image quality derived from opening and saving JPEG files, but I still get the advantages of good compression. As an added bonus I can also use the files on both Mac and IBM platforms.

When *manipulating* or *adjusting*, I always use the PSD or the Photoshop and Photoshop Elements format, as this allows me the most flexibility. I can use, and maintain, a number of different layers which can be edited and saved separately. Even when I share my work, I regularly supply the original PSD file so that last minute editing or fine-tuning can continue right up to going to

press. If, on the other hand, I don't want my work to be easily edited, I supply the final image in a TIFF format, that can be opened by both Mac and Windows machines.

With the introduction of *multi-page* documents in Photoshop Elements 5.0 any projects produced with the new creations options are saved in the new Photoshop Elements file format or PSE.

If the final image is to be used for *web*, then I use GIF, PNG or JPEG depending on the numbers of colors in the original and whether any parts of the image contain transparency. There is no firm rule here. A balance between size and image quality is what is important, so I will try each format and see which provides the best mix. See Table 3.2.

File Type	Compression	Color Modes	Layers	Metadata	Uses
Photoshop (.PSD)	×	RGB, CMYK*, Indexed color, Grayscale	√	√	Desktop publishing (DTP), Internet, publishing, photographic work
Photoshop Elements (.PSE)	×	RGB, Indexed color, Grayscale	√	√	The new Elements multi-page document format used for saving creation projects and their contents
GIF (.GIF)	√	Indexed color	×	×	Internet
JPEG (.JPG)	√	RGB, CMYK*, Grayscale	×	√	DTP, Internet, publishing, photographic work
TIFF (.TIF)	√	RGB, CMYK*, Indexed color, Grayscale	\checkmark	√	DTP, Internet, publishing, photographic work
PNG (.PNG)	✓	RGB, Indexed color, Grayscale	×	×	Internet
Digital Negative (.DNG)	√	RAW color data	x	√	A format used for saving the RAW file data from your digital camera

Table 3.2 This table lists the characteristics of different file types and their suitability for use with different tasks. * Photoshop Elements doesn't support the CMYK color mode.

Step 8: Organizing your pictures

Over the last couple of releases Adobe has packed Photoshop Elements with a range of management and organizational features that help bring order to the vast number of picture files that we are all accumulating on our hard drives.

Many of these features are contained in the Photo Browser or Organizer workspace. Here images are not just previewed as thumbnails but can be split in different catalogs, located as members of different groups or searched based on the keywords associated with each photo. Unlike a traditional browser system, which is folder based (that is, it displays thumbnails of the images that are physically stored in the folder), the Elements Photo Browser creates a catalog version of the pictures and uses these as the basis for searches and organization. With this approach it is possible for one picture to be a member of many different groups and to contain a variety of different keywords. So with this in mind let's look at how to use **tags** (Elements' title for keywords) and **Collections** to help manage our photos.

Tags

Tags are special keywords that can be attached to photographs and are used to help sort, organize and display sets of pictures in the Organizer workspace. The tagging features in the Tags pane (see Figure 3.42) of the Photo Browser workspace allows you to create, manage and add and remove tags from pictures. Multiple tags can be applied to the one picture and then all the photographs in the browser can be searched for the individual images that feature a specific tag.

By default six different categories of tags are included in the Elements Tags pane – People, Places, Events, Favorites, Hidden and Other. New categories and sub-categories can be created via the New button in the top left of the pane.

Tags are applied to a picture by selecting and dragging them from the pane onto the thumbnail or alternatively the thumbnail can be dragged directly onto the Tags pane. Multiple tags can be attached to a single picture by multi-selecting the tags first and then dragging them to the appropriate thumbnail.

Figure 3.42 The Tags pane at the right of the Organizer workspace houses current keyword tags and allows you to create new tags, categories and subcategories

Collections

A Photoshop Elements' Collection is another way that you can order and sort your photos. After creating a collection you drag selected images from the Photo Browser to the Collections pane,

Figure 3.43 Collections are the Photoshop Elements way to group your photos into different subject or project groups. Use the options in the Collection pane (Windows > Collections) to create new collections and the right-click pop-up menu (aside) to add pictures to collections.

or vice versa, where they can be used to make a new Photo Creation project or displayed using the Full Screen slide show feature. Photos from the Organizer workspace can be added directly to any collection by right-clicking and selecting Add to Collection from the pop-up menu. See Figure 3.43. Unlike when working with tags, pictures grouped in a collection are numbered and can be sequenced. The same photo can be a part of several different collections.

When adding your photos to a collection you are not duplicating these photos but rather adding the pictures to a visual list of the group's contents. In this way, only one copy of the original photo is stored on the computer but it can be viewed and used in many ways. To quickly add photos to a collection, drag the collection onto the photos.

Stacks and Auto Stacks

The idea of grouping together like photos in a single stack was introduced in version 3.0 of the program. New for 5.0 is the ability to auto stack images as they are downloaded from camera, imported into Elements from folders or even when displayed in the Organizer workspace. See Figure 3.44.

To auto stack pictures already in your catalog select a group of thumbnails and then choose Automatically Suggest Photo Stacks from either the Edit > Stack or the right-click pop-up menus. To stack when importing choose the Automatically Suggest Photo Stacks option in the Get Photos dialog. Either of these two options will then display a new window with alike pictures pre-grouped. Choosing the Stack All Groups button converts the groups to Stacks. The Remove Group button prevents the group of pictures being made into a Stack.

Figure 3.44 The Automatically Suggest Photo Stacks option is available when you import photos from folder, camera or memory card. The feature groups alike photos ready for conversion to Stacks.

Book resources at: www.guide2elements.com

Step 9: Backing up your files

There is no doubt that for most of us the many digital photographs that are saved on our computers are irreplaceable both in terms of their content and also the countless hours spent in capturing and enhancing. Given this scenario it is always puzzling to me that most people do not make duplicates or backups of such a valuable asset. Thankfully Adobe includes an easy-to-use backup feature in Elements. The last step in your photographic workflow should be to regularly back up your photos,

Organizer: File > Backup

The feature is designed for copying your pictures (and catalog files) onto DVD or CD for archiving purposes. Follow the steps in the wizard to make a copy or backup of all the photos you have currently listed in your Photo Browser. There is also an option to move selected files from your hard disk to CD or DVD to help free up valuable hard disk space. Simply activate the feature and follow the wizard's step-by-step prompts to create your own backup. See Figure 3.45.

Figure 3.45 Elements contains its own backup options making protecting your precious photos a simple task of using the feature regularly.

Multi Disk Backups

In version 5.0 the Backup Catalog feature has been enhanced so that now it is possible to backup your catalog over a series of CD or DVD disks. Multiple disk options like this are sometimes referred to as 'disk spanning'.

In previous versions, the Backup feature only allowed writing to a single disk and even with the growing use of DVD-ROMs for archive scenarios, many digital photographers have a catalog of photos that far exceeds the space available on a single disk.

The revised Backup feature estimates the space required for creating the backup copy of the catalog and, after selecting the drive that will be used for archiving, the feature also determines the number of disks required to complete the action. During the writing process the feature displays instruction windows at the end of writing each disk and when you need to insert a new disk.

All disks need to be written for the Backup to be complete. To restore a catalog from a set of backup disks use the File > Restore Catalog option in the Organizer workspace.

More details about managing your photographs with Elements can be found in Chapter 14.

Simple Image Changes

Three levels of editing

Setting up your screen for Elements

Brightness and contrast changes

Dodge and Burn tools

Color corrections

Using filters and effects

Getting help with Elements

Three levels of editing

Photoshop Elements 5.0 provides a variety of edit and enhancement options for users to change and alter their digital photographs. The options can be grouped around three different approaches to the task (see Figure 4.1):

- 1 **Automatic:** The simplest tools are almost always fully automatic with the user having little control over the final results. These are the types of color, contrast and brightness controls that are available in the Organizer (via the Edit > Auto Smart Fix and Auto Red Eye Fix). This is the place to start if you are new to digital photography and want good results quickly and easily.
- 2 Semi-Automatic: The second level of features sits in the middle ground between total user control and total program control over the editing results. The tools in this group are primarily available in the Quick Fix editor but also encompass some of the more automatic or

- Simple control using the Auto Smart Fix and Auto Red Eye Fix
- Most changes applied automatically
- New users start here for good, quick results
- Automatic control of: contrast, color, shadow and highlight detail
- See Chapter 3 for details

- Middle-level control using the Quick Fix and Standard editors
- Some changes applied automatically, others via a usercontrolled slider
- New users progress here with experience and understanding
- Control of: cropping, rotation, contrast, color saturation, hue, temperature, tint, shadow and highlight detail, red eye, midtone contrast and sharpening
- See Chapter 4 for details

easy-to-use controls available in the Standard editor workspace. Move to these tools once you feel more confident with the digital photography process as a whole (downloading, making some changes, saving and then printing) and find yourself wanting to do more with your pictures.

3 **Manual:** The final group of tools are those designed to give the user professional control over their editing and enhancement tasks. Many of the features detailed here are very similar to, and in some cases exactly the same as, those found in the Photoshop program itself. These tools provide the best quality changes available with Elements, but they do require a greater level of understanding and knowledge to use effectively. The extra editing and enhancement power of these tools comes at a cost of the user bearing all responsibility for the end results. Whereas the automatic nature of many of the features found in the other two groups means that bad results are rare, misusing or overapplying the tools found here can actually make your picture worse. This shouldn't stop you from venturing into these waters, but it does mean that it is a good idea to apply these tools cautiously rather than with a heavy hand.

- Sophisticated control using the features in the Standard editor workspace
- Most editing changes applied manually
- Great for complex editing and enhancement tasks performed by more experienced users
- The most control of all the major editing and enhancing of your digital photographs
- See Chapter 5 for details

Figure 4.1 Photoshop Elements 5.0 has three different levels of editing and enhancement tools available to users:
(1) Automatic,
(2) Semi-Automatic and
(3) Manual.
This means that you will have features that suit your skills level no matter how much digital photography experience you have.

Including three levels of editing features is Adobe's way of providing digital photographers with exactly the tools they need irrespective of their experience level and understanding. It also means that users can progress to more sophisticated tools as their confidence and knowledge grow. This said, it can be a little confusing for those of you who are new to the program to know 'what tool to use when'. For this reason I have broken the features into the three categories detailed above and have separated their introduction into separate chapters in the book.

Setting up your screen for Elements

In the previous chapter we looked at how to download, crop, rotate, auto-enhance, print and save images directly from the Photo Browser or Organizer workspace. Now you can try your hand at some simple changes courtesy of the editor components of Elements 5.0. It is here that you will start to see the power of the digital process. With a few clicks of the mouse you can perform basic picture adjustments and enhancements easier than ever before. This chapter will take you step by step through these changes and also show you how to use these techniques.

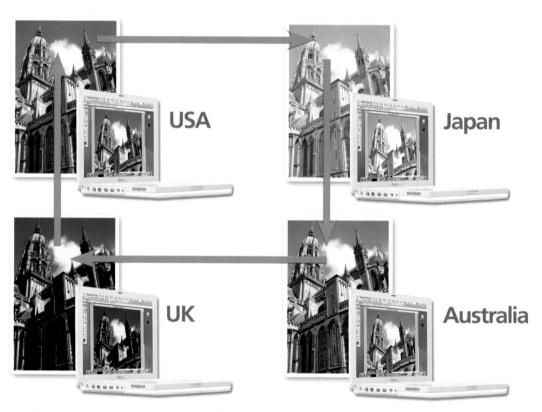

Figure 4.2 Even with exactly the same file and editing program, images can appear very different on several machines.

Popularity can be a problem

One of the truly amazing features of digital imaging is the diversity of people using the technology. Many individuals in a range of occupations, using various brands of equipment, in different countries across the world use computer-based picture making as part of their daily work or personal life. The popularity of the system is both its strength and, potentially, one of its weaknesses. On the positive side it means that an image I make in Australia can be viewed in the United Kingdom, enhanced in the United States and printed in Japan. Each activity would involve importing my picture into a different computer, with a different screen, running an image-editing package like Elements. This is where problems can occur. Even though the program and image are exactly the same, the way that the computer is set up can mean that the picture will appear completely different on each machine. On my computer the image exhibits good contrast and has no apparent color casts. In the UK, however, it might look a little dark, in the USA slightly blue and in Japan too light and far too green. See Figure 4.2.

Before you start

To help alleviate this problem, Adobe has built into its imaging programs a color management system that will help you set up your machine so that what you see will be as close as possible to what others see. For this reason, it is important that you set up your computer using the system before starting to make changes to your images. The critical part of the process is the calibration of your monitor. To achieve this, use the following steps:

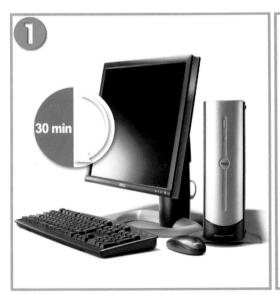

To start the calibration process make sure that your monitor has been turned on for at least 30 minutes.

Check that your computer is displaying thousands (16-bit color) or millions (24- or 32-bit color) of colors.

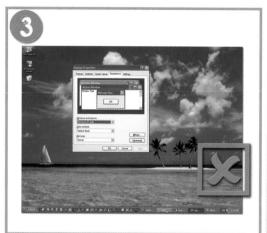

Remove colorful or highly patterned backgrounds from your screen, as this can affect your color perception.

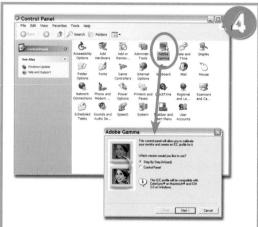

Start the Adobe Gamma utility. In Windows, this is located in the Control Panel.

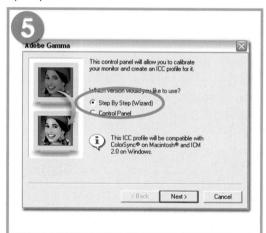

Use the step-by-step wizard to guide you through the setup process. If a default profile was not supplied with your computer, contact your monitor manufacturer or check their website for details.

Save the profile, including the date in the file name. As your monitor will change with age, you should perform the Gamma setup every couple of months. Saving the setup date as part of the profile name will help remind you when last you used the utility.

Now that your screen is correctly calibrated you need to ensure that the Photoshop Elements program is set to use the results of your hard work.

Go to Photo Browser: Edit > Color Settings or Editor: Edit > Color Settings and make sure that either the Optimize for Computer Screens, Optimize for Printing or Allow Me to Choose setting is selected. With this option activated the pictures you create will be color managed throughout the whole digital photography process.

Calibrate all screens and use color management wherever possible Keep in mind that for the color management to truly work, all your friends or colleagues who will be using your images must calibrate their systems as well.

Brightness and contrast changes

As we saw in Chapter 1, a digital picture is made up of a grid of pixels, each with a specific color and brightness. The brightness of each pixel is determined by a numerical value between 0 and 255. The higher the number, the brighter the pixel will appear; the lower the value, the darker it will be. The extremes of the scale, 0 and 255, represent pure black and white, and values around 128 are considered midtones. In a correctly exposed image with good brightness and contrast, the tones will be spread between these two extremes. If an image is underexposed, then the picture will appear dark on screen and most of its pixels will have values between 128 and 0. In contrast, images that have been overexposed appear light on screen and the majority of their pixels lie in the region between 128 and 255. See Figure 4.3.

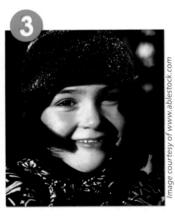

Figure 4.3 A well-exposed photograph (2) will have good brightness and contrast, and will display a good spread of tones between black and white or shadow and highlight. An underexposed image (3) appears dark on screen whereas an overexposed image (1) appears light on screen.

The best method for correcting these situations is for you to recapture the picture, changing the settings on your scanner or camera to compensate for the exposure problem. Good exposure not only ensures a good spread of tones, but also gives you the chance to capture the best detail and quality in your photographs. It is a misunderstanding of the digital process to excuse poor exposure control by saying 'it's okay, I'll fix it in Elements later'. You will not get the best quality pictures possible if you use Elements to correct shooting or scanning mistakes as images that are too dark or light are pictures where vital detail has been lost forever. See Figure 4.4. Sometimes, though, a reshoot is not possible or a rescan is not practical. In these circumstances, or in a situation where only slight changes are necessary, Elements has a range of ways to change the brightness and contrast in your photos.

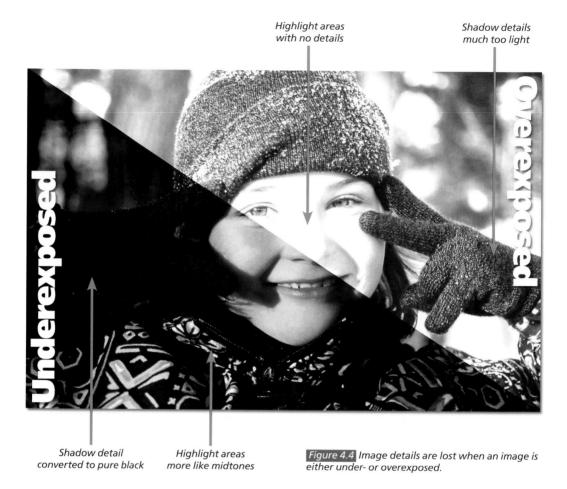

Editor: Enhance > Adjust Lighting > Brightness/Contrast

Version 4.0: Enhance > Adjust Lighting > Brightness/Contrast

The Brightness/Contrast command helps you make basic adjustments to the spread of tones within the image. When opened you are presented with a dialog containing two slider controls. Click and drag the slider to the left to decrease brightness or contrast, or to the right to increase the value. Keep in mind that you are trying to adjust the image so that the tones are more evenly distributed between the extremes of pure white and black. Too much correction using either control can result in pictures where highlight and/or shadow details are lost. As you are making your changes, watch these two areas in particular to ensure that details are retained. See Figure 4.5.

- 1 Select Enhance > Adjust Lighting > Brightness/Contrast.
- 2 Move sliders to change image tones.3 Left to decrease brightness/contrast, right to increase.
- 5 Lett to decrease brightness/contrast, right to increas
- 4 Click OK to finish.

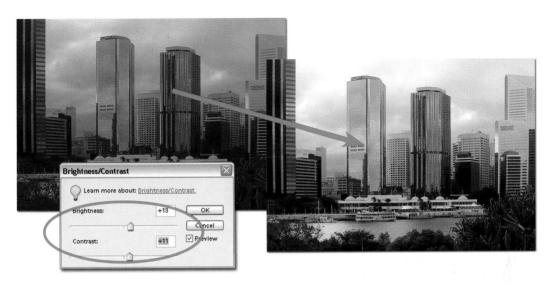

Figure 4.5 The Brightness/Contrast feature is located under the Adjust Lighting section of the Enhance menu. After adjusting the brightness and contrast of an image, the picture will appear clearer and its tone will be spread more evenly.

Editor: Enhance > Auto Contrast

Version 4.0: Enhance > Auto Contrast

The Auto Contrast command can be used as an alternative to the Brightness/Contrast sliders. In this feature Elements assesses all the values in an image and identifies the brightest and darkest tones. These pixels are then converted to white and black, and those values in between are spread along the full tonal range. Auto Contrast works particularly well with photographic images but could produce unpredictable results with graphic illustrations. See Figure 4.6.

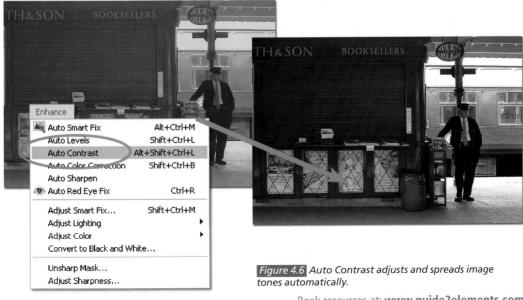

Book resources at: www.quide2elements.com

Figure 4.7 Auto Levels adjusts and spreads the tones of each individual color channel. In some pictures this feature can help to reduce color casts.

Editor: Enhance > Auto Levels

Version 4.0: Enhance > Auto Levels

The Auto Levels command is similar to Auto Contrast in that it maps the brightest and darkest parts of the image to white and black. It differs from the previous technique because each individual color channel is treated separately. In the process of mapping the tones in the Red, Green and Blue channels, dominant color casts can be neutralized. See Figure 4.7. This is not always the case; it depends entirely on the make-up of the image. In some cases the reverse is true; when Auto Levels is put to work on a neutral image a strong cast results. If this occurs, undo (Edit > Undo) the command and apply the Auto Contrast feature instead.

Editor: Enhance > Auto Smart Fix

Version 4.0: Enhance > Auto Smart Fix

The Auto Smart Fix feature enhances both the lighting and color in your picture automatically. The command is used to balance the color and improve the overall shadow and highlight detail. Most images are changed drastically using this tool. In some cases the changes can be too extreme, in which case the effect should be reversed using the Edit > Undo command and the more controllable version of the tool - Adjust Smart Fix - used instead. See Figure 4.8.

Editor: Enhance > Adjust Smart Fix

Version 4.0: Enhance > Adjust Smart Fix

The Adjust Smart Fix version of the feature provides the same control over color, shadow and highlight detail but with the addition of a slider control that determines the strength of the enhancement changes. Moving the slider from left to right will gradually increase the amount of correction applied to your picture. This approach provides much more control over the enhancement process and is a preferable way to work with all but the most general photos. The Auto button, also located in the dialog, automatically applies a fix amount of 100% and provides a similar result to selecting Enhance > Auto Smart Fix. See Figure 4.8.

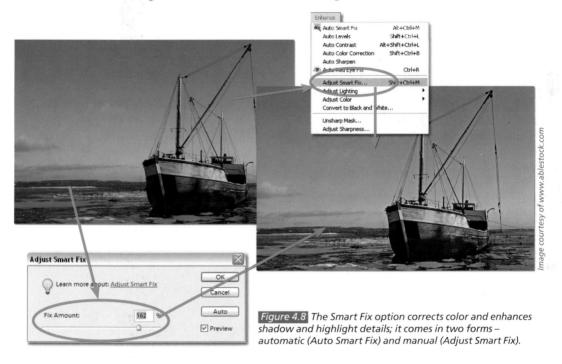

The Quick Fix editor – 'quick change central'

The Quick Fix editor is home for many of the automatic or 'quick and easy' enhancement tools. You can access and apply the features via the menu system or take advantage of the controls displayed in the Palette Bin.

Here you will find features that will enable you to quickly and easily adjust lighting, color, sharpening and, with the Smart Fix option included, highlight and shadow detail as well. You can let the program apply the changes for you by pressing the Auto button, or you can take control of the changes you apply by using the slider controls. Best of all, you can see the before and after results of your changes on screen via the zoomable previews.

There is no doubt that for making speedy adjustments of your favorite images in Elements, the Quick Fix editor is the best place to start. See Figure 4.9.

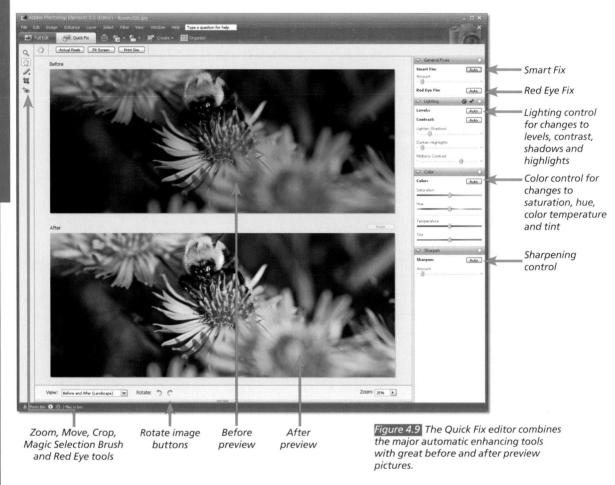

Altering a few tones only

Now that we have changed the brightness and contrast of the image so that the tones are more evenly spread between black and white, we can start to look at individual areas or groups of tones that need special attention.

For instance, when you are taking pictures on a bright sunny day, or where the contrast of the scene is quite high, the shadows in the image can become so dense that important details are too dark to see. A traditional method used by photographers to lighten the shadows is to capture the scene using a combination of existing light and a small amount of extra light from a flash. The flash illuminates the shadows, in effect 'filling' them with light, hence the name 'Fill Flash'. This is a great solution for a difficult problem.

Similarly, if the foreground or center section of a scene is dark, then the exposure system in a digital camera can overcompensate and cause the surrounding area to become too light. 'No problem', you say, as you adjust the brightness so that the whole picture is darker, but this action also affects the shadow and midtone areas of the picture, causing them to lose detail.

So how can we alter the brightness of just the shadow or only the highlight areas? Well, Adobe provided quite a clever solution to these problems in the previous versions of the program, employing two previously unknown features – Fill Flash and Adjust Backlighting (see details below for their uses). Version 3.0 introduced yet another new feature called the Shadow/ Highlight control. The tool combines two different controls that performed similar functions in previous versions of the product into one dialog.

Editor: Enhance > Adjust Lighting > Shadows/Highlights

Version 4.0: Enhance > Adjust Lighting > Shadows/Highlights

Designed as a replacement for both the Fill Flash and Adjust Backlighting controls, this one little dialog contains the same power as the previous two features in an easy-to-use format. The tool contains three sliders – the upper one is for Lightening Shadows which replaces the Fill Flash tool, the control in the middle Darkens Highlights and is a substitute for the Adjust Backlighting tool and the final slider adjusts Midtone Contrast.

Moving the Shadows control to the right lightens all the tones that are spread between the middle tones and black. Sliding the Highlights control to the right darkens those tones between middle values and white. The beauty of this feature is that unlike the Brightness/Contrast tool, these changes are made without altering other parts of the picture. To fine-tune the tonal changes a third slider is also included in the dialog. Moving this Midtone control to the right increases the contrast of the middle values and movements to the left decrease the contrast.

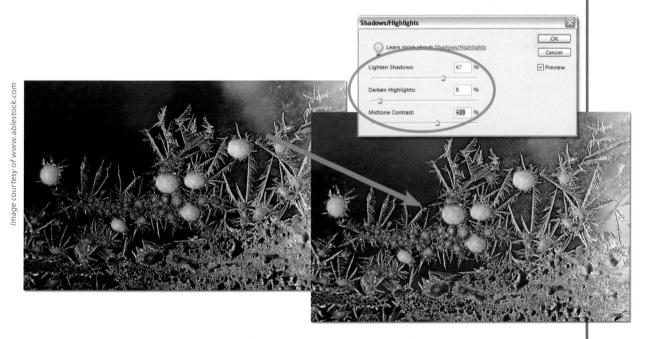

Figure 4.10 The Shadows/Highlights feature replaces both the Fill Flash and Adjust Backlighting tools available in earlier versions of Elements.

making the image 'flatter'. In Photoshop Elements 5.0 you can also use the Midtone Contrast slider in the Advanced Options of the new Adjust Color Curves dialog box to produce similar results. See Figure 4.10 on page 89.

- $1~{\it Select Enhance} > {\it Adjust Lighting} > {\it Shadows/Highlights}.$
 - 2 Move all sliders so that their values are set to 0%.
- ₹ 3 Move the Lighten Shadows slider to the right to lighten the dark tones.
 - 4 Move the Darken Highlights slider to the right to darken light areas.
- 5 Adjust the Midtone Contrast slider to restore any lost contrast to the picture.

Dodge and Burn tools

It is no surprise, given Adobe's close relationship with customers who are professional photographers, that some of the features contained in both Photoshop and Elements have a heritage in traditional photographic practice. The Dodge and Burn tools are good examples of this. Almost since the inception of the medium, photographers have manipulated the way their images have printed. In most cases this amounts to giving a little more light to one part of the picture and taking a little away from another. This technique, called dodging and burning, effectively lightens and darkens specific parts of the final print.

Adobe's version of these techniques involves two separate tools. See Figure 4.11. The Dodge tool's icon represents its photographic equivalent – a cardboard disk on a piece of wire. This device was used to shade part of the photographic paper during exposure. Having received less exposure, the area is lighter in the final print. When you select the digital version from the Elements toolbox, you will notice the cursor change to a circle which you can click and drag over your image to lighten the selected areas. The size and shape of the circle is based on the current brush size and shape. This can be changed via the palette in the options bar. Also displayed here are other options that allow you to lighten groups of tones like shadows, midtones and highlights independently. There are also controls to change the strength of the lightening process by adjusting the exposure. See Figures 4.12, 4.13.

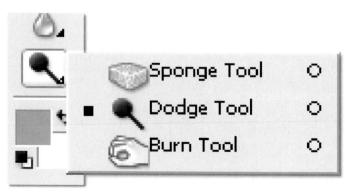

Figure 4.11 The Dodge and Burn tools are used to lighten and darken different parts of the picture.

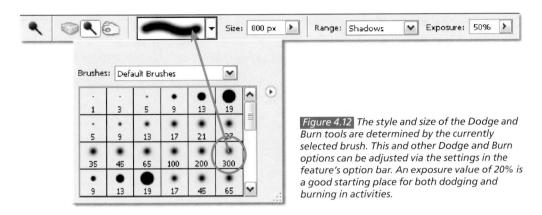

- 1 Select the Dodge tool from toolbox.
- 2 Choose the brush size from palette in the options bar.
- 3 Select the group of tones to adjust highlights, midtones or shadows.
- 4 Set the strength of the effect via the exposure value.
- 5 Click and drag the cursor over the image to lighten.

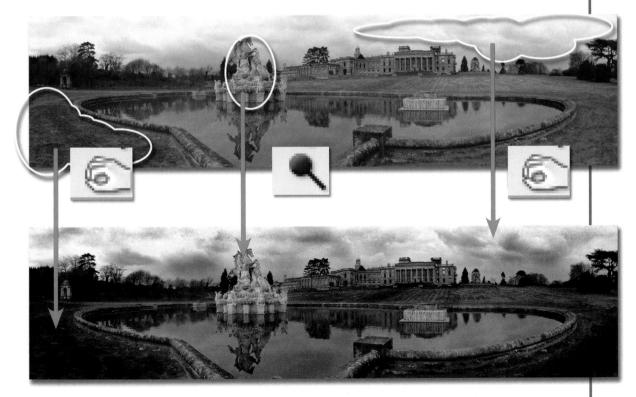

Figure 4.13 Skillful dodging and burning can help improve the appearance of specific dark and light picture areas.

The Burn tool's attributes are also based on the settings in the options bar and the current brush size, but rather than lightening areas this feature darkens selected parts of the image. Again, you can adjust the precise grouping of tones, highlights, midtones or shadows that you are working on at any one time. See Figure 4.14.

- 1 Select the Burn tool from toolbox.
- 2 Choose the brush size from the palette in the options bar.
- 3 Select the group of tones to adjust highlights, midtones or shadows.
- 4 Set the strength of the effect via the exposure value.
- 5 Click and drag the cursor over the image to darken.

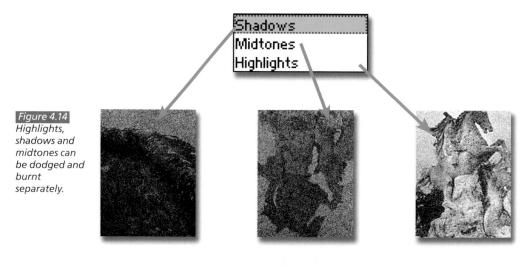

As with many digital adjustment and enhancement techniques, it is important to apply dodging and burning effects subtly. Overuse is not only noticeable, but you can also lose the valuable highlight and shadow details that you have worked so hard to preserve. See Figure 4.15.

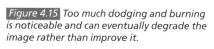

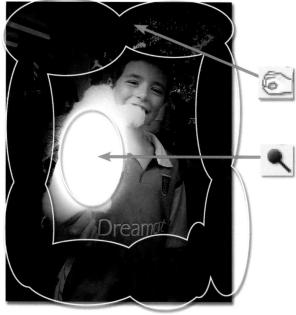

Book resources at: www.guide2elements.com

Figure 4.16 The dominant color cast in an image changes when it is shot under different light sources.

- (1) Fluorescent.
- (2) Household bulb.
- (3) Candlelight.
- (4) Daylight.

Color corrections

Our eyes are extremely complex and sophisticated imaging devices. Without us even being aware, they adjust to changes in light color and level. For instance, when we view a piece of white paper outside on a cloudy day, indoors under a household bulb or at work with fluorescent lights, the paper appears white. Our eyes adapt to each different environment.

Unfortunately, digital sensors, including those in our cameras, are not as clever. If I photographed the piece of paper under the same lighting conditions, the pictures would all display a different color cast. Under fluorescent lights the paper would appear green, lit by the household bulb it would look yellow and when photographed outside it would be a little blue. See Figure 4.16.

This situation occurs because camera sensors are generally designed to record images without casts in daylight. As the color balance of the light for our three examples is different from daylight – that is, some parts of the spectrum are stronger and more dominant than others – the pictures record with a cast. Camera manufacturers are addressing the problem by including Auto White Balance functions in their designs. These features attempt to adjust the captured image to suit the lighting conditions it was photographed under, but even so some digital pictures will arrive at your desktop with strange color casts. See Figure 4.17.

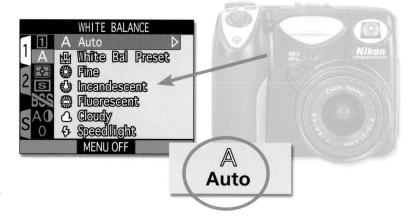

Figure 4.17 Some cameras include an Auto White Balance feature designed to compensate for different light sources.

Editor: Enhance > Auto Color Correction

Version 4.0: Enhance > Auto Color Correction

The Auto Color Correction feature, first seen in version 2.0 of the program, works in a similar way to tools like Auto Levels and Auto Contrast, providing a one-click fix for most color problems. As with all 'I'll let the computer decide' features, sometimes such automatic fixes do not produce the results that you expect. In these scenarios use the Undo (Edit > Undo) command to reverse the changes and try one of the manual tools detailed below. See Figure 4.18.

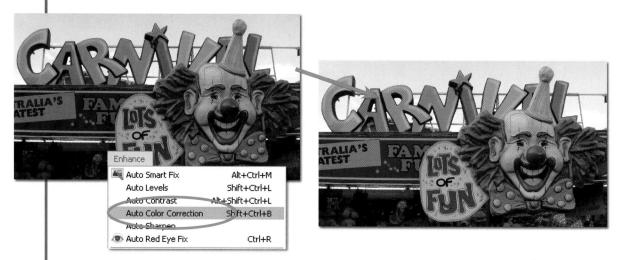

Figure 4.18 Auto Color Correction provides a one-click correction for most cast problems.

Editor: Enhance > Adjust Color > Remove Color Cast

Version 4.0: Enhance > Adjust Color > Remove Color Cast

To help provide a more selective solution to the color cast problem, Adobe included the Color Cast command in Elements. This function is designed to be used with images that have areas that are meant to be white, gray or black. By selecting the feature you can then click onto the neutral area and all the colors of the image will be changed by the amount needed to make the

area free from color casts. This command works particularly well if you happen to have a white, gray or black area in your scene. See Figure 4.19. Some image makers include a gray card in the corner of scenes that they know are going to produce casts in anticipation of using Color Cast to neutralize the hues later.

- 1 Select Enhance > Adjust Color > Remove Color Cast.
- 2 Use the Eyedropper tool to click on a part of the image that is meant to be either a neutral white, gray or black.
- 3 If you are unhappy with the results, click the Reset button to start again or keep clicking until you get a suitable result.
- 4 Click OK when the cast has been removed.

Keep in mind that this command produces changes based on the assumption that what you are clicking with the Eyedropper is meant to be neutral – that is, the color should contain even amounts of red, green and blue. In practice, it is not often that images have areas like this. For this reason Elements contains another method to help rid your images of color casts.

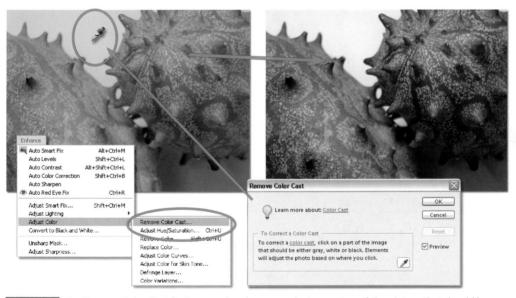

Figure 4.19 The Remove Color Cast feature works when you select a portion of the picture that should be neutral (white, gray or black) but exhibits a cast. Elements then rebalances the rest of the hues in the image to ensure that this part of the picture is cast free.

Editor: Enhance > Adjust Color > Color Variations

Version 4.0: Enhance > Adjust Color > Color Variations

An alternative to using the Remove Color Cast feature is the Color Variations command. From version 2.0 Elements has included a revised and simplified Color Variations dialog. The color changing thumbnails have been rationalized so that users only have to make simple decisions about increasing or decreasing the red, green or blue components of their images.

Now the Color Variations feature is divided into four parts. See Figure 4.20. The top of the dialog contains two thumbnails that represent how your image looked before changes and its appearance after. The radio buttons in section 2 (middle left) allow the user to select the parts of the image they wish to alter. In this way, highlights, midtones and shadows can all be adjusted independently. The Amount slider in section 3 (bottom left) controls the strength of the color changes. The final parts, sections 4 and 5 (bottom), is taken up with six color and two brightness preview images. These represent how your picture will look with specific colors added or when the picture is brightened or darkened. Clicking on any of these thumbnails will change the 'after' picture by adding the color chosen. To add a color to your image, click on a suitably colored thumbnail. To remove a color, click on its opposite.

- 1 Select Enhance > Adjust Color > Color Variations.
- 2 Choose the tones you want to change (shadows, midtones or highlights) or alternatively select saturation.
- 3 Adjust the Amount slider to set the strength of each change.
- $4\,$ Click on the appropriate thumbnails to make changes to your image.
- 5 Click OK to finish.

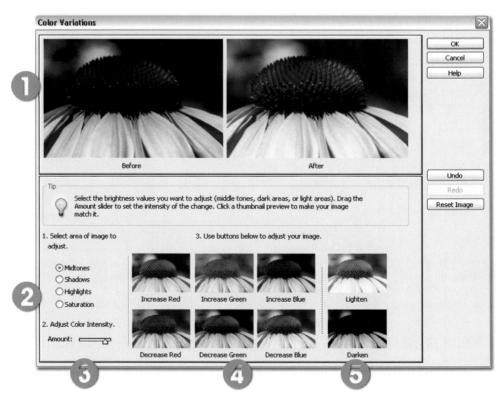

Figure 4.20 The Color Variations feature, as it appears in version 4.0, gives the user more control over color changes in the image. (1) Before and after thumbnails. (2) Image area to change. (3) Color strength or intensity. (4) Color variation thumbnails. (5) Brightness thumbnails.

The Red Eye Removal tool

Version 4.0: Red Eye Removal Tool

Using the built-in flash in your camera is a great way to make sure that you can keep photographing in any light conditions. One of the problems with flashes that are situated very close to the lens is that portrait pictures, especially when taken at night, tend to suffer from 'red eye'. The image might be well exposed and composed, but the sitter has glowing red eyes. This occurs because the light from the flash is being reflected off the back of the eye. Adobe recognized that a lot of small modern digital cameras have flashguns close to their lens — the major cause of this problem — and developed a specialist tool to help retouch these images. Called the Red Eye Removal tool since version 3.0 and the Red Eye Brush in previous releases, it changes the crimson color in the center of the eye to a more natural looking black.

To correct the problem is a simple process that involves selecting the tool and then clicking on the red section of the eye. Elements locates the red color and quickly converts it to a more natural dark gray. The tool's options bar provides settings to adjust the pupil's size and the amount that it is darkened. Try the default settings first and if the results are not quite perfect, undo the changes and adjust the option's settings before reapplying the tool. See Figure 4.21.

- 1 Select the Red Eye Removal tool from the toolbox.
- 2 Click on the red area of the eye or drag a marquee around the eye to apply the color change.
- 3 If the results are not perfect, Edit > Undo the changes and adjust the Pupil Size and Darken Amount settings in the options bar. Click on the red area to reapply the color change.

The Red Eye Removal tool is available in both the Quick Fix and Standard editing workspaces.

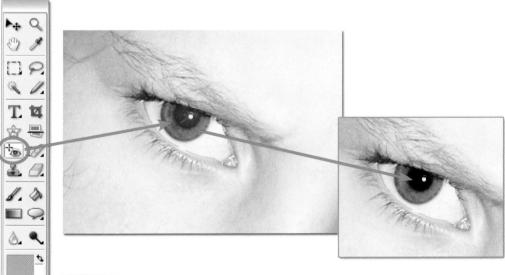

Figure 4.21 The Red Eye Removal tool is designed to eliminate the 'devil-like' eyes that result from using the inbuilt flash of some digital cameras.

Editor: Enhance > Adjust Color > Adjust Skin Tone

Adobe has added a new color control feature in Elements 4.0 that is designed to allow you to adjust the skin tones within your picture.

Making changes is a twostep process. When the feature first opens you need to use the Eyedropper tool to select a typical section of skin within the photo. Next you can adjust the color of the skin using the Tan and Blush sliders and the overall color of the picture with the Temperature control.

The picture can be reverted back to its original hues by selecting the Reset button or the changes applied by pressing the OK button. See Figure 4.22.

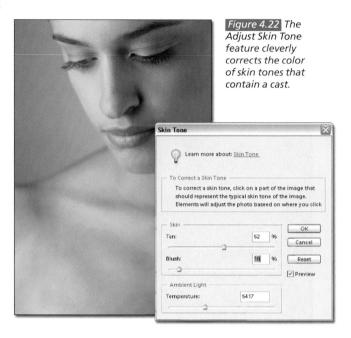

1 Select Enhance > Adjust Color > Adjust Skin Tone.

 $2\,$ Use the Eyedropper tool to click on an area of typical skin in the picture.

 $3\,$ Adjust the Skin and Blush sliders to alter skin color.

 $4\,$ Change the Temperature slider to alter the color of the whole image.

5 Click Reset to remove changes or OK to finish.

As the Skin Tone tool averages tones as it works, multiple clicks around different parts of a person's face will often refine the results. Holding down the Ctrl key while clicking turns off averaging and will resample with each click.

Using filters and effects

Editor: Filters menu

Version 4.0: Filter > Filter Gallery or Window > Styles and Effects > Filters tab

The filters contained within image-editing programs are capable of producing truly stunning effects. Digital filters are based on the traditional photographic versions, which are placed in front of the lens of the camera to change the way the image is captured. Now, with the click of a button, it is possible to make extremely complex changes to our images almost instantaneously – changes that a few years ago we couldn't even imagine.

The filters in Adobe Photoshop Elements can be found grouped under a series of subheadings based on their main effect or feature in the Filter menu. Selecting a filter will apply the effect to the current layer or selection. Some filters display a dialog that allows the user to change specific settings and preview the filtered image before applying the effect to the whole of the picture. This can be a great time saver, as filtering a large file can take several minutes. See Figure 4.23.

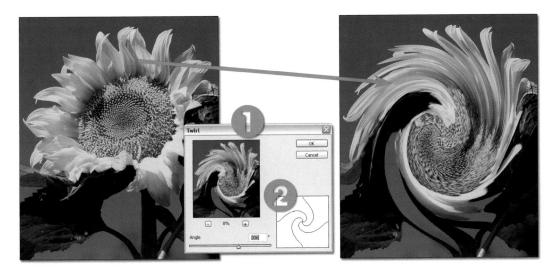

Figure 4.23 Most filters are supplied with a preview and settings dialog that allows the user to view changes before committing them to the full image. (1) Filter preview thumbnail. (2) Filter controls.

Editor: Filter > Filter Gallery

Most filters that don't work with their own dialog are incorporated into the Filter Gallery (Filter > Filter Gallery) feature which was first introduced in version 3.0. Designed to allow the user to apply several different filters to a single image it can also be used to apply the same filter several different times. The dialog consists of a preview area, a collection of filters that can be used with the feature, a settings area with sliders to control the filter effect and a list of filters that are currently being applied to the picture.

Multiple filters are applied to a picture by selecting the filter, adjusting the settings to suit the image and then clicking the New effect layer button at the bottom of the dialog. Filters are arranged in the sequence they are applied. Applied filters can be moved to a different spot in the sequence by click-dragging them up or down the stack. Click the eye icon to hide the effect of the selected filter from preview. Filters can be deleted from the list by selecting them first and then clicking the dustbin icon at the bottom of the dialog.

Most of the filters that can't be used with the Filter Gallery feature are either applied to the picture with no user settings or make use of the filter preview and settings dialog detailed in Figure 4.24.

If neither of these preview options are available, then as an alternative, you can make a partial selection of the image using the Marquee tool first and then use this to test the filter. Remember, filter changes can be reversed by using the Undo feature.

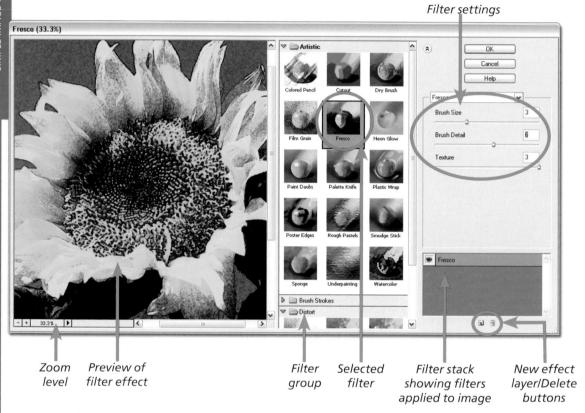

Figure 4.24 The Filter Gallery feature, first introduced in version 3.0, allows users to preview filter effects, alter filter settings and even apply several different filters to the same image interactively.

Editor: Window > Artwork and Effects

The number and type of filters available can make selecting which to use a difficult process. To help with this decision, Elements also contains a Filter Browser type feature that displays thumbnail versions of different filter effects. The browser is located with other thumbnail previews of shapes, graphics, themes, frames and layer styles in the new Artwork and Effects palette (Window > Artwork and Effects). Double-clicking the filter preview thumbnail will either open the Filter Gallery or a filter dialog, where settings can be adjusted, or simply apply changes directly to your picture. The selection of filters previewed in the gallery at any one time can be changed by altering the selection in the pop-up menu at the top of the palette. See Figure 4.25.

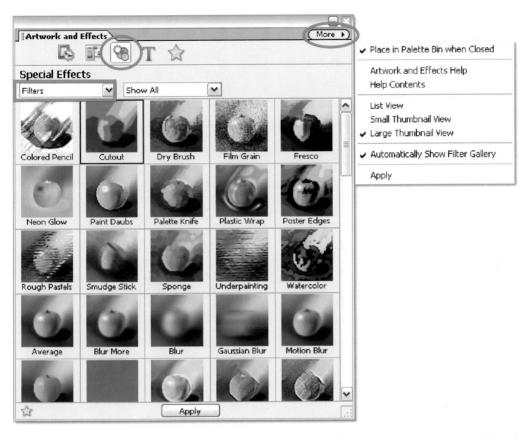

Figure 4.25 The filter browser, located within the new Artwork and Effects palette, gives users a good idea of the types of changes that a filter will make to an image when selecting a specific filter.

Let's get filtering

To give you a head start with your filtering, the next couple of pages contain some examples of the effects of a range of filters when applied to the same base image. See Figure 4.26. The results, along with the filter preview/settings and dialogs, are also included. See Figures 4.27 and 4.28. After that, the use and control of some of the selected filters are also featured in more detail.

Figure 4.26 The base image used for all filter examples over the next few pages.

Book resources at: www.guide2elements.com

Figure 4.27 Many of the filters that you use in Photoshop Elements will open up via the Filter Gallery feature. This will give you the added ability to be able to combine filter effects and even reapply the same effect several times. Some of the filters that work with the Filter Gallery include:

- (1) Filter > Sketch > Bas Relief.
- (2) Filter > Brush Strokes > Spatter.
- (3) Filter > Artistic > Colored Pencil.
- (4) Filter > Texture > Stained Glass.

- (5) Filter > Texture > Craquelure. (6) Filter > Artistic > Plastic Wrap. (7) Filter > Stylize > Glowing Edges, and (8) Filter > Distort > Ocean Ripple.

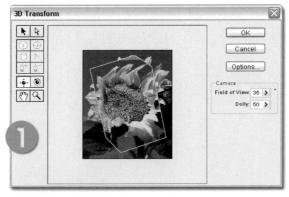

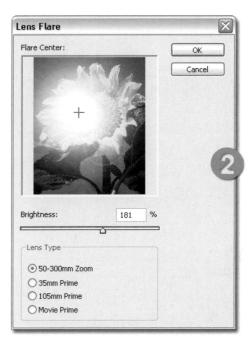

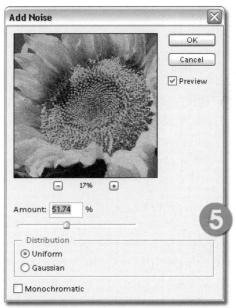

Figure 4.28 Filters that are not included in the Filter Gallery often have their own preview and settings dialog. These include:

- (1) Filter > Render > 3D Transform.
- (2) Filter > Render > Lens Flare.
- (3) Filter > Adjustments > Gradient Map.
- (4) Filter > Render > Lighting Effects.
- (5) Filter > Noise > Add Noise, and
- (6) Filter > Adjustments > Threshold.

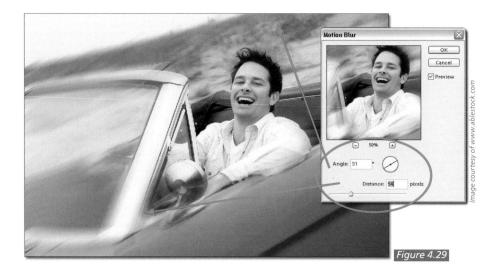

Editor: Filter > Blur > Motion Blur

The Motion Blur filter is great for putting back a sense of movement into action pictures that have been frozen by being photographed with a fast shutter speed. Used by itself, the filter produces photos that are very blurred and often lack any recognizable detail. Unless this is the effect you are looking for, it is best to apply this filter via a feathered selection to help retain sharpness in some picture parts whilst blurring others. See Chapter 6 for more details on selection techniques.

The filter dialog contains a single slider, a preview window and a motion direction (Angle) dial. The Angle dial determines the direction of the blur and should be set to simulate the natural direction of the subject. The Distance slider controls the amount of blur added to the picture – higher values create longer streaks and a more dramatic effect, smaller settings produce more subtle results. See Figure 4.29.

- 1 Before applying the filter we need to set up some controls over where the motion blur will be applied in our picture. To do this we start by selecting the area to remain sharp. Here I have used the Lasso tool to draw a freehand selection around the driver. Next, I invert the selection (Select > Inverse) so that the entire image except the driver is now selected.
- 2 To soften the transition between the sharp and blurred sections of the picture I applied a large feather (Select > Feather) to the selection. This replaces the normal sharp edge of the selection with a gradual change between selected and non-selected areas. I used a feathering of about 10% (100 pixels) of the total width of the picture.
- 3 Next I hid the selection using the shortcut keys Ctrl + H (the selection is still active, you just cannot see the marching ants) and opened the Motion Blur dialog (Filter > Blur > Motion Blur). I adjusted the Angle and Distance settings to suit the picture. Make sure that the Preview option is selected so that you can see the results in the full image. Click OK to complete.

EATURE

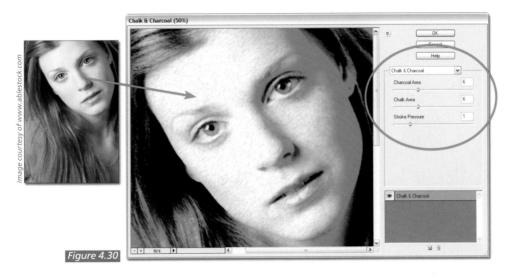

Editor: Filter > Sketch > Chalk & Charcoal

The Chalk & Charcoal filter is one of several drawing-like filters that can be found in the Sketch section of the Filter menu. The feature simulates the effect of making a drawing of the photograph with white chalk and black charcoal. The tones in the photograph that range from shadow to mid-gray are replaced by the charcoal strokes and those lighter values (from mid-gray to white) are 'drawn' in using the chalk color.

The filter dialog gives you control over the balance of the amount and placement of the charcoal and chalk areas as well as the pressure of the stroke used to draw the picture. Higher values for the Charcoal and Chalk Area sliders will increase the number and variations of tones that are drawn with these colors. High settings for the Stroke Pressure slider produce crisper transitions between tones and a more contrasty result. See Figure 4.30.

- 1 Set the foreground colors to default (foreground black, background white) by clicking the small black and white squares in the bottom left of the tool bar. The filter uses the foreground color as the 'charcoal' color and the background color as the 'chalk' color. If you have the same color set for background and foreground then a warning dialog will appear.
- 2 Select the Chalk & Charcoal filter from the Filter > Sketch menu. Using the preview window as a guide, adjust the Charcoal and Chalk Area sliders until you have situated the two tones in the positions most suited for the image. In the example I wanted to ensure that the shadow areas remained dark but still contained detail and that the skin tones were still fairly light.
- 3 Next, move your attention to the Stroke Pressure slider. Adjust the setting until you achieve a good balance of both detail and contrast. You may need to readjust the Chalk and Charcoal Area sliders to ensure a good spread of tones after the Pressure slider alterations.

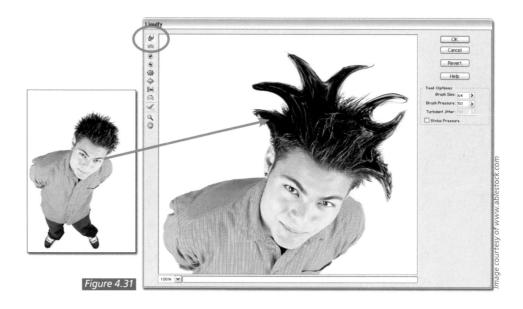

Editor: Filter > Distort > Liquify

The Liquify filter is a very powerful tool for warping and transforming your pictures. The feature contains its own sophisticated dialog box complete with a preview area and no fewer than eight different tools that can be used to twist, warp, push, pull and reflect your pictures with such ease that it is almost as if they were made of silly putty. See Figure 4.31.

- 1 Open an example image and then the Liquify filter (Filter > Distort > Liquify). The dialog opens and has a preview in the center, tools to the left and tool options to the right (use the Size, Pressure and Jitter options to control the effects of the tools). We will start with a simple manipulation designed to broaden the subject's smile. Select the Warp tool and drag the edge of the lips sideways and upwards. Make the brush smaller if too much of the surrounding detail is being altered as well.
- 2 Now let's exaggerate the perspective in the existing picture. Select the Pucker tool and increase the size of the Brush to cover the entire bottom of the figure. Click to squeeze in the subject's feet and legs. Now select the Bloat tool and place it over the upper portion of the subject; click to expand this area. If you are unhappy with any changes you can use the keyboard shortcuts for Edit > Undo (Ctrl + Z) to remove the last changes. If you want you can bloat the eyes as well.
- 3 To finish the caricature switch back to the Warp tool and drag some hair out and away from the subject's head. You can also use this tool to drag down the chin and lift the cheekbones. The picture can be selectively restored at any point by choosing the Reconstruct tool and painting over the changed area. Click OK to apply the changes that you have previewed to the fuller image. Depending on the size of the original this can take some time.

EATURE

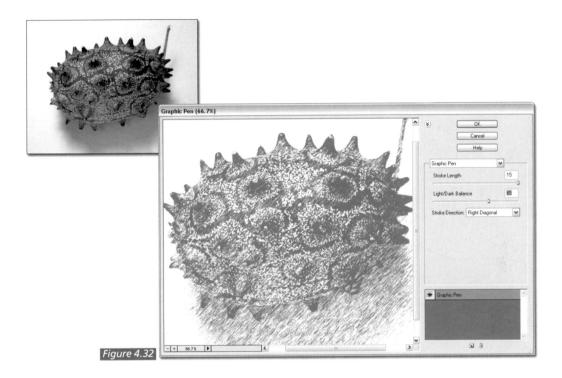

Editor: Filter > Sketch > Graphic Pen

The Graphic Pen filter is one of the group of Sketch filters. The feature simulates the effect of making a drawing of the photograph with a thin graphic arts pen. Close overlapping strokes are used for the shadow areas; midtones are represented by balancing strokes with the paper color showing through; and highlight details are drawn with a few sparse strokes.

The filter dialog gives you control over the balance of light and dark (paper and stroke) and the length of the pen stroke used to draw the picture. There is also a drop-down menu for selecting the direction of the pen strokes. See Figure 4.32.

- 1 Set the foreground colors to default (foreground black, background white) by clicking the small black and white squares in the bottom left of the tool bar. The Graphic Pen filter uses the foreground color as the 'ink' color and the background color as the 'paper' color.
- 2 Select the Graphic Pen filter from the Filter > Sketch menu. Using the preview window as a guide adjust the Stroke Length, Light/Dark Balance and Stroke Direction controls. Click OK to filter the picture.
- 3 To add a little more color to your Graphic Pen 'drawings' select colors other than black and white for the foreground and background values. Double-click each swatch to open the color swatch palette, where you can select the new color.

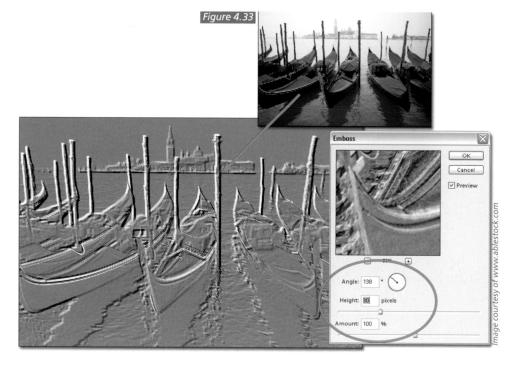

Editor: Filter > Stylize > Emboss

The Emboss filter converts your picture to flat areas of gray, fringed by lighter tones of various colors. The final result simulates an embossing effect, making the picture appear as though it has been beaten into a sheet of thin metal. See Figure 4.33.

The filter dialog contains two sliders, a preview window and a light direction (Angle) dial. The Angle dial determines the direction of the light used to produce the shadows and highlights that create the depth of the embossing effect. The Height slider controls the size of the edge outlines and adjusting the Amount slider determines the level of picture detail used in the final result.

- 1 With your picture open select the Emboss filter from the Stylize group in the Filter menu.
- 2 With the filter dialog open make sure that the Preview option is clicked and that the preview window is set to 100%. Turn the Angle dial to adjust the lighting direction used in the effect. Next move the Height slider until the edges of the effect are the size you desire. Movements to the right increase the size of the edge lines.
- 3 Now turn your attention to the Amount slider. Move the control until the embossing effect is applied to the level of texture you desire. Movements to the right increase the detail in the result. If necessary, drag the visible area in the preview window to examine more closely the changes in other areas of the picture. Click OK to complete.

FEATURE

Third party filters

Ever since the early versions of Photoshop Elements Adobe provided the opportunity for third party developers to create small pieces of specialist software that could plug into the program. The modular format of the software means that Adobe and other software manufacturers can easily create extra filters that can be added to the program at any time. In fact, some of the plug-ins that have been released over the years have became so popular that Adobe themselves incorporated their functions into successive versions of Elements. This is how the Photo filter, which made its first appearance in Elements 3.0, came into being.

Most plug-ins register themselves as extra options in the Filter menu, where they can be accessed just like any other Elements feature.

The Digital SHO filter from Applied Science Fiction is a great example of plug-in technology. Designed to automatically enhance the shadow detail in digital photographs, when installed it becomes part of a suite of filters supplied by the company that are attached to the Filter menu.

See Figure 4.34.

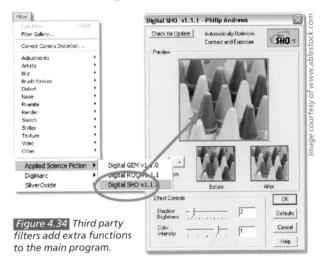

The 10 commandments for filter usage

- 1 Subtlety is everything. The effect should support your image not overpower it.
- 2 Try one filter at a time. Applying multiple filters to an image can be confusing.
- 3 View at full size. Make sure that you view the effect at full size (100%) when deciding on filter settings.
- 4 Filter a layer. For a change, try applying a filter to one layer and then using the Layer opacity slider to control how strongly the filter image shows through.
- 5 Print to check effect. If the image is to be viewed as a print, double-check the effect when printed before making final decisions about filter variables.
- 6 Fade strong effects. If the effect is too strong, try fading it. Apply the filter to a duplicate image layer that is above the original. Then reduce the opacity of this layer so the unfiltered original shows through.
- 7 Experiment. Try a range of settings before making your final selection.
- 8 Select then filter. Select a portion of an image and then apply the filter. In this way you can control what parts of the image are affected.
- 9 Different effects on different layers. If you want to combine the effects of different filters, try copying the base image to different layers and applying a different filter to each. Combine effects by adjusting the opacity of each layer.
- 10 Did I say that subtlety is everything?!

Getting help with Elements

In developing Elements, Adobe designed a range of learning aids that can help you increase your skills and understanding of the program. There is the usual Help menu complete with a dedicated window containing Contents, Topics, Search and Index listings for the whole program, but alongside this traditional approach Adobe also developed a couple of new help devices – namely the tool and feature Hints and the terrific How To guided tutorial system.

Hints

The Hints feature provides instant descriptions and help for the tool or feature that you are currently using. In versions 1.0 and 2.0 of the program the Hint details were displayed in a special Hints palette. The palette was located in the Palette Well or under the Window menu. From version 3.0 onwards the same information can be found by clicking the help or hyperlink associated with the feature or tool. See Figure 4.35.

Figure 4.35 The Hints function is an extension of the Help system and offers the user a detailed explanation of the tool, menu or feature selected and is activated by clicking the hyperlink next to the tool or displayed in the feature palette or dialog.

The How To feature

Version 5.0/4.0: Window > How To

The How To palette, known as the Recipes palette in version 1.0 of Elements, is an inbuilt tutorial system designed to take you step-by-step through a range of common enhancement and editing activities. Rather than just simple text-by-text instruction, the Recipes are interactive. If you are unable or unsure how to perform a specific step, then you can ask the program to 'Do this step for me'. To make best use of the feature, keep the window open whilst performing each step on your own image. See Figure 4.36.

- $1\ \mbox{Select Window}>\mbox{How To or click the How To tab in the Palette Well.}$
- 2 Choose a recipe category and pick the recipe to use.
- $3\,$ Work through the step-by-step instructions.
- 4 Click the 'Do this step for me' link if you are unsure of how to proceed.

Figure 4.36 The How To or Recipe palette provides step-by-step tutorials covering major adjustment and enhancement techniques. (1) Recipe groups. (2) Step-by-step instructions. (3) Action buttons.

Help

The Photoshop Elements Help system was completely revamped for version 4.0 and since that time has been centered around the Help dialog (Help > Photoshop Elements Help). See Figure 4.38. From here you can search for, and more importantly, locate specific information on tools, menu items and program features from the vast array of Help files that accompany the program. Over the last few years more and more software companies have published the many pages that detail how their programs work in electronic form rather than weighty paper volumes that used to come with your favorite software. Having the information in this format means that you can easily search for and list all the documents that deal with a specific subject in a matter of seconds. Add to this interactive contents, index and glossary sections and you have a Help system that generally supplies answers quickly and is far more efficient than the old software manual.

The Help system looks and works in the same way as the system found in other Adobe products such as Photoshop and InDesign. Rather than just providing information on how to use a specific tool or feature, the new design also includes ways for you to access extra support and product resources.

Figure 4.37 The Help feature in Elements provides a variety of ways to access the massive amount of Help files shipped with the package. You can browse through the Contents list, choose from Index headings, locate details in the Glossary or use the Search feature to hunt down the information you need.

The Help center also acts as a resource 'portal' providing direct access to tips and tutorials archive, support forums and training opportunities. See Figure 4.37.

Hands on Techniques

Better digital capture

Elements RAW Processing Step-by-step

Manual tonal control

Specialized color control

High quality sharpening techniques

Retouching techniques

Adding texture to an image

Changing the size of your images

hotoshop Elements has always been a software program that could produce professional results that go way beyond what you would expect given its modest price. I guess one of the main reasons for this is the fact that so many of the tools and features in the package are built on the same professional-level editing technology that gives Photoshop its strength. So it should come as no surprise when we come across tools and features that are very similar, and in some cases exactly the same, as those found in Photoshop. It is these very features, when coupled with a professional approach to their use, that will get you producing high quality digital photographs just like the pros (but at a fraction of the price!).

Elements 5.0 carries on this tradition by including plenty of great 'high-end' tools for us to play with. The most dramatic of these are the built-in RAW import editor (yes just like Photoshop) and the ability to support 16 bits per channel color pictures. These features might not mean much to you now but this chapter will introduce these and other quality editing tools, techniques and ideas that will ensure that you produce the absolute best quality pictures possible.

Figure 5.1 Unlike TIFF and JPEG formats, RAW files contain the unprocessed image and shooting data. In many cameras this visual information is laid out in the pattern (1) of the original sensor. The RAW data needs to be interpolated to create the full color digital file we normally associate with camera output (2).

Better digital capture

More and more medium- to high-end cameras are being released with the added feature of being able to capture and save your pictures in the RAW format. Selecting RAW, instead of the usual JPEG, stops the camera from processing the color information from the sensor and reducing the image's bit depth, and saves the picture in this unprocessed file type. This means that the full description of what the camera 'saw' is saved in the image file and is available to you for use in the production of quality pictures. Many photographers call this type of file a 'digital negative' as it has a broader dynamic range, extra colors and the ability to correct slightly inaccurate exposures.

Sounds great, doesn't it? All the quality of an information-rich image file to play with, but what is the catch? Well, RAW files have to be processed before they can be used in a standard image-editing application. To access the full power of these digital negatives you will need to employ a special dedicated RAW editor. Photoshop Elements 3.0 was the first version of the program to have such an editor built into the program. Called Adobe Camera Raw, this feature is designed specifically to allow you to take the unprocessed RAW data directly from your camera's sensor and convert it into a usable image file format. The Elements RAW editor also provides access to several image characteristics that would otherwise be locked into the file format. Variables such as color depth, white balance mode, image sharpness and tonal compensation (contrast and brightness) can all be accessed, edited and enhanced as part of the conversion process. Performing this type of editing on the RAW data provides a better and higher quality result than attempting these changes after the file has been processed and saved in a non-RAW format such as TIFF or IPEG. See Figure 5.1.

So what is in a RAW file?

To help consolidate these ideas in your mind try thinking of a RAW file as having three distinct parts:

Camera Data, usually called the EXIF or metadata, including things such as camera model, shutter speed and aperture details, most of which cannot be changed.

Image Data which, though recorded by the camera, can be changed in the Elements RAW editor and the settings chosen here directly affect how the picture will be processed. Changeable options include color depth, white balance, saturation, distribution of image tones and application of sharpness.

The Image itself. This is the data drawn directly from the sensor in your camera in a non-interpolated form. For most RAW-enabled cameras, this data is supplied with

Camera Data f-stop, shutter speed, ISQ, camera

Image Data (white balance, sharpening,

Figure 5.2 The RAW file is composed of three separate sections: Camera Data, Image Data and the Image itself. By keeping these components separate it is possible to edit variables like white balance and color depth, which are usually a fixed part of the file format, in the RAW file editor.

a 16 bits per channel color depth, providing substantially more colors and tones to play with when editing and enhancing than found in a standard 8 bits per channel camera file. See Figure 5.2.

RAW in action

When you open a RAW file in Elements 5.0 you are presented with the Adobe Camera Raw editing dialog containing a full color interpolated preview of the sensor data. Using a variety of menu options, dialogs and image tools you will be able to interactively adjust image data factors such as tonal distribution and color saturation. Many of these changes can be made with familiar slider-controlled editing tools normally found in features like Levels and the Shadows/

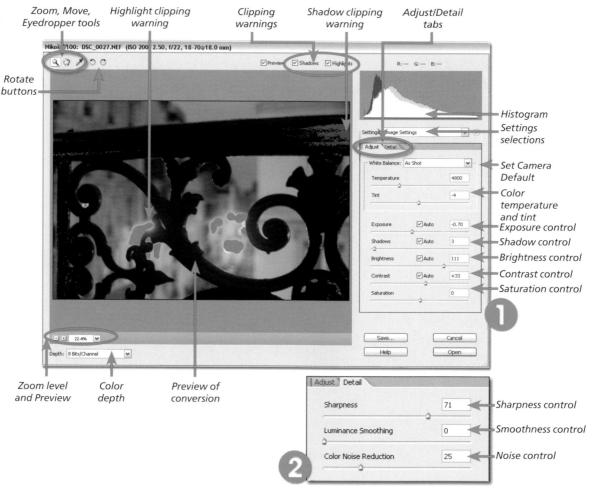

Figure 5.3 When you open a RAW file in Elements the Camera Raw editor is activated, providing you with a range of sophisticated controls for the enhancement and conversion of your RAW files. After making your changes, click Open – the plug-in closes and the converted file is placed into the Elements workspace. (1) Adjust tab options. (2) Detail tab options.

Highlights control. The results of your editing can be reviewed immediately via the live preview image and associated histogram graphs.

After these general image-editing steps have taken place you can apply some enhancement changes such as filtering for sharpness, removing color noise and applying some smoothing. The final phase of the process involves selecting the color depth and image orientation. Clicking the OK button sets the program into action applying your changes to the RAW file, whilst at the same time interpolating the Bayer data to create a full color image, and then opening the processed file into the full Elements workspace. See Figure 5.3.

The RAW advantage

The real advantages of editing and enhancing at the RAW stage are that these changes are made to the file at the same time as the primary image data is being converted (interpolated) to the full color picture. Editing after the file is processed (saved by the camera in 8 bits per channel versions of the JPEG and TIFF format) means that you will be applying the changes to a picture with fewer tones and colors.

A second bonus for the dedicated RAW shooter is that actions like switching from the White Balance option selected when shooting to another choice when processing are performed without any image loss. This is not the case once the file has been processed with the incorrect white balance setting, as anyone who has inadvertently left the tungsten setting switched on whilst shooting in daylight can tell you.

Elements Raw processing step by Step

Opening the Raw file

1. Opening the raw file in the Editor workspace

Once you have downloaded your raw files from camera to computer you can start the task of processing. Keep in mind that in its present state the raw file is not in the full color RGB format that we are used to, so the first part of all processing is to open the picture into a conversion utility or program. Selecting File > Open from inside Elements will automatically display the photo in the Adobe Camera Raw (ACR) utility.

2. Starting with the Organizer

Starting in the Organizer workspace simply right-click on the thumbnail of the raw file and select Go to Full Edit or Quick Fix from the pop-up menu to transfer the file to the Elements version of ACR in the Editor workspace.

Rotate

3. Rotate Right (90 CW) or Left (90 CCW)

Once the raw photo is open in ACR you can rotate the image using either of the two Rotate buttons at the top of the dialog. If you are the lucky owner of a recent camera model then chances are the picture will automatically rotate to its correct orientation. This is thanks to a small piece of metadata supplied by the camera and stored in the picture file that indicates which way is up.

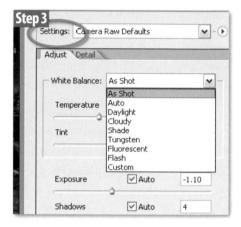

Adjusting white balance

Unlike other capture formats (TIFF, JPEG) the white balance settings are not fixed in a raw file. ACR contains three different ways to balance the hues in your photo. See steps 4 to 6 below.

4. Preset changes

When it comes to the White Balance options applied to your photo you can opt to stay with the settings used at the time of shooting ('As Shot') or select from a range of light source specific settings in the White Balance drop-down menu of ACR. For best results, try to match the setting used with the type of lighting that was present in the scene at the time of capture. Or choose the Auto option from the drop-down White Balance menu to get ACR to determine a setting based on the individual image currently displayed.

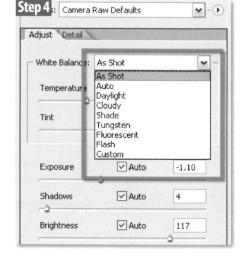

Book resources at: www.guide2elements.com

5. Manual adjustments

If none of the preset White Balance options perfectly matches the lighting in your photo then you will need to fine-tune your results with the Temperature and Tint sliders (located just below the Presets drop-down menu). The Temperature slider settings equate to the color of light in degrees kelvin – so daylight will be 5500 and tungsten light 2800. It is a blue to yellow scale, so moving the slider to the left will make the image cooler (more blue) and to the right warmer (more yellow). In contrast the Tint slider is a green to magenta scale. Moving the slider left will add more green to the image and to the right more magenta.

6. The White Balance tool

Another quick way to balance the light in your picture is to choose the White Balance tool and then click on a part of the picture that is meant to be neutral gray or white. ACR will automatically set the Temperature and Tint sliders so that this picture part becomes a neutral gray and in the process the rest of the image will be balanced. For best results when selecting lighter tones with the tool ensure that the area contains detail and is not a blown or specular highlight.

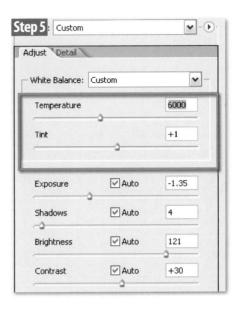

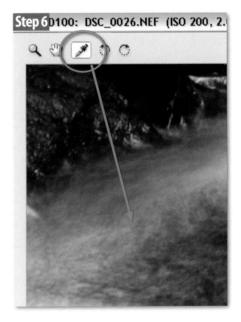

Tonal control

The next group of image enhancements alters the tones within the photo. There are five different slider controls each dealing with a specific group of image tones. Each of the controls has an Auto option that when checked will let ACR decide on the best tonal setting to use. Use the following steps if you want a little more control than that provided with the Auto options.

7. Setting the white areas

To start, adjust the brightness with the Exposure slider. Moving the slider to the right lightens the photo and to the left darkens it. The settings for the slider are in f-stop increments with a +1.00 setting being equivalent to increasing exposure by 1 f-stop. Use this slider to peg or set the white tones. Your aim is to lighten the highlights in the photo without clipping them (converting the pixels to pure white). To do this, hold down the Alt/Option whilst moving the slider. This action previews the photo with the pixels being clipped against a black background. Move the slider back and forth until no clipped pixels appear but the highlights are as white as possible.

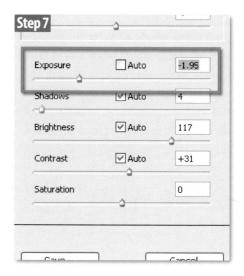

8. Adjusting the shadows

The Shadows slider performs a similar function with the shadow areas of the image. Again the aim is to darken these tones but not to convert (or clip) delicate details to pure black. Just as with the Exposure slider, the Alt/Option key can be pressed whilst making Shadows adjustments to preview the pixels being clipped. Alternatively the Shadow and Highlights Clipping Warning features can be used to provide instant clipping feedback on the preview image. Shadow pixels that are being clipped are displayed in blue and clipped highlight tones in red.

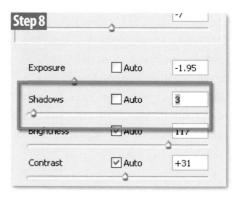

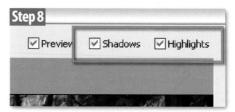

9. Brightness changes

The next control, moving from top to bottom of the ACR dialog, is the Brightness slider. At first the changes you make with this feature may appear to be very similar to those produced with the Exposure slider but there is an important difference. Yes, it is true that moving the slider to the right lightens the whole image, but rather than adjusting all pixels the same amount the feature makes major changes in the midtone areas and smaller jumps in the highlights. In so doing the Brightness slider is less likely to clip the highlights (or shadows), as the feature compresses the highlights as it lightens the photo. This is why it is important to set white and black points first with the Exposure and Shadows sliders before fine-tuning the image with the Brightness control.

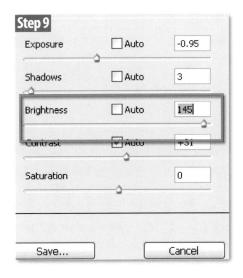

10. Increasing/Decreasing contrast

The last tonal control in the dialog, and the last to be applied to the photo, is the Contrast slider. The feature concentrates on the midtones in the photo with movements of the slider to the right increasing the midtone contrast and to the left producing a lower contrast image. Like the Brightness slider, Contrast changes are best applied after setting the white and black points of the image with the Exposure and Contrast sliders.

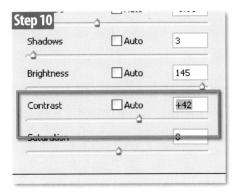

Color strength adjustments

As one of the primary roles of the Adobe Camera Raw utility is to interpolate the captured colors from their Bayer mosaic form to the more usable RGB format, it is logical to include a color strength adjustment as one of the controls in the process.

11. Saturation control

The strength or vibrancy of the colors in the photo can be adjusted using the Saturation slider. Moving the slider to the right increases saturation with a value of +100 being a doubling of the color strength found at a setting of 0. Saturation can be reduced by moving the slider to the left with a value of -100 producing a monochrome image. Some photographers use this option as a quick way to convert their photos to black and white but most prefer to make this change in Photoshop Elements proper where more control can be gained over the conversion process with features such as the new Convert to Black and White control.

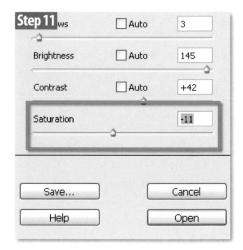

Sharpness/Smoothness and Noise Reduction

With the tones and colors now sorted let's turn our attention to sharpening and noise reduction. Both these image enhancements can be handled in-camera using one of a variety of auto settings found in the camera setup menu, but for those image makers in pursuit of imaging perfection these changes are best left until processing the file back at the desktop. These options are located under the Detail tab in the ACR dialog.

12. To sharpen or not to sharpen

The Sharpening control in ACR is based on the Unsharp Mask filter and provides an easy-to-use single slider Sharpening option. A setting of 0 leaves the image unsharpened and higher values increase the sharpening effect based on Radius and Threshold values that ACR automatically calculates via the camera model, ISO and exposure compensation metadata settings.

13. Reducing noise

ACR contains two different noise reduction controls. The Luminance Smoothing slider is designed to reduce the appearance

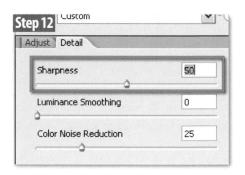

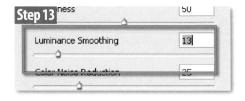

of grayscale noise in a photo. This is particularly useful for improving the look of images that appear grainy. The second type of noise is the random colored pixels that typically appear in photos taken with a high ISO setting or a long shutter speed. This is generally referred to as chroma noise and is reduced using the Color Noise Reduction slider in ACR. The noise reduction effect of both features is increased as the sliders are moved to the right.

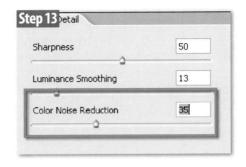

Remember: When using these tools keep in mind that overuse can lead to flat, textureless photos so ensure that you zoom into the image (at least 100%) and check the results of your settings in important areas of details.

Output options

Now to the business end of the conversion task – outputting the file. The Photoshop Elements version of ACR contains only the Color Depth output option.

14. Controlling color depth/space and image size/resolution

The section below the main preview window in ACR contains the output options settings. Here you can adjust the color depth (8 or 16 bits per channel) of the processed file. Earlier versions of Photoshop Elements were unable to handle 16 bits per channel images but the latest releases have contained the ability to read, open, save and make a few changes to these high color files.

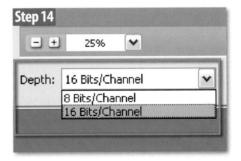

Save, Open or Done

The last step in the process is to apply the enhancement changes to the photo. This can be done in a variety of ways.

15. Opening the processed file in Photoshop Elements

The most basic option is to process the RAW file according to the settings selected in the ACR dialog and then open the picture into the Editor workspace of Photoshop Elements. To do this simply select the OK button. Select this route if you intend to edit or enhance the image beyond the changes made during the conversion.

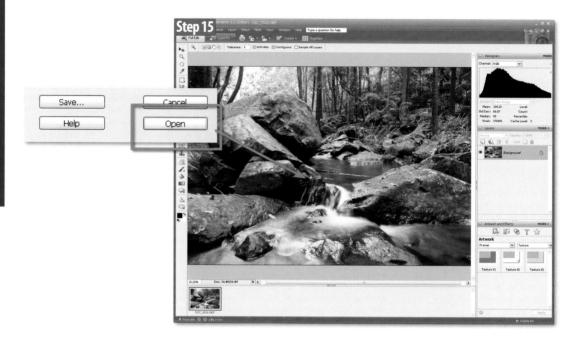

16. Saving the processed RAW file

Users have the ability to save converted RAW files from inside the ACR dialog via the Save button. This action opens the Save Options dialog which contains settings for inputting the file name as well as file type specific characteristics such as compression. Use the Save option over the Open command if you want to process photos quickly without bringing them into the Editing space.

Pro's tip: Holding down the Alt key whilst clicking the Save button allows you to store the file (with the raw processing settings applied) without actually going through the Save Options dialog.

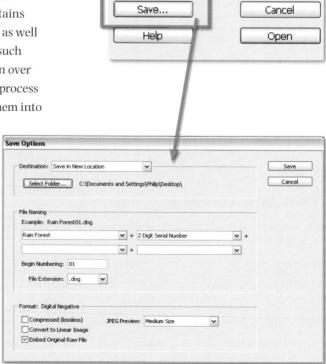

Step 16

17. Applying the RAW conversion settings

There is also an option for applying the current settings to the RAW photo without opening the picture. By Alt-clicking the OK button (holding down the Alt key changes the button to the Update button) you can apply the changes to the original file and close the ACR dialog in one step.

The great thing about working this way is that the settings are applied to the file losslessly. No changes are made to the underlying pixels, only to the instructions that are used to process the RAW file. When next the file is opened, the applied settings will show up in the ACR dialog ready for fine-tuning, or even changing completely.

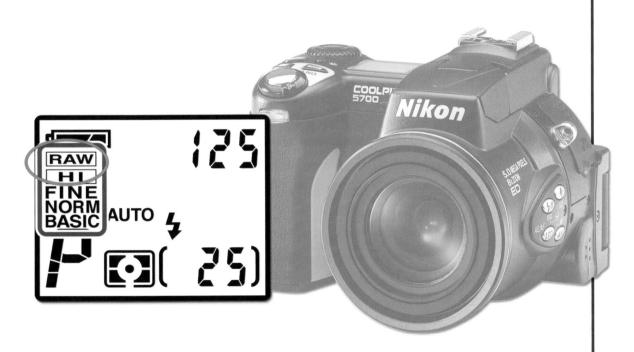

Figure 5.4 If you want the best quality pictures always make sure that your scanner or camera captures in 16 bit per channel or 48-bit mode. On most cameras this is referred to as the TIFF or RAW setting.

Color depth or 'What do you mean 8 bits per channel?'

Each digital file you create (capture or scan) is capable of representing a specific number of colors. This capability, usually referred to as the 'mode' or 'color depth' of the picture, is expressed in terms of the number of 'bits'. Most photos these days are created in 24-bit mode. This means that each of the three color channels (red, green and blue) is capable of displaying 256 levels of color (or 8 bits per channel). When the three channels are combined, a 24-bit image can contain a staggering 16.7 million separate tones/hues.

This is a vast amount of colors and would be seemingly more than we could ever need, see or print, but many modern cameras and scanners are now capable of capturing up to 16 bits per channel or 'high-bit' capture in either RAW or TIFF file formats. This means that each of the three colors can have as many as 65,536 different levels and the image itself, with all three channels combined, a whopping 281,474,976 million colors (last time I counted!). But why would we need to capture so many colors? See Figures 5.4 and 5.5.

More colors equals better quality

Most readers would already have a vague feeling that a high-bit file (16 bits per channel) is 'better' than a low-bit (8 bits per channel) alternative, but understanding why is critical for ensuring the best quality in your own work.

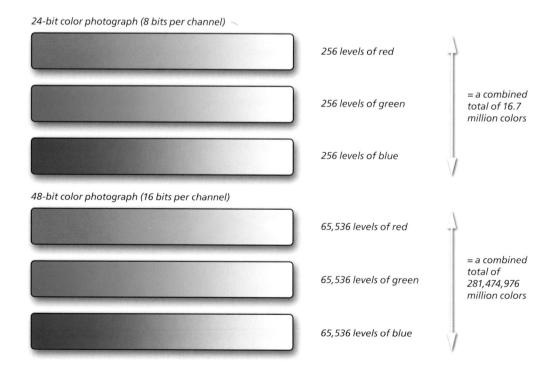

Figure 5.5 The higher the bit depth of an image the more levels of tone and numbers of colors it can display.

Book resources at: www.guide2elements.com

Here are the main advantages in a nutshell:

- 1 Capturing images in high-bit mode provides a larger number of colors for your camera or scanner to construct your image with. This in turn leads to better color and tone in the digital version of the continuous tone original or scene.
- 2 Global editing and enhancement changes made to a high-bit file will always yield a better quality result than when the same changes are applied to a low-bit image.
- 3 Major enhancement of the shadow and highlight areas in a high-bit image is less likely to produce posterized tones than if the same actions were applied to a low-bit version.
- 4 More gradual changes and subtle variations are possible when adjusting the tones of a high-bit photograph, using tools like Levels, than is possible with low-bit images.

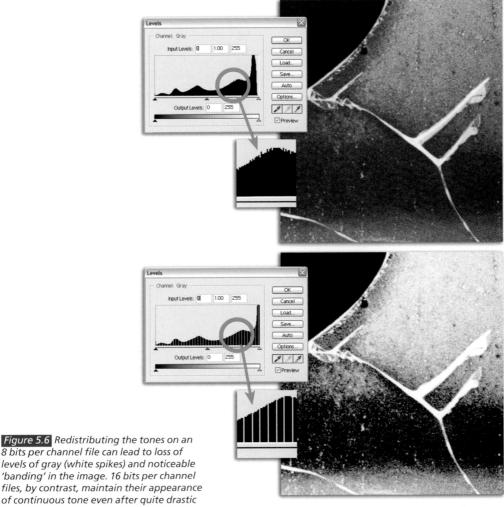

levels of gray (white spikes) and noticeable 'banding' in the image. 16 bits per channel files, by contrast, maintain their appearance of continuous tone even after quite drastic

editing and enhancement actions.

Photoshop Elements is 16-bit enabled

But why all this talk about 16 bits per channel files (48-bit color in total)? Well, since the version 3.0 release of Elements the program has been 16-bit enabled. This means that if you have a camera or scanner that is capable of capturing in this mode you can now take advantage of the extra color and tone it provides. 'Fantastic!' you say. 'No more 8 bits per channel (24-bit image) tweaking for me, I'm a 16 bits per channel fanatic from here on in.' But there is a catch (you knew there had to be).

Despite the power and sophistication of Elements, only a subset of its features is available for working on 16-bit files. Of the tools, the Rectangular and Elliptical Marquee and Lasso, Eyedropper, Move and Zoom tools all function in this mode. In addition, you can rotate, resize, apply auto levels, auto contrast or auto color correct or use more manual controls such as Levels, Shadows/Highlights and Brightness/Contrast features. The Sharpen, Noise, Blur and Adjustment filter groups also work here. Does this mean that making enhancement changes in 16-bit mode is unworkable? No, you just need to use a different approach. Read on.

Global versus local enhancement

Because of the limitations when working with a 16 bits per channel file in Elements, some digital photographers break their enhancement tasks into two different sections – global and local.

Global, or those changes that are applied at the beginning of the process to the whole picture. These include general brightness and contrast changes, some color correction and the application of a little sharpening.

Local changes are those that are more specific and are sometimes applied to just sections of the picture. They may include dodging and burning in, removal of unwanted dust and scratches, the addition of some text and the application of special effects filters.

This separation of enhancement tasks fits neatly with the way that the 16-bit support works in Photoshop Elements. Global changes can be applied to the photograph whilst it is still in 16-bit mode; the file can then be converted to 8 bits per channel (Image > Mode > 8 Bits/channel) and the local alterations applied. This is the process that the professionals have been using for years and now Elements gives you the power to follow suit.

Common high-bit misconceptions

- 1 Elements can't handle high-bit images. Not true. Previous versions of the program couldn't handle high-bit pictures but since Elements 3.0 the program has contained a reduced feature set that can be used with 16 bits per channel images. And even with this limitation there are enough features available to ensure quality enhancement of your images.
- 2 High-bit images are too big for me to handle and store. Yes, high-bit images are twice the file size of 8-bit pictures and this does slow down machines with limited resources but, if this is

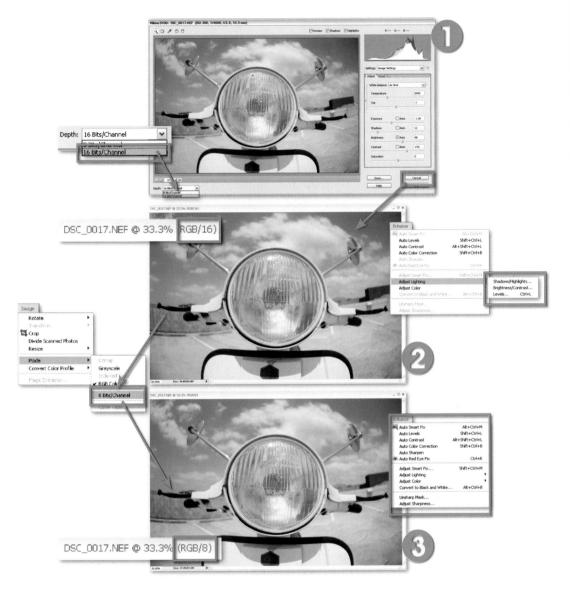

Figure 5.7 Try to perform as many of your standard editing tasks on the 16-bit file as this will give you the best overall editing results. Once these changes have been made it is then time to convert the file to 8-bits per channel to finish your enhancement techniques. (1) Create 16-bit files from RAW format pictures. (2) Perform all possible enhancement steps whilst the image is in 16-bit mode. (3) Convert to 8 bit mode and complete editing and enhancing the photo with tools and techniques that are only possible with 8-bit files.

- a concern, put up with the inconvenience of a slow machine whilst you make tonal and color changes then convert to a speedier 8-bit file for local changes.
- 3 I can't use my favorite tools and features in high-bit mode so I don't use high-bit images at all. You are losing quality in your images needlessly. Perform your global edits in 16-bit mode and then convert to 8-bit mode for the application of your favorite low-bit techniques. See Figure 5.7.

Ensure quality capture and enhancement with 16-bit and RAW files

- $1\,$ Capture all images in the highest color depth possible. This will help to ensure the best possible detail, tone and color in your pictures.
- 2 If you have a camera that can capture RAW files then ensure that this feature is activated as well, as it provides the best quality files to work with.

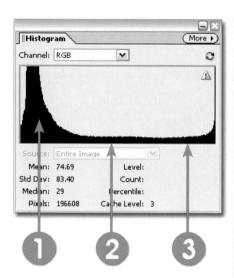

Figure 5.8 The Histogram provides graph-based information about the spread of pixel tones within your image so that you can see the number of pixels grouped in the shadows (1), midtones (2) and highlights (3) areas.

Manual tonal control

The Brightness/Contrast feature that we looked at in the last chapter is a great way to start to change the tones in your images, but as your skill and confidence increase you might find that you want a little more control. Adobe included the Histogram feature and the Levels function from Photoshop in Elements for precisely this reason.

Editor: Window > Histogram

Version 5.0/4.0: Window > Histogram

The first step in taking charge of your pixels is to become aware of where they are situated in your image and how they are distributed between black and white points. The Histogram palette displays a graph of all the pixels in your image. The left-hand side represents the black values, the right the white end of the spectrum. As we already know, in a 24-bit image there are a total of 256 levels of tone possible from black to white – each of these values is represented on the graph. The number of pixels in the image with a particular brightness or tone value is displayed on the graph by height. See Figure 5.8.

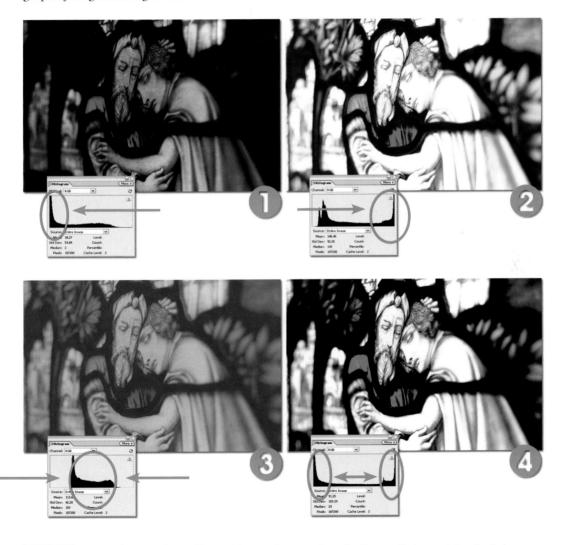

Figure 5.9 You can diagnose the problems with your photos and predict the way that your picture looks by the shape of the graph in the Histogram palette and the Levels feature. (1) The pixels are bunched to the left end of the graph for underexposed images and (2) to the right end for overexposed ones. (3) Pixels are bunched together in the middle of the graph for flat images. (4) The pixels are spread right out to the left and right edges for contrasty pictures.

Knowing your images

After a little time viewing the histograms of your images, you will begin to see a pattern in the way that certain styles of photographs are represented. Overexposed pictures will display a large grouping of pixels to the right end of the graph, whereas underexposure will be represented by most pixels bunched to the left. Flat images or those taken on an overcast day will show all pixels grouped around the middle tones and contrasty pictures will display many pixels at the pure white and black ends of the spectrum. See Figure 5.9.

Previously in this book, we have fixed these tonal problems by applying one of the automatic correction features, such as Auto Contrast or Auto Levels, found in Elements, or by using a simple slider control such as Brightness/Contrast. All of these tools remap the pixels so that they sit more evenly across the whole of the tonal range of the picture. Viewing the histogram of a corrected picture will show you how the pixels have been redistributed. See Figure 5.10.

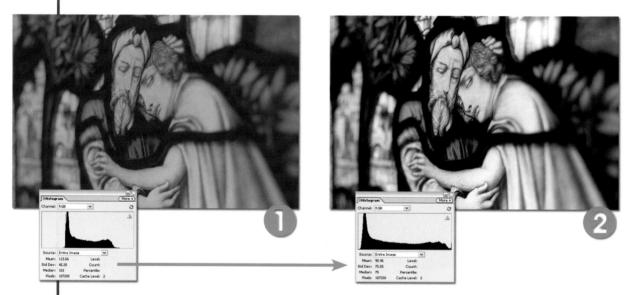

Figure 5.10 The Auto Levels or Auto Contrast feature redistributes pixels in the graph between the black and white points. (1) Before Auto Levels. (2) After Auto Levels.

Editor: Enhance > Adjust Lighting > Levels

Version 5.0/4.0: Enhance > Adjust Lighting > Levels

If you want to take more control of the process than is possible with the auto solutions, open the Levels dialog. Looking very similar to the Histogram, this feature allows you to interact directly with the pixels in your image. As well as a graph, the dialog contains two slider bars. The one directly beneath the graph has three triangular controls for black, midtones and white, and represents the input values of the picture. The slider at the bottom of the box shows output settings, and contains black and white controls only. See Figure 5.11.

To adjust the pixels, drag the input shadow (left end) and highlight (right end) controls until they meet the first set of pixels at either end of the graph. When you click OK, the pixels in the original image are redistributed using the new white and black points. Altering the midtone control will change the brightness of the middle values of the image, and moving the output black and white points will flatten, or decrease, the contrast. Clicking the Auto button is like selecting Enhance > Auto Levels from the menu bar.

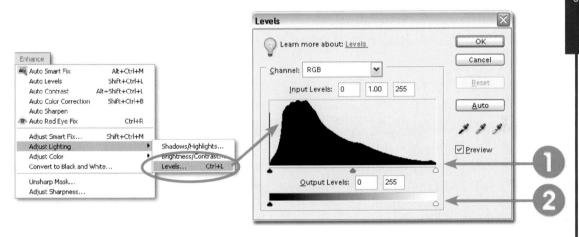

Figure 5.11 The Levels control allows you to interactively control the spread of pixels within your image. (1) Input values. (2) Output values.

Pegging black and white points

readouts for Delta X (X), Delta Y (Y), angle (A), and distance (D).

On the right-hand side of the Levels dialog is a set of three eyedropper buttons used for sampling the black, gray and white pixels in your image. Designed to give you ultimate control over the tones in your image, these tools are best used in conjunction with the Info palette (Window > Info). See Figure 5.12.

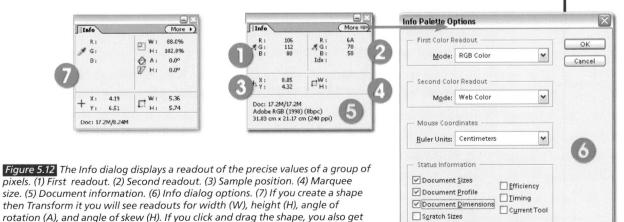

Book resources at: www.guide2elements.com

To use this technique, start by making sure that the Info palette is visible (Window > Info) and then select the black point eyedropper from the Levels dialog. Locate the darkest point in the picture by moving the dropper cursor over your image and watching the values in the Info palette. Your aim is to find the pixels with RGB values as close to 0 as possible. By clicking on the darkest area you will automatically set this point as black in your graph (and your picture). Next, select the white point eyedropper, locate the highest value and again click to set. With Highlight and Shadow values both pegged, all the values in the picture will be adjusted to suit. Note that the Info palette will show before and after values when making changes, for example 42/48 (before/after). When sampling white areas, you should avoid specular highlights such as the shine from the surface of a metallic object as these parts of the picture contain no printable details. See Figure 5.13.

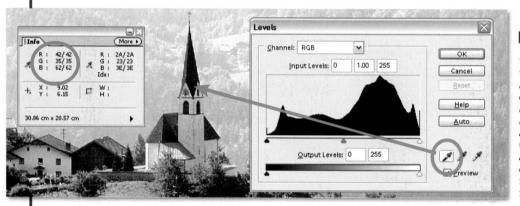

Figure 5.13
With the aid of the details in the Info dialog locate the darkest and lightest points in your picture and peg these with the black and white point eyedroppers from the Levels feature.

Color correction with the gray point eyedropper

The gray point eyedropper performs in a similar manner to the Color Cast command. With the tool selected, the user clicks on an area in the picture that should be a neutral gray. The color of the area is changed to neutral gray or equal amounts of red, green and blue, changing with it all the other pixels in the image. This tool is particularly useful for neutralizing color casts.

- 1 Select Window > Info.
- 2 Select Enhance > Adjust Lighting > Levels.
- 3 Peg highlights and shadow areas using the Levels' eyedropper tools and values in the Info palette.
- 4 Select OK to finish.

Make Levels changes in 16-bit mode

Levels changes can be performed and indeed should be performed when your photographs are in 16-bit mode. Adjusting your contrast and brightness here will give you much smoother gradation of tones and preserve more detail in your final picture.

Book resources at: www.guide2elements.com

Adjusting tones with Levels summary

Use the following guide to help you make tonal adjustments for your images using Levels:

- 1 *To increase contrast* Move the input black and white controls to meet the first group of pixels.
- 2 *To decrease contrast* Move the output black and white points towards the center of the slider.
- 3 To make middle values darker Move the input midtone control to the right.
- 4 To make middle values lighter Move the input midtone control to the left.
- TURE
- $1\ \ Select\ Enhance > Adjust\ Lighting > Levels.$
- 2 Change contrast and midtone values by adjusting input and output sliders.
- 3 Select OK to finish.

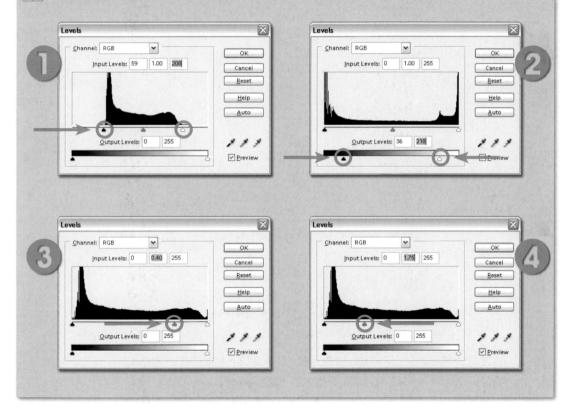

Specialized color control

In traditional imaging it is very difficult to manipulate the hues in an image. Thankfully, this is not the case in digital picture making. Fine control over color intensity and location is an integral part of the new technology. Apart from the Variations and Color Cast features that we looked at in the last chapter, Elements also contains the Hue/Saturation command and the Auto Color feature.

Editor: Enhance > Auto Color Correction

Version 5.0/4.0: Enhance > Auto Color Correction

This feature works in a similar way to Auto Levels and Auto Contrast in that it identifies the shadows, midtones and highlights in an image and uses these as a basis for image changes. The feature adjusts the contrast of the image by remapping the shadows and highlights to black and white, and neutralizes any color casts by balancing the red, green and blue values in the picture's midtones.

As with most auto functions, this tool works well for the majority of images. For most users this is a good place to start to enhance and correct images, but for those occasions where Auto Color Correction produces poor results then my suggestion is to undo the automatic changes and rework the picture using either the Variations or Color Cast features. See Figure 5.14.

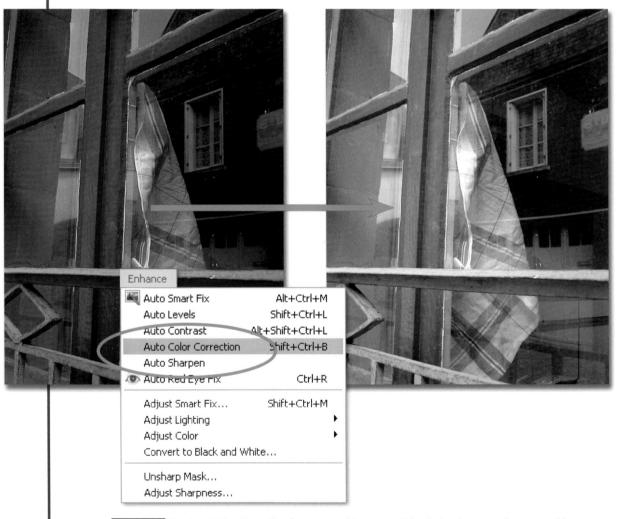

Figure 5.14 The Auto Color Correction feature provides a one-click solution to most color cast problems.

Editor: Enhance > Adjust Color > Adjust Hue/Saturation

Version 5.0/4.0: Enhance > Adjust Color > Hue/Saturation

To understand how this feature works you will need to think of the colors in your image in a slightly different way. Rather than using the three-color model (Red, Green, Blue) that we are familiar with, the Hue/Saturation control breaks the image into different components – Hue or color, Saturation or color strength, and Lightness (HSL). See Figure 5.15.

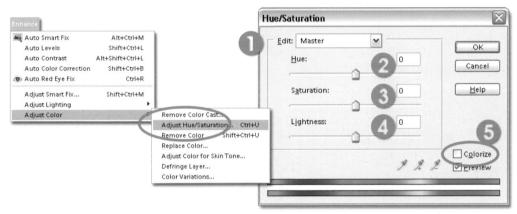

Figure 5.15 The Hue/Saturation control provides control over the color within your image. (1) Target tones selected for adjustment. (2) Color slider. (3) Strength slider. (4) Lightness slider. (5) Colorize option.

The dialog itself displays slider controls for each component, allowing the user to change each factor independently of the others. Moving the Hue control along the slider changes the dominant color of the image. From left to right, the hue's changes are represented in much the same way as colors in a rainbow. Alterations here will provide a variety of dramatic results, most of which are not realistic and should be used carefully. Moving the Saturation slider to the left gradually decreases the strength of the color until the image is reduced to just gray tones. In contrast, adjusting the control to the right increases the purity of the hue and produces images that are vibrant and dramatic. The Lightness slider changes the density of the image and works the same way as the Brightness slider in the Brightness/Contrast feature. You can use this feature to make slight adjustments when a color change darkens or lightens the midtones of the image but more critical brightness changes should be made with the Levels feature.

By selecting the Colorize option and then moving the Hue control, it is possible to simulate sepiaor blue-toned prints. The option converts a colored image to a monochrome made up of a single dominant color and black and white. See Figure 5.16.

- 1 Select Enhance > Adjust Color > Hue/Saturation.
- 2 Select the Colorize option to make toned prints.
- 3 Change Hue, Saturation and Lightness by adjusting sliders.
- 4 Select OK to finish.

Figure 5.16 The Hue/Saturation feature provides you with the ability to change the color in your pictures in a variety of ways. (1) Original picture.

- (2) Moving the Hue slider changes the dominant colors in the image.
- (3) The Saturation slider controls the strength or purity of colors in the picture.
- (4) Movements of the Lightness slider control the brightness of the picture.
- (5) Selecting the Colorize option changes the image to a monochrome, containing tones made up of one main color, white and black. Moving the Hue slider with this option checked produces 'toned' photographs.

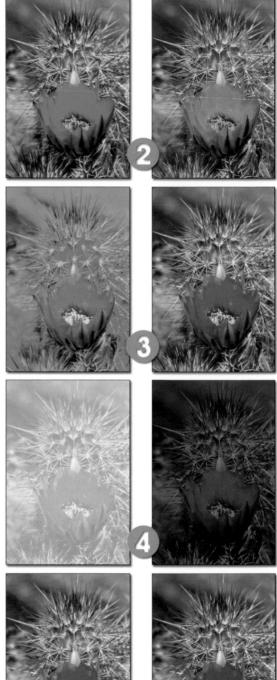

ige courtesy of www.ablestock.co

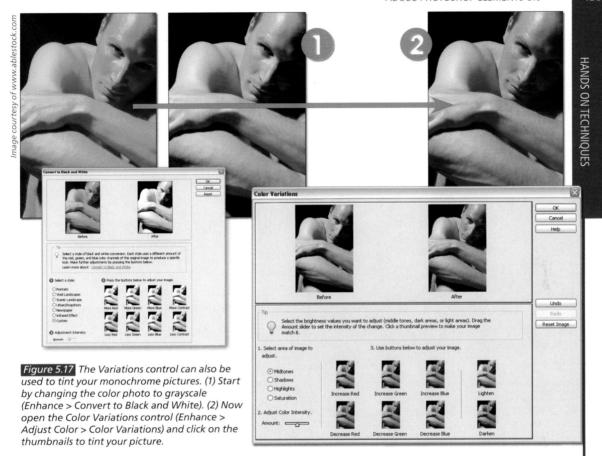

Editor: Enhance > Adjust Color > Color Variations

Version 5.0/4.0: Enhance > Adjust Color > Color Variations

The Variations command that we looked at in the last chapter can also be used to convert full color images to tinted monochromes. First, change your color image to grayscale using the brand new Enhance > Convert to Black and White feature. Your image will now appear to be a grayscale but the file is still in RGB mode so color can be added at any time. Open the Variations command (Enhance > Adjust Color > Color Variations) and tone your picture by clicking on the appropriate thumbnails. For some users this method might be a little easier to use than the Hue/Saturation command, as the results and color alternatives are previewed and laid out clearly. See Figure 5.17.

- 1 Open color image.
- 2 Select Enhance > Convert to Black and White.
- 3 Select Enhance > Adjust Color > Color Variations.
- 4 Adjust strength of the color changes using the Color Intensity slider.
- 5 Pick the thumbnails to change image color and check progress by viewing the Before After thumbnails. Click OK to finish.

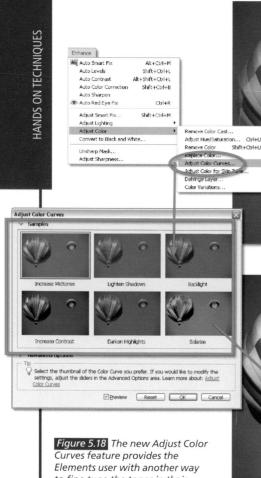

to fine tune the tones in their pictures.

Editor: Enhance > Adjust Color > Adjust Color Curves

The new Adjust Color Curves option provides another way that you can alter the the brightness and contrast in your photo. Unlike the very basic Brightness/ Contrast control, Adjust Color Curves provides separate controls for altering

the brightness of highlights, shadows and midtones as well as a separate slider for changing midtone contrast. The feature is divided into two different sections – Samples and Advanced Options. Each section can be opened or closed by clicking the small triangle next to the section heading in the dialog.

The Samples area contains six thumbnail previews of your photo with standard enhancement changes applied. Clicking on a thumbnail will apply the adjustment to your photo. With the Preview option selected you will be able to see the tonal changes on the full image.

The **Advanced Options** section contains four slider controls plus a curves graph that plots the tonal relationships in the picture. Whereas the Samples thumbnails provided a one-click adjustment the controls here allow multiple, additive, fine-tuning changes.

The best approach is to apply a thumbnail version of the change that you are requiring first, e.g. Lighten Shadows, and then fine-tune the results with the sliders in the Advanced Options section. After making some fine-tuning slider adjustments, clicking the existing sample thumbnail again resets the sliders back to 0 position, so you can start again with the same setting. Pressing Reset will re-select the default thumbnail, Increase Midtones and its values. See Figure 5.18 and Figure 5.19.

- $1\ \ {\it Open color image and Select Enhance} > {\it Adjust Color} > {\it Adjust Color Curves}.$
- 2 Ensure that both the Sample and Advanced options areas are showing and that the Preview option is selected.
- 3 Click on one or more thumbnails to make major changes to the photo.
- 4 Use the slider controls to fine-tune the results and then click OK to apply the changes or Reset to start again.

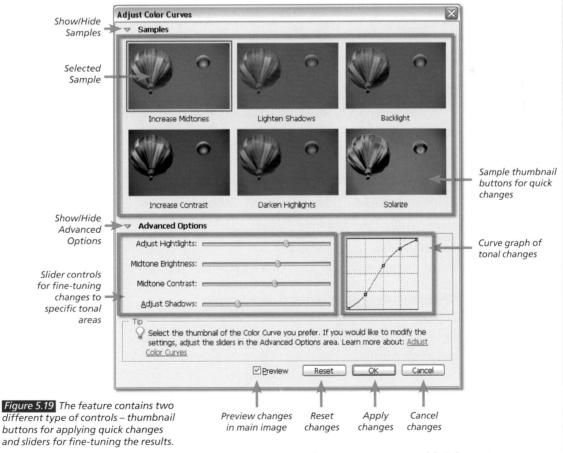

Book resources at: www.guide2elements.com

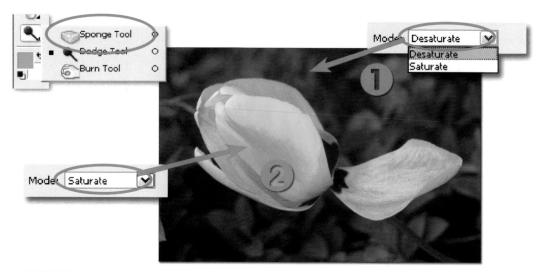

Figure 5.20 The Sponge tool can be used to selectively increase or decrease the saturation of parts of the image. (1) Desaturate. (2) Saturate.

Sponge

It is possible to draw a viewer's attention to a particular part of an image by increasing its saturation. The difference in color (contrast) makes the saturated part of the picture a new focal point. The effect can be increased greatly by desaturating (reducing the color strength) the areas around the focal point. The Sponge tool is designed to make such saturation changes to the color within your photos. It can be used to saturate or desaturate and, in grayscale mode, it will even decrease or increase contrast. As with most other tools, size and mode can be changed in the options bar. Changing the Flow settings in the bar alters the rate at which the image saturates or desaturates. See Figure 5.20.

- 1 Pick the Sponge tool from the toolbox.
- 2 Select brush size, type and flow rate from the options bar.
- 3 Select the mode to use Saturate or Desaturate.
- 4 Drag over the image part to change.

Editor: Filter > Adjustments > Posterize

Version 5.0/4.0: Filter > Adjustments > Posterize

The Posterize feature reduces the number of color levels within an image. This produces a graphic design type illustration with areas of flat color from photographic originals. This type of image has very little graduation of tone; instead, it relies on the strength of the colors and shapes that make up the image for effect. The user inputs the number of tones for the images and Elements proceeds to reduce the total palette to the selected few. See Figure 5.21.

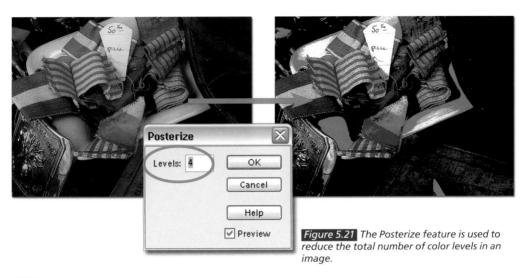

1 Select Filter > Adjustments > Posterize.

2 Input the number of levels required.

3 Select OK to finish.

Editor: Filter > Adjustments > Invert

Version 5.0/4.0: Filter > Adjustments > Invert

The Invert command produces a negative version of your image. The feature literally swaps the values of each of the image tones. When used on a grayscale image the results are similar to a black and white negative. However, this is not true for a color picture as the inverted picture will not contain the typical orange 'mask' found in color negatives. See Figure 5.22.

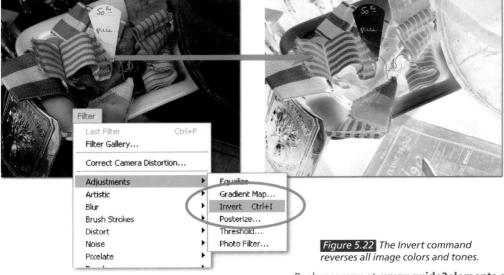

Book resources at: www.guide2elements.com

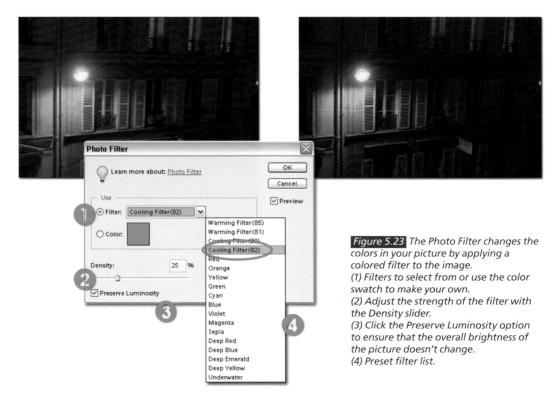

Editor: Filter > Adjustments > Photo Filter

Version 5.0/4.0: Filter > Adjustments > Photo Filter

The Photo Filter was added to the feature line-up in Elements in version 3.0 after first appearing in the CS version of Photoshop. The tool applies a colored filter to your picture and simulates the effects that traditional photographers could achieve by screwing a colored piece of glass, or gel, to the front of their camera lenses. The change in color that this technique produces can be used for visual effect, such as making a cloudy day appear more sunny (by applying a warm-up filter) or to help correct color cast problems like those displayed in Figure 5.23. Here a Cooling Filter(82) is applied to the warm image to help eliminate the yellow cast.

Also included in the feature dialog are areas for you to select the exact color of the filter applied, a Density slider that controls the strength of the filter, and the Preserve Luminosity check box which ensures that the overall tone of your picture doesn't darken or lighten with your filter changes.

- 1 Select the Filter > Adjustments > Photo Filter.
- 2 Ensure that the Preview and Preserve Luminosity options are selected.
- 3 Pick the filter from the drop-down list or double-click the color swatch to pick the color more precisely.
- 4 Adjust the density of the filter to suit the image. Click OK to apply.

High quality sharpening techniques

Sometimes, during the image capture process, the picture loses some of the subject's original clarity. This can be especially true if you are scanning small prints or negatives at high resolutions. To help restore some of this lost clarity, it is a good idea to get into the habit of applying sharpening to images straight after capture (although ensure that your digital camera has not already done this as an automatic feature). I should say from the outset that although the specialist features in Elements will improve the appearance of sharpness in an image, it is not possible to use these tools to 'focus' a picture that is blurry. In short, sharpening won't fix problems that arise from poor camera technique; the only solution for this is ensuring that images are focused to start with. That said, let's get sharpening.

Adobe revamped the sharpening options offered in Elements 5.0. Whereas in previous releases all sharpening activity was based around the Filter menu, now three sharpening options are grouped under the Enhance menu. The Unsharp Mask filter from previous releases is now joined with the new Auto Sharpen and Adjust Sharpenss features. These together with the specialized sharpening tool provide a variety of methods for adding extra clarity to your pictures.

Editor: Enhance > Auto Sharpen

Version 5.0/4.0: Filter > Sharpen > Sharpen

Most digital sharpening techniques are based on increasing the contrast between adjacent pixels in the image. When viewed from a distance, this change makes the picture appear sharper. The new Auto Sharpen feature applies basic sharpening to the whole of the image. See Figure 5.24.

Figure 5.24 The two basic sharpening filters provide automatic sharpening of all the pixels in your photographs.
(1) No sharpening.
(2) With Auto Sharpen applied.

Editor: Enhance > Unsharp Mask

Version 5.0/4.0: Filter > Sharpen > Unsharp Mask

This feature is based on an old photographic technique for sharpening images that used a slightly blurry mask to increase edge clarity. The digital version offers the user control over the sharpening process via three sliders – Amount, Radius and Threshold. By careful manipulation of the settings of each control the sharpness of images destined for print or screen can be improved. Beware though, too much sharpening is very noticeable and produces problems in the image, such as edge haloes, that are very difficult to correct later. See Figure 5.25.

Before using the Unsharp Mask filter, make sure that you are viewing your image at 100%. If you intend to print the sharpened image, make test prints at different settings before deciding on the final values for each control. Repeat this exercise for any pictures where you want the best quality, as the settings for one file might not give the optimum results for another picture that has a slightly higher or lower resolution.

The Unsharp Mask controls

The **Amount** slider controls the strength of the sharpening effect. Values of 50–100% are suitable for low-resolution pictures, whereas settings between 150% and 200% can be used on images with a higher resolution. See Figure 5.26.

The **Radius** slider value determines the number of pixels around the edge that is affected by the sharpening. A low value only sharpens edge pixels. Typically, values between 1 and 2 are used

for high-resolution images, and settings of 1 or less for screen images. See Figure 5.27.

The **Threshold** slider is used to determine how different the pixels must be before they are considered an edge and therefore sharpened. A value of 0 will sharpen all the pixels in an image, whereas a setting of 10 will only apply the effect to those areas that are different by at least 10 levels or more from their surrounding pixels. To ensure that no sharpening occurs in sky or skin tone areas, set this value to 8 or more. See Figure 5.28.

- .1 Select Filter > Sharpen > Unsharp Mask.
- 2 Adjust Amount slider to control strength of filter.
- 3 Adjust Radius slider to control the number of pixels surrounding an edge that is included in the effect.
- 4 Adjust Threshold slider to control what pixels are considered edge and therefore sharpened.

Figure 5.25 Overuse of the Unsharp Mask filter can lead to irreversible problems.
(1) Too much contrast.
(2) Coarse skin tones.
(3) Haloes.

Figure 5.26

The Amount slider controls the strength of the sharpening effect.

- (1) Amount = 50%.
- (2) Amount = 150%.
- (3) Amount = 500%.

Figure 5.27

The Radius slider determines the number of edge pixels that are sharpened.

- (1) Radius = 1.0 pixels.
- (2) Radius = 20 pixels.
- (3) Radius = 250 pixels.

Figure 5.28

The Threshold slider controls the point at which the effect is applied.

- (1) Threshold = 0 levels.
- (2) Threshold = 8 levels. (3) Threshold = 100 levels.

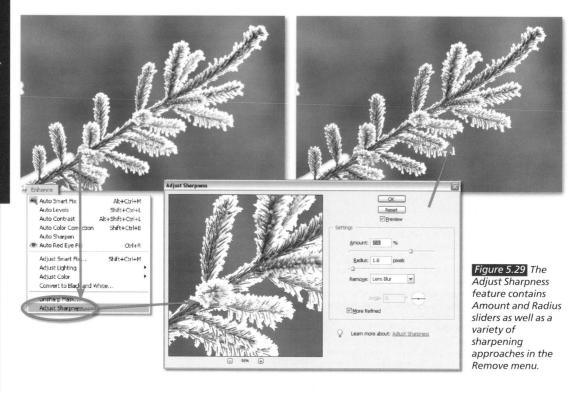

Editor: Enhance > Adjust Sharpness

The new Adjust Sharpen feature provides all the control that we are familiar with in the Unsharp Mask dialog plus better edge detection abilities, which leads to better results and in particular less apparent sharpening halos. The feature's dialog contains a zoomable preview, two slider controls, a drop-down menu to choose the sharpening approach used and a More Refined option. See Figure 5.29.

The user can control the sharpening effect with the following settings:

Amount – Strength of sharpening effect.

Radius - Determines the extent of sharpening. Higher values equal more obvious edge effects.

Remove – Determines sharpening algorithm used. Gaussian Blur uses the same approach as the Unsharp Mask filter. Lens Blur concentrates on sharpening details and produces results with fewer halos. Motion Blur reduces the effects of blur caused by camera shake or subject movement.

Angle – Sets Motion Blur direction.

More Refined – Longer processing for better results.

For best results, choose the Remove setting first. The Lens Blur option provides a good balance between sharpening effects and minimal sharpening artifacts. Enlarge the preview to at least 100%. Next, select a low Radius value -1 or 2 for high-resolution images and 1 or less for low-resolution photos. Now gradually move the Amount slider from left to right, stopping occasionally to check the results of the sharpening. When you reach a setting that provides good sharpening, but doesn't create halo artifacts, click OK to apply.

To see the results of your sharpening being reflected in the Elements document itself, make sure that the Preview option is selected.

Applying sharpening makes permanent and irreversible changes to your photos so it is always a good idea to keep an unsharpened copy of your image as an original.

Elements' sharpening tools

In addition to using a filter to sharpen your image, it is also possible to make changes to specific areas of the picture using one of the two sharpening tools available. The Blur and Sharpen tools are located in the Elements toolbox. See Figure 5.30.

The size of the area they change is based on the current brush size. The intensity of the effect is controlled by the Strength value found in the options bar.

Figure 5.30 The Blur and Sharpen tools can be used to apply sharpening to specific areas within an image.

As with the Airbrush tool, the longer you keep the mouse button down the more pronounced the effect will be. These features are particularly useful when you want to change only small parts of an image rather than the whole picture. See Figure 5.31.

- $1\,$ Select the Blur or Sharpen tool from the toolbox.
- $2\,$ Adjust the size and style of the tool with the Brush palette in the options bar.
- 3 Change the intensity of the effect by altering the Strength Setting.
- 4 Blur or sharpen areas of the image by clicking and dragging the tool over the picture surface.
- 5 Increase the change in any one area by holding the mouse button down.

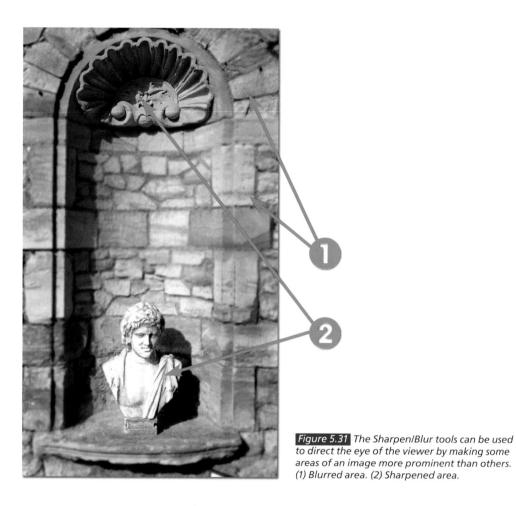

Retouching techniques

Used for more than just enhancing existing details, these techniques are designed to rid images of visual information, like dust and scratches, which can distract from the main picture.

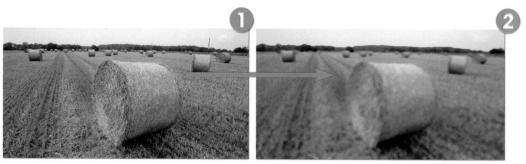

Figure 5.32 Too much Dust & Scratches filtering can destroy image detail and make the picture fuzzy. (1) Original picture. (2) Photo after too much Dust & Scratches filtration.

Editor: Filter > Noise > Dust & Scratches

Version 5.0/4.0: Filter > Noise > Dust & Scratches

It seems that no matter how careful I am, my scanned images always contain a few dust marks. The Dust & Scratches filter in Elements helps to eliminate these annoying spots by blending or blurring the surrounding pixels to cover the defect. The settings you choose for this filter are critical if you are to maintain image sharpness whilst removing small marks. Too much filtering and your image will appear blurred, too little and the marks will remain. See Figure 5.32.

To find settings that provide a good balance, first try adjusting the Threshold setting to zero. Next, use the Preview box in the Filter dialog to highlight a mark that you want to remove. Use the zoom controls to enlarge the view of the defect. Now drag the Radius slider to the right. Find, and set, the lowest Radius value where the mark is removed. Next, increase the Threshold value gradually until the texture of the image is restored and the defect is still removed. See Figure 5.33.

- 1 Select Filter > Noise > Dust & Scratches.
- 2 Move preview area to highlight a mark to be removed.
- 3 Zoom the preview to enlarge the view of the mark.
- 4 Ensure that the Threshold value is set to zero.
- 5 Adjust the Radius slider until the mark disappears.
- 6 Adjust Threshold until texture returns and the mark is still not visible.
- 7 Click OK to finish.

Figure 5.33 Follow the threestep process to ensure that
you choose the optimal
settings for the Dust &
Scratches filter. (1) Set both
sliders to minimum (all the
way to the left). Preview the
dust mark area. (2) Adjust the
Radius slider until the mark
disappears. (3) Raise the
Threshold slider to regain
texture in the non-marked
area of the image.

Book resources at: www.guide2elements.com

Clone Stamp

In some instances the values needed for the Dust & Scratches filter to erase or disguise picture faults are so high that it makes the whole image too blurry for use. In these cases it is better to use a tool that works with the problem area specifically rather than the whole picture surface.

The Clone Stamp tool samples an area of the image and then paints with the texture, color and tone of this copy onto another part of the picture. This process makes it a great tool to use for removing scratches or repairing tears or creases in a photograph. Backgrounds can be sampled and then painted over dust or scratch marks, and whole areas of a picture can be rebuilt or reconstructed using the information contained in other parts of the image. See Figure 5.34.

Using the Clone Stamp tool is a two-part process. The first step is to select the area that you are going to use as a sample by Alt-clicking the area. See Figure 5.35. Now move the cursor to where you want to paint, and click and drag to start the process. See Figure 5.36.

The size and style of the sampled area are based on the current brush and the Opacity setting controls the transparency of the painted section.

- 1 Pick the Clone Stamp tool from the toolbox.
- 2 Adjust the brush size via the Brush palette in the options bar.
- 3 Set the opacity for the painted area.
- 4 Position the mouse cursor on a part of the image you want to sample and Alt-click (Windows) or Option-click (Macintosh) to set.
- 5 Move the tool to the area of the image you want to use the sample to cover and click and drag to paint.

EATURE UMIMARY

Figure 5.34 The Clone Stamp tool is perfect for retouching the marks that the Dust & Scratches filter cannot erase.

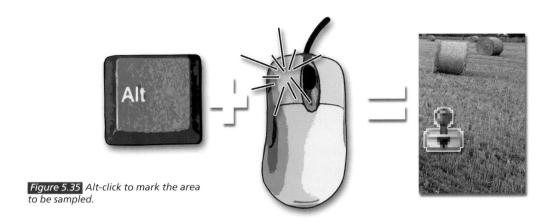

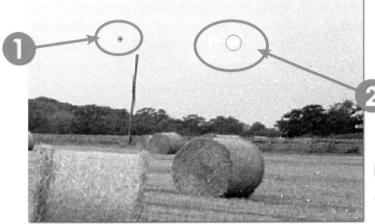

Figure 5.36 Move the cursor over the mark and click to paint over with the sampled texture. (1) Sample point. (2) Retouching area.

Spot Healing Brush

In recognition of just how tricky it can be to get seamless dust removal with the Clone Stamp tool, Adobe decided to include the Spot Healing Brush in Elements. After selecting the tool you adjust the size of the brush tip using the options in the tool's option bar and then click on the dust spots and small marks in your pictures. The Spot Healing Brush uses the texture that surrounds the mark as a guide to how the program should 'paint over' the area. In this way, Elements tries to match color, texture and tone whilst eliminating the dust mark. The results are terrific and this tool should be the one that you reach for first when there is a piece of dust or a hair mark to remove from your photographs. See Figure 5.37.

- 1 Locate the areas to be repaired.
- 2 Adjust the brush size to suit the size of the mark.
- 3 Click on the spot to repair.

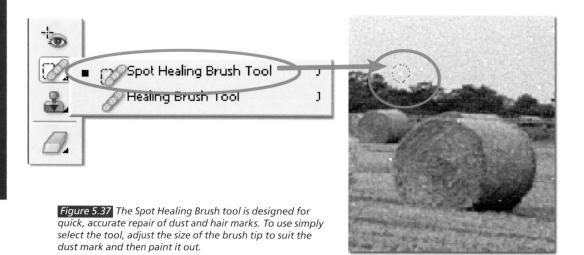

Healing Brush tool

The Clone Stamp tool is good, but the best way to remove unwanted detail from your pictures is with the amazing Healing Brush tool. Designed to work in a similar way to the Clone Stamp tool, the user selects the area (Alt-click) to be sampled before painting and then proceeds to drag the brush tip over the area to be repaired. The tool achieves such great results by merging background and source area details as you paint. Just as with the Clone Stamp tool the size and edge hardness of the current brush determine the characteristics of the Healing Brush tool tip.

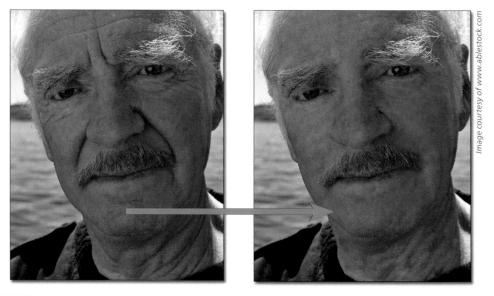

Figure 5.38 The new Healing Brush tool works wonders for removing unwanted details. It can even provide a little digital plastic surgery when required.

One of the best ways to demonstrate the sheer power of the Healing Brush is to remove the wrinkles from an aged face. Though I'm not sure of the ethics of such an action it is a request that is often put to me. In Figure 5.38, the deep crevices of the fisherman's face have been easily removed with the tool. The texture, color and tone of the face remain even after the 'healing' work is completed because the tool merges the new areas with the detail of the picture beneath.

- 1 The first step is to locate the areas of the image that need to be retouched.
- 2 Hold down the Alt key (Option key Mac) and click on the area that will be used as a sample for the brush. Notice that the cursor changes to cross hairs to indicate the sample area.
- 3 Move the cursor to the area to heal and click and drag the mouse to 'paint' over the problem picture part. After you release the mouse button Elements merges the newly painted section with the image beneath. See Figure 5.39.

You can remove wrinkles on a duplicate layer and then fade the opacity of this layer to create a more natural appearance, where wrinkles are softened and not completely removed.

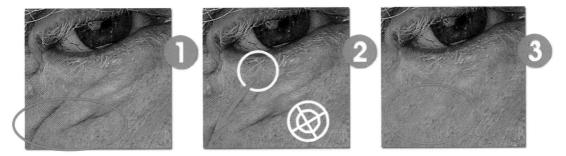

Figure 5.39 (1) Locate the areas to be healed. (2) Alt-click the source that you will use in the repairs. (3) Drag the brush tip over the area to be repaired.

Editor: Filter > Noise > Reduce Noise

Version 5.0/4.0: Filter > Noise > Reduce Noise

Many new digital cameras have a variety of ISO settings to choose from. When shooting in sunny or bright conditions you generally use values of 100 or 200, giving sharp and noise-free results, but when you select a higher value such as 1600 for use at night, or in low light, the resultant pictures can become very noisy. Camera manufacturers often include Noise Reduction features as part of the camera functions but sometimes the length of time the camera takes to process the file means that it is almost impossible to take a series of night-time pictures rapidly. If this is your requirement then you are stuck with grainy photographs because you have had to shoot with the Noise Reduction feature turned off.

With just this sort of problem in mind, the Adobe engineers included a new Noise Reduction filter (Filter > Noise > Reduce Noise) in version 3.0 of Elements. The feature includes a preview window, a Strength slider, a Preserve Details control and a Reduce Color Noise slider. As with the Dust & Scratches filter you need to be careful when using this filter to ensure that you balance removing noise whilst also retaining detail.

The best way to guarantee this is to set your Strength setting first, ensuring that you check the results in highlights, midtone and shadow areas. Next, gradually increase the Preserve Details value until you reach the point where the level of noise that is being reintroduced into the picture is noticeable and then back off the control slightly (make the setting a lower number). For photographs with a high level of color noise (random speckles of color in an area that should be a smooth flat tone) you will need to adjust this slider at the same time as you are playing with the Strength control. See Figure 5.40.

- $1\,$ Open the noisy image and select the Filter > Noise > Reduce Noise filter.
- 2 Drag the Preserve Details slider to the left and then gradually move the Strength slider to the right until the noise is at an acceptable level.
- 3 Now slowly move the Preserve Details slider to the right until there is an acceptable balance between detail and noise in your picture.
- 4 To reduce the appearance of JPEG compression select the Remove JPEG Artifact check box in version 4.0 of the feature's dialog.

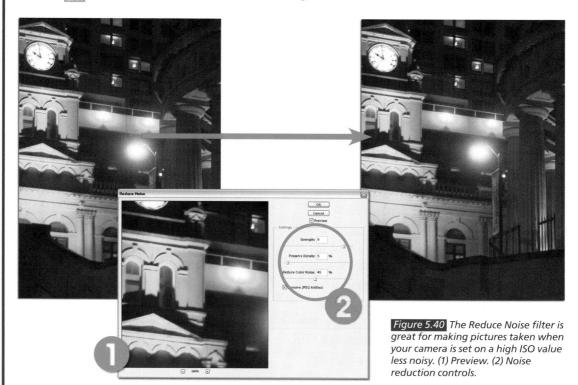

Book resources at: www.guide2elements.com

Adding texture to an image

At first, the idea of making a smooth, evenly graduated image more textured seems to be at odds with the general direction that digital technology has been heading over the last few years. Research scientists and technicians have spent much time and money ensuring that the current crop of cameras, scanners and printers is able to capture and produce images so that they are in effect textureless or grainless. The aim has been to disguise the origins of the final print so that the pixels cannot be seen.

For me to introduce to you at this stage a few techniques that intentionally add noticeable texture to your image may seem a little strange, but despite the intentions of the manufacturers, many digital image makers do like the atmosphere and mood that a 'grainy' picture conveys. See Figure 5.41. All the techniques use filters to alter the look of the image. Filter changes are permanent, so it is always a good idea to keep a copy of the unaltered original file on your hard drive, just in case.

Editor: Filter > Noise > Add Noise

Version 5.0/4.0: Filter > Noise > Add Noise The Add Noise filter is one of four options contained under the Noise heading in the Filter menu. Using this feature adds extra contrasting pixels to your image to simulate the effect of high-speed film. See Figure 5.42. When the filter is selected, you are presented with a dialog that contains several choices. A small zoomable thumbnail window is provided so that you can check the appearance of the filter settings on your image. There is also the option to preview the results on the greater image by ticking the Preview box. The strength of the effect is controlled by the Amount slider and the type of noise can be switched from Uniform, a more even effect, to Gaussian, for a speckled appearance. The Monochromatic option adds pixels that contrast in tone only and not color to the image. See Figure 5.43.

Figure 5.41 Despite all the techniques in the previous section, which were designed to reduce the marks in our pictures, there are many photographers who like texture and who regularly use other techniques to intentionally put back desirable textures into their photographs.

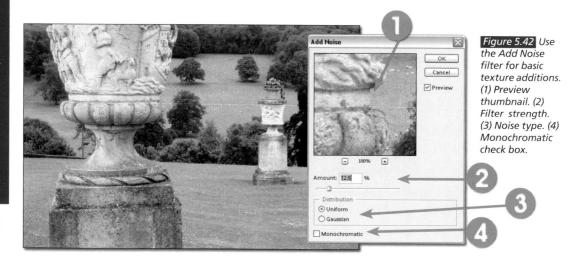

- 1 Select the Add Noise filter from the Noise section of the Filter menu.
- 2 Adjust thumbnail preview to a view of 100% and tick the Preview option.
- 3 Select Uniform for an even distribution of new pixels across the image, or pick Gaussian for a more speckled effect.
- 4 Tick the Monochromatic option to restrict the effect to changes in the tone of pixels rather than color.
- 5 Adjust the Amount slider to control the strength of the filter, checking the results in both the thumbnail and full image previews.
- 6 Click OK to finish.

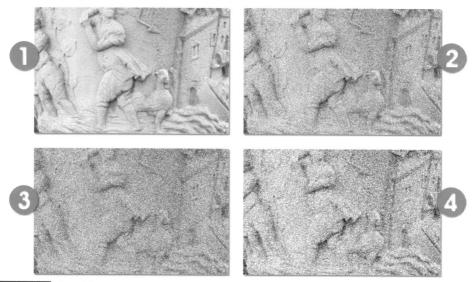

Figure 5.43 The Add Noise filter settings control the look of the final texture. (1) Original non-filtered picture. (2) Uniform Distribution selected. (3) Gaussian Distribution selected. (4) Uniform Distribution and Monochrome setting selected.

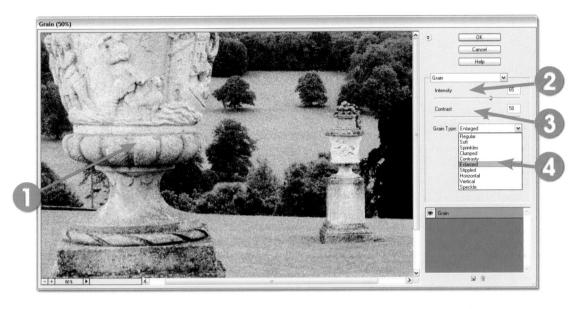

Figure 5.44 The Grain filter provides a little more control over the type of texture that is added to your images. (1) Preview thumbnail. (2) Filter strength. (3) Effect contrast. (4) Grain style.

Editor: Filter > Texture > Grain

Version 5.0/4.0: Filter > Texture > Grain

Found under the Texture option in the Filter menu, the Grain filter, at first glance, appears to offer the same style of texture changes as the Add Noise feature, but the extra controls in the dialog give users the chance to add a range of different texture types to their images. See Figure 5.44.

The dialog provides a thumbnail preview of filter changes. The Intensity slider controls the strength of the effect and the Contrast control alters the overall appearance of the filtered image. The Grain Type menu provides 10 different choices of the style of texture that will be added to the image. By manipulating these three settings, it is possible to create some quite different and stunning texture effects. See Figure 5.45.

- 1 Select the Grain filter from the Texture section of the Filter menu.
- 2 Adjust thumbnail preview to a view of 100%.
- 3 Select Grain Type from the menu.
- 4 Adjust the Intensity slider to control the strength of the filter, checking the results in the thumbnail preview.
- 5 Alter the Contrast slider to change the overall appearance of the image.
- 6 Click OK to finish.

Figure 5.45 The Grain filter with a range of options selected.
(1) Horizontal option set.
(2) Speckle option set.
(3) Stippled option set.

Editor: Filter > Texture > Texturizer

Version 5.0/4.0: Filter > Texture > Texturizer

The Texturizer filter provides a slightly different approach to the process of adding textures to images. With this feature much more of the original image detail is maintained. The picture is changed to give the appearance that the photo has been printed onto the surface of the texture. The Scaling and Relief sliders control the strength and visual dominance of the texture, whilst the Light direction menu alters the highlight and shadow areas. See Figure 5.46. Different surface types are available from the Texture drop-down menu. See Figure 5.47. The feature also contains the option to add your own files and have these used as the texture that is applied by the filter to the image.

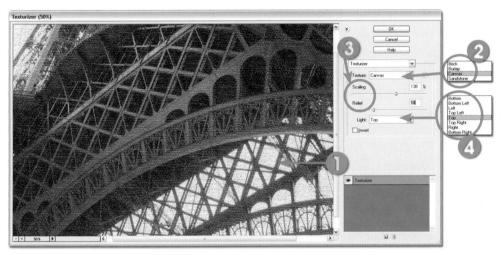

Figure 5.46 The Texturizer filter changes the image so that it appears to have been printed onto a textured surface. (1) Preview thumbnail. (2) Texture type. (3) Texture settings. (4) Light direction.

Figure 5.47 The example is textured using the Texturizer filter with (1) Brick surface selected and (2) Burlap surface selected.

- 1 Select the Texturizer filter from the Texture section of the Filter menu.
- 2 Adjust thumbnail preview to a view of 100%.
- 3 Select Texture type from the drop-down menu.
- 4 Move the Scaling slider to change the size of the texture.
- 5 Adjust the Relief slider to control the dominance of the filter.
- 6 Select a Light direction to adjust the highlights and shadow areas of the texture.
- 7 Tick the Invert box to switch the texture position from 'hills' to 'valleys' or reverse the texture's light and dark tones.
- 8 Click OK to finish.

Making your own textures

Being able to make your own texture files is the real bonus of the Texturizer filter. This ability gives the user the chance to extend the available surface options by adding customized Elements files that have been designed, or captured, especially for the purpose. Any Elements or Photoshop file (.PSD) can be loaded as a new texture via the Load Texture option in the side-arrow menu, in the top right of the Texturizer dialog. Simply locate the file using the browsing window and then adjust the Scaling, Relief and Lighting controls as you would for any of the built-in surface options.

- 1 Shoot, scan or design a texture image and save as an Elements or Photoshop file (.PSD). See Figure 5.48.
- 2 Select the Texturizer filter from the Texture options of the Filter menu.
- 3 Pick the Load Texture item from the drop-down list in the Texture menu. See Figure 5.49.
- 4 Browse folders and files to locate texture file.
- 5 Click file name and then open to select.
- 6 Once back at the Texturizer dialog, treat like any other surface option. See Figure 5.50.

Figure 5.48 Shoot your own texture photos and save the images as an Elements or PSD file.

Book resources at: www.guide2elements.com

the Texturizer filter.

Figure 5.50 Apply the new texture to your image.

Changing the size of your images

As we have seen in earlier chapters, the size of a digital image is measured in pixel dimensions. These dimensions are determined at the time of capture or creation. Occasionally, it is necessary to alter the size of your digital photograph to suit different output requirements. For instance, if you want to display an image that was captured in high resolution on a website, you will need to reduce the pixel dimensions of the file to suit.

Grouped under the Resize option of the Image menu, Elements provides a couple of sizing features which can be used to alter the dimensions of your picture. PROCEED WITH CAUTION. Increasing or decreasing the dimensions of your images directly affects the quality of your files, so my suggestion is that until you are completely at home with these controls always make a backup file of your original picture before starting to resize.

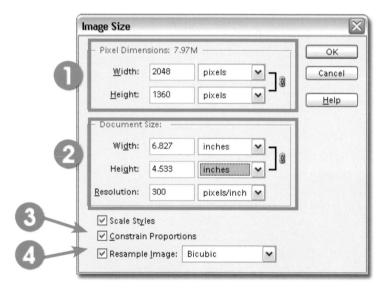

Figure 5.51 The Image Size dialog controls the dimensions and resolution of your pictures.

- (1) Pixel Dimensions section.
- (2) Document Size section.
- (3) Constrain Proportions check box.
- (4) Resample check box and drop-down menu.

Editor: Image > Resize > Image Size

Version 5.0/4.0: Image > Resize > Image Size

The Image Size dialog provides several options for manipulating the pixels in your photograph. At first glance the settings displayed here may seem a little confusing, but if you can make the distinction between the Pixel Dimensions of the image (shown in the topmost section of the dialog) and the Document Size (shown in the middle), it will be easier to understand. See Figure 5.51.

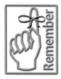

Pixel Dimensions represent the true digital size of the file.

Document Size is the physical dimensions of the file represented in inches (or centimeters) based on using a specific number of pixels per inch (resolution or dpi).

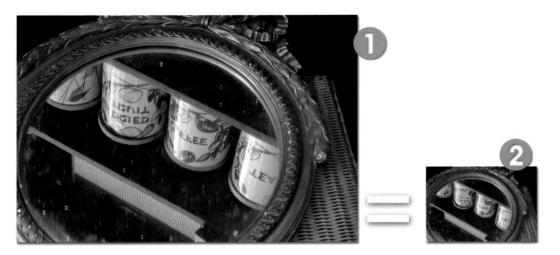

Figure 5.52 The example image contains 1800×1200 pixels and can be output to a print that is 6 inches \times 4 inches or 1.8 inches \times 1.2 inches, depending on how the pixels are spread (resolution). (1) 6×4 inches @ 300 dpi = 1800×1200 pixels. (2) 1.8×1.2 inches @ 1000 dpi = 1800×1200 pixels.

Non-detrimental size changes

A file with the same pixel dimensions can have several different document sizes based on altering the spread of the pixels when the picture is printed (or displayed on screen). In this way you can adjust a high-resolution file to print the size of a postage stamp, postcard or a poster by only changing the dpi or resolution. This type of resizing has no detrimental quality effects on your pictures as the original pixel dimensions remain unchanged. See Figure 5.52.

To change resolution, open the Image Size dialog and uncheck the Resample Image option. Next, change either the resolution, width or height settings to suit your output. See Figure 5.53.

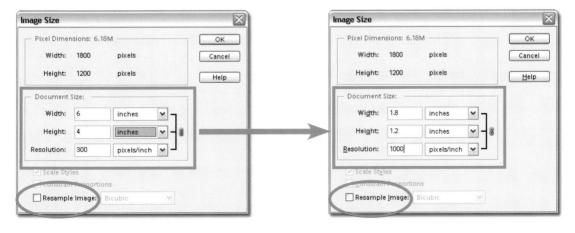

Figure 5.53 Non-detrimental size changes, or the changes that don't lose picture quality, can be made to your image if the Resample Image option is always left unchecked.

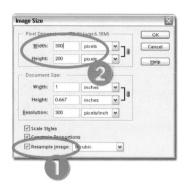

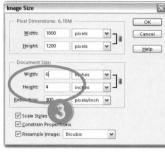

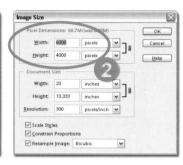

Figure 5.54 With the Resample Image option selected, it is possible to increase and decrease the total number of pixels in your image. (1) Resample Image option ticked. (2) New pixel dimensions. (3) New document size.

Upsizing and downsizing

This said, in some circumstances it is necessary to increase or decrease the number of pixels in an image. Both these actions will produce results that have less quality than if the pictures were scanned or photographed at precisely the desired size at the time of capture. If you are confronted with a situation where you are unable to recapture your pictures, then Elements can increase or decrease the image's pixel dimensions. Each of these steps requires the program to interpolate, or 'make up', the pixels that form the resized image. See Figure 5.54. To increase the pixels or upsize the image, tick the Resample Image check box and then increase the value of any of the dimension settings in the dialog. To decrease the pixels or downsize the image, decrease the value of the dimension settings.

Image Size dialog settings

To keep the ratio of width and height of the new image the same as the original, tick the Constrain Proportions check box.

Interpolation quality and speed are determined by the options in the dropdown menu next to the Resample Image check box. Bicubic is the best setting for photographic images.

- $1\,$ Select Image Size from the Resize option under the Image menu.
- 2 Tick the Resample Image check box for changes to the pixel dimensions of your image.
- 3 Uncheck the Resample Image option for changing image resolution.
- 4 Adjust the dimension settings to suit your output requirements.

FEATURE SUMIMARY

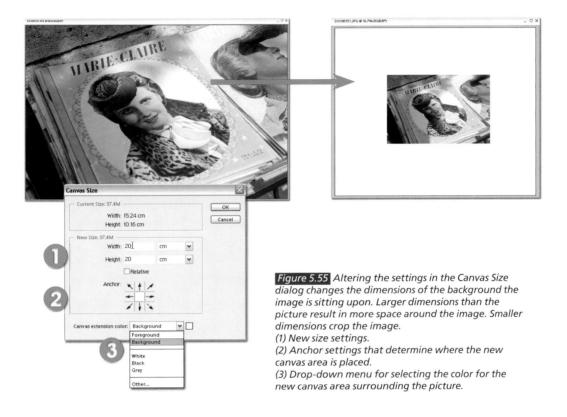

Editor: Image > Resize > Canvas Size

Version 5.0/4.0: Image > Resize > Canvas Size

Just to add a little more complexity to the picture size discussion, Elements also provides the ability to change the size of the canvas that your photograph is sitting upon. Alterations here result in no change to the size of the image itself, but the overall canvas size does change, which means that the total dimensions of the document change as well.

This feature is particularly useful if you want to add several images together. Increasing the canvas size will mean that each of the extra pictures can be added to the newly created space around the original image.

To change the canvas size, select Canvas Size from the Resize option of the Image menu and alter the settings in the New Size section of the dialog. You can control the location of the new space in relation to the original image by clicking one of the sections in the Anchor diagram. Leaving the default setting here will mean that the canvas change will be spread evenly around the image. See Figure 5.55.

- 1 Select Canvas Size from the Resize option under the Image menu.
- 2 Alter the values in the New Size section of the dialog.
- 3 Set the anchor point in the Anchor diagram.
- 4 Click OK to complete.

Increasing the canvas size with the Crop tool

Pros use the Crop tool to quickly increase the size of the canvas that the picture sits in. First, zoom out from the picture so that it sits smaller in the workspace, then select the Crop tool and drag a marquee around the whole image. After releasing the mouse button, click on one of the side or corner handles and drag the crop marquee outwards until it is the size and shape of the new canvas. Double-click to complete the canvas resize. The new canvas will be the color of the current background color. See Figure 5.56.

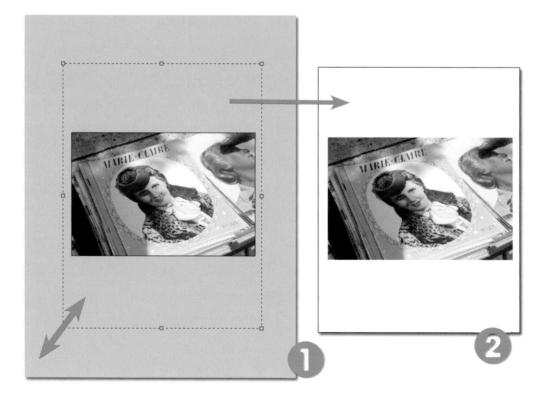

Figure 5.56 The Crop tool can be used to increase the size of the canvas by dragging the crop marquee outside the dimensions of the picture. (1) Make the crop marquee larger than the picture. (2) Double-click inside the crop marquee to increase the canvas size.

Using Selections and Layers

Selection basics

Modifying drawn and color-based selections

Selections in action

Layers and their origins

or those users who are a little familiar with both selections and layers, it might seem a bit strange to group these features together, but to my mind they both deal with a similar idea – isolating specific sections of an image to make them easier to manipulate. They also represent two Elements features that are central to many advanced manipulation and enhancement techniques.

Selection basics

Until now, we have assumed that any changes being made to an image will be applied to the whole of the picture, but before too long it will become obvious that there are many imaging scenarios that would benefit from being able to restrict alterations to a specific part of a picture. For this reason, most image-editing packages contain features that allow the user to isolate small sections of an image that can then be altered independently of the rest of the picture.

When a selection is made, the edges of the isolated area are indicated by a flashing dotted line, which is sometimes referred to as the 'marching ants'. See Figure 6.1. When a selection is active, any changes made to the image will be restricted to the isolated area. See Figure 6.2. To resume full image-editing mode, the area has to be deselected by choosing Select > Deselect or pressing the Esc key.

The selection features contained in Elements can be divided into three groups:

- *Drawing selection tools*, or those that are based on selecting pixels by drawing a line around the part of the image to be isolated.
- Color selection tools, or those features that distinguish between image parts based on the color
 or tone of the pixels, and
- the Magic Selection Brush and Magic Extractor, which combine both drawing and color selection by using an approach that automatically creates selections based on the areas that the user has painted.

Figure 6.1 The edges of an active selection are indicated using a flashing dotted line or 'marching ants'.

Figure 6.2 Image alterations made when a selection is active are restricted to the area of the selection.

Drawing selection tools (see Figures 6.3 and 6.4)

The Selection Brush tool that was first introduced in Elements 3.0, along with the tools contained in the Marquee and Lasso tool sets, are used to draw around the pixels in an image.

Marquee tools

By clicking and dragging the Rectangular or Elliptical Marquees, it is possible to draw rectangleand oval-shaped selections. Holding down the Shift key whilst using these tools will restrict the selection to square or circular shapes, whilst using the Alt (Windows) or Options (Mac) keys will draw the selections from their centers. The Marquee tools are great for isolating objects in your images that are regular in shape, but for less conventional shapes you will need to use one of the Lasso tools.

Lasso tools

The normal Lasso tool works like a pencil, allowing the user to draw freehand shapes for selections. In contrast, the Polygonal Lasso tool draws straight edge lines between mouse-click points. Either of these features can be used to outline and select irregular-shaped image parts. See Figure 6.5.

A third tool, the Magnetic Lasso, helps with the drawing process by aligning the outline with the edge of objects automatically. See Figure 6.6. It uses contrast in color and tone as a basis for determining the edge of an object. The accuracy of the 'magnetic' features of this tool is determined by three settings in the tool's options bar. See Figure 6.7. Edge Contrast is the value that a pixel has to differ from its neighbor to be considered an edge. Width is the number of pixels

Figure 6.3 The Elliptical and Rectangular Marquee tools are used for making selections in these shapes.

Rectangular Marquee Tool

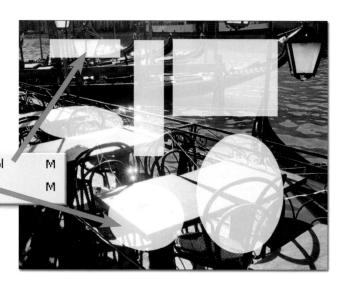

Figure 6.4 Holding down the Shift key when using the Marquee tools will constrain the selection to either a square or a circle. (1) Constrained. (2) Unconstrained.

either side of the pointer that are sampled in the edge determination process and Frequency is the distance between fastening points in the outline. For most tasks, the Magnetic Lasso is a quick way to obtain accurate selections, so it is good practice to try this tool first when you want to isolate specific image parts.

Selection Brush tool

Responding to photographers' demands for even more options for making selections, Adobe included the Selection Brush for the first time in version 2.0 of Elements. The tool lets you paint a selection onto your image. The size, shape and edge softness of the selection are based on the brush properties you currently have set. These can be altered in the Brush Presets pop-up palette located in the options bar. See Figure 6.8. In version 5.0 the Selection Brush tool is nested in the tool bar with the Magic Selection Brush.

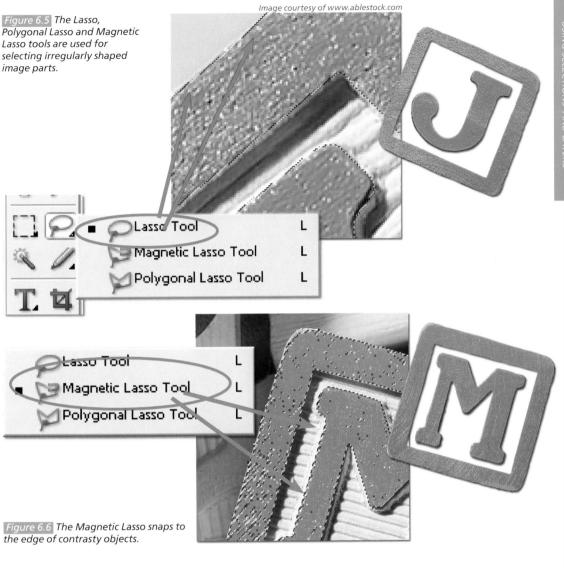

Figure 6.7 The settings in the Magnetic Lasso's options bar alter how the tool snaps to the outline of particular image parts.

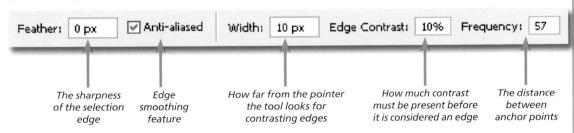

The tool can be used in two modes – Selection and Mask.

- The *Selection mode* is used to paint over the area you wish to select.
- The Mask mode works by reverse painting in the areas you want to 'mask from the selection'.
 It is particularly well suited for showing the soft or feathered edge selections made when painting with a soft-edged brush.

Holding down the Alt (Windows) or Option (Mac) keys whilst dragging the brush switches the tool from adding to the selection to taking away from the area. Alternatively you can also switch between Add and Subtract modes using the settings in the options bar. See Figure 6.9.

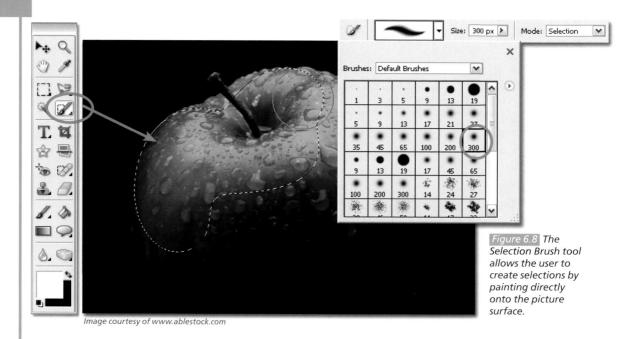

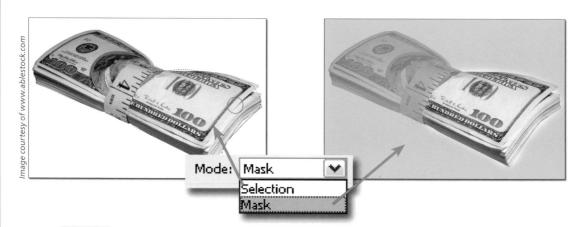

Figure 6.9 The Selection Brush can work in either Selection or Mask modes.

Drawing selection tool summaries

Rectangular and Elliptical Marquee tools

- 1 After selecting the tool, click and drag to draw a marquee on the image surface.
- 2 Hold down the Shift key whilst drawing to restrict the shape to either a square or a circle.
- 3 Hold down the Alt (Windows) or Option (Mac) key to draw the shape from its center.
- 4 Hold down the Spacebar to reposition the marquee.

Lasso tool

- 1 After selecting the tool, click and drag to draw the selection area by freehand.
- 2 Release the mouse button to join the beginning and end points and close the outline.

Polygonal Lasso tool

- 1 After selecting the tool, click and release the mouse button to mark the first fastening point.
- 2 To draw a straight line, move the mouse and click again to mark the second point.
- 3 To draw a freehand line, hold down the Alt (Windows) or Option (Mac) key and click and drag the mouse.
- 4 To close the outline, either move the cursor over the first point and click or double-click.

Magnetic Lasso tool

- 1 After selecting the tool, click and release the mouse button to mark the first fastening point.
- 2 Trace the outline of the object with the mouse pointer. Extra fastening points will be added to the edge of the object automatically.
- 3 If the tool doesn't snap to the edge automatically, click the mouse button to add a fastening point manually.
- $4\,$ Adjust settings in the options bar to vary the tool's magnetic function.
- 5 To close the outline, either double-click or drag the pointer over the first fastening point.

Selection Brush tool

- 1 After selecting the tool, adjust the settings in the options bar to vary the brush size, shape and hardness (edge softness).
- 2 To make a selection, change the mode to Selection and paint over the object with the mouse pointer.
- 3 To make a mask, change the mode to Mask and paint over the area outside the object with the mouse pointer.
- 4 Holding down the Alt (Windows) or Option (Mac) whilst painting will change the action from adding to the Selection/Mask to taking away from the Selection/Mask.

EATURE UMIMARY

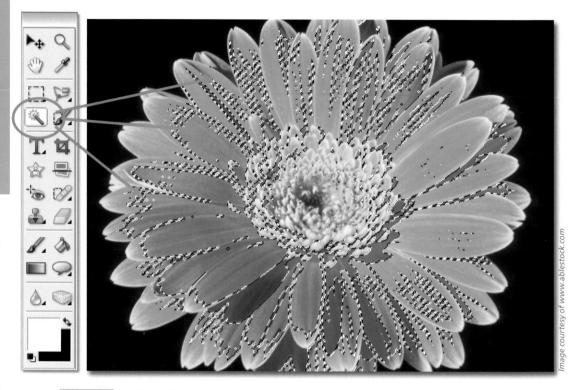

Figure 6.10 The Magic Wand selects pixels of similar color and tone.

Color selection tools

Unlike the Lasso and Marquee tools, the Magic Wand makes selections based on color and tone. See Figure 6.10. When the user clicks on an image with the Magic Wand tool, Elements searches the picture for pixels that have a similar color and tone. With large images this process can take a little time, but the end result is a selection of all similar pixels across the whole picture.

How identical a pixel has to be to the original to be included in the Magic Wand selection is determined by the Tolerance value in the options bar. See Figure 6.11. The higher the value here, the less alike the two pixels need to be, whereas a lower setting will require a more exact match before a pixel is added to the selection. Turning on the Contiguous option will only include the pixels that are similar and are adjacent to the original pixel in the selection. See Figure 6.11 and Figure 6.12.

- E.
- 1 With the Magic Wand tool active, click onto the part of the image that you want to select.
- 2 Modify the Tolerance of the selection by altering this setting in the options bar then deselect then click the tool again to reselect with the new Tolerance settings.
- 3 Constrain the selection to adjacent pixels only by checking the Contiguous option.

Figure 6.11 The Tolerance setting determines how alike pixels need to be before they are included in the selection. (1) Tolerance setting 10. (2) Tolerance setting 50. (3) Tolerance setting 130.

Figure 6.12 The Contiguous option restricts the selection to those pixels adjacent to where the tool was first clicked on the image surface. (1) A selection made with the Contiguous option turned on. (2) A selection with the option turned off.

Modifying drawn and color-based selections

With some complex images, no one selection technique will be able to isolate all the pixels required; instead, a combination of tools is needed to make the final outline. To aid with this, Adobe has included several selection possibilities in the options bar of the previous tools. See Figure 6.13.

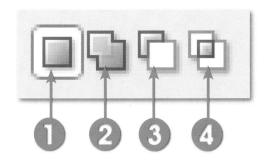

Figure 6.13 The choices in the selection tools options bar determine how the new selection interacts with the existing one.

- (1) New selection.
- (2) Add to selection.
- (3) Subtract from selection.
- (4) Intersect with selection.

With these options, it is possible to 'add to', or 'subtract from', an existing selection or even use the 'intersection' of two separate selections as the basis for a third. Simply choose a different selection option when using a new tool. For those users who prefer to use keyboard shortcuts, holding down the Shift key whilst using a selection tool will add to an existing outline, whereas using the Alt (Windows) or Option (Mac) keys will subtract. See Figures 6.14 and 6.15.

All of this may seem a little complex to start with, but it is important to persevere, as good selecting skills are critical for a lot of advanced editing techniques and besides, after some practice, making multi-tool complex selections will become second nature to you.

- 1 Add to a selection by either holding down the Shift key whilst using another selection tool or clicking the Add to selection button in the options bar.
- 2 Subtract from a selection by either holding down the Alt (Windows) or Option (Mac) keys whilst using another selection tool or clicking the Subtract from selection button in the options bar.
- 3 Use the intersection of a new and existing selection to form a third outline by clicking the Intersect with selection button in the options bar before making a new selection.

Figure 6.14 Hold down the Shift key whilst drawing a selection to add to an existing outline.

Figure 6.15 Hold down the Alt (Windows) or Option (Mac) key whilst drawing a selection to subtract from an existing outline.

The Magic Selection Brush

Along with the Selection Brush tool, the Magic Selection Brush provides Elements users with a unique approach to creating and modifying selections. As we have seen, when using the Selection Brush the user must paint over the area to be encompassed by the selection. The accuracy of this painting step determines the accuracy of the final selection. For example, painting over an edge accidentally will result in the creation of a selection that goes beyond this picture part.

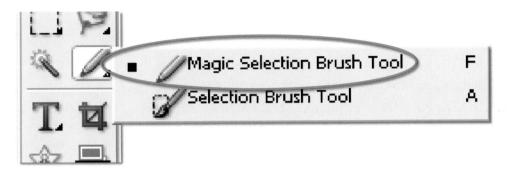

Figure 6.16 The Magic Selection Brush is coupled with the Selection Brush in the Elements 5.0 tool bar.

The Magic Selection Brush provides a quicker, easier and, in most cases, more accurate way to make selections by combining both the drawing and color selection approaches of the other tools we have covered. To make a selection choose the tool from the tool bar. If it is hidden from view click the small arrow at the bottom right of the Selection Brush button to reveal the tool. See Figure 6.16. Now use the tool to scribble or place some dots on the picture parts that you want to select. Once you finish drawing release the mouse button; Elements will then create a selection based on the parts you have painted. You don't have to be too careful with your initial painting as the program registers the color, tone and texture of the picture parts and then intelligently searches for other similar pixels to include in the selection. See Figure 6.17.

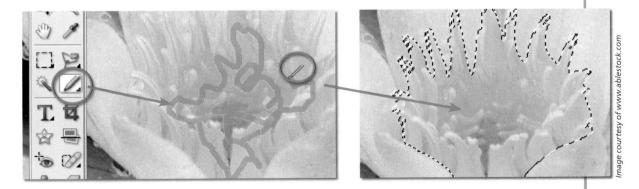

Figure 6.17 After using the Magic Selection Brush to draw over the picture parts to be selected, Elements automatically generates a selection of all the adjacent areas in the picture that have similar color, texture or tone.

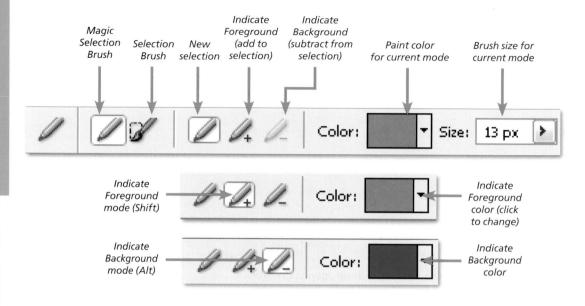

Figure 6.18 The options bar of the Magic Selection Brush contains several modes that can be used for altering or refining the selection created by the tool. You can add other picture parts to a selection by clicking on the Indicate Foreground mode and then painting over the new area. Parts already selected can be removed by changing to the Indicate Background mode and painting on these areas.

Refining the areas selected with Magic Selection Brush

Although this tool does a pretty good job of selecting alike areas there will always be occasions when either too much or too little of the picture has been included. Just like the other tools we have looked at, the Magic Selection Brush allows you to easily modify existing selections.

To include other areas in the selection click the Indicate Foreground button in the tool's options bar and paint or place a dot on a new picture part. This step will cause Elements to regenerate the selection to include your changes. To remove an area from the selection, click on the Indicate Background button and scribble or dot the part to eliminate. Again Elements will regenerate the selection to account for the changes. The Shift and Alt keys can be used whilst drawing to change modes 'on the fly' and add to or subtract from the selection. See Figure 6.18.

The Magic Selection Brush is available in both the Standard and Quick Fix editor workspaces.

- 1 With the Magic Selection Brush active, scribble or place dots on the area to select.
- 2 Add to the selection by painting over new areas after switching to the Indicate Foreground mode.
- 3 Subtract from the selection by painting over new areas after switching to the Indicate Background mode.

The Magic Extractor feature

Also introduced in Photoshop Elements 4.0, the Magic Extractor feature quickly removes the background of a picture whilst retaining the subject in the foreground. This too is an extension of the technology that makes the Magic Selection Brush possible. Just as is the case with the brush, the Magic Extractor works by marking, with a scribbled line or a series of dots, the foreground (to be kept) and the background (to be removed) parts of the picture. Elements then automatically finds all the background parts in the picture and removes them from the document, filling the space with your choice of black, gray, white or transparency.

The Magic Extractor works within its own window, which includes a zoomable preview area, a set of tools for marking the foreground and background parts of a photo, touch-up options to refine extraction results as well as settings to select the background area once it is removed. See Figure 6.19.

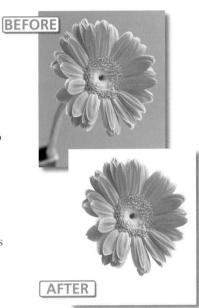

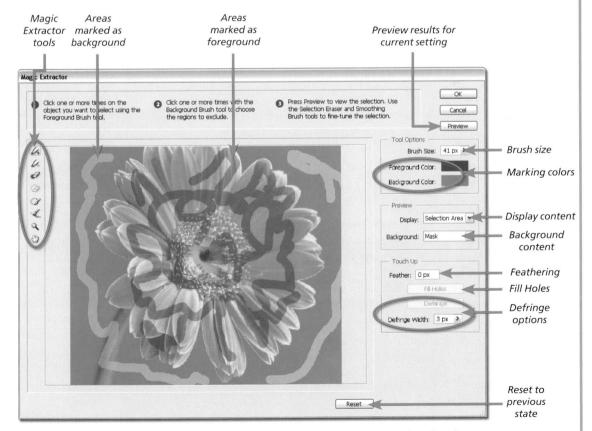

Figure 6.19 The new Magic Extractor isolates and removes background picture parts based on the user identifying foreground and background details with painted dots or scribbles.

Using the new Magic Extractor tool is a three-step process. You start by selecting the Foreground Brush tool and scribbling or placing dots over the areas that you want to retain. Next you switch to the Background Brush tool and scribble over the areas to be removed. See Figures 6.20 and 6.21.

- 1 Display the Magic Extractor option by choosing the Magic Extractor option from the Image menu.
- 2 Next, select the Foreground Brush and paint, scribble or place dots on the areas to be kept.
- 3 Now select the Background Brush tool and paint over the picture parts that will be deleted as part of the extraction process.
- 4 To check the accuracy of the extraction press the Preview button.
- 5 To add extra sections to the extracted area reselect the Foreground Brush, switch the Preview Display option to Original Photo and paint over the extra parts.
- 6 To remove unwanted parts from the selection do the same thing but using the Background Brush instead.
- 7 Finally, to clean up the edges of the extraction select the Smoothing Brush tool and drag it over the edges of the extraction.
- 8 Click OK to process the extraction and return the completed results to the main editing workspace.

When adding or removing parts from your extraction click the 'X' key toggle between the preview and extracted views.

Figure 6.20 The tool bar in the Magic Extractor contains the brushes that are used for painting on foreground and background picture parts as well as tools for adjusting the extraction results and altering the view.

Figure 6.21 The Defringe option in the Magic Extractor feature removes any stray background colored pixels from the edge of an extracted foreground detail (1), whereas the Feather option softens the edge of the detail (2).

Selections in action

Advanced dodging and burning

Previously, we have used the Dodge and Burn tools to adjust the tones in our images. Now, using carefully made selections, it is possible to darken, or lighten, whole areas of your pictures.

- 1 To start, use the Lasso or Selection Brush tool to select a portion of your image.
- 2 Next, open the Levels dialog (Enhance > Adjust Lighting > Levels).
- 3 Move the midtone Input slider to the left to lighten the selected tones, or to the right to darken them. Notice that the Levels changes have successfully dodged, or burned, the image. There is one problem with the results though the changes are noticeable because of the sharp edge of the selection. A little modification is needed.
- 4 Undo (Edit > Undo) the Levels adjustment and then, with the selection still active, apply a Feather (Select > Feather) to its edge. This command will soften the edge of the selection and make the change between areas that have been altered, and sections that have been left unchanged, more gradual. See Figures 6.22 and 6.23.

Figure 6.22 Changes made with a sharpedged selection (1) are more obvious than when they are applied to a selection with a feathered edge (2).

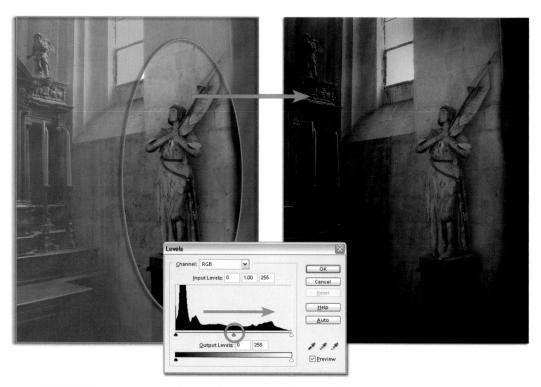

Figure 6.23 Using a feathered edge selection it is possible to easily lighten or darken whole areas of an image.

Figure 6.24 Shallow depth of field effects are the current picture fashion for food photographers.

Artificial depth of field

These days it is difficult to open the color magazine from a weekend paper without being confronted by a shallow depth of field picture. It seems that this photographic technique is very popular with food photographers in particular; the majority of the image is blurry, save for a single small and sharply focused portion. See Figures 6.24 and 6.25.

A similar effect can be created digitally using simple selection techniques.

- 1 Again, start the process by making a feathered selection of the part of your image that you want to remain sharp.
- 2 Next, invert (Select > Inverse) the selection so that the rest of the image is now isolated.
- 3 Using the Gaussian Blur filter (Filter > Blur > Gaussian Blur), change the sharpness of the selection until the desired effect is achieved.

Figure 6.25 You can create a digital look-alike version of shallow depth of field effects by combining a feather selection and the Gaussian Blur filter.

- (1) Before depth of field technique.(2) After depth of field technique.
- Book resources at: www.guide2elements.com

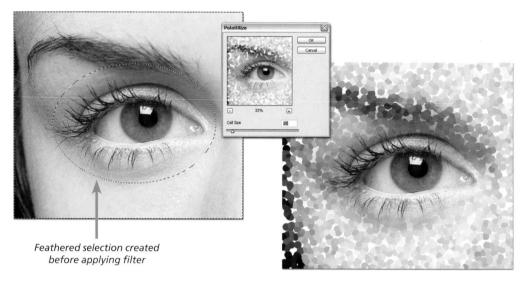

Figure 6.26 The effects of filters can be restricted to specific areas of a picture by making a selection first and then applying the filter.

Filtering a selection

In Chapter 4 we looked at some of the dramatic ways that we can change the look of an image using the filters that are supplied with Photoshop Elements. You can gain more control over where and how the filters are applied to your pictures by combining their use with carefully created selections.

- 1 By selecting a portion of the picture first, it is possible to restrict the effects of a filter to this one section of the image.
- 2 Feathering the selection before applying the filter will help blend the changes into the rest of the image. See Figure 6.26.

Selective saturation changes

Color, as well as tone, texture and focus, can direct the viewer's eye within a picture. Burning and dodging and depth of field effects are designed to control the way that the audience sees an image and, more importantly, which parts of the picture become the points of focus. Using the selection tools, as well as the Hue/Saturation control, Elements provides a further option for helping to establish focal points within your pictures.

The result is a photograph where the viewer's eye is drawn to the saturated area of the image. Remember, complete desaturation will result in a grayscale image. Making this degree of change to the inverted selection would produce a dramatic picture that is both black and white and color. See Figure 6.27.

- 1 Start by making a selection of the most visually important part of the picture.
- 2 Next, open the Hue/Saturation feature (Enhance > Adjust Color > Hue/Saturation) and increase the saturation of this part of the picture.
- 3 Finally, invert (Select > Inverse) the selection so that the rest of the image is now selected and, using the Hue/Saturation control again, reduce the saturation.

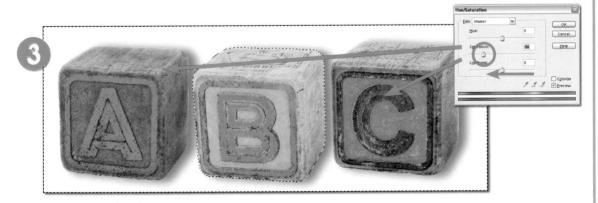

Figure 6.27 Focal points can be created in an image by saturating a selection and desaturating the inverse selection. (1) Select the focal point. (2) With the selection active, saturate this portion of the picture. (3) Inverse the selection and desaturate the rest of the picture.

Layers and their origins

The first image-editing programs used a flat file format. See Figure 6.28. All the information for the file was contained in a single plane and all changes made to the image were permanently and irreversibly stored in this file. It did not take users and software manufacturers long to realize that a more efficient and less frustrating way to work was to build an image from a series of picture parts each contained on its own layer.

The concept was not entirely new; the cell animation industry has used the idea for years. Each character and prop was painted onto a transparent plastic sheet, which was then layered together over a solid background. When seen from above, the components and the background appeared to be a single image.

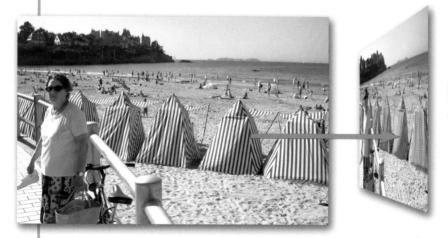

Figure 6.28 A flat file contains all the image information in a single plane.

Adobe in Photoshop and Photoshop Elements has based its layers system on this idea. See Figure 6.29. When an image is first created and opened in the editing package, it becomes the background by default. Any other images that are copied and pasted onto the image, or text that is added to the picture, become a layer that sits on top of this background. Just as with the animation version, the uppermost layer is viewed first and the other layers and background then show through the transparent areas of each other layer.

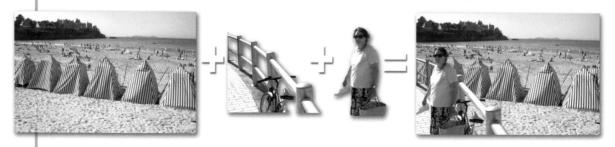

Figure 6.29 Multi-layered image files are used by most editing programs as a way to separate different picture components whilst keeping them available for editing and enhancement purposes.

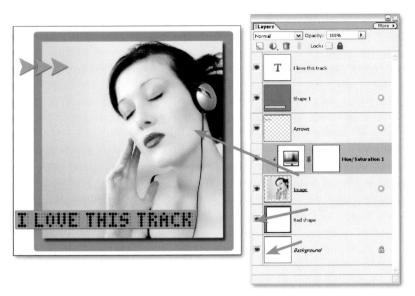

Figure 6.30 The Layers palette in Elements shows the content and position of each layer within the stack.

The Layers palette

Undoubtedly this whole idea might seem a little confusing to the new user, but the benefits of a system that allows picture parts to be moved and adjusted independently far outweigh the time it will take to understand the concept. To help visualize the setup, Elements contains a specialized Layers palette that shows each of the individual layers, their position in the layer stack and a small thumbnail of their contents. See Figure 6.30.

A transparent area is represented by a checkerboard gray and white pattern that surrounds any image parts that are smaller than the background. The eye, sitting to the left of the thumbnail, shows that the layer is visible. Clicking on this icon will make the eye disappear and visually remove the image part from the whole picture. Only one layer in the stack can be edited at a time and for this reason it is called the working layer. See Figure 6.31. This layer will be colored differently to the others in the stack. Clicking on a different layer in the area to the right of the thumbnail will make this layer the new working layer. See Figure 6.32.

When the full image is saved as an Elements file in PSD format, all the individual layers are maintained and can be manipulated individually when the picture is opened next. This is not true if the image is saved in other formats like standard JPEG. Here the information contained in each layer is merged together at the time of saving to form one flat file.

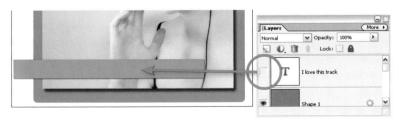

Figure 6.31 Clicking the eye icon removes that layer from view in the image.

Layer types

Image layers

Several different types of layers can be added to an Elements image; of these the most simple, and probably the most obvious, is the image layer. When an image part is copied and pasted it automatically makes a new layer. This is true whether the picture part came from the original image or from another picture that is already opened. When this new layer is selected as the working layer it can be moved around the image surface using the Move tool. The contents can also be changed in size and shape using one of the four options found in the Transform menu (Image > Transform > Free Transform or Skew or Distort or Perspective). See Figure 6.33. These features allow you to manipulate the layer to fit the other components of the image.

The background layer is a special image layer. Its dimensions define the image size. It is also locked by default, meaning that it cannot be moved. You can restrict the movement of other key layers by clicking the lock icon in the top part of the Layers palette. Ticking the Transparency option located next to the lock icon will not allow any changes made to the layer to impinge on the transparent area.

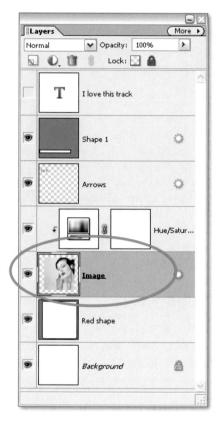

Figure 6.32 The active or working layer is a different color to the others in the stack.

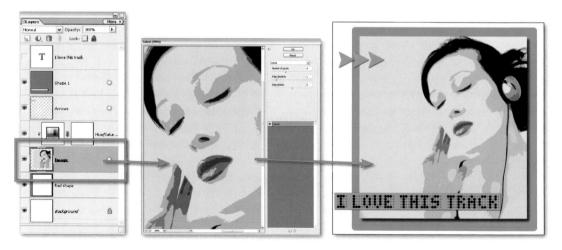

Figure 6.33 Individual image layers can be manipulated independently of other layers in the stack.

Type layers

Type layers do not show a thumbnail of their contents in the Layers palette. See Figure 6.34. A large 'T' is positioned in its place and the first few words of the text are used as the layer's name. Unlike other packages, Elements' type layers remain editable even after they have been saved, provided that the file has been saved in the PSD, TIFF or PDF formats.

Shape layers

Drawing with any of the shape tools creates a new vector-based shape layer. The layer contains a thumbnail for the shape as well as the color of the layer. Shape layers need to be simplified or changed to a standard image layer before they can be enhanced or filtered.

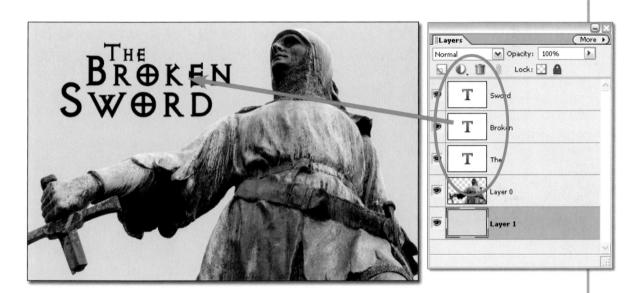

Figure 6.34 Elements uses editable type layers for any text that is added to images.

Adjustment layers

Adobe added adjustment layers to Elements as a way for users to change the look of images whilst retaining the integrity of the image file. Familiar image-change features, such as Levels and Hue/Saturation, are available as adjustment layers and, depending on where they are placed in the layer stack, will alter either part, or all, of the image. See Figure 6.35.

Adjusting your images using these types of layers is a good way of ensuring that the basic picture is not changed in any way. The other advantage is that the settings in the adjustment layers can be edited and changed at a later date, even after the file has been saved. Users can access the original settings used to make the alteration by double-clicking the dialog icon on the left-hand side of the adjustment layer.

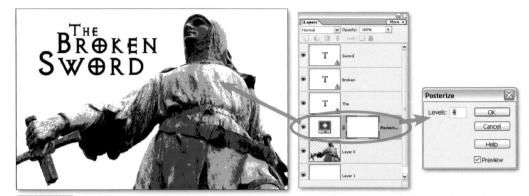

Figure 6.35 Adjustment layers alter the look of all layers that are positioned beneath them in the stack, unless they are grouped with the layer beneath by holding the Alt key down and clicking the dividing line between each in the Layers palette.

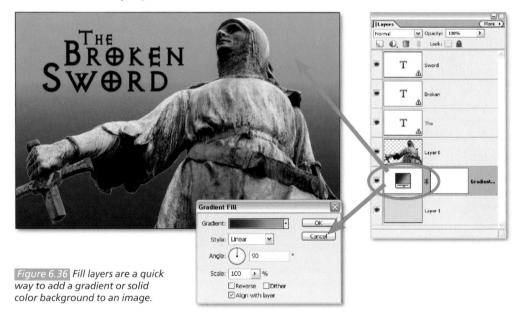

Fill layers

Users can also apply a Solid Color, Gradient or Pattern to an image as a separate layer. These three selections are available as a separate item (Layer > New Fill Layer) under the Layer menu or grouped with the adjustment layer options via the Quick button at the bottom of the Layers palette. See Figure 6.36.

Frame Layers

In Elements 5.0 Adobe introduces a new layer type to coincide with its Photo Layout creation project (see Chapter 9 for more details). Called the Frame layer, its role is to store both the frame and the picture that sits within it. This would not be a difficult task if, once the frame and picture

were combined, both parts became one entity, but this approach would not provide much room for fine-tuning later. So, instead, the development team created the Frame layer, borrowing some of the technology from the Smart Layer feature in Photoshop.

In Frame layers both the component parts remain as separate individual images despite being stored as one layer. What does this mean in day-to-day editing? Well it means that you can do things like change the size, shape and orientation of either the frame, or the picture, independently of each other. This level of flexibility is a godsend for those photographers who regularly compose album or scrapbook pages. Individual photos and their frames can be pushed, pulled, twisted and sized until the composition is just right. See Figure 6.37.

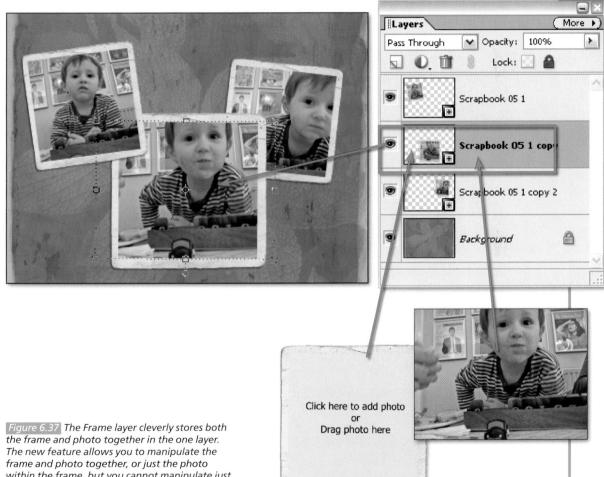

within the frame, but you cannot manipulate just the frame alone.

Frame layers appear like a standard image layer except they have a small plus sign in the bottom right-hand corner of the layer thumbnail to distinguish them from other layer types. Like text and shape layers, Frame layers are also resolution independent. See Figure 6.38.

Figure 6.38 Frame layers look different from other layer types because they have a small plus symbol at the bottom left of the layer thumbnail.

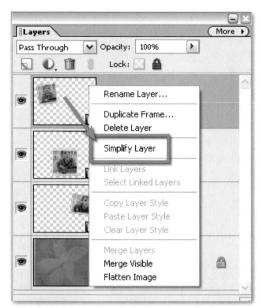

Figure 6.39 Like Shape and Text layers, Frame layers are resolution independent and so need to be simplified before you can edit them directly.

The upside of this characteristic is that the frame and photo content can be up- or downsized many times with minimal or no damage to picture components. This is not the case for a standard image layer where such changes over time cause the photo to become less clear. The downside, you knew there had to be one, is that because of this basic structure you cannot edit or enhance the pixels in a Frame layer directly. Any attempt to adjust brightness, color, contrast or even filter the photo or the frame meets with a warning dialog that states that you must Simplify the Frame layer first. Simplifying the layer means converting it from its resolution independent 'frame plus photo' state to a standard pixel-based image layer. See Figure 6.39.

For more details on Frame layers and how to use then go to Chapter 9.

Layer transparency

Until this point we have assumed that the contents of each layer were solid. When a layer is placed on top, and in front, of the contents of another layer, it obscures the objects underneath completely. And for most imaging scenarios this is exactly the way that we would expect the layers to perform, but occasionally it is desirable to allow some of the detail, color and texture of what is beneath to show through. To achieve this effect, the 'transparency' of each layer can be interactively adjusted via the Opacity slider control in the top right-hand corner of the palette. See Figure 6.40. Keep in mind that making the selected layer less opaque will result in it being more transparent.

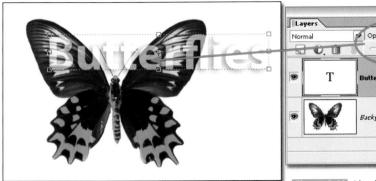

Figure 6.40 Altering the opacity of a layer allows the color, texture and tone of the image beneath to show through.

Layer blend modes

The layer blending modes extend the possibilities of how two layers interact. See Figures 6.41 and 6.42. Twenty-three different mode options are available in the drop-down menu to the left of the Opacity slider in the Layers palette. For ordinary use the mode is kept on the Normal selection, but a host of special effects can be achieved if a different method of interaction, or mode, is selected. The mode options are the same ones available for use with tools like the Paintbrush and Pencil, and some advanced editing or enhancement techniques are based on their use. Experimenting with different modes will help you understand how they affect the combining of layers and will also help you to determine the best occasions to use this feature.

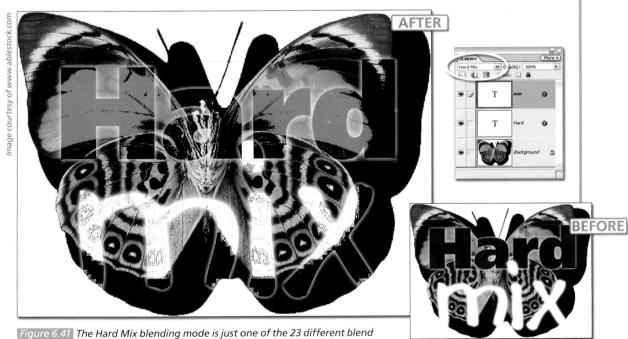

modes available in Elements that alter the way that two layers interact.

Figure 6.42 Layer blending modes control the way that two separate layers interact. The examples above indicate the different effects that are possible when selecting one of the 23 that are available. (1) Normal. (2) Dissolve. (3) Darken. (4) Multiply. (5) Color Burn. (6) Linear Burn. (7) Lighten. (8) Screen. (9) Color Dodge. (10) Linear Dodge. (11) Overlay. (12) Soft Light. (13) Hard Light. (14) Vivid Light. (15) Linear Light. (16) Pin Light. (17) Difference. (18) Exclusion. (19) Hue. (20) Saturation. (21) Luminosity. (22) Hard Mix. (23) Color.

Layer Styles

Early on in the digital imaging revolution, users started to place visual effects like drop shadows or glowing edges on parts of their pictures. A large section of any class teaching earlier versions of Photoshop was designated to learning the many steps needed to create these effects. With the release of packages like Elements, these types of effects have become built-in features of the program. Now, it is possible to apply an effect like a 'drop shadow' to the contents of a layer with the click of a single button. See Figure 6.43.

Adobe has grouped all these layer effects under a single heading 'Special Effects' in the palette called Artwork and Effects. As with many features in the program, a thumbnail version of each style provides a quick reference to the results of applying the effect. To add the style to a selected layer, simply click on the thumbnail and then press the Apply button.

Multiple styles can be applied to the one layer and the settings used to create the effect can be edited by double-clicking the starburst icon on the selected layer in the palette. Remove a layer style by selecting Layer > Layer Style > Clear Layer Style whilst selecting the layer with the style applied.

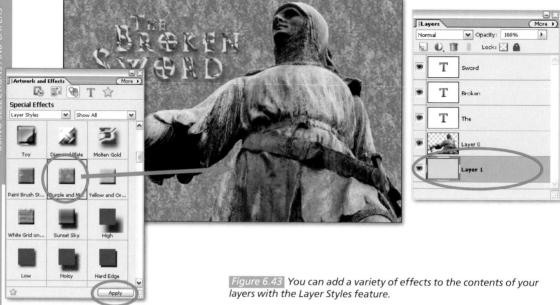

Customizing of layer styles

In Elements 5.0 Adobe has increased the ability to customize the layer styles in your Elements documents. Now when you select a layer in the Layers palette and then choose Layer > Layer Style > Style Settings a new dialog appears. The Style Settings dialog groups together a variety of sliders and settings that control the look of the style. Here you can not only adjust the settings of the applied style but you can also apply other styles. This option is new for Elements 5.0. See Figure 6.44.

Adding Elements' Layer Styles

If you spread your styles wings a little further there are many sites on the web that offer free downloadable styles that can be added to your library. Usually, the files are downloaded in a compressed form such as a zip. The file needs to be extracted and then saved to the Adobe\Photoshop Elements 5.0\Presets\Styles folder before use. The next time you start Elements you will have a smorgasbord of new styles to apply to your images. See Figure 6.45.

Figure 6.44 Customize the look of the Layer Styles in your documents by changing the values in the Style Settings dialog.

Figure 6.45 Extending the library of styles you have available to you is as simple as downloading new examples from the Net and installing them in the Elements Styles folder.

Organizing layers

Moving

Layers can be moved up and down the layer stack by click-dragging them to a new position. Moving a layer upwards will mean that its picture content may obscure more of the details in the layers below. Moving downwards progressively positions the layer's details further behind the picture parts of the layers above. You can reposition the content of any layers (except background layers) using the Move tool.

Linking

Two or more layers can be joined together so that when the content of one layer is moved the other details follow precisely. This process is called linking and preserves the content of each layer but allows them to be moved as if they were just one entity.

Adobe provided a new way to link layers in Elements 4.0. Firstly the layers are multi-selected using Shift-click to select layers that are consecutive and Ctrl-click to choose random layers to link. The selected layers will change to the active layer color – gray in use in Figure 6.46. After selecting, the layers are linked by clicking the chain icon at the top of the Layers palette. To unlink reverse these steps.

Before these changes in the new release, you simply clicked on the box on the right of the eye symbol in the Layers palette to link them together. When linked the box is filled with a chain symbol to indicate that this layer is now linked with others in the palette.

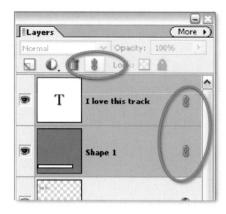

Figure 6.46 Layers are linked by multi-selecting first and then clicking the chain icon in the Layers palette.

Merging

The content of multi-selected layers can be combined into a single layer using the Merge Layers option in the Layer menu. In a similar way, a layered document can be flattened into a picture that only contains a background via the Layer > Flatten Image command. Merging or flattening layers are not steps that are recommended though, as both actions remove the ability of editing the content or position of each layer individually.

Deleting

Unwanted layers can be deleted by dragging them to the dustbin icon at the bottom of the Layers palette or by selecting the layer and clicking the icon.

Quick guide to Layer shortcuts

- 1 To display Layers palette Choose Windows > Layers
- 2 To access layer options Click the More button in the upper right of the Layers palette
- 3 To change the size of layer thumbnails Choose Palette options from the Layers palette menu and select a thumbnail size
- 4 To make a new layer Choose Layer > New > Layer
- 5 To create a new adjustment layer Choose Layer > New Adjustment Layer and then select the layer type
- 6 To create a new fill layer Choose Layer > New > New Fill Layer and select the layer type
- $7\,$ To add a style or effect to a layer Select the layer and click on a thumbnail in the Styles and Effects palette

Combining Text with Your Images

Creating simple type
Creating paragraph text
Basic text changes
Creating and using type masks
Reducing the 'jaggies'
Warping type
Applying styles to type layers
New text alternatives in version 5.0
Debunking some type terms

igital imaging has blurred the boundaries between many traditional industries. No longer does the image maker's job stop the moment the illustration or photograph hits the art director's desk. With the increased abilities of software like Photoshop Elements has come the expectation that not only are you able to create the pictures needed for the job, but you are also able to perform other functions like adding text. See Figure 7.1.

Combining text and images is usually the job of a graphic designer or printer, but the simple text functions that are now included in most desktop imaging programs mean that more and more people are trying their hand at adding type to pictures. Elements provides the ability to input type directly onto the canvas rather than via a type dialog. This means that you can see and adjust your text to fit and suit the image beneath. Changes of size, shape and style can be made at any stage by selecting the existing text and applying the changes via the options bar. As the type is saved as a special type layer, it remains editable even when the file is closed, so long as it is saved and reopened in the Elements PSD format. See Figure 7.2.

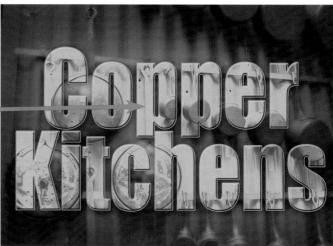

Figure 7.1 Elements has a range of sophisticated text features built right into the main program. This means that combining text and images in the one document has become a task that is easier to complete than ever before.

Paragraph Text

In earlier versions of Elements text was entered one line at a time. The user needed to press the Enter key at the end of each line in order to start a new line of text underneath. From version 4.0 this way of working was no longer necessary. Now text entered in Paragraph mode will automatically wrap when the cursor reaches the text box edge. See Figure 7.3.

WYSIWYG font previews

Also new for version 5.0 is the WYSIWYG (What You See Is What You Get) preview that is displayed on the Text tool font menu. Now you can see an example of how the letter shapes for each font family appear right in the menu itself. See Figure 7.4.

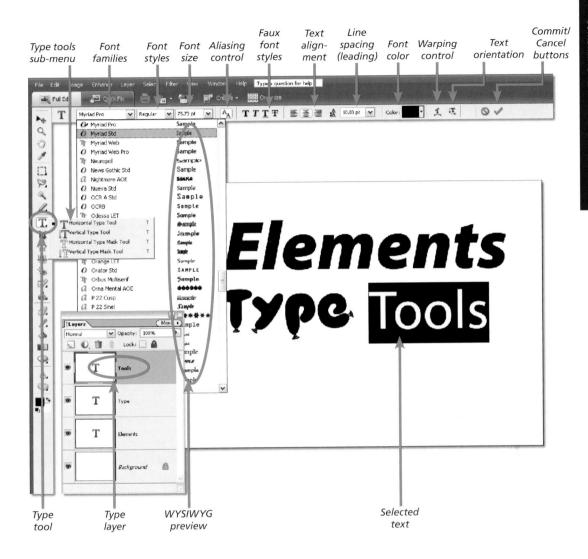

Figure 7.2 The advanced type tools in Elements' Editor workspace allow the user to enter (and edit) text directly in the Editor workspace.

Figure 7.3 Paragraph text automatically wraps from one line to the next.

Figure 7.4 The font family menu (Text tool options bar) displays a WYSIWYG example of the font.

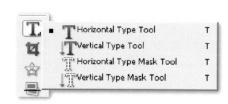

Figure 7.5 Four text options are available via the Type tool selection in the toolbox.

Figure 7.6 Any text entered must be 'committed' to a type layer before other tools or menu choices can be used. As well as pressing the commit button you can click another tool, or apply a layer style or menu command. The type will then auto-commit.

Creating simple type

Two new Type tools were added to Elements in version 2.0 of the program over and above the two that were present in the initial release of the program. In version 5.0 you can select from Horizontal and Vertical Type tools, as well as Horizontal and Vertical Type Mask tools.

Of the standard Type tools (non-mask varieties), one is used for entering text that runs horizontally across the canvas and the other is for entering vertical type. See Figure 7.5. To place text onto your picture, select the Type tool from the toolbox. Next, click onto the canvas in the area where you want the text to appear. Do not be too concerned if the letters are not positioned exactly, as the layer and text can be moved later. Once you have finished entering text you need to commit the type to a layer. Until this is done you will be unable to access most other Elements functions. To exit the Text editor, either click the tick button in the options bar or press the Control + Enter keys in Windows. See Figure 7.6.

Creating Paragraph Text

In version 4.0 Adobe introduced the Paragraph Text options to the simple type ones detailed above. To create a paragraph, select the Type tool and then click and drag a text box on the surface of the picture. Automatically Elements positions a cursor inside the box and creates a new layer to hold the contents. Typing inside the box will add text that automatically wraps when it reaches the box edge. When you have completed entering text, either click the tick button in the options bar, or press the Control + Enter keys.

You can resize or even change the shape of the box at any time by selecting a Type tool and then clicking onto the area where the paragraph text has been entered. This action will cause the original text box to display. The box can then be resized by moving the cursor over one of the handles (small boxes at the corners/edges) and click-dragging the text box marquee to a new position. The text inside the box will automatically rewrap to suit the new dimensions.

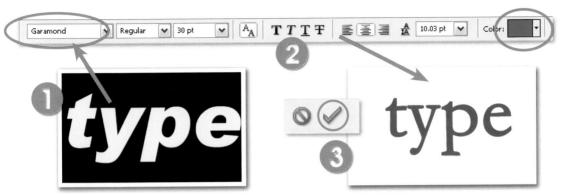

Figure 7.7 The text options bar contains a number of settings for altering the style, font, color, aliasing, alignment and size of the type entered. To change the settings of your type, (1) select the text, (2) make the changes in the Type tool options bar and then (3) commit the changes by clicking the tick icon in the bar.

Basic text changes

All the usual text changes available to word processor users are contained in Elements. It is possible to alter the size, style, color and font of your type using the settings in the options bar. See Figure 7.7. You can either make the selections before you input your text or later by highlighting (clicking and dragging the mouse across the text) the portion of type that you want to change. In addition to these adjustments, you can also alter the Justification or alignment of a line or paragraph of type. After selecting the type to be aligned, click one of the justification buttons on the options bar. Your text will realign automatically on screen. After making a few changes, you may wish to alter the position of the text; simply click and drag outside of the type area to move it around. If you have already committed the changes to a text layer then select the Move tool from the toolbox, making sure that the text layer is selected (just roll the mouse over text until you see the blue outline and click), then click and drag to move the whole layer. See Figure 7.8.

Creating and using type masks

The Type Mask tools are used to provide precise masks or selections in the shape and size of the text you input. Rather than creating a new text layer containing solid colored text, the mask tools produce a selection outline. From this point on the text mask can be used as you would use any other selection. See Figure 7.9.

- 1 Choose the Type tool from the toolbox. To change between Type tools, click and hold on the tool to reveal the hidden options.
- 2 Click on the picture surface to position the start of the text or click-drag to create a text box.
- 3 Make changes to font type, size, style, justification and color by altering the settings in the options bar.
- 4 Enter your text using the keyboard or by pasting sections (Edit > Paste) from a copied word processing document.
- 5 For non-masked text, click and drag to move the text over the image background.
- 6 Commit entered text or changes to a type layer by clicking 'tick' in the options bar or by pressing Control + Enter.

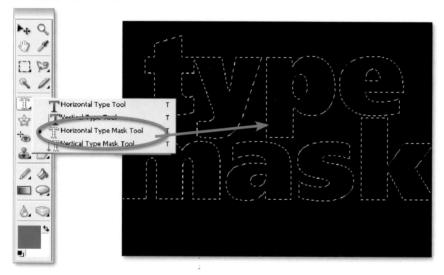

Figure 7.9 The Type Mask tools are used to make text-shaped selections.

Figure 7.10 The anti-aliasing setting helps smooth out the edges of 'jagged' text. (1) Anti-aliased feature off. (2) Anti-aliased feature on.

Reducing the 'jaggies'

One of the drawbacks of using a system that is based on pixels to draw sharp-edged letter shapes is that circles and curves are made up of a series of pixel steps. Anti-aliasing is a system where the effects of these 'jaggies' are made less noticeable by partially filling in the edge pixels. This technique produces smoother looking type overall and should be used in all print circumstances

and web applications. See Figure 7.10. The only exception is where file size is critical, as antialiased web text creates larger files than the standard text equivalent. Anti-aliasing can be turned on and off by clicking the Anti-aliased button or checking the box (version 1.0) in the options bar.

- 1 Turn anti-aliasing on by clicking the Anti-aliased button in the options bar, or by selecting Laver > Type > Anti-Alias On.
- 2 Turn anti-aliasing off by reclicking the button, unchecking the box (version 1.0) in the options bar or by selecting Layer > Type > Anti-Alias Off.

Warping type

One of the special features of the Elements type system is the Warping feature. This tool forces text to distort to one of a range of shapes. An individual word, or even whole sentences, can be made to curve, bulge or even simulate the effect of a fish-eye lens. See Figure 7.11. The strength and style of the effect can be controlled by manipulating the Bend and Horizontal and Vertical Distortion sliders.

This feature is particularly useful when creating graphic headings for posters or web pages. See Figure 7.12.

- 1 Choose a completed type layer.
- 2 Select Layer > Type > Warp Text or pick the Type tool from the toolbox and click the Warp button in the options bar.
- 3 Choose the warp style from the drop-down menu.
- 4 Adjust the Bend, Horizontal Distortion and Vertical Distortion sliders.
- 5 Click OK to finish.

Applying styles to type layers

Elements' Layer Styles can be applied very effectively to type layers and provide a quick and easy way to enhance the look of your text. Everything from a simple drop shadow to complex surface and color treatments can be applied using this single-click feature. See Figure 7.13. A collection of included styles can be found under the Layer Styles heading in the Styles and Effects palette. A variety of different style groups are available from the drop-down list and small example images of each style are provided as a preview of the effect. See Figure 7.14.

Additional styles can be downloaded from websites specializing in resources for Elements users. These should be installed into the Adobe\Photoshop Elements\Presets\Styles folder. The next time you start Elements, the new styles will appear in the Styles and Effects palette. Extra type effects are also located in the effects group of the Styles and Effects palette.

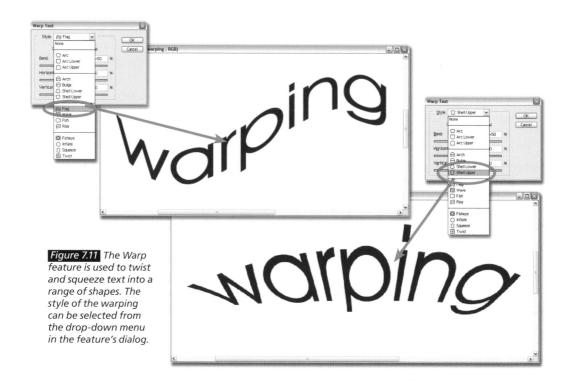

Warping

Figure 7.12 The degree of bend (1) and distortion (2) of the text can be altered using the settings in the Warp Text dialog.

Figure 7.13 The look of text can be changed with a single click using Layer Styles. (1) Drop shadow. (2) Inner Ridge Bevel. (3) Wood Grain. (4) Pink Glass. (5) Purple Neon. (6) Waves. (7) Brushed Metal. (8) Molten Gold. (9) Cactus. (10) Chrome Fat.

To apply a style to a section of type, make sure that the text layer is currently active. Do this by checking that the layer is highlighted in the Layers palette. See Figure 7.15. Next, open and view the Layer Styles group in the Special Effects section in the Artwork and Effects palette. Click on the thumbnail of the style you want to apply to the text and then click the Apply button at the bottom of the palette.

The changes will be immediately reflected in your image. See Figure 7.16. Multiple styles can be applied to a single layer and unwanted effects can be removed by using the Step Backward button (Undo) in the shortcuts bar or the Undo command (Edit > Undo Apply Style).

Figure 7.14 Layer Styles are grouped in menus around a common theme such as Drop Shadows, Bevels and Glass Buttons. In version 5.0 of Elements Layer Styles are grouped with other effects and filters in the Artwork and Effects palette.

The settings of individual styles can be edited by double-clicking on the star icon in the text layer and adjusting one or more of the Style Settings. See Figure 7.17.

- 1 Ensure that the text layer is selected.
 - 2 View the Layer Styles group by clicking the Special Effects tab in the Artwork and Effects palette and then choosing the Layer Styles option from the drop-down menu.
 - 3 Choose the group and style to apply to your text from the drop-down list and thumbnails.
 - 4 Edit Style Settings by double-clicking the starburst symbol in the text layer.
- 5 Remove effects by selecting Edit > Undo Layer Styles or by clearing Layer Styles.

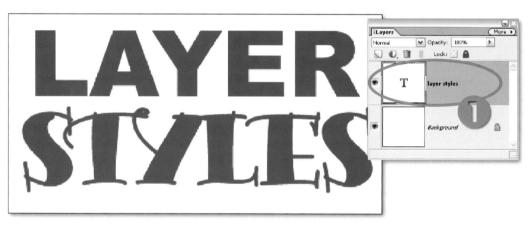

Figure 7.15 Make sure the type layer is selected before applying a layer style. (1) Active text layer.

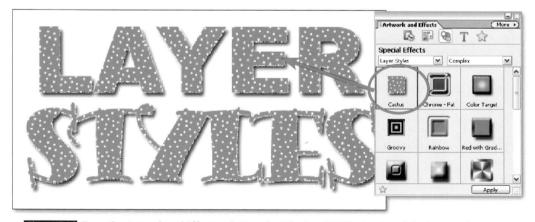

Figure 7.16 Open the Artwork and Effects palette, select the Special Effects tab and the Layer styles group you want to use and then click the thumbnail of the style you want to add before pressing the Apply button.

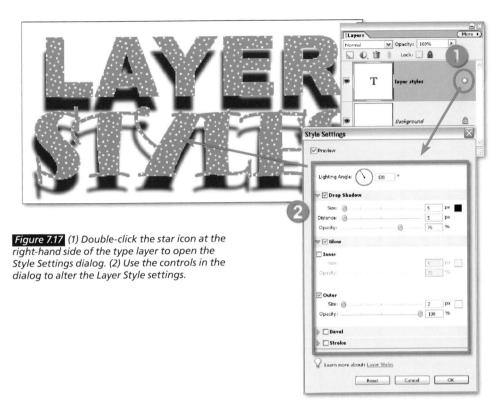

New text alternatives in version 5.0

Adobe created a couple of new ways to handle the text in your photos for Photoshop Elements 5.0. Grouped with the Artwork, Themes, Special Effects and Favorites headings in the new Artwork and Effects palette is a Text tab which contains thumbnail previews of a variety of text effects.

On the simplest level the design options listed here can be used in much the same way as the layer style entries we looked at in the previous section. To change the look of existing text layers, select the layer in the Layers palette first and then choose the text style by clicking one of the thumbnails. Add the style to the layer by pressing the Apply button at the bottom of the palette. The star icon is added to the text layer to indicate that it now has a style associated with it. See Figure 7.18.

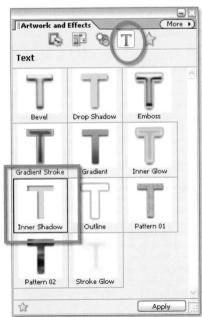

Figure 7.18 The Text section of the Artwork and Effects palette contains a range of text styles that can be added to the type in your photos.

Book resources at: www.guide2elements.com

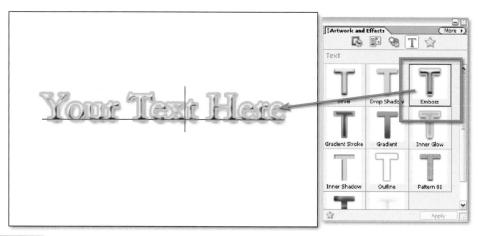

Figure 7.19 Applying a Text style with no type layer selected will automatically create a new type layer and input some placeholder text in the style of your choosing.

Editing or customizing the style is as simple as double-clicking the star icon to display the Styles Settings dialog and then altering the controls for each style characteristic (drop shadow, glow, bevel, stroke).

If you have not yet created the text layer then there is no need to add it first before selecting the style. Just click on the thumbnail style of your choice and then press the Apply button. This action will automatically create a new text layer in your document and input some placeholder text, 'Your Text Here', with the style applied. From this point on it is a simple matter to replace this generic text with your own. Just double-click on the text with the Move tool; Elements will then switch tools to the Type tool and select all of the place holder text. Now type in the new text to complete the replacement. Alternatively you can click on the text and then choose Edit Text from the Move tool's context menu See Figure 7.19.

Figure 7.20 To change the units of measurement used for type, (1) go to the Units & Rulers option in the Preferences menu and then (2) select the measure unit you want from the drop-down Type menu.

Debunking some type terms

Font size

The size of the text you place in your image files is measured as pixels, millimeters or points. I find the pixel setting most useful when working with digital files, as it indicates to me the precise size of my text in relationship to the whole image. Millimeter and points values, on the other hand, vary depending on the resolution of the picture and the resolution of the output device. Some of you might be aware that 72 points approximately equals 1 inch, but this is only true if the picture's resolution is 72 dpi. At higher resolutions the pixels are packed more closely together and therefore the same 72 point type is smaller in size.

EATURE UMMARY To change the unit of measurement used for text in Elements:

- 1 Windows users, select Edit > Preferences > Units & Rulers.
- 2 Then alter the unit of measurement for Type. See Figure 7.20.

Font family and style

The font family is a term used to describe the way that the letter shapes look. Most readers would be familiar with the difference in appearance between Arial and Times Roman. These are two different families each containing different characteristics that determine the way that

Figure 7.21 The family and style of a font determine its look.

the letter shapes appear. The font style refers to the different versions of the same font family. Most fonts are available in regular, italic, bold and bold italic styles. See Figure 7.21.

You can download new fonts from specialist websites to add to your system. Some families are available free of charge, others can be purchased online. After downloading, the fonts should be installed into the fonts section of your system directory. Windows and Macintosh users will need to consult their operating system manuals to find the preferred method for installing new fonts on their computer.

Alignment and justification

These terms are often used interchangeably and refer to the way that a line or paragraph of text is positioned on the image. The left align, or left justify, feature will arrange all text to the left of the picture. When applied to a group of sentences, the left edge of the paragraph is organized into a straight vertical line whilst the right-hand edge remains uneven or ragged. Right align works in the opposite fashion, straightening the right-hand edge of the paragraph and leaving the left ragged. Selecting the center text option will align the paragraph around a central line and leave both left and right edges ragged. See Figure 7.22.

The left align, or justification, feature will arrange all text to the left of picture. When applied to a group of sentences the left edge of the paragraph is organized into a straight vertical line whilst the right-hand edge remains uneven or ragged. Right align works in the opposite fashion, straightening the right hand edge of the paragraph and leaving the left ragged. Selecting the center text option will align the paragraph around a central line and leave both left and right edges ragged.

The left align, or justification, feature will arrange all text to the left of picture. When applied to a group of sentences the left edge of the paragraph is organized into a straight vertical line whilst the right-hand edge remains uneven or ragged. Right align works in the opposite fashion, straightening the right hand edge of the paragraph and leaving the left ragged. Selecting the center text option will align the paragraph around a central line and leave both left and right edges ragged.

The left align, or justification, feature will arrange all text to the left of picture. When applied to a group of sentences the left edge of the paragraph is organized into a straight vertical line whilst the right-hand edge remains uneven or ragged. Right align works in the opposite fashion, straightening the right hand edge of the paragraph and leaving the left ragged. Selecting the center text option will align the paragraph around a central line and leave both left around a central

Figure 7.22 Type alignment controls how the text is arranged in the image. (1) Left align. (2) Center. (3) Right align.

Leading

Originally referring to the small pieces of lead that were placed in between lines of metal type used in old printing processes, nowadays it is easier to think of the term referring to the space between lines of text. Unlike earlier versions of the program, Elements 3.0/4.0 includes the ability to alter the leading of the type input in your documents. Start with a value equal to the font size you are using and increase or decrease from here according to your requirements. See Figure 7.23.

Delit dio corem iriusci psuscilit augait, quisi ea feugue consed exerostrud molent nim autate facidunt il lummodo lorper

Delit dio corem iriusci psuscilit augait, quisl ea feugue consed

2 exerostrud

Figure 7.23 Leading is the space between lines of text. 24 pixel type with (1) 18 pixel leading and (2) 48 pixel leading.

Using Elements' Painting and Drawing Tools Cookie Cutter tool Painting tools Better with a tablet Painting tools in action **Drawing tools**

215

t some point during your imaging life you will need, or want, to create an image from scratch. Until now, we have concentrated on editing, adjusting and enhancing images that have been generated using either a camera or scanner; now we will look at how to use Elements' painting and drawing tools to create something entirely new.

Although the names are the same, the tools used by the traditional artists to paint and draw are quite different from their digital namesakes. The painting tools (the Paint Brush, Pencil, Eraser, Paint Bucket and Airbrush) in Elements are pixel based. That is, when they are dragged across the image they change the pixels to the color and texture selected for the tool. These tools are highly customizable and, in particular, the painting qualities of the Brush tool can be radically changed via the brush More Options palette.

The drawing tools (the Shape tools), in contrast, are vector or line based. The objects drawn with these tools are defined mathematically as a specific shape, color and size. They exist independently of the pixel grid that makes up your image. They produce sharp-edged graphics and are particularly good for creating logos and other flat colored artwork. See Figure 8.1.

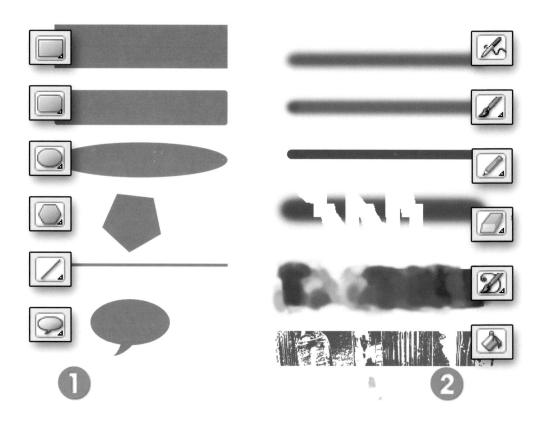

Figure 8.1 Drawing and painting tools are used to add non-photographed information to your images. (1) Drawing tools. (2) Painting tools.

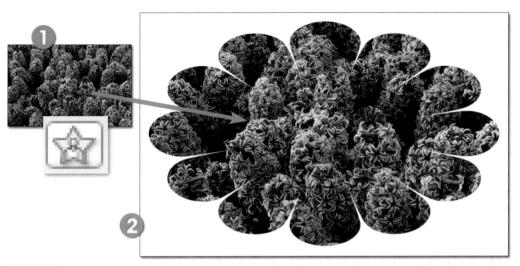

Figure 8.2 The Cookie Cutter tool that was first introduced in Elements 3.0 functions much like a fancy cropping feature, allowing users to remove the edges of their pictures in a range of graphic hard-edged shapes. Adding a feather value via the options bar softens the edge of the crop, producing smoother transitions between the filled shape and the background. (1) Original photo. (2) Photo cropped with the Cookie Cutter tool.

Cookie Cutter tool

Also included in this vector type (hard-edged) drawing tool group is the Cookie Cutter tool. Though not strictly a drawing tool, the feature works in a very similar way to the Custom Shape tool as it too allows users to select and draw a range of predesigned shapes in the workspace. It is after the drawing step that the two tools differ. The shape drawn with the Cookie Cutter is used to define the edges of the current image. In this way the feature functions as a fancy Crop tool, providing a range of graphic designs that can be used to stamp out the edges of your pictures. See Figure 8.2.

Painting tools

Paint Brush

The four main painting tools all apply color to an image in slightly different ways.

The Paint Brush lays down color in a similar fashion to a traditional brush. The size and shape of the brush can be selected from the list in the Brush Presets list (versions 5.0, 4.0, 3.0 and 2.0) or Brush palette (version 1.0) in the options bar. Changes to the brush characteristics can be made by altering the settings in the options bar and the More Options palette. See Figure 8.3.

In addition to changes to the size, painting mode and opacity of the brush, which are made via the options bar, you can also alter how the Paint Brush behaves. The Brush Dynamics palette (displayed by pressing the More Options button) is used to creatively control your brush's characteristics.

The More Options palette

- **Spacing** determines the distance between paint dabs measured in brush diameters, with high values producing dotty effects.
- The *Fade* setting controls how quickly the paint color will fade to nothing. Low values fade more quickly than high ones.
- *Hue Jitter* controls the rate at which the brushes' color switches between foreground and background hues. High values cause quicker switches between the two colors.
- Hardness sets the size of the hard-edged center of the brush. Lower values produce soft brushes.
- The *Scatter* setting is used to control the way that strokes are bunched around the drawn line. A high value will cause the brush strokes to be more distant and less closely packed.
- *Angle* controls the inclination of an elliptical brush.
- The *Roundness* setting is used to determine the shape of the brush tip. A value of 100% will produce a circular brush, whereas a 0% setting results in a linear brush tip. See Figure 8.4.

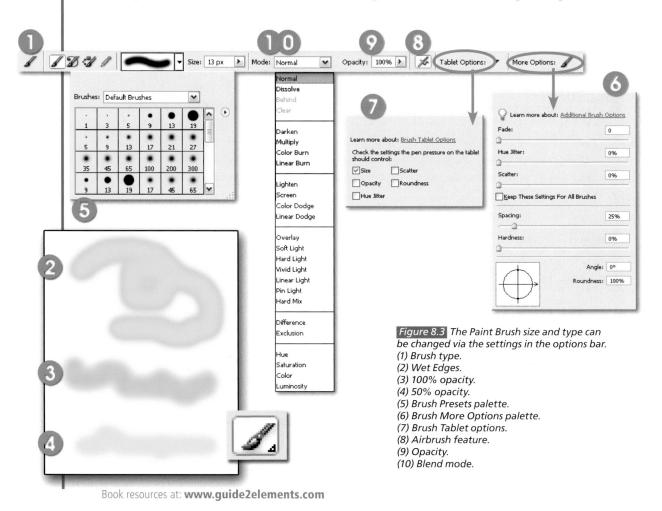

Version 1.0 users have a more limited set of brush controls accessed by clicking the thumbnail of the currently selected brush, in addition to pressing the More Options button. Completely new brushes can be added to the palette, in either version of the program, by selecting the side arrow in the Brush palette and choosing the New Brush option.

For the truly creative among us, extra custom-built brush sets are available for download and installation from websites specializing in Elements resources.

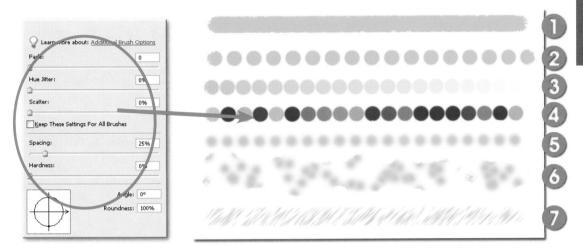

Figure 8.4 The Elements brush engine provides a range of Brush Dynamics settings that allow users to completely control the behavior and characteristics of their brushes. (1) Normal. (2) Spacing increased. (3) Fade introduced. (4) Hue Jitter increased. (5) Hardness decreased. (6) Scatter increased. (7) Angle = 45°, Roundness = 0%.

Airbrush

The Airbrush tool, located on the options bar of the Brush tool, sprays the paint color over the surface of the image. Although the size and style of the spray are determined by the selected brush (in the options bar), the edge of the area painted with this tool is a lot softer than the equivalent paint brush. Holding the mouse button down in one spot will build up the color in much the same way as paint from a spray can. See Figure 8.5.

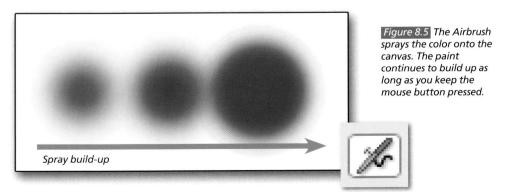

Book resources at: www.guide2elements.com

Pencil

The Pencil differs from the other tools we have looked at so far in that it paints freehand lines. The thickness of these lines is dependent on the selected brush size. By clicking and dragging the mouse, the user can create free form lines just as if you were using a pencil and a piece of paper. Using the tool in conjunction with the Shift key means that you can draw straight lines by clicking at the beginning and end points.

Don't confuse the Pencil with the line version of the Shape tool. The Pencil draws with pixels; the line tool defines a beginning and end point to a mathematical pixel-free line that is drawn only at the time that it is printed. See Figure 8.6.

In version 4.0 the Pencil tool is located as a mode selection in the Brush tool's options bar.

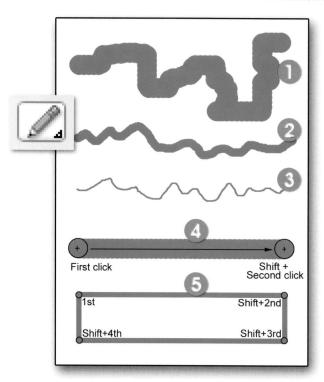

Figure 8.6 The Pencil tool draws hard-edged lines.

- (1) 70 pixel pencil.
- (2) 30 pixel pencil.
- (3) 8 pixel pencil.
- (4) To draw a straight line click to start the line and hold down the Shift key and click the mouse button a second time to mark the end of the line. (5) The shift + click technique is used to
- (5) The shift + click technique is used to draw a rectangle.

Paint Bucket

The Paint Bucket, though not usually considered a painting tool, is considered here because its main role is to apply color to areas of the image. The best way to describe how it functions is to imagine a Magic Wand tool that selected areas based on their color and then filled these selections with the foreground tint. In this way, the Paint Bucket selects and fills in a one-step action. See Figure 8.7.

Just like the Magic Wand, the Paint Bucket makes its selection based on the Tolerance value in the options bar. Higher Tolerance values mean pixels with greater difference in tone and color

will be marked for color changes by the tool. The Anti-aliased, Contiguous and Use All Layers settings also work in the same was as they do for the Magic Wand.

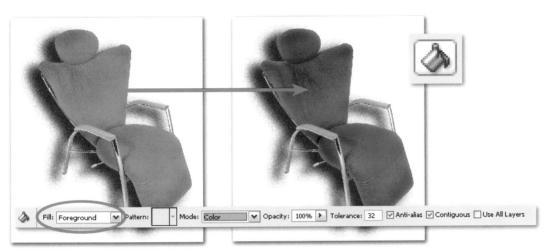

Figure 8.7 The Paint Bucket tool selects and fills an area in the image based on pixel colors.

In addition to applying color to selected areas, the Paint Bucket can also fill the area with a pattern. See Figure 8.8. Several default patterns are supplied with Elements or, if you are feeling adventurous, you can create your own using the following steps.

- 1 Select an area of an image using the Rectangular Marquee.
- 2 With the selection still active, select Define Pattern from Selection in the Edit menu.
- 3 Enter a name in the New Pattern dialog.
- 4 The new pattern is now available for use from the Pattern palette of the Paint Bucket tool.

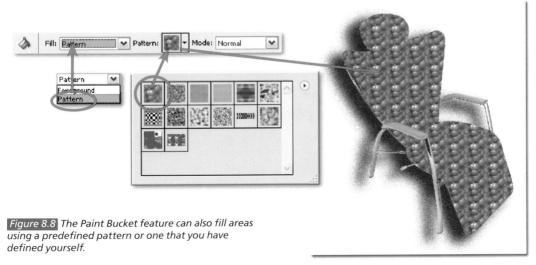

Book resources at: www.guide2elements.com

Choosing my paint colors

The color of the paint for all tools is based on the foreground color selected in the toolbox. To change this hue you can double-click the swatch and select another color from the palette or you can use the Eyedropper to sample a color already existing in your image. See Figure 8.9.

Figure 8.9 All brushes paint with the color that is selected in the foreground/background swatches. (1) Foreground color. (2) Switch colors. (3) Default colors. (4) Background color. (5) Changing color using the Color Picker. (6) Changing color using the Eyedropper to sample a new hue from a picture. With the Color Picker selected, if you move the cursor over the image, it will turn into the Eyedropper tool, allowing you to sample color directly from the image.

Painting tools summary

- 1 Pick foreground color (painting color).
- 2 Select the Painting tool from the toolbox.
- 3 Click the down arrow next to the sample brush in the options bar to select brush type.
- 4 Adjust brush opacity.
- 5 Adjust other options for a particular tool.
- 🚟 6 Drag brush over image surface to paint.

The Impressionist Brush tool

In addition to these standard painting options, Elements has a specialist Impressionist Brush tool that allows you to repaint existing images with a series of stylized strokes. By adjusting the special paint style, area, size and tolerance options, you can create a variety of painterly effects on your images. See Figure 8.10.

- 1 Pick Impressionist Brush from the toolbox (hidden under the Brush tool in Versions 5.0/4.0/3.0).
- 2 Select brush size, mode and opacity from the options bar.
- 3 Set the style, area and Tolerance values from the More Options palette.
- \mathbb{H}_{K} 4 Drag the brush over the image surface to paint.

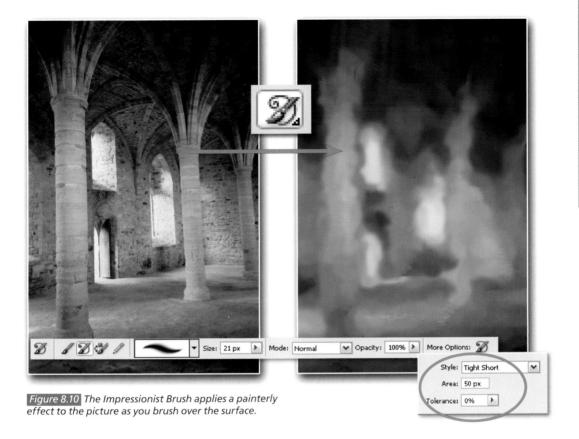

Color Replacement tool

The Color Replacement tool locates and replaces a specific color in an image with one of your choosing. In this way it works a little like a more sophisticated version of the Red Eye Removal tool in that you can choose both the color to be replaced as well as its substitute hue. See Figure 8.11.

- 1 Pick the Color Replacement tool from the toolbox (hidden under the Brush tool).
- 2 Select brush size and set mode to Hue, Sampling to Background Swatch and Limits to Discontiguous in the options bar.
- 3 Using the Eyedropper tool select the color from the picture that you want to replace as the foreground color swatch.
- 4 Switch foreground and background swatches.
- 5 Double-click on the foreground swatch and select a replacement color.
- 6 Click and drag the Color Replacement brush over the image surface to substitute the colors.

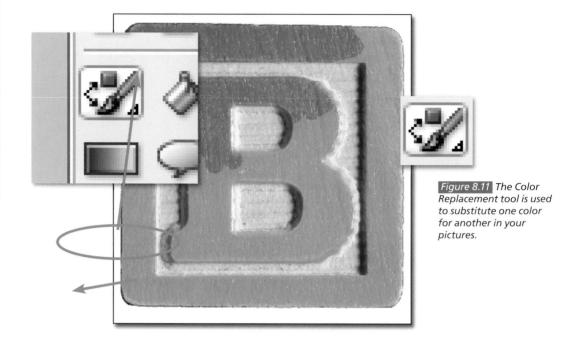

Erasing

The Eraser tool changes image pixels as it is dragged over them. If you are working on a background layer then the pixels are erased or changed to the background color. In contrast, erasing a normal layer will convert the pixels to transparent, which will let the image show through from beneath. See Figure 8.12.

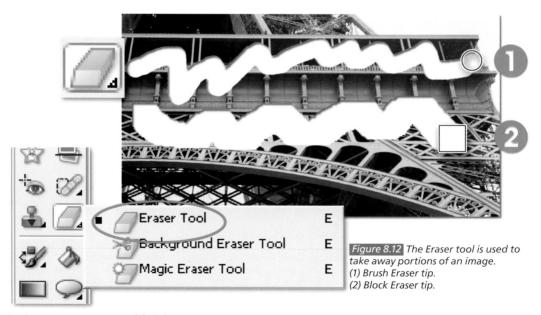

Book resources at: www.guide2elements.com

As with the other painting tools, the size and style of the eraser is based on the selected brush. But unlike the others the eraser can take the form of a paint brush, pencil or block. Setting the opacity will govern the strength of the erasing action. Apart from the straight Eraser tool, two other versions of this tool are available – the Background Eraser and the Magic Eraser. These extra options are found hidden under the eraser icon in the toolbox.

The *Background Eraser* is used to delete pixels around the edge of an object. This tool is very useful for extracting objects from their backgrounds. The tool pointer is made of two parts – a circle and a cross hair. The circle size is based on the brush diameter. To use the tool, the cross hair is positioned and dragged across the area to be erased, whilst at the same time the circle's edge overlaps the edge of the object to be kept. The success of this tool is largely based on the contrast between the edge of the object and the background. The greater the contrast, the more effective the tool. Again, a Tolerance slider is used to control how different pixels need to be in order to be erased. See Figure 8.13.

The *Magic Eraser* uses the selection features of the Magic Wand to select similarly colored pixels to erase. This tool works well if the area of the image you want to erase is all the same color and contrasts in tone or color with the rest of the image. See Figure 8.14.

- $1\ \mathrm{Pick}$ the Eraser tool type from the toolbox.
- 2 For the Eraser tool select a brush size and style and choose the form that the tool will take.
- 3 For Magic Eraser and Background Eraser set Tolerance and Contiguous values.
- 4 Drag over or click on the image to erase.

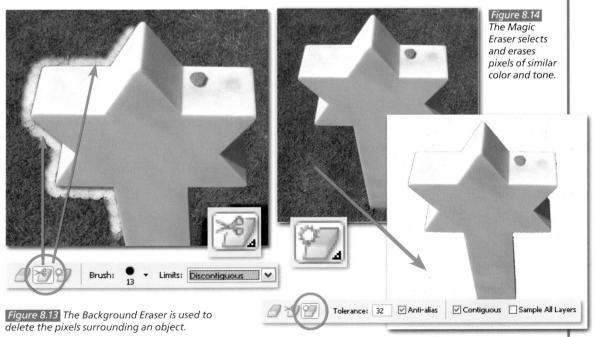

Book resources at: www.guide2elements.com

Smart erasing

As we have seen in Chapter 6, one of the great technologies introduced in the last version of Elements was the Magic Extractor feature (Image > Magic Extractor). In 5.0 the feature's selecting powers have been boosted so that your results will be more accurate than ever. The tool automatically erases some picture parts whilst retaining others. The user marks the areas in the photo that are to be retained or erased by painting over these sections with dots or scribbles of different colors. Elements then goes to work intelligently erasing and retaining parts throughout the photo. It is this intelligent erasing power that warrants the new features inclusion in this part of the text. See Figure 8.15.

Used carefully, the Magic Extractor has both the power and fine-tuning abilities to make it a regular part of your erasing tool set. For more details on how to use the feature turn to the selection section in Chapter 6.

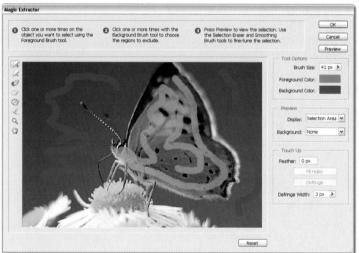

Figure 8.15 The new Magic Extractor feature acts as an intelligent Eraser tool by allowing the user to mark (scribble or dot) picture parts to be retained (foreground) and areas to be erased (background).

Better with a tablet

Many professionals prefer to work with a stylus and tablet when working with complex drawing tasks. The extra options provided by the pressure sensitivity of the stylus, along with the familiar 'pencil and paper' feeling, make using this approach more intuitive and often faster than using a mouse. When a stylus and tablet are installed on your machine you will be able to access the extra pen or stylus options available through the program. See Figure 8.16.

Figure 8.16 Elements contains support for pressure-sensitive devices such as Wacom Stylus and Tablets. Elements enables the user to link specific settings to the pressure setting of the stylus.

Painting tools in action Hand coloring black and white photos

In this technique, we will use the Elements Brush tool to apply a color tint to a photograph. But to ensure that the detail from the image shows through the coloring we must modify the way the hue is added. By switching the Brush mode (this is similar to the Layers blend mode options) from its Normal setting to a specialized Color setting the paint starts to act more like traditional water-color paint. When the hue is applied the detail is changed in proportion to the tone beneath. Dark areas are changed to a deep version of the selected color and lighter areas are delicately tinted. See Figure 8.17.

- 1 With your image open in Elements check to see what Color mode the picture is stored in. Do this by selecting Image > Mode and then locate which setting the tick is next to. For most black and white photographs the picture will be in Grayscale mode. If this is the case change it to RGB Color (Image > Mode > RGB Color).
- 2 You will not notice any difference in the picture as a result of its mode change but now the image is capable of holding colors (not just grays). Now double-click on the foreground swatch in the toolbox and select a color appropriate for your picture. Here I chose a dark green for the leaves.
- 3 Now select the Paint Brush tool from the toolbox and adjust its size and edge softness using the settings in the options bar. Start to paint onto the surface of the picture. You will notice straight away that the paint is covering the detail of the picture beneath. This is because the brush is still in Normal mode. Use Ctrl + Z to undo your painting.
- 4 In order for the brush to just color the picture (keeping the details from beneath) the tool must be in the Color mode. To make the change click on the Mode drop-down menu in the options bar and select the Color option towards the bottom of the list.

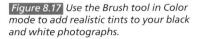

Book resources at: www.guide2elements.com

- 5 With the Color mode now selected start to apply the color again. Immediately you will notice the difference. The brush is now substituting the color for the gray tones in the picture and it is doing so proportionately: dark gray = dark green, light gray = light green.
- 6 Once the leaves and stems have been colored, select new colors for the flowers and finally the bucket. The amount and areas of the picture that you choose to color is up to you. Some photographs look great with only one colored section and the rest black and white.

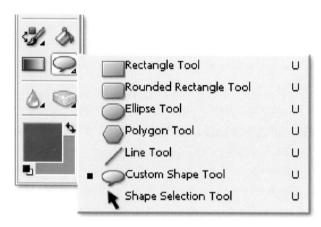

Figure 8.18 Only one Shape tool is shown in the toolbox, but others can be viewed by clicking and holding the mouse over the small triangle in the bottom right corner of the button.

Drawing tools

With the Shape tool it is possible to draw lines, rectangles, polygons and ellipses, as well as creating your own custom shapes. After selecting the tool and picking the fill color, you can draw the shape by clicking and dragging the mouse. Although only one Shape tool is visible in the toolbox at any time, you can select a different option by clicking and holding the mouse button down over the tool icon and then selecting the new tool from the list as it appears. See Figures 8.18 and 8.19.

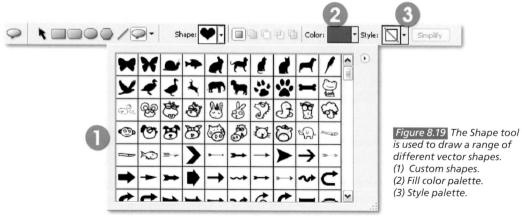

A new shape layer is opened automatically when you select a tool and draw a new shape. Double-clicking the shape thumbnail in the Layers palette allows you to change the color. See Figure 8.20.

When you create multiple shapes on a single layer you have the opportunity to decide how overlapping areas interact. Two or more different shapes can be added to form a third and the intersection of shapes can be added or subtracted from the image. At first the Shape tool can seem a little confusing, but with practice you will be able to build up complex images by gradually adding and subtracting shapes. See Figure 8.21.

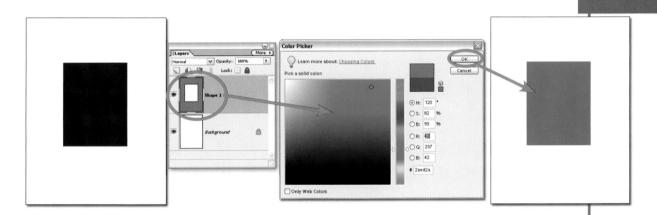

Figure 8.20 The fill color of a shape can be changed by double-clicking the shape in the shape's layer or the color icon (earlier versions of Elements).

- 1 Pick the Shape tool you require from the toolbox. Click and hold down the mouse button to reveal hidden options.
- 2 For a new shape pick the Create New Shape Layer option. For adding to an existing shape layer, select the layer and select the Shape Area option that suits your needs. You can pick from Add, Subtract, Intersect and Exclude.
- 3 Click on the color swatch to specify the fill color for the shape.
- 4 Click and drag on the image surface to draw the shape.

Even more shapes

Elements comes supplied with a vast range of shapes. New shape sets can be added to those already visible as thumbnails by clicking the side-arrow button in the Custom Shape Picker palette. If you can't find a favorite here then why not try some of the extra shape sets that can be downloaded from specialist Elements resources websites?

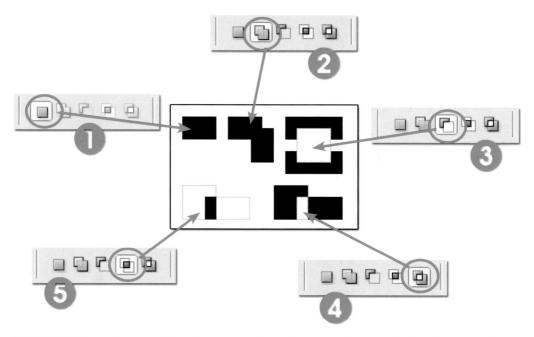

Figure 8.21 The way that successively drawn custom shapes interact can be customized via buttons on the options bar. (1) Single new shape. (2) Add shape to existing shape. (3) Subtract shape from existing shapes. (4) Subtract overlapping areas of existing shapes. (5) Use the intersection of the areas as a new shape.

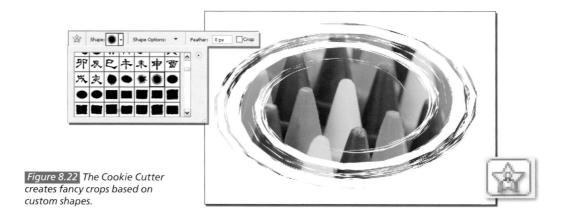

Cookie Cutter tool

The Cookie Cutter tool is a two-step feature that crops your pictures in the shape of one of many 'cookie' designs that Elements is shipped with. The feature is a great way to add interesting edge effects to your pictures. See Figure 8.22.

- 1 Open an image to crop and select the Cookie Cutter tool from the toolbox.
- 2 Click the Shape button in the options bar to reveal the pop-up menu of cookie shapes. Select the shape to use.

- 3 To soften the edge of the cookie cutter crop, add a Feather value in the options bar before you drag the shape.
- 4 Click and drag the tool over the surface of the picture. Let the mouse button go and click and drag the edge handles to adjust the size of the cookie shape to suit the picture.
- 5 Double-click inside the cookie shape or click the tick icon in the options bar to crop.

Shapes and graphics in the new Artwork and Effects palette

As we have already seen, a new feature in version 5.0 is the Artwork and Effects palette (Window > Artwork and Effects). This is a central location for storing of layer styles, frames, backgrounds, themes and filters options and is a key place to look for small picture elements to add to compositions when you are creating Photo Layouts.

In addition, you will also find a variety of shapes and graphics stored in the palette. Both groups of picture elements are vector based (resolution independent) and so can be scaled, rotated, twisted and distorted to fit your compositions with no loss in quality. Unlike the custom shape tool though, you do not need to draw the shape onto the canvas surface: simply click on the thumbnail of your choice and then press Apply at the bottom of the palette. See Figure 8.23.

Elements automatically creates a new layer and places the picture element on the canvas. From this point you can rotate, size and distort the shape/graphic using the handles situated on its edges. Apply the changes by clicking the green tick or Commit button that appears at the bottom edge.

More > Artwork and Effects **Artwork** Graphics Show All Backgrounds ٨ Cake 01 Frames Graphics Shapes Cake 02 Candle 01 Candle 02 Candle 03 Candle 04 Gift 01 V W Apply

Figure 8.23 You can also draw shapes and add graphics to your Photo Layouts by dragging them from the Artwork section of the Artwork and Effects palette.

To scale proportionately – Click and drag a corner handle.

To squish or stretch non-proportionately – Click and drag a side handle.

To scale or squish from the center – Hold down the Alt key whilst dragging a handle.

To rotate – Click and drag the rotate handle located in the middle of the bottom edge of the graphic/shape. Alternatively move the mouse cursor outside the edges of the graphic and then click-drag to rotate.

To distort or twist – Ctrl-click side or corner handles to distort or change perspective.

Shapes added to the document from the Artwork and Effects palette are stored in a standard Shape layer whereas Graphics are stored in a new Smart Object layer. The Smart Object layer is similar to a Frame layer in that it is resolution independent and must be simplified before you can edit it directly. Simplifying the layer looses its ability to be scaled and distorted non-destructively.

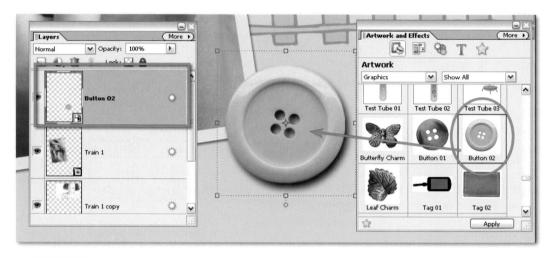

Figure 8.24 Click-drag graphics and shapes from the Artwork and Effects palette to an open document before repositioning, sizing, and adding layer styles.

Adding shapes or graphics from the new Artwork and Effects palette is an easy task. Follow the steps below to place, size and position one of these picture elements. See Figure 8.24.

- 1 Display the Artwork and Effects palette (Window > Artwork and Effects) and then select the Artwork button (little sun and frame icon on the left).
- 2 Select the Graphics or Shapes option from the drop-down menu on the left and then a subcategory from the drop-down menu on the right.
- 3 With the thumbnails displayed, either click and drag the shape/graphic from the palette onto the open document or select the thumbnail and press the Apply button at the bottom of the palette.
- 4 To move the shape/graphic around the canvas, move the mouse cursor onto the picture element and click and drag to a new position.
- 5 To resize, click and drag a corner or side handle. To pivot, click and drag the rotate handle.

Photo Layouts Four steps to Photo Layout creation

Editing existing Photo Layout designs Adding, removing and replacing photos Adding, moving and deleting pages The Artwork and Effects palette

he Photo Layout feature is brand new to Elements 5.0 but owes it's heritage, at least in part, to the album page creation wizards of previous versions of the program. The new feature combines the template-like production of the older feature with:

- the ability to auto place and size a series of selected photos,
- a new layer type (Frame layer) that can store, and provide edit options, for both an image and its frame.
- a new multi-page document format called the Photo Creation or .PSE document,
- the option to apply frames, backgrounds and whole themes (a combination of frames and backgrounds) to Photo Layout projects (see Figure 9.1),
- a series of new or revamped Photo Creation wizards (see Figure 9.2), and
- the ability to add text, graphics, shapes and special effects to the project from those listed in the Artwork and Effects palette.

Photo Layouts are a real bonus for all those users who regularly want to produce either a single page (or print) or a series of pages containing multiple photos. The scrapbooking fraternity will certainly find plenty to love as the feature provides more ease of use, flexibility and customization than was previously available, but if you are not a devotee of this infectious hobby do not avoid creating a few Photo Layouts. Far from being a simple scrapbooking feature, it is a new and exciting way for photographers to arrange and present their work.

In this chapter we will take a closer look at Photo Layouts, work step-by-step through the creation of an initial multi-page document and then look at how to customize an existing design.

Figure 9.1 The new Photo Layout feature in Photoshop Elements 5.0 can be used to quickly create a series of photo album pages using photos selected in the Organizer workspace. A variety of layout designs are shipped with the program, with other variations promised as downloads in the future.

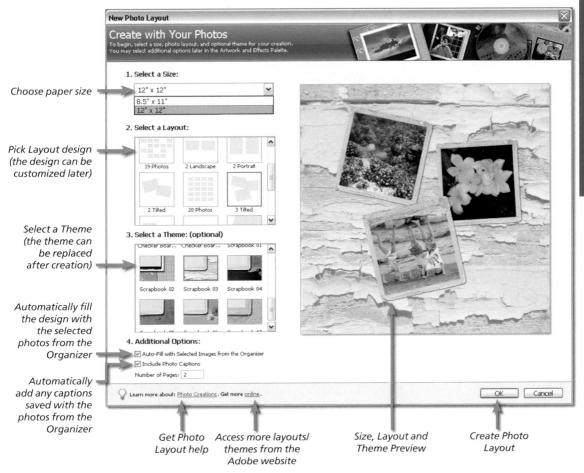

Figure 9.2 The New Photo Layout dialog groups together the options that govern the way that your multipage photo layout document is created. The documents created with this process are editable later inside the Standard Editor workspace where extra images, text, graphics, effects and pages can be added or removed.

Edit pictures before adding to a Photo Layout

The production of Photo Layouts, or any of the other Photo Creation projects in Photoshop Elements, is essentially a presentation exercise for photos that have already been enhanced. For this reason it is a good idea to complete any preliminary editing work such as color and tonal correction, spotting and retouching changes and the application of sharpening before including the picture in a new photo layout.

This is especially true when working with the special framed picture elements of a Photo Layout, as these visual components are stored in a special Frame layer which has to be simplified before it can be edited. The act of simplification, which is also called rasterization, converts the Frame layer to a standard image layer and in the process removes the layer's ability to scale, rotate and distort repeatedly without image quality loss.

Four steps to Photo Layout creation

Using the new Photo Layout feature, one of the new Photo Creation options in Elements 5.0, is a simple four-step process with the Creation options centered around the New Photo Layout dialog.

Select the images to include
The process of creating a Photo Layout, one of the new Photo Creation options, will generally start in the Organizer workspace. Here you can multi-select the photos that will be used in the layout. To choose a series of images click on the first thumbnail and then hold down the Shift key and click the last picture in the series. To pick non-sequential photos, select the first one and then hold down the Control key whilst clicking on other thumbnails to be included in the selection.
With the images highlighted, the next step is to choose > Create > Photo Layout from the File menu.

Alternative starting options

Using an Elements' Collection as a starting point you can alter the order or sequence in which the photos appear in the multi-page document. After rearranging the position of photos in the collection multi-select those to be included in the layout. Alternatively a blank document can be created by selecting the File > Create > Photo Layout option in either the Editor or Organizer spaces. Photos can then be dragged into the blank document from the Photo Bin area of the Editor.

Book resources at: www.quide2elements.com

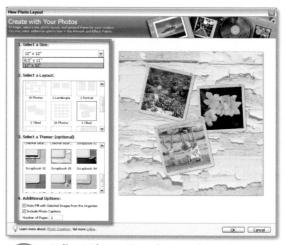

Adjust Photo Creation options
After selecting to create a multi-page document, Elements displays the New Photo Layout dialog. The window contains a preview area and four sections for adjusting the characteristics of the document.

At the top you can select the **Size** of the photo layout from those contained in the drop-down list. Next the Layout design is chosen. This option controls the number and general position of the pictures on the document pages. The Theme options provide the chance to refine the way that the layout looks. Here you can choose background and frame treatments. The last section provides the **Additional Options** of auto filling the pages created with selected photos, adding caption details and altering the total number of pages created. The choices you make will change the example preview to the right of the dialog. Extra pages and images can be added or removed after the Photo Layout has been created from inside the Standard editor. The frames, backgrounds and themes can also be changed by applying an alternative design from those listed in the Artwork and Effects palette.

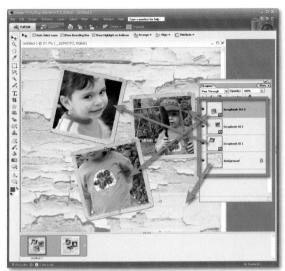

Create Photo Layout

Once the Photo Layout or other Photo Creation's characteristics are set then clicking the OK button at the bottom of the dialog will instruct Elements to create the multi-page document. This process can take a little while as the program creates the pages and then sources, sizes and inserts the pictures into the new Photo Layout.

Each photo is stored on a separate Frame layer which is indicated by a small plus icon in the bottom right of the layer's thumbnail.

Frame layers are unlike other image layers in that they contain both the photo as well as its surrounding frame. These picture parts are stored separately and remain editable even though they appear as a

single layer. When the creation process is finished you can flip between pages by clicking on the next (or previous) page in the Photo Bin.

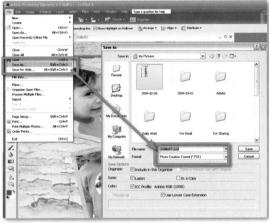

Save Photo Layout

Unlike the album pages in earlier versions of Elements, Photo Layouts and the other Photo Creations, and their contents, remain editable after they have been saved and reopened. To enable this new ability Adobe created a completely new file format for the multi-page editable documents. Called the Photo Creation Format it has an extension of .PSE as opposed to the .PSD that is associated with standard Photoshop and Photoshop Elements documents.

When saving a newly created Photo Layout the file format in the Save dialog automatically changes to .PSE. By default the Include in the Organizer option is also selected ensuring that the new document is cataloged and displayed in the Organizer space. A small

multi-page icon is displayed at the top right of the thumbnail of each Photo Layout document.

Editing existing Photo Layout designs

As we have seen, the Photo Layout feature can create a multi-page document complete with photos in frames on a background. In producing this design Elements will make decisions about the size and position of the frames and the pictures within them. On many occasions you will probably want to use the pages the feature produces with no alterations, but there will be times when you will want to tweak the results. At these times use the following techniques to edit the automatically produced designs.

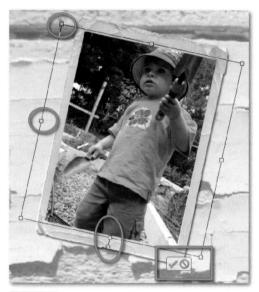

Figure 9.3 The frame and its contents can be edited using either the handles on the edge or options in the right-click menu.

Figure 9.4 Right-clicking the picture when the frame is selected produces the menu above.

Adjusting the Frame and Picture

To move the picture and frame combination to a new position on the canvas just click and drag the combination. The size and orientation of the Frame/Picture can be altered by clicking on the picture and frame first, to select it, and then using the corner, edge and rotate handles to scale or pivot. Click on the Commit button (green tick) at the bottom of the selected picture to apply the changes. To disregard the changes click the Cancel button (red circle with diagonal line through it) instead. See Figure 9.3.

Other adjustment options are available via the right-click menu when the Move tool is selected. See Figure 9.4. Selections in this menu allow you to:

Rotate 90° Right or Left – Pivot the frame and picture by a set amount.

Position Photo in Frame – Switch to Picture Select mode to allow scaling, rotating and moving the photo within the frame.

Fit Frame to Photo – Automatically adjust the frame size to accommodate the dimensions and format of the place photo. Use this option if you don't want to crop the photo with the edges of the frame.

Replace Photo – Displays a file dialog where you can select a new photo for the frame.

Clear Photo – Removes the photo but keeps the frame.

Clear Frame – Removes the frame but keeps the photo.

Bring to Front/Bring Forward – Moves the frame and photo up the layer stack. **Send to Back/Send Backward** – Moves the frame and photo down the layer stack. **Edit Text** – Switches text layers to the Edit mode.

Adjusting the Picture

As well as being able to alter the characteristics of the frame by selecting the photo you can perform similar changes to the picture itself. Double-clicking or choosing the Position Photo in Frame option from the right-click menu selects the photo and displays a marquee around the picture. A small control panel is also displayed at the top of the marquee. See Figure 9.5.

To move the position of the photo in the frame simply click and drag on the image, releasing the mouse button when the picture is correctly placed.

You can alter the size of the photo within the frame by moving the Scale slider (in the control panel) or by dragging one of the handles of the marquee. Moving a corner handle will scale the photo proportionately, whereas dragging a side handle will squish or stretch the image.

The picture can be rotated in 90 degree increments (to the left) by clicking the Rotate button in the control panel. Alternatively, you can rotate the image to any angle using the rotate handle (middle of the bottom edge of the marquee) or by click-dragging the cursor outside the boundaries of the marquee.

The photo can be replaced with a new picture by clicking the Replace button in the control panel and then selecting the new picture from the file dialog that is displayed.

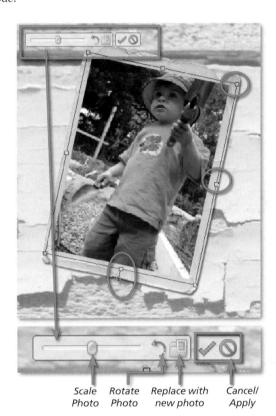

Figure 9.5 The picture inside the frame can be scaled and rotated independent of the frame by firstly double-clicking the photo (to select the picture without the frame) and then click-dragging the side, corner or rotate handles. Alternatively you can scale, rotate 90° left, replace the current picture with a new one and apply or cancel the changes with the buttons in the new pop-up control that appears at the top of the picture border.

Figure 9.6 Right-clicking a selected picture will also display a range of adjustment options.

Book resources at: www.guide2elements.com

Extra image adjustment options are available from the right-click menu. See Figure 9.6 on page 239. These include the ability to switch the default action of dragging a marquee handle from scaling, as it is in the Free Transform mode, to alternatives such as Skew or Distort. To return to the default action choose Free Transform from the right-click menu. The actions available are:

Free Transform – The default mode where dragging the corner of the marquee scales proportionately and dragging the edges squashes or stretches the picture. The following keys alter the action of dragging a handle when in this mode:

- **Shift + corner handle** to scale proportionately,
- Ctrl + any handle to distort the picture,
- Ctrl + Shift + middle edge handle to skew the picture, and
- Ctrl + Alt + Shift + corner handle to apply perspective.

Scale – Resizes in the same manner as the Free Transform mode.

Free Rotate Layer – Rotates the image when click-dragging outside of the marquee.

Skew – Skews the photo when dragging an edge handle.

Distort – Distorts the picture when moving any handle.

Perspective – Applies a perspective effects when dragging a corner handle.

Adding, removing and replacing photos

Photo Layouts do not become static documents once they are created. In the previous section we saw how it is possible to adjust the size, position and orientation of both the photo and frames that were added during the initial creation process, but the feature's flexibility doesn't end there. You can also add new photos, replace existing pictures with alternative choices and even remove images that you no longer want to keep. Here's how.

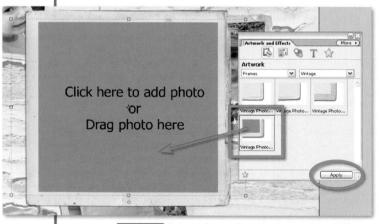

Figure 9.7 Select a frame from the Artwork and Effects palette and then click Apply to add to the page.

Adding new photos

All editing of Photo Creations occurs in the Full Editor workspace. So to add new photos to an existing layout you need to add a new blank frame to the composition. Do this by clicking on the selected frame in the Artwork section of the Artwork and Effects palette and pressing the Apply button. See Figure 9.7. A new frame will be created on the current page of the document.

To add a photo to the frame, click-drag one from the Photo Bin to the frame or click the

Figure 9.8 Click-drag a new photo to the blank frame.

text in the empty frame and select a photo from the file browser that opens. Using this approach you can add a photo without it first having to be open in the Photo Bin. When moving the photo make sure that the frame is highlighted with a blue rectangle before releasing the mouse button to insert the picture. See Figure 9.8.

The last part of the process is to fine-tune the picture by adjusting size, orientation and position within the frame. Use the techniques in the previous section to make these alterations.

Replacing existing photos

It is just as easy to replace existing photos with different images whilst still retaining the frame. Select the frame first and then click-drag a picture from the Photo Bin to the frame. This action swaps the two pictures but you will need to have the replacement image already open in the Full Editor workspace beforehand. If this isn't the case, then an alternative is to select the Replace Photo entry from the right-click menu and choose a new picture via the file dialog that is displayed. See Figure 9.9.

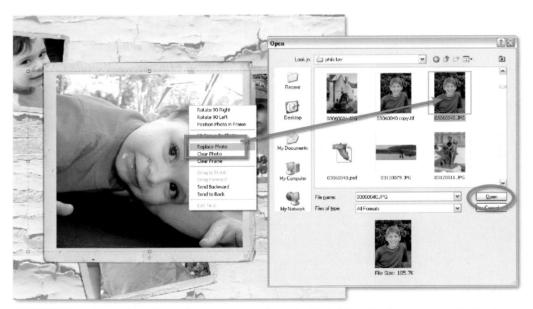

Figure 9.9 To replace a photo either drag a new image from the Photo Bin to the frame or select the Replace Photo option from the right-click menu.

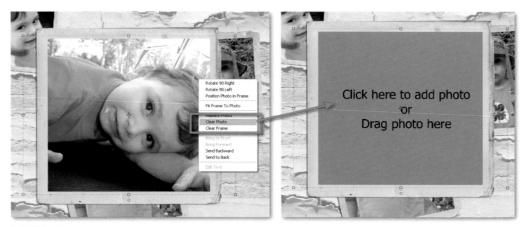

Figure 9.10 To remove a picture but leave the frame in place select the Clear Photo option from the right-click menu. To remove both frame and photo select the frame, press the Delete key and then answer Yes to the Delete Selected Layers warning.

Removing photos

Pictures inserted into frames can be removed whilst still retaining the frame by selecting the Clear Photo option from the right-click menu. The frame will then revert back to a blank state providing the opportunity to add a new image to the composition. See Figure 9.10.

If you want to remove both the frame and the photo it contains then select the frame first and click the Delete key. A warning window will display asking you if you want to delete Selected Layers. Answer Yes to remove the frame and picture from the composition.

Adding, moving and deleting pages

If you selected the Auto Fill option when first creating your Photo Layout then Elements will have generated enough pages to insert the photos that were initially included. If you want to add images, some text or graphics later on then you will need to add some extra pages. The new Photo Creation file format (.PSE) was developed especially to handle multi-page documents and to ensure that tasks such as adding, deleting and moving pages was as easy as possible.

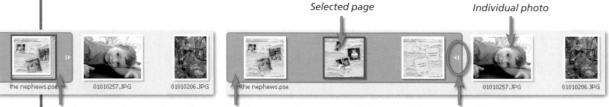

PSE document shown collapsed

PSE document shown expanded

Collapse/Expand button

Figure 9.11 Multi-page Photo Creation (.PSE) documents are displayed in the Photo Bin with a shaded background. The document can be expanded or collapsed via the sideways arrow button on the right of the last thumbnail on the right.

All page management activities are centered around the PSE document in the Photo Bin. The document can be displayed collapsed, where all the pages are grouped together on top of each other, or expanded, where each of the thumbnails representing a single page can be viewed separately. See Figure 9.11.

Adding pages

All new pages in a PSE document are added after the current selected page. So start by expanding the multi-page document in the Photo Bin and then selecting the thumbnail of the page before the position where the new page is to be created.

In Elements you have two options for creating new pages:

Add Blank Page – Use this option to add a white page with no frames, backgrounds or themes present. Once the page is created then text, graphics, shapes, frames, backgrounds and special effects can be added from the Artwork and Effects palette.

Add Page Using Current Layout – This feature duplicates the layout settings of the selected page when creating the new one. Use this option to add new pages to a group of pages that already contain a background and frames as it will help to keep the look of the whole document consistent.

To add a new page choose either the Add Blank Page or Add Page Using Current Layout option from the Edit menu. The new page is then added to the document and a new thumbnail is displayed in the Photo Bin to the right of the selected page. These Add Page options are also available from the right-click menu when your select a page in the Photo Bin. See Figure 9.12.

Moving pages

The position of pages (from left to right) in the Expanded view of a multi-page document in the Photo Bin indicates the page's location in the production. The first page in the document is the

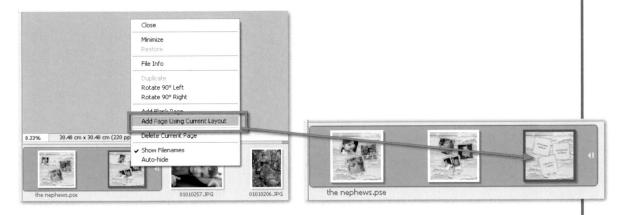

Figure 9.12 Pages are added to a PSE document by selecting the page before the new entry in the Photo Bin and then choosing the Add Page option either from the Edit menu or the right-click menu.

one position furtherest to the left, the second page is the next one along to the right and so on. Changing the position of the page thumbnail in the Photo Bin preview alters the page's actual position in the document. Moving pages is a simple task, just click on the page to move and drag it to a new location in the document, release the mouse button and the page is relocated. See Figure 9.13.

Figure 9.13 To relocate a page in a PSE document select the page (1) in the Expanded view in the Photo Bin and click-drag it to a new location (2). Releasing the mouse button will insert the page in the new location (3).

Deleting pages

Pages, and the frames and photos they contain, can be deleted from a multi-page document by selecting the page thumbnail in the Photo Bin and then choosing Edit > Delete Current Page. Alternatively, the Delete Current Page entry can also be selected from the right-click menu. See Figure 9.14.

Viewing pages

Navigate between the different pages of your PSE document by selecting the thumbnail of the page that you want to display from the Photo Bin. Alternatively you can move from one page to the next using the Forward and Back buttons located at the bottom of the document window. See Figure 9.15.

Figure 9.14 Delete pages and their contents by right-clicking the page thumbnail in the Photo bin and then selecting Delete Current Page from the menu.

Figure 9.15 Navigate to different pages by clicking the Forward and Back buttons at the bottom of the document window or selecting a different page thumbnail in the Photo Bin.

The Artwork and Effects palette

The Artwork and Effects palette replaces the Style and Effects palette of version 4.0 and is the central place for the storage of a variety of design components that can be used to enhance the look of your Photo Layout compositions. Once a multi-page document is created it is the various components that are housed in this palette that can be used to add to or alter the look and feel of your design The palette contains five separate sections which are accessed via the buttons at the top of the palette frame. See Figure 9.16.

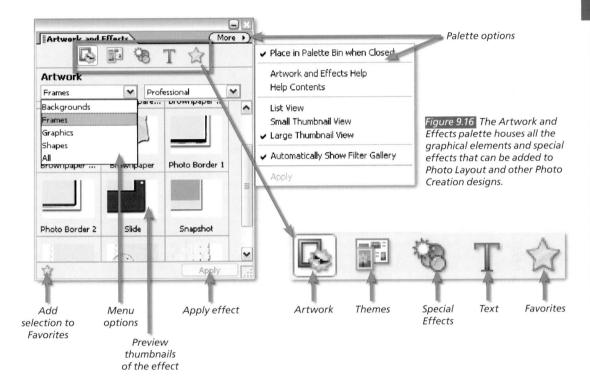

The **Artwork** section contains backgrounds, frames, graphics and shapes. The **Themes** area houses prebuilt and fully styled layout designs for a variety of projects including scrapbook pages, CD/DVD jackets and greetings cards. Many of the frame and theme options featured in these sections are also available in the Photo creations dialogs. The **Special Effects** group includes filters, layer styles, and photo effects. The **Text** section contains a variety of one-click text effects that can be added quickly and easily to type. The **Favorites** group holds user selected favorites chosen from the other areas. See Figure 9.17.

To add a theme, frame, background or any other entry from the palette select the entry and then click the Add to Favorites button. To apply a style, effect or add artwork to a document select the palette entry and click the Apply button. Extra palette options and preferences are available via the More button at the top of the palette.

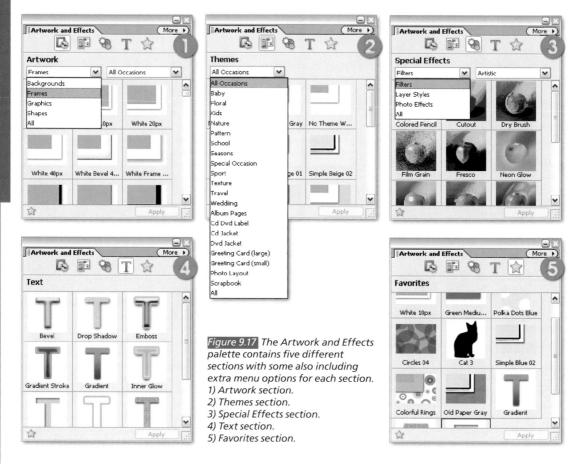

Artwork and Effects > Artwork

The Artwork section of the Artwork and Effects palette contains backgrounds, picture frames, graphics and shapes that can be added to your layouts. Backgrounds, graphics and shapes all create their own layers when added. Frames, on the other hand, are applied to existing layers. To add a piece of artwork click on the thumbnail in the palette and the press the Apply button. To add a picture to a Frame drag the image from another open document to the frame.

All artwork except Backgrounds can be scaled and rotated via the corner, middle edge and rotate handles. Click the image layer to activate the handles.

Artwork and Effects > Themes

The Themes section lists a variety of predesigned backgrounds and matched frame sets that can be applied to your Elements' document. A document can only have one theme at a time so trying to apply a second theme will replace the existing background and frames. See Figure 9.18.

Themes are a great place to start when you want to provide a consistent look and feel to your album or scrapbook pages. Commencing you project with themes doesn't mean that you can't add other frames, graphics, shapes or text later. Just choose and apply the Frame from the Artwork and Effects palette as you would normally.

You can also change the theme's background by picking and applying a new background. Different frame styles can be substituted by dragging the new style over the existing frame and letting go when the layer border turns blue.

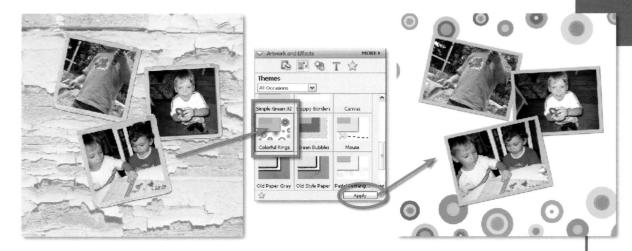

Figure 9.18 Themes are design sets that contain match frames and backgrounds. You can apply a theme to a document by selecting the theme thumbnail in the Artwork and Effects palette and then clicking the Apply button at the bottom of the palette.

Artwork and Effects > Special Effects

The Special Effects section of the Artwork and Special Effects palette groups together filters, layer styles and photo effects.

The Filters group contains many of the options that are listed under the Filter menu. To apply a filter select the layer to change, then the thumbnail in the palette and click Apply.

Layers styles add effects such as drop shadows, outer glows and strokes to selected layers. These can be applied to text, image and shape layers, and the characteristics of the styles can be customized via the Layer > Layer Style > Style Settings dialog.

Photo Effects alter your photos via a series of automatic editing steps. Options include Convert to Black and White, Create a Photo Frame and Add Soft Focus. Some Photo Effects are applied to standard image layers, others only work with background layers. After selecting the effect to apply, a pop-up dialog will indicate if you are working with the wrong layer type. To correct, simply convert image layers to background, or vica versa, and apply the effect again.

Artwork and Effects > Text

The Text section contains a variety of text effects that you can apply to the type in your Elements documents. The effects include bevels, drop shadows, glows and gradients, and only work with text layers. To apply a text effect select the text layer in the Layers palette first, then the thumbnail of the effect that you want to apply before finally clicking the Apply button. In addition you can also click Apply to create a new type layer. Like Layer Styles the attributes of the text effects (size of drop shadow, color of stroke etc.) can be adjusted via the Layer > Layer Style > Style Settings. See Figure 9.19.

Text effects can be removed by selecting the Layer > Layer Style > Clear Layer Style entry.

Figure 9.19 The attributes of the text effects or Layer Styles can be adjusted using the Style Settings dialog which is displayed by double-clicking the star icon in the layer or by selecting Layer > Layer Style > Style Setting

Artwork and Effects > Favorites

The Favorites section of the Artwork and Special Effects palette lists all the artwork, effects, themes and styles that you have nominated as favorites.

This area is a great place to store the Artwork and Effects entries that you use time and time again. For instance when you find a layer style or filter that you particularly like then, rather than have to search for it each time you want to use it, simply click the Add Favorites star at the bottom of the palette to store the style in the Favorites area.

Remove items from the Favorites by right-clicking on the thumbnail of the Favorites entry and selecting Remove from Favorites entry in the pop-up menu.

Creating Great Panoramas

Taking Photomerge images

Editing your panorama

Photomerge from the Photo Browser

Photomerge in action

Fixing panorama problems

Top tips from panoramic professionals

anoramic images have always been a very inspiring aspect of photography. Until now, making these types of pictures has been restricted to a small set of lucky individuals who are fortunate enough to own the specialized cameras needed to capture the wide images. With the onset of the latest image-editing packages, software manufacturers have now started to include features that allow users with standard cameras to create wonderful wideangle vistas digitally. See Figure 10.1.

These extra pieces of software are sometimes referred to as 'stitching programs', as their actual function is to combine a series of photographs into a single picture. The edge details of each successive image are matched and blended so that the join is not detectable. See Figure 10.2.

Once all the photographs have been combined, the result is a picture that shows a scene of any angle of anything up to a full 360° . See Figure 10.3.

Figure 10.2 The panorama is made by stitching sequentially shot images together.

Figure 10.1 Many digital editing packages like Elements now include stitching packages that allow you to make dramatic panoramas from standard camera images.

Photomerge (Editor: File > New > Photomerge Panorama) is included free within Elements and is Adobe's version of the stitching technology. The feature has undergone a variety of enhancements over the last few releases so that now Photomerge includes enhanced support for larger file sizes, better fine-tuning controls, improved edge-matching capabilities and the option to produce the final composition as separate source picture layers.

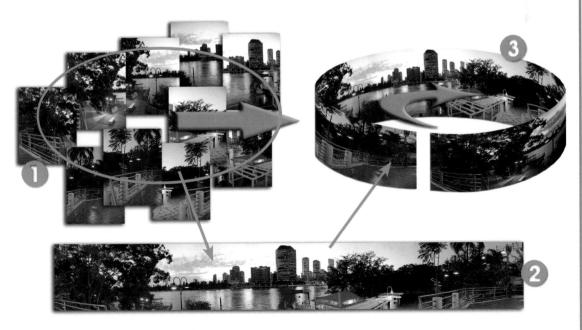

Figure 10.3 The stitched result can be made up of many individual images and can encompass a view up to a full 360°. (1) Individual source photos. (2) Stitched panorama. (3) 360° spinning panorama.

Taking Photomerge images

Although the Photomerge feature is designed to simplify and solve many of the problems associated with image stitching, a great deal of your own success will be based on how your source images are taken in the first place. A little care and planning at the shooting stage can ensure a successful panorama with little or no 'touch-up' work later. Use the following guidelines to help capture those vistas.

Image overlap

Photomerge works by identifying common edge elements in sequential images and using these as a basis for blending the two pictures together. When you are making your source photographs, ensure that they overlap by a minimum of 15% and a maximum of 30%. See Figure 10.4.

These settings give the program enough information to ensure accurate stitching. I find that if I locate a feature about one-third of the way in from the right-hand side of the viewfinder (or display screen) in one shot and then position the same detail one-third from the left in the next shot, I end up with sufficient overlap for Elements to process the picture. Overlapping images by more than 50% may seem like a good idea, but this can cause the image blending process to be less effective.

Figure 10.4 It is important to overlap source images by between 15% and 30%. (1) Overlap between successive photographs.

Keep the camera level

Although Photomerge is designed to adjust images that are slightly rotated, it is far better to ensure that all source images are level to start with. The easiest way to achieve this is by photographing your scene with your camera connected to a level tripod with a rotating head. If you are out shooting and don't have a tripod handy, try to locate a feature in the scene that remains horizontal in all shots and use this as a guide to keep your camera level when photographing your image sequence. See Figure 10.5.

Maintain focal length

Sometimes it is tempting to zoom in to capture a closer view of important details when you are in the middle of shooting a panorama sequence. Doing so will change the focal length of the lens and will make it very difficult or impossible to stitch this picture with all the others from the scene. Check what is the optimum focal length for the vista before starting to photograph and once you start to shoot don't touch the Zoom control. See Figure 10.6.

Pivot around the lens

Photomerge uses sophisticated perspective calculations to help reconstruct the scene you photographed. Changing your position, even by a few inches, will alter the perspective of all the images taken from that point on. Even the way that you hold and rotate the camera can alter the picture's vanishing point. To get the best results always try to pivot the camera around the axis (nodal point) of its lens; this will ensure that all the images in your sequence will have a similar perspective.

Special panoramic heads designed to position the lens above the center of the tripod are available for this purpose. These virtual reality (VR) heads offset the camera so the nodal point of the lens is directly over the pivot point of the camera. Models are available for specific cameras or you can purchase a multi-purpose design that can be adjusted to suit a range of film and digital bodies. Shooting with these heads is by far the best way to ensure that your images stitch well. See Figure 10.7. If you are capturing your scene with a hand-held camera, then try to rotate your body around the camera, not the other way around. See Figure 10.8.

Figure 10.5 Keep the camera level when shooting your scene.

Figure 10.6 Don't change focal length in the middle of a shooting sequence.

Figure 10.7 A panoramic head for tripods is available for users who regularly shoot wide vistas. (Source: Kaidan and Manfrotto panoramic tripod heads.)

Book resources at: www.quide2elements.com

Figure 10.8 If no tripod is available, pivot the camera around its lens, not around your body.

Maintain exposure

Modern cameras contain specialized metering systems designed to obtain the best exposure for a range of lighting conditions. Each time the camera is aimed at a scene, a new calculation is made for the brightest and darkest areas of the view. This system, though very helpful for normal picture taking, can be problematic when shooting panoramas, as the exposure needs to be constant throughout the shooting sequence.

Figure 10.9 Change the exposure system to manual to keep images consistent.

Changing the exposure settings automatically for different image parts of the same scene will mean that key areas will appear as different tones in the stitched picture. See Figure 10.9. If possible, you should change your camera's metering system to manual for the period whilst you are capturing panoramic source images to ensure consistent exposures.

In shooting environments where there is a large range of brightness change from one part of the scene to the other, it is a good idea to shoot the source images for the scene twice using two different exposures – one set for the highlights and the other for the shadows. Before importing your images into Photomerge, you can combine the captured details from the two exposures and then stitch the evenly exposed result. See the 'Fixing panorama problems' section at end of this chapter for an example of this technique.

Keep white balance consistent

A similar problem can occur with the auto white balance system contained in many digital cameras. This feature assesses not the amount of light entering the camera but the color of the light, in order to automatically rid your images of color casts that result from mixed light sources in the scene. Leaving this feature set to auto can mean drastic color changes from one frame to the next as the camera attempts to produce the most neutral result. Switching to manual can produce results that are more consistent, but you must assess the scene carefully to ensure that you base your white balance settings on the most prominent light source in the scene. See Figure 10.10.

For instance, if you are photographing a wedding and two-thirds of the source shots are lit by sunlight, then this would probably be the best setting to use. For the experimenters amongst us, the one-third of the panorama not lit by sunlight could be shot a second time using a White Balance setting that suits and these images substituted before stitching.

Figure 10.10 Be careful of changes in color cast from frame to frame resulting from inconsistent White Balance settings.

Watch the edges

The edges of the image frame are the most critical part of the source picture. It is important to make sure that moving details such as cars, or pedestrians, are kept out of these areas. Objects that appear in the edge of one frame and not the next cause problems for the stitching program and may need to be removed or repaired later with other tools like the Clone Stamp. See Figure 10.11.

Figure 10.11 Try to avoid placing moving objects at the edge of frames, as they will disappear or be ghosted when the images are stitched.

Editing your panorama

Now that we have successfully captured our source pictures let's set about stitching them together to form a panorama. When opening Photomerge from inside the Editor workspace you are presented with a simple dialog with Browse/Open and Remove options which prompt the user to nominate the picture files that will be used to make up the panorama. Suitable files are 'browsed' for and 'opened' into the Source Files section of the box. Any of the files listed here can be removed if incorrectly added by highlighting the file name and clicking the Remove button. See Figure 10.12. Clicking OK exits the dialog and starts the initial opening and arranging steps in Photomerge. You will see the program load, match and stitch the image pieces together.

If the pictures are stored in RAW or 16-bit form they will be converted to 8-bit mode during this part of the process as well. For the most part, Photomerge will be able to correctly identify overlapping sequential images and will place them side by side in the editing workspace. In some instances, a few of the source files might not be able to be automatically placed and Elements will display a pop-up dialog telling you this has occurred. Don't be concerned about this as a little fine-tuning is needed even with the best panoramic projects, and the pictures that haven't been placed can be manually moved into position in the main Photomerge workspace. See Figure 10.13.

You can also start the creation of a panorama from source images that you have multi-selected in the Organizer workspace. Simply Shift-click the thumbnails to include and then choose File > New > Photomerge Panorama to automatically place these photos in the Photomerge source files dialog.

Editor: File > New > Photomerge Panorama

Whilst in the Photomerge workspace you can use the Select Image tool to move any of the individual parts of the panorama around the composition or from the layout to the Light box area. Click and drag to move image parts. Holding down the Shift key will constrain movements to horizontal, vertical or 45° adjustments only. The Hand or Move View tool can be used in conjunction with the Navigator window to move your way around the picture. For finer control use the Rotate Image tool to make adjustments to the orientation of selected image parts. See Figure 10.14.

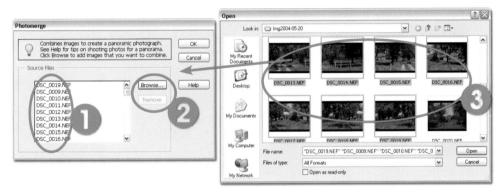

Figure 10.12 Pick the files you want to use for the stitching process using the Browse dialog box. (1) Selected source files. (2) Browse and Remove buttons. (3) Add files window.

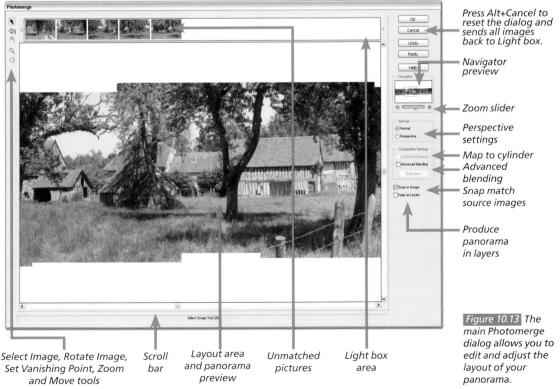

Book resources at: www.guide2elements.com

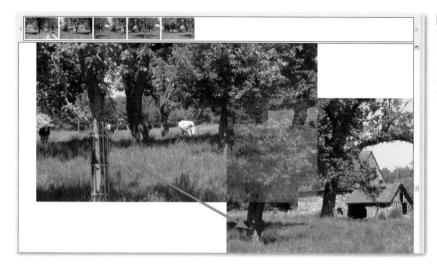

Figure 10.14 You can move source images to and from the Light box and Layout areas by clicking and dragging them.

The Use Perspective option, together with the Set Vanishing Point tool, manipulates the perspective of your panorama and its various parts. Keep in mind when using the perspective tools that the first image that is positioned in the Composition area is the base image (light green border), which determines the perspective of all other image parts (red border). To change the base image, click on another image part with the Set Vanishing Point tool. To correct some of the 'bow-tie'-like distortion that can occur when using these tools, check the Cylindrical Mapping option in the Composition area of the dialog. See Figure 10.15. The Advanced Blending feature, also available here, can be used to help minimize color inconsistencies or exposure differences between sequential images. It is not possible to use the perspective correction tools for images with an angle of view greater than 120°, so make sure that these options are turned off.

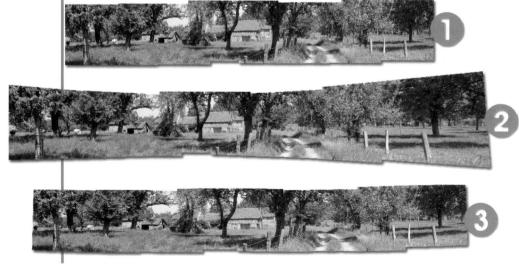

correct the 'bow-tie' effect that can result from perspective adjustments. (1) Panorama with normal setting. (2) Perspective setting applied. (3) Cylindrical Mapping and Advanced Blending applied to perspective corrected panorama.

Figure 10.15 The Cylindrical Mapping feature will help

Book resources at: www.guide2elements.com

After making the final adjustments, the panorama can be completed by clicking the OK button in the Photomerge dialog box. This action creates a stitched file that no longer contains the individual images.

- 1 Select Photomerge Panorama from the File > New menu to start a new panorama.
- 2 Click the Browse button in the dialog box.
- 3 Search through the thumbnails of your files to locate the pictures for your panorama.
- 4 Click the Open button to add files to the Source Files section of the dialog.
- 5 Select OK to open the Photomerge main workspace. Edit the layout of your source images.
- 6 To change the view of the images use the Move View tool or change the scale and the position of the whole composition with the Navigator.
- 7 Images can be dragged to and from the light box to the work area with the Select Image tool.
- 8 With the Snap to Image function turned on, Photomerge will match like details of different images when they are dragged over each other.
- 9 Ticking the Use Perspective box will instruct Elements to use the first image placed into the layout area as the base for the composition of the whole panorama. Images placed into the composition later will be adjusted to fit the perspective of the base picture.
- 10 The Cylindrical Mapping option adjusts a perspective corrected image so that it is more rectangular in shape.
- 11 The Advanced Blending option will try to smooth out uneven exposure or tonal difference between stitched pictures.
- 12 The effects of Cylindrical Mapping as well as Advanced Blending can be viewed by clicking the Preview button.
- 13 The final panorama file is produced by clicking the OK button.
- 14 To produce the panorama document where the source images are kept as separate layers click the Keep as Layers check box.

When moving the cursor over the photos in the Preview area, hold down the Alt key to see which image is active. This is useful when you are changing the vanishing point of your images.

Photomerge from the Photo Browser Photo Browser: File > New > Photomerge Panorama

From version 3.0 of Elements for Windows, the Photomerge feature has also been able to be accessed from the Photo Browser or Organizer workspace as well as from within the Standard Editor window. This means that you can locate and multi-select a series of source files using the Photo Browser before selecting the File > New > Photomerge Panorama in the Editor menu option. This action will then open the Standard Editor workspace and then automatically add

the selected pictures to the Photomerge Add Files dialog. At this point you can remove any of the files listed or add more pictures to the group. Once you click OK then Photomerge proceeds as normal. See Figure 10.16.

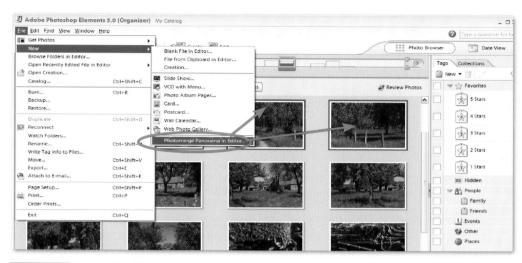

Figure 10.16 From version 3.0 onwards Photomerge can be accessed from the Photo Browser or Organizer workspace as well as from inside the Standard editor.

Photomerge in action

Vertical stitches

For most of the time you will probably use Photomerge to make horizontal panoramas of wide vistas, but occasionally you may come across a situation where you can make use of the stitching technology to create vertical panoramas rather than horizontal ones.

When capturing the vertical source images, be sure to follow the same guidelines used for standard panoramas – check exposure, focus, white balance, focal length and shooting position. See Figure 10.17.

Document stitches

Don't restrict yourself to using the Photomerge technology for creating architectural or landscape images; the tool can also come in handy when you are trying to scan a document that is larger than your scanner bed. Take the situation of recreating a digital version of an old wall map.

Take the situation of recreating a digital version of an old wall map. The size of the document means that it will need to be captured in a series of section scans. The resultant files can then be stitched together to recreate a highly detailed digital version of the original document. See Figure 10.18.

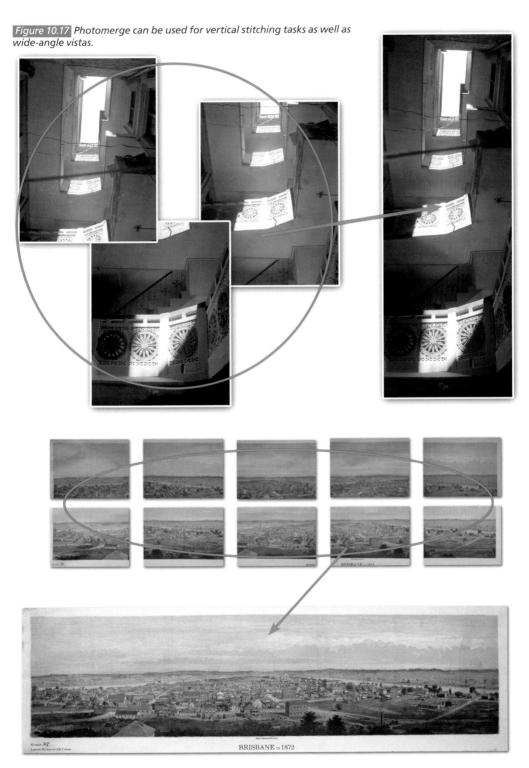

Figure 10.18 Document stitching allows you to scan a large document in sections and then 'glue' it all back together again.

Making panoramas that spin

When you produce a panorama that covers the full 360° of a scene, you not only have an image that can be used to make a wide vista print, but you also have the basic building block needed for creating an Apple QuickTime Virtual Reality (VR) movie. QuickTime allows the viewer to stand in the middle of the action and spin the image around themselves. It is like you are actually there.

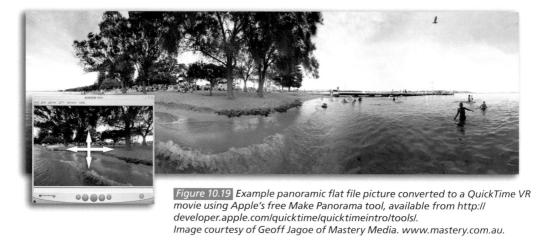

Figure 10.20 The Pano2exe utility provides a convenient and economical way to convert your Photomerge vistas to distributable navigable panoramas. See www.change7.com for details.

Creating a QuickTime VR movie from your finished file is as simple as saving the stitched image as a Macintosh PICT file and then converting it to QuickTime format using Apple's free Make Panorama tool. The resulting file can be watched with any QuickTime player and has the added bonus of being able to be uploaded to the web and viewed online.

Windows users can make similar spinning panoramas using a small, economical utility called Pano2exe. The program converts JPEG output from Photomerge to a self-contained EXE or program file, which is a single easily distributable file that contains the image itself as well as a built-in viewer. See Figures 10.19 and 10.20.

Fixing panorama problems

No matter how sophisticated the stitching technology Photomerge included, there are often some small problems in the final picture where the blending process has not produced perfect results. Some of these defects can be corrected by re-editing the panorama itself: arranging, rotating and manually moving the problem source images to create a better blend. But there are also occasions where the stitching process is not at fault.

The causes of these problems usually fall into one of two groups – subjects moving or changing at the edges of overlapping frames and differences in lighting and/or color between sequential images.

Solution 1 – Time your shooting sequence to accommodate moving objects in the frame. Wait till the objects are in the middle of the frame or are not in the frame at all before pushing the button.

Solution 2 – Shoot a single frame featuring the moving object so that, after stitching, the object can be cut and pasted into position over the top of the completed panorama.

Solution 3 – Shoot two complete sequences of source images: one with the camera's exposure system to suit the highlights of the scene and one with the settings adjusted for the shadows. Try adjusting your camera to 2 stops under the camera setting for the highlight picture and

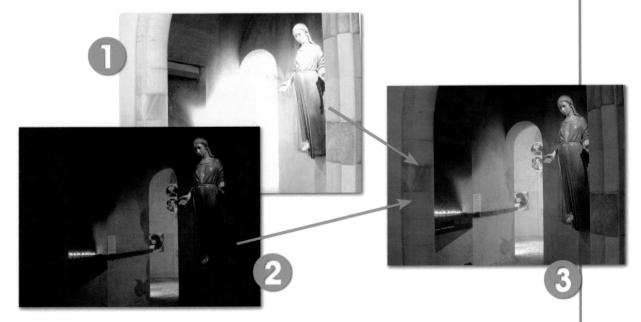

Figure 10.21 Tricky exposure situations can be solved by shooting twice – make one image so that the exposure is adjusted for shadows and one for highlights – and then combine the details of both shots to produce the frame that contains both shadows and highlights that will be used for stitching. (1) Shadow details captured. (2) Highlight details captured. (3) Combined photograph with both highlights and shadows.

2 stops over for the image in which the shadows are captured. Before stitching, combine the individual images into a single document. Arrange the layers so that the darkest picture is on top. Change the blend mode of the dark layer to Multiply and open the Levels feature. Drag the black point output slider to the center of the dialog to add the highlight detail to the midtone and shadow areas of the layer beneath. Save the combined image and then use the correctly exposed and detailed picture as one of the source images used for creating the panorama. See Figures 10.21 and 10.22.

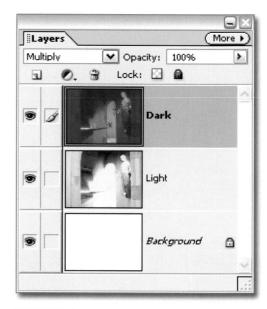

Figure 10.22 Combine the two images to form a composite with details in highlights and shadows.

Top tips from panoramic professionals

- 1 Panoramas are first and foremost a photographic exercise. Composition, lighting and point of view are all critical, although they have to be dealt with differently to traditional photography.
- 2 Adobe Photoshop Elements is your friend. The editing and enhancement tools found here can help fix those tiny image areas where Photomerge hasn't quite made the perfect stitch.
- 3 For web panoramas, use a source file with lots of pixels and compress heavily with Elements' Save for Web JPEG feature. This often gives better results than a small number of pixels with light compression.
- $4\,$ Pay attention to the level of your camera (or VR head), as level shots are much easier to stitch together.
- 5 If the lighting is difficult or there are moving items in the scene, shoot twice as many frames (usually by going around twice) with bracketing if appropriate. 'Panos are often taken with fixed values for exposure'.

From Geoff Jagoe of Mastery Media

Preparing Images for the Web or E-mail

Images and the Net

Web compression formats side by side

Making your own web gallery

Sending images as e-mail attachments

Making simple web animations with Elements

Creating your own slide shows

Editing the slide photos

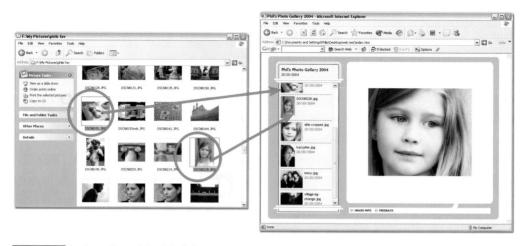

Figure 11.1 In the web age it is critical that users are able to output their images in a format that is suitable for Net use quickly and easily.

Since the first edition of this book, the World Wide Web has become an even greater part of our daily lives and, as I mentioned then, it is no longer sufficient to concentrate solely on the process of making great prints from digital files, as knowing how to output your pictures so that they are suitable for the web is not just a nice idea, it is now an essential part of the imagemaking process. In fact, there is a growing band of professional photographers whose work never becomes a print and only ever exists on our screens. Therefore, over the next few pages we will look at the skills you need to become a web-savvy image maker. See Figure 11.1.

Figure 11.2 Preparing any content for web use is concerned with balancing quality and file size. This is especially true when placing your pictures on the Internet. Too much quality will mean that your photos will take a long time to display, too little and they will download quickly but be of poor quality.

Images and the Net

As most people access the web through a modem and telephone line, the size of the images used for web work is critical. The larger the picture file, the slower it will download to your machine. So preparing your files for Net use is about balancing picture quality and file size. To help with this, several different file formats have been developed to include a compression system that shrinks file sizes to a point where they can be used on a website or attached to e-mails. See Figure 11.2. The most popular of these is GIF and JPEG. The problem with both these file formats is that small file size comes at a cost of image quality.

GIF

With the GIF or Graphics Interchange Format, it is only possible to save a picture with a maximum of 256 colors. As most photographic pictures are captured and manipulated in 24-bit color (16.7 million colors), this limitation means that GIF images appear posterized and coarse compared with their full color originals. This isn't always the case, but because of the color restrictions this format is mainly used for logos and headings on web pages and not photographic imagery. GIF is also used for simple animations, as it has the ability to flick through a series of images stored in the one file. See Figure 11.3.

Figure 11.3 The compression technology built into the GIF format makes files smaller by reducing the number of colors in your pictures to a maximum of 256 (8-bit color). This means that GIF images are small and fast to display but the lack of colors makes them unsuitable for use with photographs. (1) Original 3.53 Mb picture containing 16.7 million colors. (2) Detail of original. (3) Detail of the same file converted to GIF format so that it is 0.43 Mb in size and contains 32 colors only.

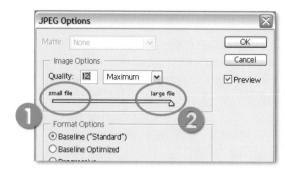

Figure 11.4 The compression level in the JPEG format is selectable via the Quality slider in the JPEG dialog. Moving the slider to the left (1) creates a small, low quality file; moving it to the right (2) produces a better quality image but with a bigger file size.

JPEG

In contrast, the JPEG format was developed specifically for still images. It is capable of producing very small files in full 24-bit color. When saving in this format it is possible to select the level of quality, or the amount of compression, that will be used with a particular image. See Figure 11.4. In more recent years, two new formats – PNG (Portable Network Graphics) and JPEG 2000 – have been developed that build upon the file format technology of JPEG and GIF. At present, these file types are not used widely but as time passes they are gaining more popularity.

JPEG 2000

JPEG 2000 (JPX or JP2) uses wavelet compression technology to produce smaller and sharper files than traditional JPEG. The downside to the new technology is that to make use of the files created in the JPEG 2000 file format online users need to install a plug-in into their web viewers. Native (i.e. built-in) browser support for the new standard will undoubtedly happen, but until then Elements users can freely exchange JP2 files with each other as support for the format is built right into the software. From version 2.0 Elements has supported the saving of pictures to the newest version of the JPEG format – JPEG 2000. The controls for this format are accessed in the format's own preview dialog via the Save As option in the File menu.

PNG

PNG24 is a format that contains a lossless compression algorithm, the ability to save in 24-bit color mode and a feature that allows variable transparency (as opposed to GIF's on and off transparency choice). File sizes are typically reduced by 5-25% when saved in the PNG format. Greater space savings can be made by selecting the PNG8 version of the format, which allows the user to select the number of colors (up to 256) to include in the picture. Reducing the size of the color set results in smaller files and works in a similar way to the GIF. Most browsers and image-editing programs support the PNG format natively, so no extra viewer plug-in is necessary.

Flash

Elements 5.0 is the first edition of the program to be released after Adobe's purchase of Macromedia and as such the Web Gallery feature has been totally revised so that it now outputs its pages using the Flash file format. Like JPEG, the Flash format, or SWF, is designed to quickly display high quality photos on the Internet using small file sizes.

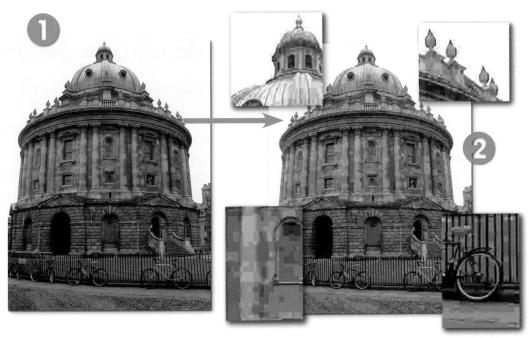

Figure 11.5 Too much JPEG compression introduces artifacts or visual errors into your pictures. (1) Original uncompressed picture. (2) Overcompressed version of the photo showing extensive artifacts.

Getting the balance right

Editor: File > Save for Web and Editor: File > Save As > JPEG 2000

Both JPEG formats, as well as GIF and PNG8, make small files by using 'lossy' compression algorithms. This means that image quality and information are lost as part of the compression process. In simple terms, you are degrading the picture to produce a smaller file. Too much JPEG compression, in particular, and the errors or 'artifacts' that result from the quality loss become obvious. See Figure 11.5.

So how much compression is too much? Well, Elements includes a special Save for Web feature that previews how the image will appear before and after the compression has been applied. See Figure 11.6. Start the feature by selecting the Save for Web option from the File menu of either the Standard or Quick Fix editor workspaces. You are presented with a dialog that shows 'before' and 'after' versions of your picture side by side. The settings used to compress the image can be changed in the top right-hand corner of the screen. Each time a value is altered, the image is recompressed using the new settings and the results redisplayed.

JPEG, GIF and PNG can all be selected and previewed in the Save for Web feature. To preview JPEG 2000 compressed images use the Save As option in the File menu and select JPEG 2000 as the file type. This step will open the preview dialog specifically designed for this format. See Figure 11.7.

By carefully checking the preview of the compressed image (at 100% magnification) and the file size readout at the bottom of the screen, it is possible to find a point where both the file size and image quality are acceptable.

By clicking OK it is then possible to save a copy of the compressed file to your hard drive ready for attachment to an e-mail or use in a web page.

- 1 With an image already open in Elements, pick the Save for Web (Editor: File > Save for Web) or Save As (Editor: File > Save As > JPEG 2000) option.
- 2 Adjust the magnification of the images in the preview windows to at least 100% by using the Zoom tool or the Zoom drop-down menu.
- $3\,$ Select the file format from the Settings area of the dialog.
- 4 Alter the image quality for JPEG and JPEG 2000 or the number of colors for GIF and PNG8.

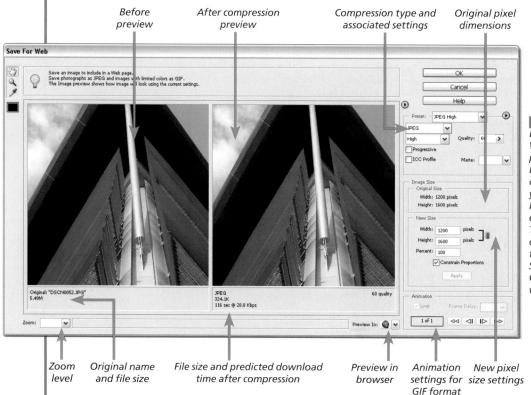

Figure 11.6 The Elements Save for Web feature produces a side-by-side comparison of your image before and after compression. The Save for Web option is available from both the Standard and Quick Fix editor workspaces.

Book resources at: www.guide2elements.com

- 5 Assess the compressed preview for artifacts and check the file size and estimated download times at the bottom of the dialog.
- 6 If the results are not satisfactory, then change the settings and recheck file size and image quality.
- 7 Click OK to save the compressed, web-ready file.

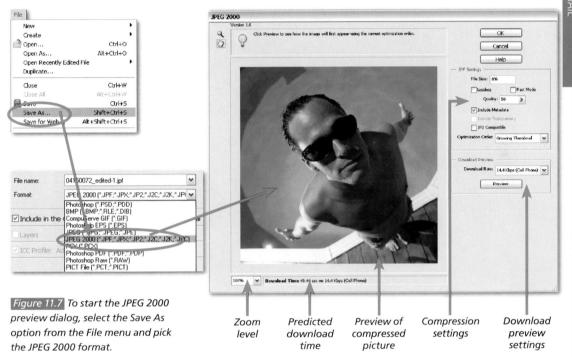

Web compression formats side by side

To give an indication of the abilities of each particular format, I optimized the same image and saved it in five different web formats. The differences in image quality and file sizes, as well as the best uses and features of each format, can be viewed in Table 11.1 and Figures 11.8 and 11.9.

Figure 11.8
Details of
compression
comparisons.
(1) JPEG
maximum
compression.
(2) JPEG 2000
minimum
compression.
(3) PNG8, 16
colors.

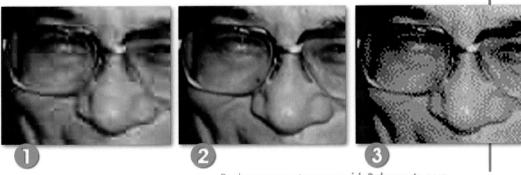

Book resources at: www.guide2elements.com

Figure 11.9 Side-by-side comparisons of the image quality of a variety of web optimized file formats at different compression settings. (1) JPEG, minimum compression. (2) JPEG, maximum compression. (3) JPEG 2000, minimum compression. (4) JPEG 2000, maximum compression. (5) PNG8, 256 colors. (6) PNG8, 16 colors. (7) PNG24. (8) GIF, 256 colors. (9) GIF, 16 colors.

Book resources at: www.guide2elements.com

		Best uses or format features						
File format	Compression settings	Photo	Logo	Heading	Anim- ation	Trans- parency	File size	Detail*
JPEG	Minimum	✓					791 Kb	1
	Maximum	✓					60 Kb	2
JPEG 2000	Minimum	✓					880 Kb	3
	Maximum	✓					49 Kb	4
PNG8	256 colors		✓	✓		✓	502 Kb	5
	16 colors		✓	√		\checkmark	216 Kb	6
PNG24	_	✓				✓	1358 Kb	7
GIF	256 colors		✓	√	✓	√	398 Kb	8
	16 colors		✓	✓	√	√	201 Kb	9

Table 11.1 Comparison of file formats suitable for web use. * See detail of the compression type and setting applied to the same photograph in Figure 11.9.

Making your own web gallery

Organizer: File > Create > Photo Galleries or Editor: File > Create > Photo Galleries

Never before in the history of the world has it been possible to exhibit your work so easily to so many people for such little cost. The web is providing artists, photographers and business people with a wonderful opportunity to be seen, but many consider making your own website a prospect too daunting to contemplate. Adobe has included in Elements an automated feature that takes several images and transforms them into a fully functioning website in a matter of a few minutes.

The Photo Galleries feature (previously called the HTML Photo Galleries or Web Photo Galleries) can be found under the File > Create menus in both the Editor and Organizer workspaces. See Figure 11.10. The wizard contains sections where you can set the template and style of the website, the heading and colors used on the pages, where you want the project saved and more importantly how the website is to be shared.

Figure 11.10 The Photo Galleries feature is one of the photo creations that can be found in the File > Create menus of both the Editor and Organizer workspaces.

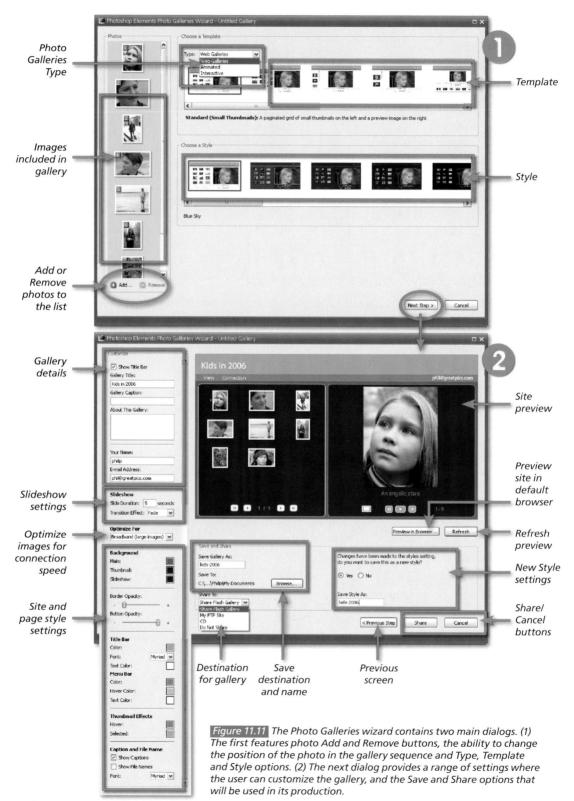

Multi-select pictures to include

Users are able to multi-select pictures from the Photo Browser first, before entering the feature, rather than having to use all the pictures located in a single folder or directory as was the case in previous versions. In the same vein the revised Photo Galleries dialog contains a very useful Add/Remove Pictures section which displays a thumbnail list of those photos currently selected for inclusion in the website. In addition, the order that pictures appear in the web gallery can be changed by clicking and dragging thumbnails to new spots in the list. See Figure 11.11.

For the first time version 5.0 includes animated and interactive gallery types as well as the more traditional static thumbnail and display image templates. Selecting which gallery type to produce is a choice made at the beginning of the Photo Galleries wizard. See Figure 11.12. The options are:

Web Galleries – A set of thumbnail images together with a larger display photo. Clicking on a thumbnail displays the selected photo in the preview space.

Animated – A selection of animated galleries placing framed images against colorful sets or backgrounds. Images change by clicking Forward and Back buttons.

Interactive – A variety of designs that allow the user to navigate through the sequence of images or move the photos on screen.

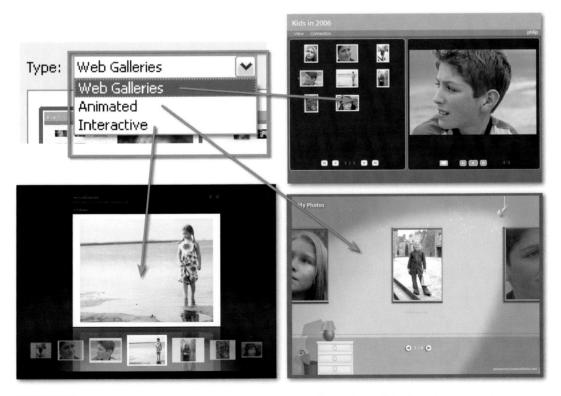

Figure 11.12 The websites created with the Photo Galleries wizard move beyond simple static pages and now include Animated and Interactive options.

Built for speed

In the process of creating the site, all your images will be converted to JPEG files, so there are also options in the Photo Galleries dialog to alter the level of compression that is applied. Rather than having to select the exact compression and image dimensions, the values for these variables are set via the site style selected as well as the entry chosen in the Optimize For section. See Figure 11.13.

Figure 11.13 The option selected in the Optimize For section of the Photo Galleries dialog determines the size and compression setting used for the photos in the gallery. Broadband creates larger less compressed photos than the dial-up selection.

Figure 11.14 The completed website has to be transferred from your computer to a space on the Net hosted by an Internet Service Provider or ISP.

Going live

With the site completed, the next step is to transfer all the files to some server space on the Net. Companies called ISPs, or Internet Service Providers, host the space. See Figure 11.14. The company that you are currently using for 'dial-up' or cable connection to the Net will probably provide you with 5–10 Mb of space as part of your access contract. As an alternative there are a range of hosting businesses worldwide that will store and display your gallery for free, as long as you allow them to place a small banner advertisement at the top of each of your pages. Whatever route you take, you will need to transfer your site's files from your home machine to the ISP's machine. In previous versions of Elements this process was handled by a small piece of software called an FTP or File Transfer Protocol program. Thankfully the new Photo Galleries feature contains an integrated FTP utility within the Share To section of the dialog. See Figure 11.15.

You can choose between the following Share options:

Photoshop Showcase – Upload to a free online sharing area provided by Adobe Photoshop Services.

My FTP Site – Transfer to your own ISP or Net space provider.

CD – An option for burning the gallery to a CD.

Do Not Share – The option used for just saving the gallery.

Figure 11.15 The My FTP Site option uses a File Transfer Protocol (FTP) utility to upload your files to a server on the web.

Step-by-step Photo Galleries creation

Use these steps to guide you through creating your first photo website.

- 1 Select the pictures you want to include in the site from those thumbnails displayed in the Organizer workspace. Hold down the Ctrl key to multi-select individual files and the Shift key to select all the files in a list. Alternatively, and new for 5.0, you can also drag a selection marquee around thumbnails in the photo browser.
- 2 Select Organizer: File > Create > Photo Galleries.
- 3 Add or remove photos from the list of those to be included in the gallery (thumbnails on the left). Adjust the position of the images in the presentation sequence by click-dragging the thumbnail within the group.
- 4 Choose the Type and Template from those listed in the Template section of the first dialog in the wizard. See Figure 11.16.

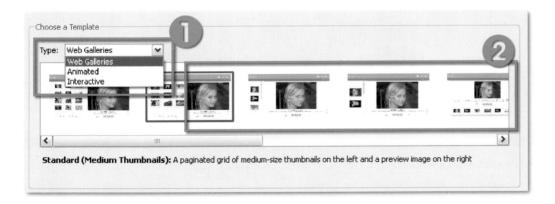

Figure 11.16 You can select between three different gallery types in the Template section of the feature's dialog: Web Galleries, Animated and Interactive (1). The option you pick here then determines the range of templates (2) that are available in the next section. Click on one of the template thumbnails to make a selection.

5 Next select a style from those thumbnails displayed in the Choose A Style section of the dialog. See Figure 11.17. Varying styles are not available when you select animated or interactive gallery types. Click the Next Step button to proceed to the second dialog.

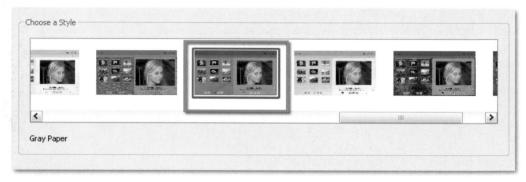

Figure 11.17 The Style section of the Web Galleries dialog determines the basic color scheme of the template that you selected in the previous step. The majority of these colors can be adjusted with the settings contained in the next dialog.

- 6 Select the Show Title Bar option and input gallery Title, Caption and About details.

 Also type in the gallery owner's name and contact e-mail address. The exact options for adding gallery details will change according to the gallery type and style you select.
- 7 The next step if you opted to produce a web galleries style is to adjust the Slideshow settings. You can alter the Duration and Transition Effect settings. See Figure 11.18.

Figure 11.18 The duration and transition effect for the Slide show area adjusted using the settings in the second dialog of the Web Gallery feature.

- 8 Select the download speed used by the majority of the viewers who will be surfing your site. Broadband creates a site with better quality and larger photos whereas dial-up makes smaller files for faster loading.
- 9 Adjust the color, opacity and text that will be used for the site and then choose whether you want to include any captions or file names under the display pictures.
- 10 With all the options set preview the website in the computer's default browser by clicking the Preview in Browser option. See Figure 11.19.

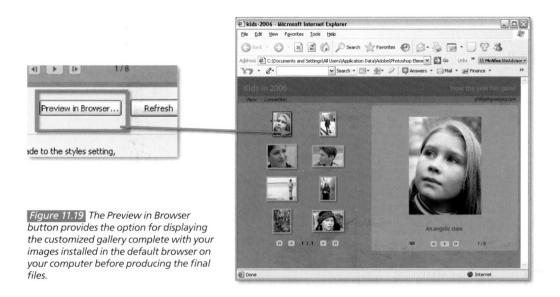

- 11 If you have changed any of the basic style settings and wish to save them as a new style then click the Yes radio button and add in a name to the Save Style As area. You can reuse this setting later by selecting it from the Style section in the first dialog.
- 12 Input the file name for the gallery and the location of the saved files before selecting the Output option from the Share To menu. Here the My FTP Site option was selected. Click the Next Step button. This action saves the project, produces the site and opens the FTP utility.
- 13 Add in the details for your FTP site, which can be obtained from your service provider, and then click Upload to transfer the website to the web server. See Figure 11.20.

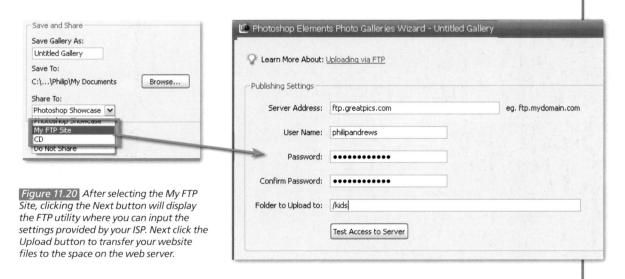

Sharing online - the Web Photo Galleries alternative

Organizer: File > Share Online

The online sharing facilities that are available inside Elements are an interesting alternative to creating a web Photo Galleries. Multi-selected pictures or even whole catalogs can be uploaded and shared online. The pictures are stored on the web in an album format that has options to run as a slide show via space provided by third parties such as the Kodak Easy Share Gallery service. Selected friends and relatives are automatically e-mailed and invited to view (and, of course, buy prints) as part of the sharing process. This approach is a lot easier than creating your own web pages and then having to upload them to an ISP server space that you have to organize. The downside to e-sharing your photos this way is that you have few choices over the way that the pictures are displayed. See Figure 11.21.

- 1 Multi-select the files to include from the Organizer workspace then choose a Sharing option from those listed in the Share menu access via the Share shortcut button.
- 2 Register for the sharing service using the next few screens or if you are already a member simply log in.
- 3 Select the recipients that you want to invite to share you online album from those in your contact book. Add extra names and contact details if need be.
- 4 Add a subject heading and message to be included in the notification e-mail and choose whether the viewers need to sign in to see the album.
- 5 The photos will then be uploaded and the invitation e-mails sent out to the people in your contact list that you selected. At the same time a confirmation e-mail is sent to your own e-mail address letting you know that the album has been shared.

FEATURE SUMMARY

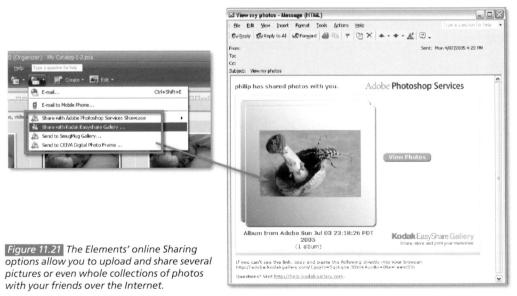

Book resources at: www.quide2elements.com

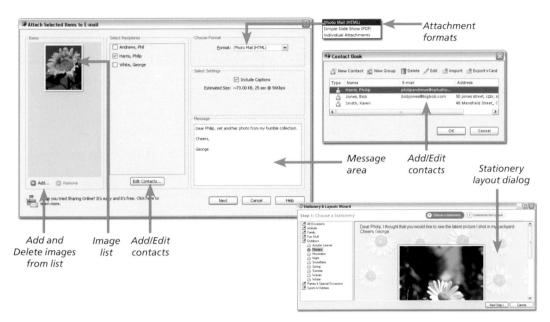

Figure 11.22 The File > E-mail dialog provides a range of ways that you can attach your pictures to e-mails. You can also add and remove contacts, via the Contacts Book, and type your message directly into the window. Pressing OK opens your e-mail program, adds in your message and recipient details and attaches an optimized version of your picture to the new e-mail document. If you have selected the PhotoMail format then you will be prompted to choose the stationery and decide on the layout of the message as part of the e-mailing process.

Sending images as e-mail attachments

Organizer: File > E-mail and Editor: Share Shortcut > E-mail

For many people, sharing images by sending them as e-mail attachments has become a commonplace activity. Whether you are showing grandparents in another country just how cute their new granddaughter is, or providing a preview look at some holiday property, using e-mail technology to send pictures is both fast and convenient.

Starting with Elements version 2.0 Adobe included a special Attach to E-mail function designed just for this purpose. Things have progressed with the new releases and now Elements 5.0 users have a Contact book dialog in place of the old Add a Recipient option found in previous releases. Here you can add individual contacts, make groups from several e-mail addresses, and import and export to and from common e-mail contact formats such as vCards or Microsoft Outlook.

Attach Selected Items to E-mail dialog

The Attach to E-mail dialog is the center of the emailing process. Here you can attach photographs as individual files (the way you do through your e-mail program), as a PDF slide show (that Elements makes on the fly for you) or you can add the photos to an HTML e-mail complete with choice of a range of fancy backgrounds and borders. The images that will be

attached to the e-mail can be selected in the Organizer workspace before opening the feature or can be added or removed via the thumbnail listing on the left of the dialog. See Figures 11.22 (page 281) and 11.23.

- 1 You can elect to use a photo that is currently open in the Editor workspace or multi-select images from inside the Organizer workspace.
- 2 Select the File > E-mail to start the feature and display the new dialog.
- 3 Add or delete photos from the thumbnail list of those to include with the buttons at the bottom left of the dialog.
- 4 Choose an existing recipient from the contacts list or add a new contact.
- 5 Choose the format that the pictures will appear in from the drop-down menu.
- 6 For PDF Slide Show and Individual Attachment options select the size that the pictures will be converted to as part of the attachment process.
- 7 For the Photo Mail (HTML) option select the stationery to use as a background for the email.
- 8 Add in your message and click OK.
- 9 When your e-mail program displays the new message click Send to e-mail the message.

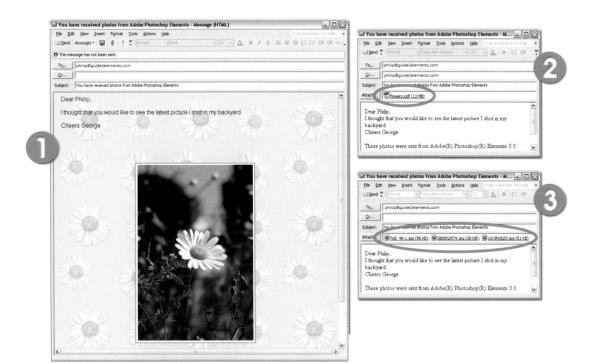

Figure 11.23 With the Organizer: File > E-mail feature you can choose between (1) HTML, (2) PDF slide show and (3) Individual file e-mail formats.

Making simple web animations with Elements

In Chapter 6, we looked at how layers can be used to separate different image parts so that they are easier to enhance and manipulate. Here we will use layers to create simple animations for your website.

Traditional animation

Whether it is the production of a Disney classic or the construction of a small moving cursor for your web page, the basics of making animations remain the same. A series of images, or frames, are created with slight changes recorded from one picture to the next. The sequence is then compiled and each frame is shown in quick succession. As your eye sees a new image, your brain remembers the last, with the result that the still images appear to move.

Historically, the frame images were drawn and painted on a series of acetate cells. Large productions could use thousands of cells, each representing a small slice of movement, to produce just a few seconds of animation on screen. These days, many animation companies use digital versions of this old way of working, but despite all the technological changes, all animation is based on a sequence of still images.

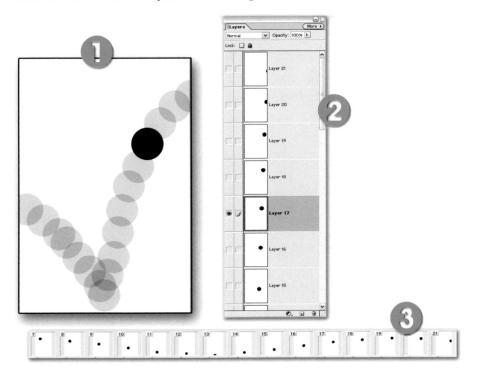

Figure 11.24 Each layer of a multi-layer Elements file becomes a different frame in a GIF animation. (1) GIF animation. (2) Elements' image layers. (3) Layers as animation frames.

Animation - the Elements method

Adobe has merged traditional techniques with the multi-layer abilities of its PSD file structure to give Elements users the chance to produce their own animations. Essentially, the idea is to make an image file with several layers, the content of each being a little different from the one before. See Figure 11.24 on page 283. The file is then saved in the GIF format. In the process, each layer is made into a separate frame in an animated sequence. As GIF is a format that is used for small animations on the Net, the moving masterpiece can be viewed with any web browser, or placed on the website to add some action to otherwise static pages.

The easiest way to save the GIF file is via the Save for Web feature. See Figure 11.25. The Save for Web dialog contains the original image and a GIF compressed version of the picture. By ticking the Animate check box you will be able to change the frame delay setting and indicate whether you want the animation to repeat (loop) or play a single time only. This dialog also provides you with the opportunity to preview your file in your default browser. The final step in the process is to click OK to save the file. See Figure 11.26.

Figure 11.25 The Save for Web feature provides a series of settings that control the production of GIF animation files. (1) The GIF file format is used for animation. (2) The animation option must be checked. (3) Use the animation controls to set Frame Delay and Loop settings and to preview the individual frames.

Figure 11.26 Your animation can be previewed in your default web browser directly from the Save for Web window.

Animation advice

Keep in mind when you are making your own animation files that GIF formatted images can only contain a maximum of 256 colors. This situation tends to suit graphic, bold and flat areas of color rather than the gradual changes of tone that are usually found in photographic images. So, rather than being disappointed with your results, start the creation process with a limited palette; this way you can be sure that the hues you choose will remain true in the final animation. It is also worth remembering that the Elements animation feature is designed for short, non-complex compositions. If you are planning a major epic made up of large, high-resolution files that when compiled will play for an extended period of time, or even if you just want to add sound to your moving images, it would be best for you to use a dedicated animation package.

- 1 Create an Elements file with several layers of differing content.
- 2 Select File > Save for Web.
- 3 Ensure that the GIF setting is selected in the Settings section of the dialog.
- 4 Tick the Animate check box.
- 5 Adjust the Frame Delay option to control the length of time each individual image is displayed.
- 6 Tick the Loop check box if you want the animation to repeat.
- 7 Preview the animation by clicking the browser preview button. Close the browser to return to the Save for Web dialog.
- 8 Select OK to save the file.

Flipbooks – a new way to animate

Flipbooks are a new way of creating small animations from a series of individual photographs. The results simulate the 'old skool' animation technique where slightly different drawings were created on corners of successive pages of a small notebook. Flipping the pages between thumb and forefinger created a sense of motion.

The process for creating an Elements Flipbook is simple. Select the pictures to include from those displayed in the Organizer workspace and then choose File > Create > Flipbook or select the option from the Create shortcut menu. See Figure 11.27. Set the Speed in frames per second, Order and Output options in the Flipbook dialog and then

Figure 11.27 After selecting the images to be included in the flipbook choose the option from the Create shortcut menu.

click Output to create. The resultant WMV (Windows Media Video) file can be played with any Windows machine with the latest version of Windows Media Player installed. See Figure 11.28.

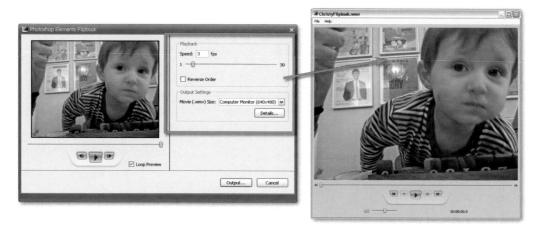

Figure 11.28 Use the settings in the Flipbook dialog to adjust the frames per second that the photos are flipped, along with the size of the final video. Flipbooks are output in WMV format, which is compatible with most Windows machines.

Creating your own slide shows

Organizer or Editor: File > Create > Slide Show
Elements 5.0 contains a Slide Show editor which can
produce no less than five different types of presentations.
The feature contains an easy-to-use interface and
options that allow users to create true multimedia slide
shows complete with music, narration, pan and zoom
effects, transitions, extra graphics, and backgrounds
and titles. The finished presentations can be output as
a file, burnt to CD or DVD, e-mailed as a slide show, sent
directly to your television (Windows XP Media Center
Edition users only) or sent to Premiere Elements for
further editing. See Figure 11.29.

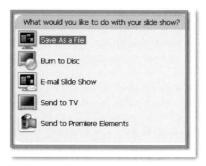

Figure 11.29 The fully featured Slide Show editor in Elements 5.0 now provides more Output options than ever before.

Creating slide shows

Creating presentations in version 5.0 uses an approach that centers all production activities around a single editor interface and it is only at the time of outputting that you choose the type of slide show that you want to create. In this way you can create (and save) a single slide show project and then repurpose the presentation in many different forms (online, DVD, PDF slide show or direct to TV) by simply selecting different output options. See Figure 11.30.

Version 5.0 slide shows in action

Though the Slide Show editor may at first seem a little complex, having all the controls in one place certainly means that you can create great multimedia presentations easily and efficiently. See Figure 11.31.

The following key features are included in the editor:

- Automatic editing: Rotate, size, change to sepia, black and white or back to color and apply Smart Fix and Red Eye Fix to your photos without leaving the Slide Show editor. Click the Preview image to display the Edit options in the Properties palette. See Figure 11.32.
- **Styled text:** Select from a range of text styles with click, drag and drop convenience (1-Fig. 11.31).
- Add graphics: The Slide Show editor now includes a variety of clip art that can be added to your presentations. Double-click or click-drag to place a selected graphic onto the current slide (2-Fig. 11.31).
- **Transitions:** Add individual transitions between slides by clicking the area in the middle of the slides in the storyboard and then selecting the transition type from those listed in the Properties pane (3-Fig. 11.31).
- Pan and Zoom: Add movement to your still pictures by panning across or zooming into your photos. Simply select the slide in the storyboard and then check the Enable Pan & Zoom option in the Properties pane. Click on the left thumbnail (Start) and set the starting marquee's (green) size and position, then switch to the right thumbnail and adjust the ending marquee's (red) size and position (4-Fig. 11.31).

Figure 11.31 The Slide Show editor provides a single workspace for the creation and editing of your presentation creations.

Add

text

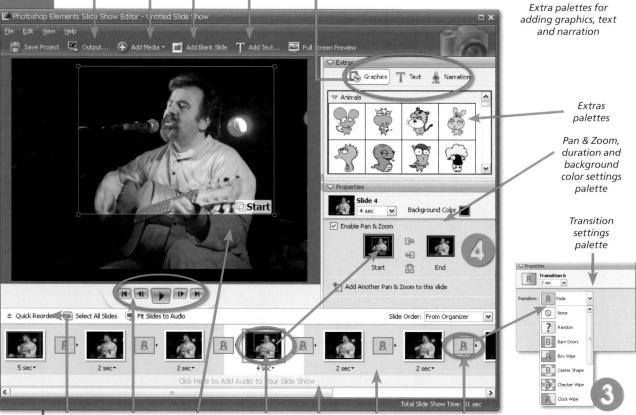

Preview/ Auto edit screen

Individual Add audio Slide Show slides bar

timeline/ storyboard

Transitions

Close and return to main screen

> Quick Reorder screen Preview

screen

Book resources at: www.guide2elements.com

- **Quick Reorder:** This new sequencing screen enables you to quickly and easily adjust the position of any one photo in the presentation sequence using click and drag (5-Fig. 11.31).
- **Music and narration:** Add music and extra audio to the show using the Add Media button and incorporate narration using the built-in slide show recorder (6-Fig. 11.31).

For more information on how to create slide shows see Chapter 13.

- 1 Preselect the photos to include in the show from within the Photo Browser and then select Organizer: File > Create > Slide Show.
- 2 Set the defaults for the presentation in the Slide Show Preferences dialog.
- 3 Adjust the slide sequence by click-dragging thumbnails within the storyboard or Quick Reorder workspaces.
- 4 Insert transitions by clicking the space in between slides and selecting a type from the menu in the Properties pane.
- 5 Add graphics and text by click-dragging from the Extras pane.
- 6 Record voice-over by selecting a slide and then using the Narration option in the Extras pane.
- 7 Add existing audio by clicking the soundtrack bar at the bottom of the storyboard.
- 8 Produce the slide show by selecting File > Output Slide Show and picking the type of presentation to produce from the Slide Show output dialog.

Editing the slide photos

The Properties palette displays several simple editing controls when you click a photo in the Preview area of the Slide Show editor. Although the best approach is to ensure that all editing and enhancement changes are applied to the photos before their incluion in a presentation project these controls can be used for making quick simple changes to the images used in individual slides. The options include:

Rotate – Pivots the photo 90 degrees left or right.

Scale – Makes the photo bigger or smaller.

Crop to Fit – Enlarges the photo to fill the whole slide frame even if this action crops the edges of the picture.

Crop to Slide – Fits the photo within the boundaries of the slide without cropping any image details.

Auto Smart Fix – Applies automatic adjustment of colour, contrast, brightness and sharpness to the picture.

Convert to Black and White – One click conversion to black and white.

Convert to Sepia – One click conversion to sepia toned monochrome.

Auto Red Eye Fix –Removes red eye from portraits taken with a flash.

More Editing – Opens the slide in Elements Editor workspace where the edited file is saved as a Version Set and added to catalog once complete. See Figure 11.32.

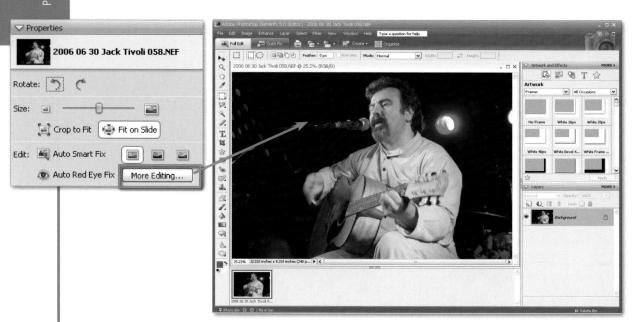

Figure 11.32 Clicking the photo in the Preview area of the editor switches the contents of the Properties palette to contain simple editing tools. These include rotate left and right, Scale and Crop options, Auto Smart Fix, convert to black and white or sepia and Auto Red Eye Fix. For more advanced editing tasks click the More Editing button to transfer the photo to the Full Edit workspace.

i905D

Preparing Images for Printing

Printing the Elements way

The link between paper type and quality prints

Making your first print

Printing a section of a full image

Making multiple prints

Aiming for the best prints

Web-Based Printing

espite the great rush of some picture makers to 'all things web', most digital images end up being printed at some stage during their existence. Contributing to this scenario is the current crop of affordable high quality inkjet printers whose output quality is nothing short of amazing. As little as 10 years ago it was almost impossible to get photographic quality output from a desktop machine for under £5000, now the weekend papers are full of enticing specials providing stunning pictures for as little as £100. See Figure 12.1.

Printer manufacturers have simplified the procedure of connecting and setting up their machines so much that most users will have their printer purring away satisfactorily within the first minutes

Figure 12.1 Current inkjet printers are capable of providing photographic quality images and cost a fraction of comparative technology just a few years ago.

of unpacking the box. Software producers too have been working hard to simplify the printing process so that now it is generally possible to obtain good output from your very first page.

Elements is a good example of these developments, providing an interactive printing system that previews the image on the paper background 'virtually' before using any ink or paper to output a print. As we have already seen in Chapter 3, the package also includes the ability to print a section of an open image, make a contact sheet of images contained within a folder and produce a print package of different sized pictures optimized to fit on a specific paper stock. See Figure 12.2.

Figure 12.2 Elements contains an interactive print system that can not only produce single image prints, but also contact sheets, picture labels and multi-print packages. (1) Individual print. (2) Contact print. (3) Picture package. (4) Picture labels.

Printing the Elements way

Editor: File > Print, Editor: File > Page Setup, Editor: File > Print Multiple Photos

All of the print settings in Elements are contained in three separate but related dialog boxes (see Figure 12.3): Print Preview – Editor: File > Print (1); Page Setup – Editor: File > Page Setup (2); and Print Photos – Editor: File > Print Multiple Photos (3). Similar output dialogs were included in previous versions of Elements but the upgraded features in the new release of the program have made the printing process much easier and more flexible.

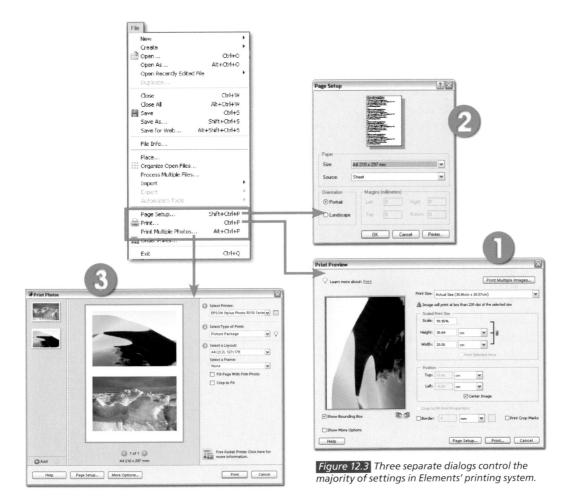

The **Print Preview** dialog is the first stop for most users wanting to make a hard copy of their digital pictures. Here you can interactively scale your image to fit the page size currently selected for your printer. By deselecting the Center Image option and ticking the Show Bounding Box feature, it is possible to click and drag the image to a new position on the page surface. These advanced preview features alone will make a lot of digital photographers very happy. See Figure 12.4.

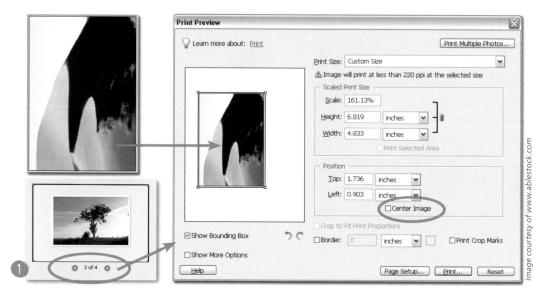

Figure 12.4 You can change the size and position of your image on its paper background via the Print Preview (Editor: File > Print) dialog. (1) When printing a multi-page Photo Creations document next/previous page Navigation buttons appear at the base of the preview area.

Once you are satisfied with the picture size and position, you can proceed to the **Page Setup** dialog using the button provided. It is here that you are able to change the settings for the printer, such as media type, size and orientation, printing resolution and color control, or enhancement. The extent to which you will be able to manually adjust these features will depend on the type of printer driver supplied by the manufacturer of your machine. When complete, click OK to return to the Print Preview dialog. To complete the output process, click the Print button. This step produces a general print dialog where the user has another opportunity to check the printer settings via the Properties button, before sending the image on its way with a click of the OK button. See Figure 12.5.

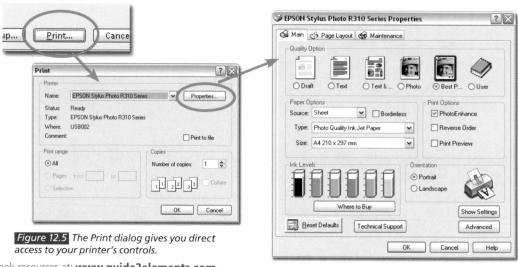

Book resources at: www.guide2elements.com

Printing from the Organizer workspace

Photo Browser: File > Print, File > Page Setup

As we have already seen in our brief introduction to printing in Chapter 3, you can output your pictures directly from the Photo Browser. In fact, with the exception of the Print Preview dialog the Print options available from the Organizer workspace are the same as those available via the Editor. For quick printing tasks the Photo Browser: File > Print option takes you directly to the same multiprint dialog that is available in the editor (File > Print Multiple Photos) and there is no practical difference between outputting your files from either space. See Figure 12.6.

Figure 12.6 The Organizer offers similar printing options to those found in the Editor workspaces.

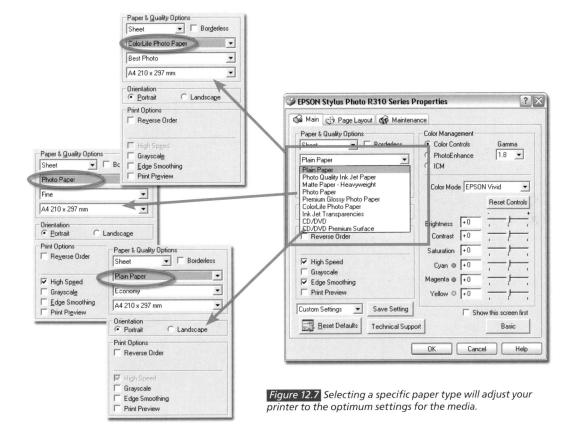

The link between paper type and quality prints

When you first start to output your own images, the wide range of printer settings and controls can be confusing. To start with it is best to stick to a standard setup and allow the built-in features of the driver to adjust the printer for you. For most printing tasks, selecting the media type in the Print Properties dialog will be sufficient to ensure good results. The manufacturers

have determined the optimum ink and resolution settings for each paper type and, for 90% of all printing tasks, using the default settings is a good way to ensure consistently high quality results. So if you are using gloss photographic paper, for example, make sure that you select this as your paper type in the Printer Settings dialog. See Figure 12.7 on page 295.

Making your first print

Editor: File > Print

With an image open in the editor workspace, open the Print Preview dialog (File > Print). Check the thumbnail to ensure that the whole of the picture is located within the paper boundaries. To change the paper's size or orientation, select the Page Setup and Printer Properties options. Whilst here, adjust the printer output settings to suit the type of paper being used. Work your way back to the Print Preview dialog by clicking the OK buttons. See Figure 12.8.

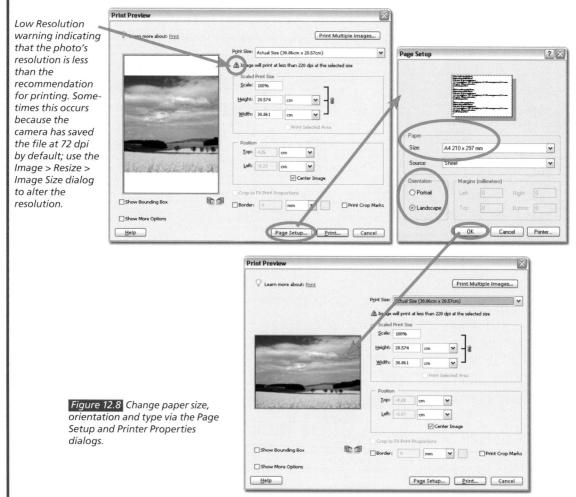

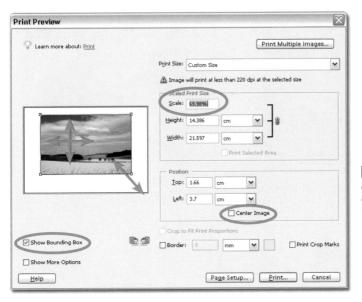

Figure 12.9 Change the size and position of the image on the page with the Print Preview dialog.

To alter the position or size of the picture on the page, deselect the Center Image option and then select the Show Bounding Box feature. Change the image size by clicking and dragging the handles at the edge and corners of the image. If you can't see the handles try inputting a number smaller than 100% in the Scale box until the edge of the picture is visible. Move the picture to a different position on the page by clicking on the picture surface and dragging the whole image to a different area. See Figure 12.9. To print, select the Print button and then the OK button.

- 1 Select Print Preview (File > Print) after ensuring that the file has sufficient resolution for printing. Minimum of 220 dpi for photo-quality printing.
- 2 Click the Page Setup button.
- 3 Pick the Printer option to set the paper type, page size and orientation, and print quality options.
- 4 Click OK to exit these dialogs and return to the Print Preview dialog.
- 5 At this stage you can choose to allow Elements to center the image automatically on the page (tick the Center Image box) and enlarge, or reduce, the picture so that it fits the page size selected (choose the Fit on Page option from the Print Size menu).
- 6 Alternatively, you can adjust the position of the picture and its size manually by deselecting these options and ticking the Show Bounding Box feature. To move the image, click inside the picture and drag to a new position. To change its size, click and drag one of the handles located at the corners of the bounding box.
- 7 With all the settings complete, click Print to output your image.

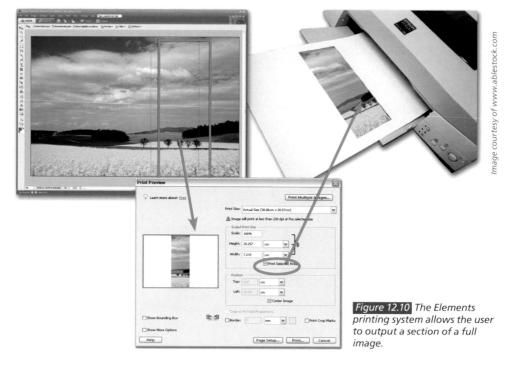

Printing a section of a full image

One very convenient feature of the Elements printing system is its ability to output a section of an image without having to modify the original picture itself. Simply pick the Rectangular Marquee tool and make a selection on the picture surface. Proceed to the Print Preview dialog and select the Print Selected Area option. See Figure 12.10. This feature is very useful for performing spot tests of important sections of large prints. The smaller prints will output faster than a full image and as long as the test areas are selected carefully, this process can be used to economically proof large and difficult images. In version 5.0 you can even use this option with multi-page Photoshop Creation documents with a unique selection possible on each page.

- MMARY
- 1 Select the area to be printed using the Rectangular Marquee tool.
- 2 Open the Print Preview dialog (File > Print).
- 3 Tick the Print Selected Area option.
- 4 Click Print to output the selection.

Making multiple prints

In the last few years the digital camera market has exploded. Now digital camera sales easily outstrip their film-based counterparts over the same selling period. And with the onslaught of these new silicon shooters has come a change in the way that people take pictures.

Users are starting to alter the way they shoot to accommodate the strengths of the new technology. One of these strengths is the fact that the act of taking a picture has no inherent cost. In comparison, film-based shooting always involves a development cost associated with the production of negatives and prints, as well as the initial purchase of the film whereas digital picture taking is essentially costless. Yes, there is the outlay for the camera and the expense associated with the storage, manipulation and output of these images, but the cost of shooting is zero. Hence, it seems that the typical digital camera user is shooting more pictures, more often, than they were when capturing to film. See Figure 12.11.

Figure 12.11 As there is no cost associated with shooting, digital camera users now take more pictures than when they were using film-based cameras.

Contact sheets

Editor: File > Print Multiple Photos > Contact Sheet

Digital photographers are not afraid to shoot as much as they like because they know that they will only have to pay for the production of the very best of the images they take. Consequently, hard drives all over the country are filling up with thousands of pictures. Navigating this array of images can be quite difficult and many shooters still prefer to edit their photographs as prints rather than on screen. The people at Adobe must have understood this situation when they developed the Contact Print feature for Photoshop and Elements. Elements 5.0 contains a version of the feature that is part of the Print Multiple Photos dialog.

From within one feature, the imaging program creates a series of small thumbnail versions of all the images in a catalog or those that were multi-selected before opening the tool. These small pictures are arranged on pages and can be labeled with file name, captions and dates. From there it is an easy task to print a series of these contact sheets that can be kept as a permanent record of a folder's images. The job of selecting the best pictures to manipulate and print can then be made with hard copies of your images without having to spend the time and money to output every image to be considered. See Figure 12.12.

Figure 12.12 The Contact Sheet option in the Print Selected Images or Print Photos dialog creates thumbnail versions of all the images from the thumbnail list.

Figure 12.13 The options in the Contact Sheet dialog allow the user to select the number of thumbnails per page by adjusting the columns value as well as what text will be included as labels.

The options contained within the Contact Sheet dialog allow the user to select the number of columns of image thumbnails and the content of the text labels that are added. The page size and orientation can be chosen via the Page Setup button.

- 1 If working in the Editor workspace open the images to be printed, otherwise multi-select the pictures from inside the Photo Browser.
- 2 Select File > Print Multiple Photos and choose Contact Sheet from the Select Type of Print menu. From the Photo Browser select File > Print and then choose contact print.
- 3 Use the Add and Remove Photos buttons to adjust the list of pictures to be included in the contact sheet.
- 4 Select the printer from the drop-down list in section 1 of the dialog. If need be, click the Printer Preferences button next to the printer selection to adjust the hardware settings to suit your output. See Figure 12.12.
- 5 In section 2 of the dialog select Contact Sheet from the drop-down list of print types. See Figure 12.12.

Book resources at: www.guide2elements.com

EATURE

- 6 In the final section 3 choose the number of columns to use (and therefore the total number of thumbnails to place on a single sheet) and select the content of the label text to be included. See Figure 12.13.
- 7 Click Print to output the contact sheet.

Picture packages

Editor: File > Print Multiple Photos > Picture Package or Organizer: File > Print > Picture Package

At some stage in your digital imaging career you will receive a request for multiple prints of a single image. The picture might be the only shot available of the winning goal from the local football match, or a very, very cute picture of your daughter blowing out the candles on her birthday cake, but whatever the story, multiple requests mean time spent printing the same image. Adobe included the Picture Package feature in its Elements and Photoshop packages to save you from such scenarios. Previously located in the Print Layouts section of the File menu where the Contact Sheet command was placed, the revamped Picture Package has now been integrated into the Print Multiple Photos dialog. The feature allows you to select one of a series of predesigned multi-print layouts that have been carefully created to fit many images neatly onto a single sheet of standard paper. Macintosh users can access the feature via the File menu in the editor or under the Automate menu in the file browser.

There are designs that place multiples of the same size pictures together and those that surround one or two larger images with many smaller versions. The feature provides a preview of the pictures in the layout. You can also choose to repeat the same image throughout the design by selecting the One Picture per Page option. There is no option to add labels as there was in version 2.0 of the feature but you can select a frame from one of the many listed to surround the photos you print.

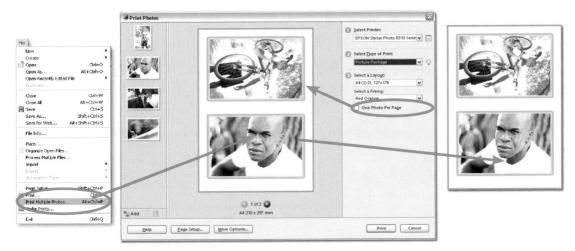

Figure 12.14 The Picture Package option lays out multiple versions of the same image or several different pictures on a single sheet of paper and includes an option for surrounding the photos with a fancy frame.

Whichever layout and frame design you pick, this feature should help you to keep both family members and football associates supplied with enough visual memories to make sure they are happy. See Figure 12.14 on page 301.

- 1 If working in the Editor workspace open the images to be printed, otherwise multi-select the pictures from inside the Photo Browser.
- 2 Select File > Print Multiple Photos and choose Picture Package from the Select Type of Print menu. From the Photo Browser select File > Print and then choose Picture Package.
- 3 Use the Add and Remove Photos buttons to adjust the list of pictures to be included in the contact sheet.
- 4 Drag the photos on the preview page to reorder their sequence or alter their position in the layout. You can also add more pictures from the film strip by dragging them from the left of the dialog into the Preview area.
- 5 Select the printer from the drop-down list in section 1 of the dialog. If need be, click the Printer Preferences button next to the printer selection to adjust the hardware settings to suit your output. See Figure 12.14.
- 6 In section 2 of the dialog select Picture Package from the drop-down list of print types. See Figure 12.14.
- 7 In the final section 3 choose the Layout and Frame design to be included. See Figure 12.15.
- 8 To repeat a single image on a page click the One Photo per Page option. To add many different pictures to the same page leave this item unchecked.

📆 9 Click Print to output the Picture Package pages.

EATURE

Figure 12.15 There are many different Layout and Frame designs included in the revised Picture Package feature.

Picture labels

Editor: File > Print Multiple Photos > Labels or Organizer: File > Print > Labels

First introduced in Elements 3.0 for Windows, this additional Multi-photo Printing option lays out and sizes the images to suit the design of commercially available sheets of adhesive labels. The layout box contains a variety of label sheet designs and just as with the Picture Package feature you can add frames to your label photos. To help with precise aligning of the print to the label sheet Adobe has also included an offset print settings box. Here you can make slight adjustments of where the pictures print on the paper surface. If the print is misaligned to the left then add a positive number to the settings; if the error is to the right then you will need to add a negative number to the dialog. See Figures 12.16 and 12.17.

- 1 If working in the Editor workspace open the images to be printed, otherwise multi-select the pictures from inside the Photo Browser.
- 2 Select File > Print Multiple Photos and choose Labels from the Select Type of Print menu. From the Photo Browser select File > Print and then choose Labels.
- 3 Use the Add and Remove Photos buttons to adjust the list of pictures to be included in the labels sheet.
- 4 Select the printer from the drop-down list in section 1 of the dialog. See Figure 12.16. If need be, click the Printer Preferences button next to the printer selection to adjust the hardware settings to suit your output.
- 5 In section 2 (See Figure 12.16) of the dialog select Labels from the drop-down list of print types.
- 6 In the final section 3 (See Figure 12.16)choose the Layout and Frame design to be included.

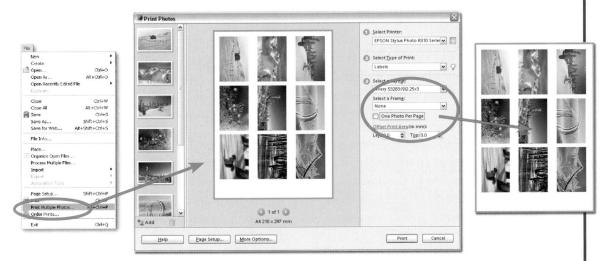

Figure 12.16 The Labels option lays out multiple versions of the same image or several different pictures in a format to suit commercially made sheets of adhesive labels.

- 7 To repeat a single image on a page click the One Photo per Page option. To add many different pictures to the same page leave this item unchecked.
- 8 Click Print to output the label pages.
- 9 If the label print doesn't quite match the perforations on the sheet then adjust the print position using the Offset Print Area settings.

Figure 12.17 As with the other Print Multiple Photos options, the Picture Labels feature allows you to print a page of labels with different images (1) or, by selecting the One Photo per Page setting, produce a whole sheet with multiple copies of the one picture (2).

Individual Prints

Editor: File > Print Multiple Photos > Individual Prints or Organizer: File > Print > Individual Prints
Included in Elements 5.0 is the ability to set up and print several individual photographs at one time. Until this version of the program the traditional Print Preview dialog (Editor: File > Print) was the only way you could print one photo on a page. This approach is fine if all you want to do is print a single photo, but what if you have 10 pictures that you want to print quickly and easily? Well this is where the Individual Print option in the Print Multiple Photos feature comes into play. This option allows the user to 'batch' a variety of one-image-to-one page photos at the same time.

Though you don't have as many options when outputting your picture with this feature you can still choose the size of the photo on the page and whether it will be cropped in order to fill the paper size fully. And for those times when you need a couple of prints of a group of pictures simply change the number of times the pictures will be used in the print batch. See Figure 12.18.

- 2 Select File > Print Multiple Photos and choose Individual Prints from the Select Type of Print menu. From the Photo Browser select File > Print and then choose Individual Prints.
- 3 Use the Add and Remove Photos buttons to adjust the list of pictures to be included in the labels sheet.
- 4 Select the printer from the drop-down list in section 1 of the dialog (See Figure 12.18). If need be, click the Printer Preferences button next to the printer selection to adjust the hardware settings to suit your output.
- 5 In section 2 of the dialog (See Figure 12.18) select Individual Prints from the drop-down list of print types.
- 6 In the final section 3 (See Figure 12.18) select the Print Size you desire. If you are using the Fit on Page option then you can also select the Crop to Fit feature designed to ensure the picture fills the print paper fully.
- 7 To obtain more than one print of each picture adjust the value in the Use each photo option.
- 8 Click Print to output the individual prints.

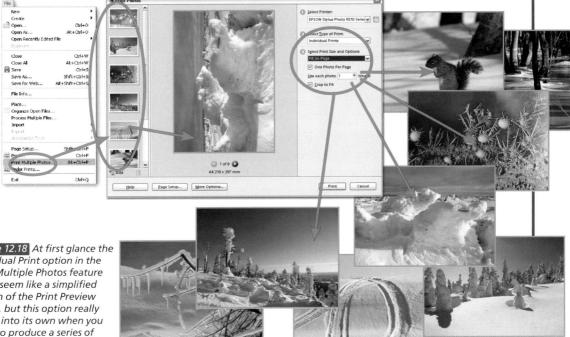

Figure 12.18 At first glance the Individual Print option in the Print Multiple Photos feature might seem like a simplified version of the Print Preview dialog, but this option really comes into its own when you want to produce a series of prints of single images quickly and easily.

Balancing image size and picture quality

The printing techniques detailed above can be used for producing good prints for the majority of images, papers, inks and printers. To gain the ultimate in control over your printed output, however, you need to delve a little deeper. Let's start by revisiting the factors that underpin good image quality.

Great prints are made from good images, and we know from previous chapters that digital image quality is based on high image resolution and high bit depth. Given this scenario, it would follow that if I want to make the best prints possible, then I should at first create pictures with massive pixel dimensions and huge numbers of colors. The problem is that such files take up loads of disk space and, due to their size, are very, very slow to work with, to the point of being practically impossible to edit on most desktop machines.

The solution is to find a balance between image quality and file size that still produces 'good prints'. See Figure 12.19. For the purposes of this book, 'good prints' are defined as those that appear photographic in quality and can be considered visually 'pixel-less'. The quality of all output is governed by a combination of the printer mechanism, the ink set used and the paper, or media, the image is printed on. To find the balance that works best with your setup, you will need to perform a couple of simple tests with your printer. See Figure 12.20.

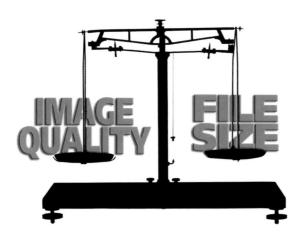

Figure 12.19 Just as was the case with photos optimized for web usage, good prints are made from files that balance file size and image quality.

Aiming for the best prints Getting to know your printer

Testing tones

There are 256 levels of tones in each channel (Red, Green and Blue) of a 24-bit digital image. A value of 0 is pure black and one of 255 is pure white. Desktop inkjet machines do an admirable job of printing most of these tones, but they do have trouble printing delicate highlight (230-255) and shadow (0-40) details. Some machines will be able to print all 256 levels of tones, others will only be able to output a smaller subset. See Figure 12.21.

Figure 12.20 The three practical factors that govern all printed output are the printer mechanism, the inks used and the paper or media the image is printed on.

To test your own printer/ink/paper setup, make a stepped grayscale that contains separate tonal strips from 0 to 255 in approximately five tone intervals. Alternatively, download the example grayscale from the book's website. Print the grayscale using the best quality settings for the paper you are using. Examine the results. In particular, check to see at what point it becomes impossible to distinguish dark gray tones from pure black and light gray values from white. Note these values down for use later, as they represent the range of tones printable by your printer/paper/ink combination. See Figure 12.22.

When you are next adjusting the levels of an image to be printed, move the output sliders at the bottom of the dialog until black and white points are set to those you found in your test. The spread of tones in your image will now meet those that can be printed by your printer/paper/ink combination. See Figure 12.23.

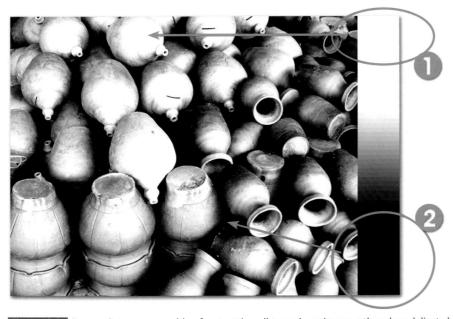

Figure 12.21 Some printers are capable of outputting all tones in an image, others lose delicate highlight and shadow details in the printing process. (1) Lost highlight. (2) Shadow detail.

Figure 12.22 Print the example grayscale, noting down the tones that your machine fails to print.

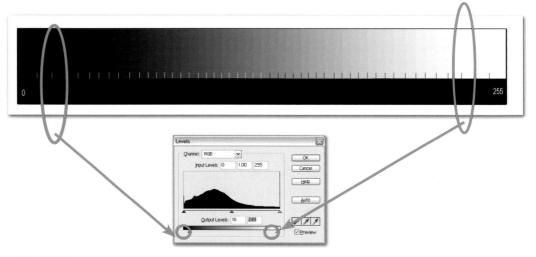

Figure 12.23 Drag the black and white output sliders till they match the values of those found in the grayscale or tone test.

Testing resolution

Modern printers are capable of incredible resolution. Some are able to output discrete dots at a rate of over 5000 per inch. Many users believe that to get the utmost detail in their prints they must match this printer resolution with the same image resolution. Although this seems logical, good results can be achieved where one pixel is printed with several printer dots. Thank goodness this is the case, because the result is lower resolution images and therefore more manageable, and smaller, file sizes. But the question still remains – exactly what image resolution should be used?

Again, a simple test can help provide a practical answer. Create a high-resolution file with good sharp detail throughout. Using Image > Resize > Image Size makes a series of 10 pictures from 1000 to 100 ppi, reducing in resolution by 100 ppi each time (i.e. 1000, 900, 800, etc.). Alternatively, download the resolution examples from the book's website (www.guide2elements. com). Now print each of these pictures at the optimum setting for your machine, with ink and paper you normally use. Next, examine each image carefully. Find the lowest resolution image where the picture still appears photographic. This is the minimum image resolution that you should use if you want your output to remain photographic quality.

For my setup, this setting varies between 200 and 300 ppi. I know if I use these values I can be guaranteed good results without using massive file sizes.

Managing color

As computer operating systems have developed, so too has the way that they have handled the management of color, from capture through the manipulation phase to output. A central part of this process is a group of settings, called a color profile, that governs the conversion of an image's color from one device to another. A well-calibrated system will contain a profile for scanner/camera, screen and printer, so that the image is passed from one managed space to another.

When printing with Adobe Elements it is possible to select the type of color management you want to apply to the output. If your printer came supplied with a profile, you can select it in the Print Space area of the Print Preview dialog. Some printers are supplied with several profiles matched to different paper types. You might have to select Show More Options to make this part of the dialog visible. If no profile is supplied, then you can either elect to use the same space the image was captured in or use the printer color management built into the driver. See Figure 12.24.

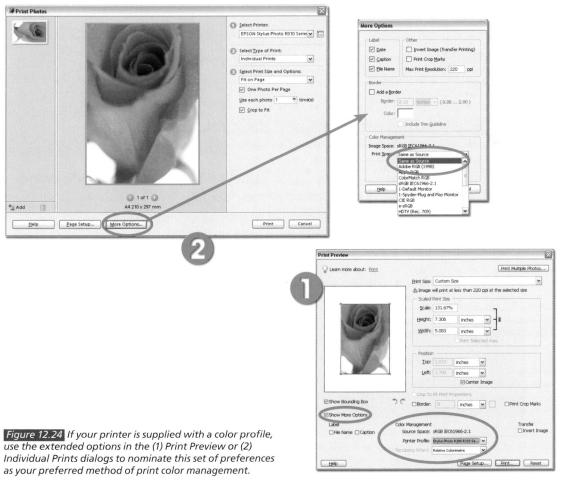

Book resources at: www.guide2elements.com

For the majority of output scenarios these options will provide good results. If you do happen to strike problems where images that appear neutral on screen continually print with a dominant cast, then most printer drivers (the special printer software that manages the activity of printing) include a feature such that individual colors can be changed to eliminate casts. See Figure 12.25.

Figure 12.25 Rid images of persistent casts using the color slider settings built into your printer's driver software.

Typical printing problems and their solutions

Surface puddling (pooling)

Prints with this problem show puddles of wet ink on the surface of the paper resulting from too much ink being applied. To help this situation, reduce the Cyan, Yellow and Magenta sliders in the printer's dialog box. Make sure that you make the same change to all three sliders, otherwise you will introduce a color cast into the print. Also increase the Saturation slider; this will decrease the volume of ink going to the black nozzle. See Figure 12.26.

Figure 12.26 Surface puddling results from too much ink hitting the paper surface.

Figure 12.27 Cleaning the print heads usually solves banding problems.

Figure 12.28 Edge bleeding can result from using an uncoated porous paper.

Banding

This problem usually results from one or more of the print heads being clogged. Consult your printer's manual to find out how to activate the cleaning sequence. Once completed, print a 'nozzle test' page to check that all are working correctly. If banding still occurs after several cleaning attempts, it may be necessary to install a new cartridge. See Figure 12.27.

Edge bleeding

Edges of the print appear fuzzy and shadow areas are clogged and too dark. This usually occurs when using an uncoated paper. Use the corrective steps detailed in 'puddling' above, as well as choosing a media or paper type such as 'Plain Paper' or 'Backlit Film'. These measures will change the amount of ink being applied and the spacing of the ink droplets to account for the absorbency of the paper. See Figure 12.28.

Web-Based Printing

Editor: File > Order Prints, Organizer: File > Order Prints

In designing Elements, Adobe realized that the web plays, and will continue to play, a large role in the life of most digital image makers. The inclusion of a Web-Based Printing option in the package shows just how far online technology has developed.

Although many images you make, or enhance, with Elements will be printed right at your desktop, occasionally you might want the option to output some prints on traditional photographic paper. The Order Prints option, located in the File menu, provides just this utility. See Figure 12.29.

Using the resources of KodakGallery.com in the USA, Elements users can upload copies of their favorite images to the company's site and have them photographically printed in a range of sizes. The finished prints will then be mailed back to you. This service provides the convenience of printing from your desktop with the image and archival qualities of having your digital pictures output using a photographic rather than inkjet process.

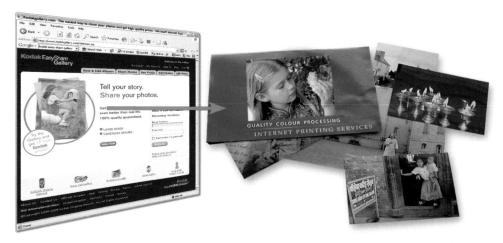

Figure 12.29 The Online Services feature allows you to print digital files photographically direct from your desktop.

Making your first online prints

In previous versions of Elements you needed to access the Online Services feature before uploading your pictures to print, but Elements 5.0 streamlines the process by allowing you to upload directly from the Editor or Organizer workspace. The first time you use the feature you will need to register for the service but from that time onwards the feature works seamlessly from inside the Elements package. See Figure 12.30.

Although kodakgallery.com does provide a set of simple online editing and enhancement tools at its main site, I prefer to alter my images in Elements first before uploading. In addition to printing your favorite pictures, kodakgallery.com also provides album creation and imagesharing services, allowing you and your friends to upload your favorite photos, review them and then print those that you like the most. See Figure 12.31.

Figure 12.30 Images that are already opened in Elements can be uploaded directly to the kodakgallery.com website.

Book resources at: www.quide2elements.com

If you like the look of true photographic quality prints, then this online option provides a quick, easy and reliable service to output your digital images from your desktop.

To print online

- 1 Select or multi-select pictures from Photo Browser.
- 2 Choose File > Order prints.
- 3 Choose print numbers and size from the Customize section of kodakgallery.com. Click Next
- 4 Select the recipient of the prints from the list or add new contact details and then click Next.
- 5 Review print and shipping charges at the next screen and then click Next.
- 6 At the Billing section insert your credit card information and add the billing address. Click Place Order, which will upload your pictures and then display an order confirmation.

To upload files for sharing

- 1 Select or multi-select pictures from the Organizer workspace.
- 2 Choose the Share Online option from the Share button in the shortcuts bar.
- 3 Choose the person you want to share the pictures with from the list or add new contact details for a new recipient. Click Next.
- 4 The files will now be uploaded and an invitation to share the pictures will be sent to the recipients selected in the previous step.

Description on the fact (explains) account interest begins:

| In | In | Proposition | Interest |

Figure 12.31 The uploaded pictures can be stored in a series of photo albums on the kodakgallery.com website ready for sharing and printing. The online service can also be used for creating and printing cards, calendars and photo books.

Options for web printing

Version 5.0 of Elements contains a streamlined method of ordering online prints. Individual or multi-selected thumbnails are dragged and dropped onto contact names in the new Order Prints pane. The photos to print are associated with the contact name and once the order is confirmed they are uploaded, printed and sent to the contact using the delivery details first entered when creating the contact. See Figure 12.32.

Using the Order Prints pane

- 1 Open the Order Prints pane by selecting Organizer: Window > Order Prints.
- 2 Select or multi-select images from the Photo Browser (Organizer) workspace to print.
- 3 Drag the selected prints to the Contact name (Target) in the pane. When the target changes color let go of the mouse button to drop the pictures.
- 📆 4 Press the Confirm Order button to process the order with the online print company.

To add a new Order Print contact

1 Open the Order Prints pane and press the Add New Contact button by selecting Organizer: Window > Order Prints. Insert the details in the dialog displayed (1). See Figure 12.32.

To review and confirm an order for a specific contact

1 Open the Order Prints pane, select a contact name from those listed and then press the View Photos in Order button. Review the photos shown in the dialog and then press the Confirm Order button to place the online print order (2). See Figure 12.32.

Figure 12.32 Use the Order Prints pane to drag and drop photos to be printed online onto the contact that they are to be sent to.

Photo Creations

The Photo Creation projects

Photo Book Pages, Photo Layout and Album Pages

Greeting Card

CD and DVD Jackets

CD/DVD Label

Slide shows on your computer or TV

VCD/DVD with Menu

Photo Gallery

Flipbook

Photo Calender

Photo Stamps

s we have already seen in previous chapters, Photoshop Elements includes a variety of special Photo Creations. These are sophisticated imaging projects that enable users to quickly and easily produce and share their pictures in a range of project forms. A few years ago it would have been sufficient for a good image-editing package to include a print command and maybe a way to export pictures in a variety of different file formats, but these days photos are compiled, shared, distributed and displayed in a much broader range of ways. With the inclusion of the Photo Creation projects in Elements you too can start to use your pictures in forms that you may never have thought possible.

The Photo Creation projects

Photo Browser: File > Create or Editor: File > Create

The Photo Creation projects can be accessed from the Organizer and the Editing spaces by selecting the option from the File > Create menu or the Create button in the shortcuts bar. These actions will provide you with a list of project types. See Figure 13.1. In previous versions of Elements this action would take you to a Creation Setup page where you could select the project type to produce. In 5.0 the File > Create menu contains a list of creation types. Selecting a project from the menu forwards you directly to the dialog for that project.

The Photo Creations main screen contains a range of project options that can be used for featuring your images. Some of the projects will already be familiar to Elements users as they have appeared in various forms in previous versions of the program, but others such as the Photo Layout, Flipbook, PhotoStamps, CD/DVD Label and CD/DVD Jacket items create new and exciting ways to share you pictures with others. See Figure 13.2.

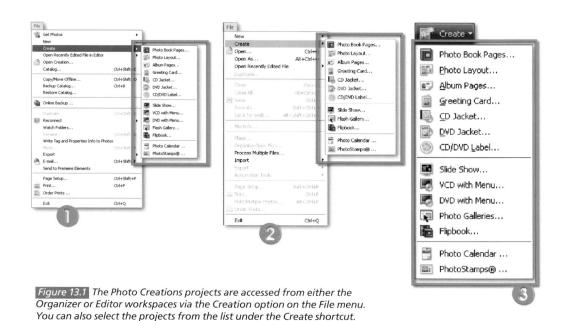

(1) Organizer. (2) Editor. (3) Create shortcut.

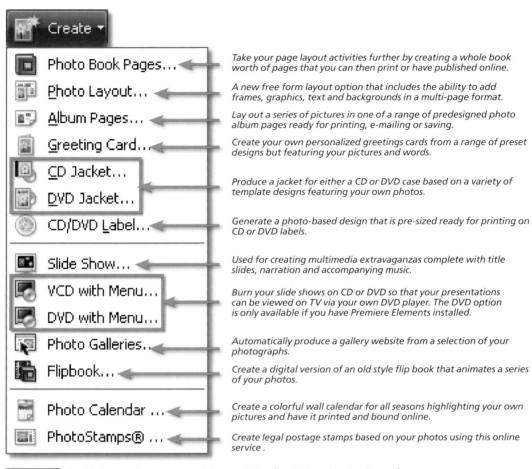

Figure 13.2 The Photo Creations menu contains a variety of project options to choose from.

Each project requires you to have some basic resources prepared before starting out. For the most part this means that you should have selected, enhanced and edited any pictures you wish to include before commencing the creation process. In the case of the VCD or DVD with Menu options you will need to create the slide shows that you want to feature before selecting these options. For this reason it is a good idea to follow the workflow detailed below when making your Photo Creations. See Figure 13.3.

Figure 13.3 As you need to have all your pictures edited and enhanced before adding them to your Photo Creation projects, start by enhancing your pictures then save the finished file back to the browser. Now select the pictures to include and then select the Photo Creations project. The selected images will now appear in the project dialog.

Photo Book Pages, Photo Layout and Album Pages

The Photo Book Pages, Photo Layout and Album Pages options use the same basic interface to create multi-page documents from a group of selected photos. All the options allow the user to automatically lay out the pictures using one of a range of templates and styles, and then edit or add to the layouts in the Full Edit workspace. The main difference is the intended outcome for each option. Photo Book Pages are designed for publishing online, Album Pages suit printing at home and Photo Layout is more of a free form layout tool that can be used for both single and multi-page compositions. For more details on creating Photo Layouts see Chapter 9.

Start by selecting the photos that you wish to include from the thumbnails displayed in the Organizer workspace. To select a group of pictures click on the first thumbnail and then hold down the Shift key whilst selecting the last photo. To pick individual images Control-click on the thumbnails. Next choose the Photo Creation project to create. This example uses the Photo Book Pages option.

Photo Book Pages are designed specifically for uploading to an online book publishing company. For this reason they have specific production requirements. After selecting the entry in the Create menu Elements displays a Help dialog to direct new users to the guidelines for online book production. Click Go to Help to read the details.

The New Photo Book Pages dialog is then displayed. Choose a Layout and Style by clicking the example thumbnail. In this example there is no need to pick a page size as only one is available for online use other Creation projects have different choices. Adjust the captions entries and then click OK to produce the multipage document. Save the completed creation.

The creation process is not complete. The next step is outputting the design. It is at this point that the Photo Book Pages option differs from Photo Layout and Album Pages. Select the Order Kodak Photo Book from the Print Publications Online shortcut menu.

The Order Kodak Photo Book dialog is displayed with the pages that you have created placed in sequence. There is a vacant space at the beginning of the page sequence for a title page. Click the Add Photos button to insert a picture or title graphic here. Pages can be reordered by click-dragging them to a new position. Press the Next Step button to continue.

In this new dialog you will see a preview of the pages in the book. Use the side arrows to navigate from one page to the next. Add text in the nominated caption areas and then select the Done button. The completed pages are uploaded to the Kodak Easy Share gallery site.

The new dialog requests the new user to register for the service and returning users to log in.

After logging in select the style of book to be produced and then complete the rest of the order conditions before clicking Ok to submit the book order.

Note that while this is the standard workflow you can also create documents without images and add photos later from the Photo Bin in the editor or by replacing the images in the Frame layers.

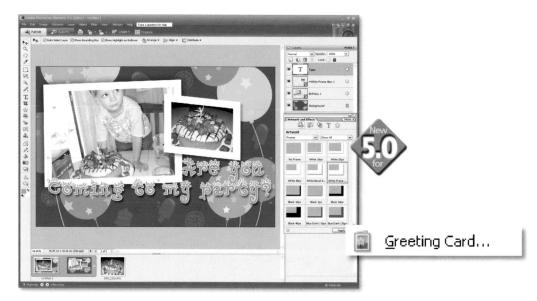

Greeting Card

Creating greetings or birthday cards customized with your own pictures and heartfelt message is a good way to make the card-giving experience a little more personal. The Photo Creations Greeting Card project contains many different template and styles ranging from formal, season's greetings, valentine and baby cards. Most have decorative borders, appropriate color schemes and places for you to add your message. Like other Photo Creation projects, Greeting Cards are created by selecting edited images from the Organizer before having them automatically placed in one or a range of templates. From here you can add graphics and text and even more images before outputting the final design to your desktop printer or online as a Photo Greeting Card.

Start by multi-selecting photos from the Organizer workspace before choosing Greeting Card from the File > Create menu. With the New Greeting Card dialog open choose the size of the card to create. Pick 4 × 6 inch for printing at home and 5 × 7 inch for ordering Photo Greeting Cards online.

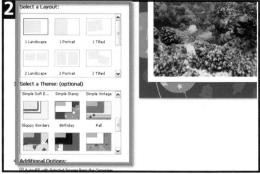

Next choose the Layout for the card. You can pick between a range of basic designs based on the number of images to be included. Don't panic if the position of the photos is not exactly what you want as this can be changed later. With the Layout selected you can now choose the Theme (frame and background design). Click OK to create the card.

Adjust the position, size, shape and orientation of the photos placed on the greeting card using the corner and side handles. See Chapter 9 for more details. When finished click the Commit button (green tick) at the bottom of the frame to apply the changes.

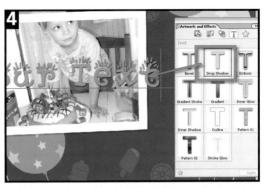

Add text to the card by double-clicking on the text style thumbnail that you want from those listed in the Text area or the Artwork and Effects palette. Replace the text that is automatically placed on the card with your own and alter color and font style in the normal manner. See Chapter 7 for more details on making changes to text.

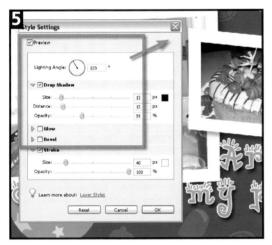

Add graphics, shapes, special effects and extra photos to the card by selecting the desired option from the Artwork and Effects palette and then clicking the Apply button. Alter the look of characteristics of shadows, strokes and bevels using the Layer > Layer Style > Style Settings dialog.

Either print the card with a desktop machine connected to your computer or upload the card to print online. Do this by selecting the Order Photo Greeting Card option from the Print Online shortcut.

CD and **DVD** Jackets

CD and DVD jackets are the sheets of paper or thin card that wrap around the outside of the CD/DVD case. The inclusion of a Photo Creation option for the creation of these jackets is new for Elements 5.0. There is no real difference between the two choices except for the size of the finished creation document. For this reason I have presented only one step-by-step technique here. After creating a jacket with a combination of your images and one of the themes provided in the creation dialog, the final design is printed, the edges trimmed and the paper inserted into the cover space of the case.

CD/DVD cases normally open like a book so remember to position the front cover details on the right-hand side of the design.

Start by multi-selecting photos from the Organizer workspace before choosing CD or DVD Jacket from the File > Create menu. Depending whether you are creating a CD or DVD jacket the size option will be different. DVDs are 11 × 7.5 inches (1) and CD jackets are 9.75 × 4.75 inches (2).

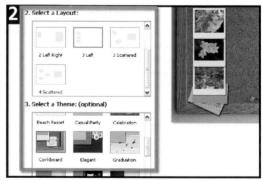

Next choose the Layout for the jacket. Select the number of photos to include in the Layout section and then choose a Theme (matched Frame and Background design) before pressing OK to create the document.

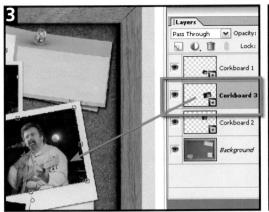

A new creation document is produced with the selected images inserted into the frames and placed onto the background. If more images were selected than the places available in the document then Elements creates a second page and places the extra photos there. Each framed image is stored on its own layer.

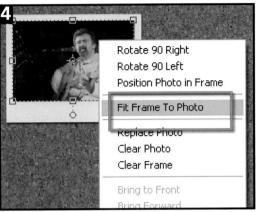

Right-click on each image in turn and choose Fit Frame To Photo. Next adjust the size and orientation of the photo and the frame using the side and corner handles. For more details on how to manipulate frames and the pictures they contain go to Chapter 9.

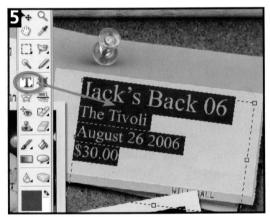

With the images in place we can now turn our attention to adding other details to the design. Here extra text is inserted in the Ticket Stub section of the theme's background. The color and style of the text are matched with the print already in the design.

For a finishing touch the pins from the corkboard background are copied and pasted into the composition on a new layer. A set of matching shadows is drawn on a separate layer and positioned beneath the pin. The two layers are duplicated and used to 'pin' the photos in position.

After saving the completed composition the CD/DVD jacket is then printed using the actual size setting to ensure that the jacket fits the case.

CD/DVD Label

Another new inclusion for Elements 5.0 is the CD/DVD Label project. This Photo Creation produces a circular design that is suitable for printing onto the surface of printable CDs or on perforated label paper. Like the other new or revised creation projects in Elements 5.0, an image or images are selected from the Organizer workspace before selecting File > Create > CD/DVD Label and proceeding to the main creation screen. Here you have no choice over the document's size as all the templates are designed with dimensions to suit a standard DVD or CD disk. The choice of layouts is largely based on the number of images to include on the CD label, but the selection you make here doesn't restrict you from adding (or taking away) images later in the design process. Some of the same themes that are available in the CD/DVD Jacket creation are also contained here and so it is possible to create matching label and jacket sets for your projects.

Start by multi-selecting photos from the Organizer workspace before choosing CD or DVD Label from the File > Create menu. There is no need to select the size as it is predetermined to suit the dimensions of a standard CD/DVD disk. Choose the Layout based on the number of photos to include and the design you like, and then customize this choice by picking a Theme to apply. Click OK.

Right-click on the photo and choose Fit Frame To Photo. Next adjust the size and orientation of the photo and the frame using the side and corner handles. Keep in mind that the edges will be cut to suit the disk shape. For more details on how to manipulate frames and the pictures they contain go to Chapter 9.

If you want to add more images to the design then locate a frame to include from the Artwork and Effects palette and then click and drag the thumbnail onto the document. A new frame will appear. To add a photo either drag one from the Photo Bin to the frame or click in the center and browse for a picture file in the file dialog that opens. To find out more about adding, removing and replacing photos in a Photo Creation document go to Chapter 9.

After positioning the pictures we can now add some text to the composition. As we are matching the design used in the CD/DVD Jacket creation the text is inserted in the Ticket Stub section of the Theme's background. The color and style of the text are matched with the print already in the design.

Once the design is completed save the creation project and then insert the CD/DVD or label sheet into the printer ready for printing. Select File > Print and ensure that the print size is set to Actual size (scale = 100%). This will guarantee that the final label is an exact match to the CD/DVD disk.

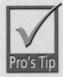

Note that for some label types some repositioning of the design might be required.

I would recommend doing a test print on plain paper and making sure that the design lines up with the label paper.

Book resources at: www.guide2elements.com

Slide shows on your computer or TV

As we have already seen in Chapter 10 the Slide Show option in Elements 5.0 is very sophisticated. Gone is the simple menu-based wizard that Elements featured in earlier versions of the product. Now, using a single Slide Show editor, you create and arrange show slides, add music, text, graphics and narration then finally produce the show in one of a range of formats. For more specific detail about how to use the Slide Show feature see Chapter 10.

Start creating your slide show by selecting the photos that you wish to include from the thumbnails displayed in the Organizer workspace.

To select a group of pictures click on the first thumbnail and then hold down the Shift key whilst selecting the last photo. To pick individual images Control-click on the thumbnails.

With the pictures selected, choose File > Create > Slide Show. This action will display the Slide Show Preferences dialog. Using the controls here set the general slide duration, transition, transition duration, background color, cropping and caption options that will be used for the whole show. There are also options to adjust how the soundtrack will be added to the presentation and the overall quality of how the show previews in the Editor space.

The Slide Show editor is displayed after clicking OK at the Preferences dialog. Adjust the sequence of the photos in the presentation by switching to the Quick Reorder screen (View > Quick Reorder). Click and drag photos to a new position to change their place in the show's sequence. When finished choose View > Quick Reorder to change back to the Slide Show editor view.

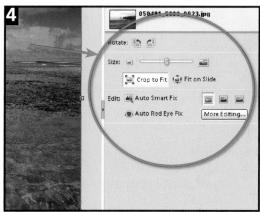

To make basic (automatic) editing changes to the slides in the presentation click on the preview picture (large) and then adjust the settings in the Properties pane. Here you can rotate, adjust picture size, alter cropping and apply Auto Smart Fix and Auto Red Eye Fixes. There are also three quick Photo Effect buttons that convert the slide to black and white, sepia and back to color.

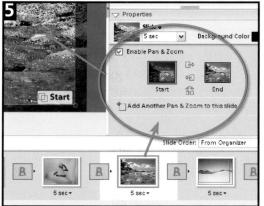

Along with the basic transition effects there is also the ability to animate the pictures in the presentation. This effect is created with the Pan and Zoom controls, which are displayed in the Properties pane when the slide thumbnail is selected in the timeline. Click the check box to enable the feature and then set the Start (Green) and End (Red) marquees on the slide preview.

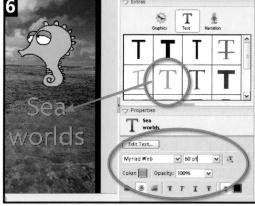

In addition the editor allows you to add graphics, text and narration to your show. Simply select the heading in the Extras pane and then drag and drop the text or graphics onto the slide and adjust size and color or effects using the options in the Properties pane. Select the Narration option to record any comments to be added to the slide.

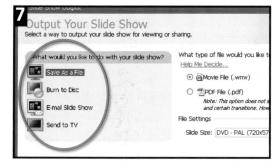

To add a music track to the show click the music bar below the timeline and browse for the file to include. The transitions added to all slides can be changed or customized by clicking on the 'A-B box' between slides in the timeline and altering the settings in the Properties pane.

Once you are happy with the presentation design save the show (File > Save Slide Show Project) before outputting (File > Output Slide Show) the presentation in one of the formats listed in the Output dialog.

VCD/DVD with Menu

I'm sure that it wouldn't take too much prompting for readers to recall the dreaded family slide shows that seem to occur regularly on lazy Sunday evenings in many households around the country. Everyone's favorite uncle would present a selection of the family archives and we would all sit around amazed at how much we had changed and try not to make rude comments about clothing styles and receding hairlines.

Well, the days when most photographers recorded the family history on slide film have long gone but the slide show events that accompanied these images are starting to make a comeback, thanks in part to the ease with which we can now organize and present our treasured digital photos on new media like CD and DVD. Gone too are the dusty projectors, being replaced instead by DVD players hooked to widescreen 'tellies'. This project converts your Elements slide shows to VCD format ready for viewing on most DVD players or computers with a DVD drive but, to be sure that your machine is compatible, check the equipment manual first.

In Elements 5.0 slide shows can be written directly to VCD or DVD with the output options found in the revised Slide Show editor; however, DVD burning does require Premier Elements to be installed alongside Photoshop Elements.

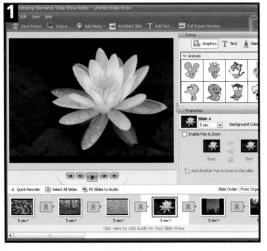

Before you can create a DVD or VCD with a menu you must have at least one slide show saved into the Photo Browser. If you don't have a candidate slide show then start the process by selecting the Slide Show option and creating a multimedia presentation complete with sound. Save the project to the Organizer.

iataigne

Select the slide shows that you want to include in the VCD from the Photo Browser and then pick VCD with Menu from the File > Create. Add or Remove slide shows from the thumbnail list if you are unhappy with your selection. Click and drag slide shows to new positions in the list to adjust where they will be placed in the menu of the VCD. The small number in the top left of each thumbnail indicates the sequence. Click Burn when you are happy with the arrangement.

The burn step is a two-part process. First, any slide show not in the Windows Media Video file will be converted to that format. The conversion can be quite lengthy if you are burning slide shows containing many high-resolution files. If you want to speed up this section of the process, convert your shows to WMV beforehand from inside the Slide Show project dialog.

The second part of the burn process is writing the CD/DVD itself. After converting the slide shows to WMV files a Burn dialog will appear. Make sure that a new blank CD/DVD is inserted into the writer and click the OK button to create the VCD.

Photo Gallery

Photoshop Elements 5.0 ships with a brand new Photo Gallery feature (previously called the HTML Photo Gallery or Web Photo Gallery). Located in the Create menu, not in the Automation menu of the Editor as it was in version 2.0, the new design consolidates all the options that were previously available in multiple screens into two single streamlined dialogs. But it is not just the interface that has changed – the way that you use the feature has altered also.

The first dialog provides options for the type and style of gallery that you create, the second dialog allows you to customize the design as well as add in photographer contact details and choose where and how you want to display the result and website.

For more details on using the Photo Gallery feature and preparing images for web display see Chapter 11.

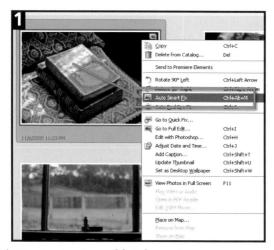

As is the case with most Photo Creation projects, you should adjust, edit or enhance the photos that are to be included in your gallery before selecting them from the Organizer workspace. Here I made use of the Rotate and Auto Smart Fix options located in the menu that is displayed when you right-click a thumbnail for some quick general adjustments. For trickier enhancement tasks you will need to move the photo to the Full or Quick Fix editing spaces.

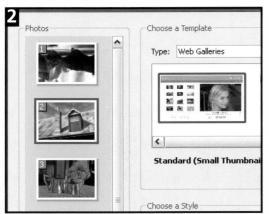

When the Photo Gallery dialog opens you will notice that the images you selected in the Organizer are listed on the left of the screen. The Add and Remove buttons at the bottom of this group of thumbnails allow you the chance to alter the photos that are to be used in producing the gallery. In addition you can click-drag the images to new positions in the sequence they will be shown in the gallery pages.

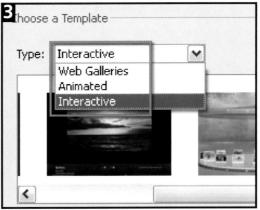

The next step is to choose a template for the website. Elements 5.0 adds animated and interactive options to the typical web gallery design that you would normally expect in a website wizard. The template type that you select determines the range of designs, and variations of designs (styles) are available. Clicking the Next Step button at the bottom of the window displays the next dialog complete with a preview of the website.

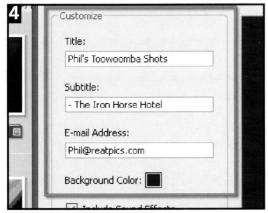

The left-hand side of the screen shows a Customize panel. The options displayed here are dependent on the design type, template and style that you selected in the first screen. For the interactive option in the example the user can add title and contact details and choose the background color and whether to include sound effects with the website.

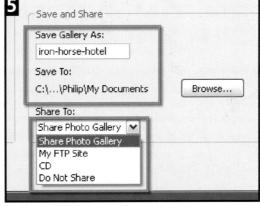

In the Save and Share section of the dialog you nominate the name that the gallery will be saved as, where the files will be stored and how you want to share the resultant web pages. Options include using your own web space (My FTP Site), the Adobe Photoshop Showcase (Share Photo Gallery), producing the gallery for CD or just saving the current files.

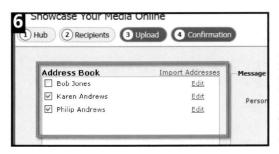

In this example the web gallery is to be shared via the Share Photo Gallery option which uploads the pages to the new Photoshop Showcase website. After selecting the Share button in the Photo Gallery dialog a new Showcase Your Media Online window is displayed. Step your way through the options in the four steps and before you know it your new gallery will be online and ready to view.

Flipbook

Until the current release of Photoshop Elements the only way to create a short animation in the program from a series of still images was to save the file as a GIF image (see Chapter 11), but now you can produce a short production with the new Flipbook feature. The feature derives its name from the old technique of drawing a slightly different picture on the successive pages of a small notebook. You would then animate the sequence by grasping the edge of the pages, arching the book and flipping the pages in quick sequence.

Unlike the animations produced in GIF format where each layer of the Elements document becomes a frame in the movie, the Flipbook feature uses a series of different images that have been selected in the Organizer space as the basis for the animation. This approach makes the feature particularly good for creating snippets of action from sequences of photos captured on the Burst or Continuous Shooting mode with your digital camera.

For more details on using the Flipbook feature see Chapter 11.

It is not just the images that you select which are important to the creation of a successful Flipbook – the position each image takes within the sequence also impacts upon the overall effect of the animation. For these reason it is a good idea to add the source photos to an Elements collection as the first step in the creation process. Of course, this should happen after each image has been enhanced and corrected.

Book resources at: www.quide2elements.com

Elements collections are a unique grouping of images in that the sequence of the photos is recorded as well as their membership in the group. When a collection of photos is displayed in the Photo Browser workspace the user can alter the position of any photos within the sequence by simply clickdragging the thumbnail to another spot. In the example I added the photos to a collection called 'Flipbook-Ellie'. To display the collection you just double-click the heading in the Collections palette.

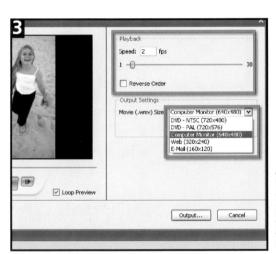

Next select the images to be included in the book from the open Collection and choose the File > Create > Flipbook option. The Flipbook dialog is then displayed. Here you can set the playback speed in frames per second (FPS), the order the sequence is played and the pixel dimensions of the output. Click the Output button to create the movie.

The newly created Flipbook movie is stored in the WMV or Windows Media Video file format at the top of the Organizer. The animation can be played by most Windows machines. Double-clicking the file in the Photo Browser displays the video with the Elements video player utility.

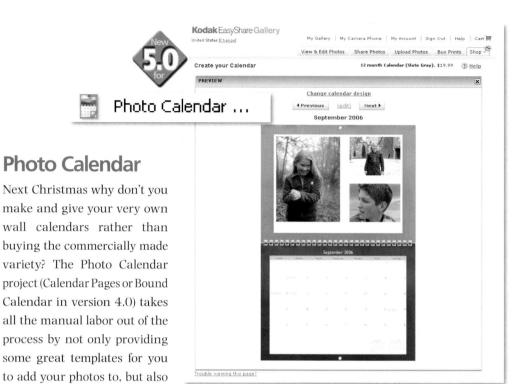

into the dialog. Simply insert the start and end dates for your calendar and Elements works out the days and dates for whatever year you choose. The hardest task you have to perform in the whole process is choosing which pictures to include and which to leave out.

In version 5.0 the two calendar options (one for online printing and one for producing at home) that were included in the previous edition of the program have been replaced with a single Photo Creation project. Images are selected in the Organizer space, the Photo Calendar option selected and then the files are uploaded to the Kodak Easy Share Gallery website. Here you can select the style and color of the calendar and choose if you want the wizard to auto fill the image spaces with your photos or allow you to add the images page by page. The final step is to order the calendar and then Kodak does the rest, producing and binding the project and then shipping it directly to you.

Make sure that all the photos that you want to include in your calendar have been carefully enhanced before starting the process. A calendar, just like a website and flipbook, has a defined sequence of images as part of the project itself. It is also a good idea to add the photos to a collection as well. When the collection is displayed you can reorder the sequence of photos so that feature images match the months they are illustrating. When complete multi-select the photos and choose File > Create > Photo Calendar.

Book resources at: www.guide2elements.com

including a date calculator built

After selecting the Photo Calendar option, Elements contacts the Kodak Easy Gallery website and displays a registration screen. First time users will need to fill out a simple registration section and nominate a log-in e-mail address and password. Returning visitors only need to supply their log-in and password details. After successfully logging in, the selected images will start to upload to the site. This process can take a while, especially if you are using high-resolution photos or have a slow Internet connection. Click Next to continue.

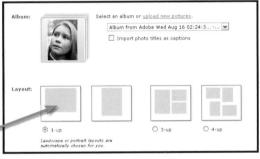

With the pictures now uploaded you will be presented with a small pop-up screen that asks if you want the images to be automatically placed on the calendar pages (Auto Fill) or if you would prefer to make the decision page by page (Manual). Next you select a template design and color and then choose the starting date for the calendar and the number of images each page will feature. Click Next to continue.

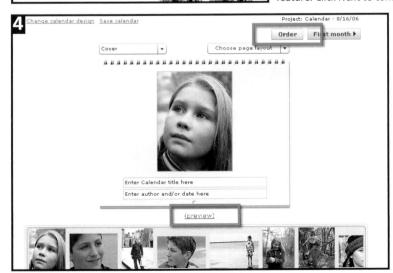

With the images in place you can now preview the calendar design, edit any pages that you are not happy with and finally order the finished project. After the order is confirmed Kodak prints, binds and ships the calendar.

Photo Stamps

Photo Stamps is a new creation project that turns your photos into postage stamps that can be used for sending mail through the United States postal system. The production part of the process takes place online and is provided by Adobe Photoshop Services in conjunction with www.stamps.com. Like the Photo Calendar project, the images used for creating Photo Stamps are selected in the Organizer first and then uploaded to the website. Here the user gets the chance to make some adjustments to the placement of the photo in the stamp design, choose the monetary value of each stamp and the quantity ordered.

After selecting the image to be used for the stamp from the Organizer, choose the Photo Stamp option from the File > Create menu. This starts the image optimization and upload process.

With the photos now uploaded to www.stamps.com you will need to select a particular picture to use as the basis for making a stamp from the Image Gallery. Next click the Create Product button.

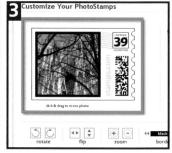

After making selections about the monetary value of the stamp the wizard provides you with some placement adjustment controls as well as some simple color choices. When the design is finalized you can proceed to the checkout to order and pay for the stamps.

Managing Your Files

Organizing your photos with Photoshop Flements 5.0

Organizing and searching features

Collections – the Elements way to group like photos

Locating files

Protecting your assets

Automating editing tasks

Multi-selection editing

ith no film or processing costs to think about each time we take a picture, it seems that many of us are pressing the shutter more frequently than we did when film was king. The results of such collective shooting frenzies are hard drives all over the country full of photos. This is great for photography, but what happens when you want to track down that once in a lifetime shot that just happens to be one of thousands stored on your machine? Well, believe it or not, being able to locate your files quickly and easily is more a task in Organizer management, naming and camera setup than browsing through loads of thumbnails.

Organizing your photos with Photoshop Elements 5.0

Figure 14.1 Most cameras provide options for selecting the way in which files are numbered. The continuous option ensures that a new number is used for each picture even if memory cards are changed in the middle of a shoot.

It starts in-camera

Getting those pesky picture files in order starts with your camera setup. Most models and makes have options for adjusting the numbering sequence that is used for the pictures you take. Generally you will have a choice between an ongoing sequence, where no two photos will have the same number, and one that resets each time you change memory cards or download all the pictures. In addition, many models provide an option for adding the current date to the file name, with some including customized comments (such as shoot location or photographer's name) in the naming sequence or as part of the metadata stored with the file.

To adjust the settings on your camera search through the Set Up section of the camera's menu system for headings such as File Numbering and Custom Comments to locate

and change the options. Ensure that number sequencing and date inclusion options are switched on and, where available, add these comments along with the photographer's name and copyright statement to the metadata stored within the picture file. See Figure 14.1.

And continues when downloading

Included in Photoshop Elements 5.0 is a new version of Adobe's popular transfer utility that moves pictures from your camera or memory card to the computer. Called the Adobe Photo Downloader,

the feature is designed to detect when a camera or card reader is attached to the computer and then automatically transfer your pictures to your hard drive. As part of the download process, the user gets to select the location of the files, apply metadata, auto tag and stack, and the way that the files are to be named and numbered. See Figure 14.2. For more details on the Adobe Photo Downloader go to Chapter 3.

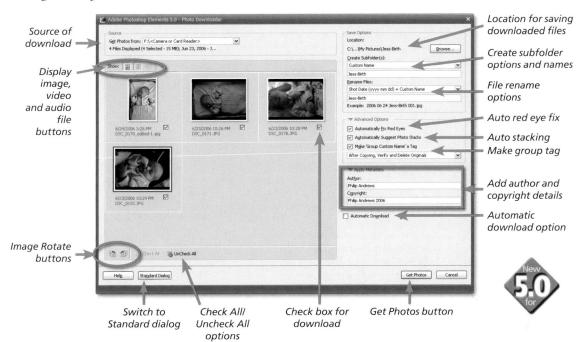

Figure 14.2 The Adobe Photo Downloader that comes bundled with Photoshop Elements 5.0 allows the user to automatically apply naming changes and to determine the location where transferred files will be saved. In addition, in the advanced mode (above) images can be auto stacked and tagged with a group name.

It is at this point in the process that you need to be careful about the type of folder or directory structure that you use. Most photographers group their images by date, subject, location or client, but the approach that you employ is up to you. Once you have selected a folder structure though, try to stick with it. Consistency is the byword of photo organization.

If your camera doesn't provide enough automatic Naming and Metadata options to satisfy your needs then use the Elements Photo Downloader feature to enhance your ability to distinguish the current images from those that already exist on your hard drive by setting the location, group tag, and filename of the picture files as you transfer them. It may also be useful to select the Auto Stack feature as a way of suggesting alike images which can be grouped into Collections or tagged together in the Organizer workspace. See Figures 14.3 and 14.4.

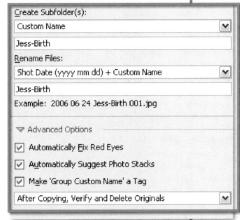

Figure 14.3 Use the options in the Photo Downloader to thoughtfully name, tag, stack and locate your digital photos.

Transferring files with the Photo Downloader

- 1 Start by connecting the memory card reader or camera/phone to your computer.
- 2 The Photo Downloader should auto launch when a camera or card reader is attached. If this doesn't occur then Select File > Get Photos > From Camera or Card Reader. Switch to the Advanced mode.
- 3 Choose the device where your photos are stored (camera or card reader) from the dropdown list in the Source section of the dialog (top left).
- 4 Scroll through the thumbnails that are displayed and select images to be transferred and deselect those to be left on the card using the check box on the bottom right of the thumbnail.
- 5 Choose the location and set the subfolder options in the Save Files section of the dialog.
- 6 Input a new title into the renaming options.
- 7 For photographs taken with a flash select the Automatically Fix Red Eyes option to remove the crimson pupils in your portraits.
- 8 Click the Get Photos button to transfer the photos and automatically categorize them in the Organizer workspace.
- 9 Once the files have transferred successfully you will be offered the opportunity to delete the files from the card or camera, freeing up the device for taking more photos.

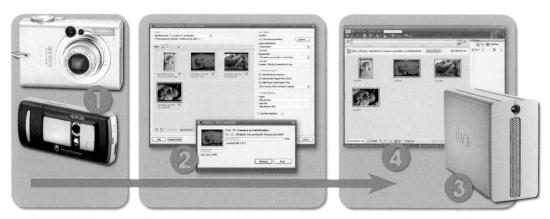

Figure 14.4 When transferring your photos from cameralphone (1) to Elements the Photo Downloader utility (2) copies the files to your hard drive (3) at the same time as cataloging the photos in the Photo Browser workspace (4). Image courtesy of www.lacie.com.

Organizing and searching features

The Organizer workspace not only provides thumbnail previews of your photos but images can be categorized with different tags (keywords), notes and caption entries, split in different collections and then searched based on the tags and metadata associated with each photo. Also, photos that are alike in appearance or subject matter can be stacked or grouped together. Unlike a traditional browser system, which is folder based (i.e. it displays thumbnails of the images that

are physically stored in the folder), the Elements' Organizer creates a catalog version of the pictures and uses these as the basis for searches and organization. With this approach it is possible for one picture to be a member of many different collections and to contain a variety of different keywords. See Figure 14.5.

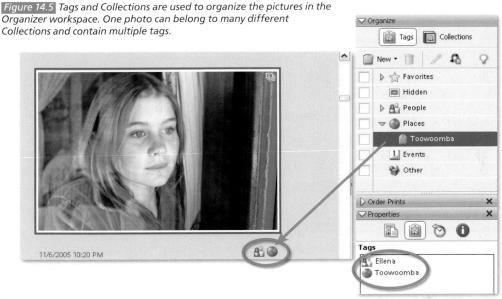

Tagging your photos

In Elements 5.0 keywords are added to your photos in the form of tags. The Tags pane stores the tags, provides an easy drag and drop approach to adding tags to selected photos, and sits to the right of the main thumbnail area in the Organizer workspace. The pane is grouped together with the Collections and Properties panes in the Organize Bin.

Tags are applied to a picture by selecting and dragging them from the pane onto the thumbnail or alternatively the thumbnail can be dragged directly onto the Tags pane. Multiple tags can be attached to a single picture by multi-selecting the tags first and then dragging them to the appropriate thumbnail.

- 1 To add a tag to a single image click and drag the tag from the Tags pane to the thumbnail image in the Organizer workspace.
- 2 To add a single tag to multiple thumbnails, multi-select the thumbnails in the images and then drag the tag from the Tags pane onto one of the selected thumbnails.

Creating new tags

New tags are created and added to the pane by selecting the New Tag option from the menu displayed after pressing the New button at the top left of the pane. Next, fill out the details of the new entry in the Create Tag dialog, select a suitable icon for the tag label and click OK. See Figure 14.6.

- 1 To create a new tag, select the New tag option from the New button menu at the top of the Tags pane.
- 2 In the File Tag dialog that is displayed select a category for the tag, add in a name and include any explanatory notes.
- 3 Next press the Edit Icon button and import for a picture to include the tag label before sizing and cropping the photo in the Edit Tag Icon dialog.
- 4 Click OK to close both dialogs and add the new tag to the tag list.

Figure 14.6 You can add to the existing set of tags using the New Tag option. There is even an option to add your own pictures as the tag icon.

New Face Tagging technology

The ability to search through a group of photos and automatically select those that contain faces was first introduced in Elements 4.0. Using this feature makes it much easier to locate and tag photos of family and friends in the batches of pictures that you import. Start by selecting a group of photos from inside the Organizer workspace. Next click the Find Faces for Tagging button in the Tags pane. The faces identified will be displayed in a new dialog box which also includes the Tags pane. See Figure 14.7. From here your tags can be quickly dragged onto individual or groups of selected face photos.

EATURE JIMIMARY

- 1 Multi-select a group of images from inside the Organizer workspace.
- 2 Either choose Find > Find Faces for Tagging or press the Find Faces for Tagging button at the top of the Tags pane.
- 3 Drag tags onto the pictures that are displayed in the Face Tagging dialog. Click Done to return to the Photo Browser workspace.

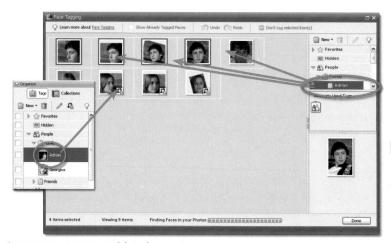

Figure 14.7 The Face Tagging option quickly scans a group of selected photos and identifies those pictures that contain faces and displays these in a separate dialog ready for tagging.

Collections – the Elements way to group like photos

Apart from tagging, Photoshop Elements also uses Collections as a way to organize your photos. Collections allows you to group images of a similar theme together in the one place, making it easier to locate these images at a later date. Another benefit is that the images contained in a collection can also be ordered manually. After creating a collection in the Collections pane, photos are simply dragged from the Photo Browser workspace to the Collection heading to be added to the group.

Figure 14.8 Sort your pictures into groups of the same subject or theme using the Elements Collections feature. (1) Collections pane.

The Collections feature allows you to allocate the same image to several different groups. Unlike in the old days, this doesn't mean that the same file is duplicated and stored multiple times in different folders; instead, the picture is only stored or saved once and a series of Collection associations are used to indicate its membership in different groups. When you want to display a group of images based on a specific subject, taken at a particular time or shot as part of a certain job, the program searches through its database of Collection keywords and only shows those images that meet your search criteria. The Collections pane is the pivot point for all your Collection activities. Here you can view, create, rename and delete collections. If the pane is not displayed in the Photo Browser workspace then click the Organize Bin at the bottom right of the browser and choose the Collections tab. See Figure 14.8.

Adding photos to a group

To start using Collections make a new collection first and then add it to your photos.

- 1 Start by making a new collection by clicking on the New button in the Collections pane and select the New Collection menu item.
- 2 In the Create Collection dialog choose the group that the new collection will belong to, add the name and include any explanation details for the group. Click OK.
- 3 Select the photos to be included in the collection in the Organizer and drag them to the Collection heading in the Collections pane.
- 4 To view all the pictures contained in a collection double-click on the Collection heading in the Collections pane.
- 5 Single photos or even groups of pictures can be added to more than one collection at a time by multi-selecting the collection names first before dragging the images to the pane.

Using Collection Groups

Different collections (and the photos they contain) can also be organized into groups that have a common interest or theme. For instance, collections that contain pictures of the kids, family vacations, birthday parties and mother and father's days events can all be collated under a single 'Family' collection group heading.

Create a Collection group by selecting New > New Collection Group from the Collections pane. Next click and drag existing collection entries listed in the pane to the group heading.

Collection and Tagging strategies:

The best way that you choose to make use of the Tagging and Collection features in Elements will depend a great deal on the way that you work, the pictures you take and the type of content that they include, but here are a few different proven methods that you can use as a starting point.

Subject:

Photos are broken down into subject groups using headings such as family, friends, holidays, work, summer, night shots, trip to Paris, etc.

This is the most popular and most applicable approach for most readers and should be the method to try first.

Timeline:

Images are sorted and stored based on their capture date (when the picture was photographed), the day they were downloaded or the date that they were imported into the organizational package. This way of working links well with the auto file naming functions available with most digital cameras but can be problematic if you can't remember the approximate dates that important events occurred. Try using the

date approach as a subcategory for subject headings, e.g. Bill's Birthday > 2005.

File type:

Image groups are divided into different file type groups. Although this approach may not seem that applicable at first glance it is a good way to work if you are in the habit of shooting RAW files which are then processed into PSD files before use.

Project:

This organizational method works well for the photographer who likes to shoot to a theme over an extended period of time. All the project images, despite their age and file type, are collated in the one spot, making for ease of access.

Client or Job:

Many working pros prefer to base their filing system around the way that their business works, keeping separate groups for each client and each job undertaken for each client.

Locating files

One of the great benefits of organizing your pictures in the Organizer workspace is the huge range of search options that then become available to you.

In fact there are so many search options that Adobe created a new menu heading 'Find' specifically to hold all the choices. See Figure 14.9. Here you will be able to search for your photos based on a selected date range, filename, caption, media type (video, photo, audio or creation), history (when an item was e-mailed, printed, received, imported, used in a creation project or even shared online) and even by the predominant color in the photo.

Shift+F Shift+J Shift+K Alt+V Alt+Shift+
Shift+K Alt+V
Alt+V
Alt+Shift+
Shift+X
Shift+Q

Figure 14.9 The Find menu in the Organizer workspace lists the many different ways to locate images within Elements.

Book resources at: www.guide2elements.com

After selecting one of the Find menu options Elements either displays files that meet the search criteria in a new window (Find by Version Sets, Media Type, Untagged Items, Items not in a Collection) or opens a new dialog where the user must enter specific details (dates, filenames, details, captions) which will be used to base the search. See Figure 14.10.

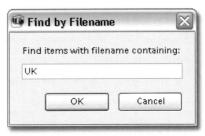

Figure 14.10 When choosing the Date Range, Caption or Note, Filename (see above), History and Details find options Elements displays a new dialog into which your search criteria can be entered.

Figure 14.11
To display all images tagged with a specific entry double-click the Tag name in the Tags pane.

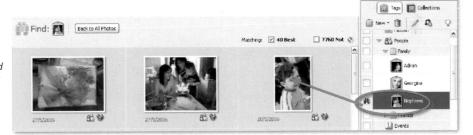

Finding tagged photos or those contained in a collection

As well as the search options located in the Organizer: Find menu, you can make use of the Tags and Collections features to quickly locate and display sets of photos from your catalog.

To find tagged photos: Double-click the Tag entry in the Tags pane. See Figure 14.11.

To display all the images in a collection: Double-click on the Collection entry in the Collections pane. See Figure 14.12.

To return the browser back to the original catalog of thumbnails: Click on the Back to All Photos button at the top of the thumbnail group. See Figure 14.12.

Figure 14.12
To show all the photos in a collection double-click the Collection name in the Collections pane. (1) Press the Back to All Photos button to return to

the catalog.

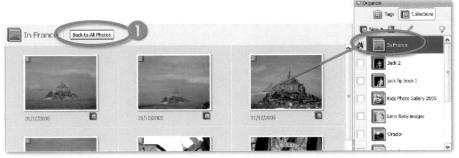

Book resources at: www.guide2elements.com

Find by details or metadata

Version 4.0 of Elements contains a new Find option that is designed to allow users to search the details or metadata that are attached to their picture files. Most digital cameras automatically store shooting details from the time of capture within the photo document itself. Called metadata, you can view this information by clicking the Metadata button inside the Properties palette.

The Find > By Details (Metadata) option displays a sophisticated search dialog that allows you to nominate specific criteria to use when looking within the metadata portion of the picture file. The dialog provides a section to input the text to search for as well as two drop-down menus where you can set where to look (Filename, Camera Make, Camera Model, Capture Date, etc.) and how to match the search text (Starts with, Ends with, Contains, etc.). See Figure 14.13.

Beyond camera-based metadata you can also use this dialog to search for any Captions, Notes, Tags or Collections that you have applied to your pictures.

1 Select Find > By Details (Metadata) from the Organizer workspace.

2 Choose the type of details that you are looking for – Filename, Camera Make, Camera Model, etc. – from the drop-down list in the Find by Details dialog.

3 Enter the text you want to search for (if needed).

4 Enter how the search text should appear in the located files (contained, not contained, etc.)

Find by Details (Metadata) Search for all photos that match the criteria entered below. Use the Add button to enter additional criteria, and the Minus button to remove criteria. Criteria Filename V Is karer Filename Carriera make nd/or file extension Starts with Camera Model Ends with Capture Date Contains Search Cancel Does not contain Catalog Date Caption/Description Pixel Width Pixel Height File Size Megapixels

Figure 14.13 The Find by Details feature allows you to customize the search options used via settings within the dialog. Choosing the type of detail to look for from the drop-down list (1) determines the contents of the rest of the dialog. In this instance selecting 'Filename' displays a second list (2) describing how to match the text you input (3). Extra search criteria can be added or removed by pressing the Plus or Minus buttons to the right of the dialog (4).

EATURE

Attaching a Map Reference

New for version 5.0 is the ability to link map references with the photos in your organizer catalog. This feature provides a new way to reference and locate your photos. See Figure 14.14. The mapping technology is provided in association with Yahoo and one of the ways that you can share your map referenced picture is via the company's popular photo sharing site www.flickr.com.

To create a map reference for a photo drag and drop the thumbnail from the main Organizer workspace onto the map pane (left). Or use the Place on Map command from the Context menu or Edit menu to type in a location. This approach can be more accurate than dragging the photo to a map. To reference a group of photos, tag these images first and then drag the tag to the map. Both these actions will place a pin on the map to indicate that there are photos linked with this area. To view photos associated with a map reference click on a pin with the Hand tool. Alternatively, to display all the photos associated with the current map, view select the Limit Search to Map Area option in the tool bar below the map display.

The referenced maps you create, and their linked photos, can be shared online by uploading either to your own website using the Photo Galleries feature or to www.Flickr.com.

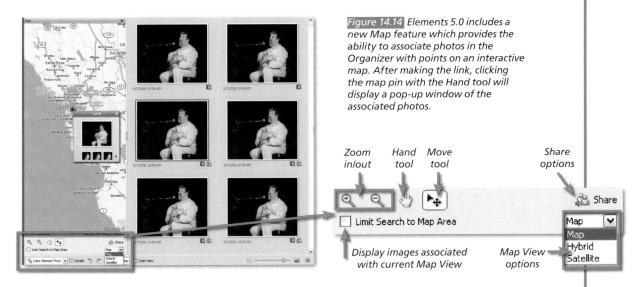

Protecting your assets

Ensuring that you keep up-to-date duplicates of all your important pictures is one of the smartest work habits that the digital photographer can learn. Ask yourself 'What images can't I afford to lose – either emotionally or financially?' The photos you include in your answer are those that are in the most need of backing up. If you are like most image makers then every

picture you have ever taken (good and bad) has special meaning and therefore is worthy of inclusion. So let's assume that you want to secure all the photos you have accumulated.

Making your first backup

Gone are the days when creating a backup of your work involved costly tape hardware and complex server software. Now you can archive your pictures from inside the very software that you use to enhance them – Photoshop Elements.

The Backup feature (Organizer: File > Backup Catalog) in Elements 5.0 is designed for copying your pictures (and catalog files) onto DVD, CD or an external hard drive for archiving purposes. To secure your work simply follow the steps in the wizard. The feature includes the option to back up all the photos you currently have cataloged in the Photo Browser along with the ability to move selected files from your hard disk to CD or DVD to help free up valuable hard disk space. See Figure 14.15.

- 1 To start the backup process Select File > Backup from the Photo Browser workspace.
- 2 Next select Backup the Catalog. Click Next.
- 3 At the next screen choose Full Backup for first time archiving or Incremental Backup for all backups after the first one. Click Next.
- 4 And finally select the place where you want the backup to be stored. This may be on a series of CDs or DVDs or on an internal drive, and then click Done to back up your files.

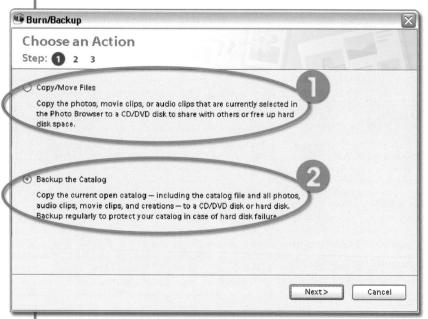

Figure 14.15 The first screen of the Elements Backup feature contains the choice of two different actions:

- (1) CopylMove Files Use this selection to make copies of files that you have selected in the Photo Browser workspace or to permanently move files to another destination.
- (2) Backup the Catalog This option provides a complete backup of all the files in your catalog and then the next time it is used allows you to add any files that have been changed or added since the last backup.

Multi-disk Backup

In version 5.0 the Backup Catalog feature has been enhanced so that now it is possible to back up your catalog over a series of CD or DVD disks. Multiple disk options like this are sometimes referred to as 'disk spanning'.

In previous versions, the Backup feature only allowed writing to a single disk and even with the growing use of DVD-ROMs for archive scenarios, many digital photographers have a catalog of photos that far exceeds the space available on a single disk.

The revised Backup feature estimates the space required for creating the backup copy of the catalog and, after selecting the drive that will be used for archiving, the feature also determines the number of disks required to complete the action. See Figure 14.16. During the writing process the feature displays instruction windows at the end of writing each disk and when you need to insert a new disk. All disks need to be written for the backup to be complete. To restore a catalog from a set of backup disks use the File > Restore Catalog option in the Organizer workspace.

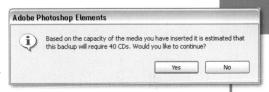

Figure 14.16 Elements 5.0 now includes the ability to back up the Organizer catalog across multiple disks.

Multi-session Backup

As well as providing the ability to back up large catalogs over multiple disks the revised Backup feature also allows multisession recording of archives. Multi-session DVD or CD-ROM recording means that you can add extra backup files to disks that you have already recorded to. This means that if you only fill a quarter of the storage space of a DVD disk when you first create a backup, you will be able to write to the non-used area in a later backup session. Most Elements users will find this useful when performing incremental backups.

Online Backup

A new online archive option is included with version 5.0, called Online Backup (Organizer: File > Online Backup) – the feature provides a way of storing a copy of important catalog files on a server on the Internet. The service is provided by Iron Mountain. See Figure 14.17. After registering Elements users can back up their catalog to the secure server.

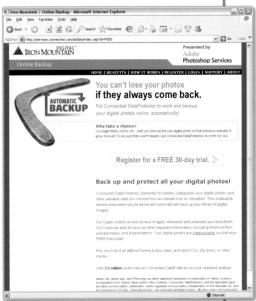

Figure 14.17 The new File > Online Backup option gives Elements user the ability to safely store their precious images off-site.

Backup glossary:

Multi-disk archive – A process, often called spanning, by which chunks of data that are larger than one disk can be split up and saved to multiple CD-ROMs or DVDs using spanning software. The files can be recompiled later using utility software supplied by the same company that wrote the disks.

Full backup – Duplicates all files even if they haven't changed since the last time an archive was produced (1).

Incremental – Backs up only those files that have changed since the last archive was produced. This makes for faster backups but means that it takes longer to restore files as the program must look for the latest version of files before restoring them (2).

Restore – Reinstates files from a backup archive to their original state on your hard drive.

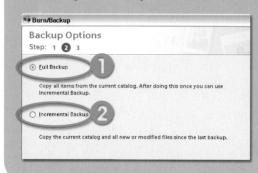

CD-ROM or DVD writer – This option is very economical when coupled with writing software that is capable of writing large numbers of files over multiple disks. The sets of archive disks can easily be stored off-site, ensuring you against theft and fire problems, but the backup and restore process of this approach can be long and tedious.

Internal hard drive – Adding an extra hard drive inside your computer that can be used for backing up provides a fast and efficient way to archive your files but won't secure them against theft, fire or even some electrical breakdowns such as power surges.

External hard drive – Connected via USB or Firewire these external self-contained units are both fast and efficient and can also be stored off-site, providing good all-round protection. Some like the Maxtor One Touch models are shipped with their own backup software. Keep in mind that these devices are still mechanical drives and that care should be taken when transporting them.

Backup hardware:

Back up regularly

There is no point having duplicate versions of your data if they are out of date. Base the interval between backups on the amount of work you do. In heavy periods when you are downloading, editing and enhancing many images at a time back up more often; in the quieter moments you won't need to duplicate files as frequently. Most professionals back up on a daily basis or at the conclusion of a work session.

Store the duplicates securely

In ensuring the security of your images you will not only need to protect you photos from the possibility of a hard drive crash but also from such dramatic events as burglary and fire. Do this by storing one copy of your files securely at home and an extra copy of your archive disks or external backup drives somewhere other than your home or office. Better still use the new Online Backup feature available in Elements 5.0. I know that this may sound a little extreme but swapping archive disks with a friend who is just as passionate about protecting their images will prove to be less painful than losing all your hard work.

Versioning your edits

Creating a good archival system goes a long way to making sure that the images you create are well protected, but what about the situation where the original photo is accidentally overwritten as part of the editing process? Embarrassing as it is, even I have to admit that sometimes I can get so involved in a series of complex edits that I inadvertently save the edited version of my picture over the top of the original. For most tasks this is not a drama as the edits I make are generally non-destructive (applied with adjustment layers and the like) and so I can extract the original file from inside the enhanced document but sometimes, because of the changes I have made, there is no way of going back. The end result of saving over the original untouched digital photo is equivalent to destroying the negative back in the days when film was king. Yep, photographic sacrilege!

So you can imagine my relief to find that in last few versions of Photoshop Elements Adobe featured a new technology that protects the original file and tracks the changes made to the picture in a series of successive saved photos. The feature is called Versioning as the software allows you to store different versions of the picture as your editing progresses. What's more the feature provides options for viewing and using any of the versions that you have previously saved. Let's see how this file protection technology works in practice.

Versions and Photoshop Elements

Versioning in Elements extends the idea of image stacks by storing the edited version of pictures together with the original photo in a special group or Version Set.

All photos enhanced in the Organizer space using tools like Auto Smart Fix are automatically included in a Version Set. Those images saved in the Quick and Full editor spaces with the Save As command can also be added to a Version Set by making sure that the Save with Original option is ticked before pressing the Save button in the dialog. See Figure 14.18.

Saving in this way means that edited files are not saved over the top of the original; instead, a new version of the image is saved in a Version Set with the original. It is appended with a file name that has the suffix '_edited' attached to the original name. This way you will always be able to identify the original and edited files. The two files are 'stacked' together in the Organizer with the most recent file displayed on top.

Figure 14.18 To create a Version Set when saving an edited file from inside the Quick or Standard Editor workspace make sure that the Save a Version Set with Original option is selected.

Figure 14.19 The bundled photos icon at the top right of the thumbnail indicates that the photo is part of a Version Set.

When a photo is part of a Version Set, there is a small icon displayed in the top left of the Photo Browser thumbnail. The icon shows a pile of photos. See Figure 14.19 on page 351.

To see the other images in the version stack simply click the new sideways arrow on the right of the thumbnail or right-click the thumbnail image and select Version Set > Reveal Photos in Version Set. See Figure 14.20 and Figure 14.21. Using the other options available in this popup menu the sets can be expanded or collapsed, the current version reverted back to its original form or all versions flattened into one picture. Version Set options are also available via the Photo Browser Edit menu.

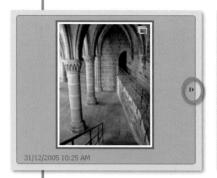

Figure 14.21 Also new for version 5.0 are the Expand and Collapse buttons, which are positioned to the right of the thumbnail of standard image stacks as well as Version Sets.

Elements' image stacks

An image stack is slightly different from a Version Set as it is a set of pictures that have been grouped together into a single place in the Organizer workspace. Most often stacks are used to group pictures that have a common subject or theme and the feature is one way that Elements users can sort and manage their pictures. To create a version stack, multi-select a series of thumbnails in the workspace then right-click on one of the selected images to show the menu and from here select the Stack > Stack Selected Photos option. See Figure 14.22. You can identify stacked image groups by the small icon in the top right of the thumbnail. See Figure 14.23.

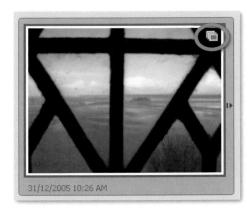

Figure 14.22 Image stacks use a layered photos icon in the top right of the thumbnail to indicate that the picture is one of several images that have been grouped.

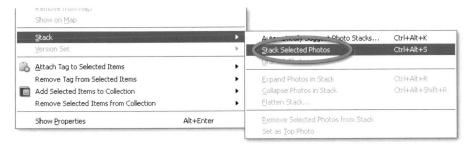

Figure 14.23 To manually group alike photos into an image stack, multi-select the pictures in the Photo Browser workspace before choosing Stack > Stack Selected Photos from the right-click menu.

Auto Stacking

The idea of grouping together like photos in a single stack was introduced in version 3.0 of the program. New for 5.0 is the ability to auto stack images as they are downloaded from camera, imported into Elements from folders or even when displayed in the Organizer workspace. The feature looks for images that are visually similar, or were captured within a short time interval when suggesting groups of images that are suitable for stacking.

You can employ the Elements' Auto Stacking feature in a couple of different ways:

Photos in the Organizer – To auto stack pictures already in your catalog select a group of thumbnails and then choose Automatically Suggest Photo Stacks from either the Edit > Stack or the right-click pop-up menus. See Figure 14.24.

Photos being imported – To stack when importing choose the Automatically Suggest Photo Stacks option in the Get Photos dialog.

Either of these two options will then display a new window with alike pictures pre-grouped. Choosing the Stack All Groups button converts the groups to Stacks.

The Remove Group button prevents the group of pictures being made into a Stack.

- 1 To Automatically stack like photos that have already been imported into the Organizer start by multi-selecting pictures from the Photo Browser.
- 2 Next right-click one of the thumbnails and choose Stack > Automatically Suggest Photo Stacks from the menu that is displayed.
- 3 Elements will then show you a new screen containing the groups of images that it suggests should be stacked. Click the Stack All Groups option to convert the groups to Stacks.
- 4 To stop a set of pictures becoming a photo stack press the Remove Group button before conversion.

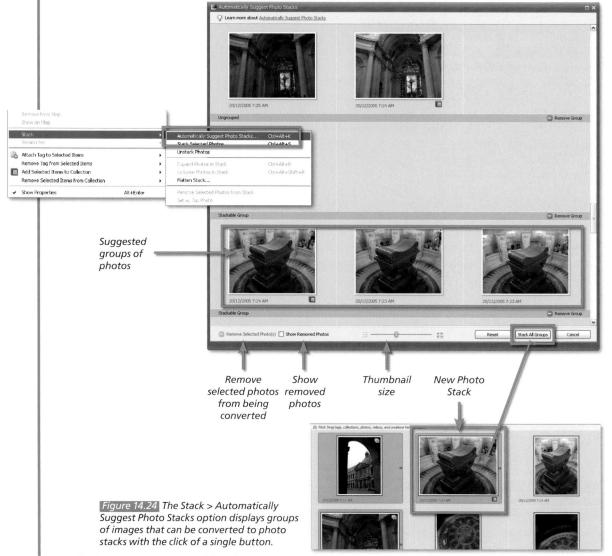

Book resources at: www.guide2elements.com

Automating editing tasks

It's true that shooting digitally has meant that many photographers have saved the time that they used to spend in the darkroom processing their images. The flip side to this coin is that now we while away the hours in on-screen production instead. Surely with all the power of the modern computer and flexibility of Elements there must be quicker ways to process files? Well yes there is!

Photoshop Elements users are able to automate a variety of editing functions with the Process Multiple Files feature located in the File menu of the Standard editor workspace. The feature is like a dedicated batch processing tool that can name, size, enhance, label and save in a specific file format a group of photos stored in a folder or selected via the file browser. See Figure 14.25. The dialog's options include:

File source – Files to be processed can be stored in a single folder, the files currently open in the workspace, pictures in the Photo Bin or images multi-selected in the file browser.

File destination – Sets the location where processed files will be saved.

File naming – Options for naming or renaming of selected files including a range of preset naming styles.

Image sizing – Specify size and resolution changes after choosing the unit of measure to work with from the drop-down menu. Proportions can be constrained.

File format type – Select the file format that processed files will be saved or converted to.

Quick Fix enhancement – Use the options here to apply automatic enhancement of the files being processed.

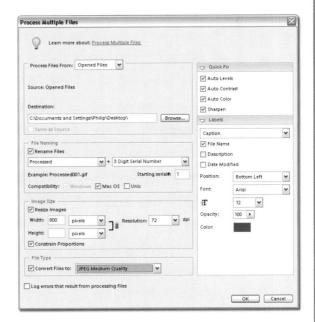

Figure 14.25 Elements users can automate the application of basic enhancement and editing features to a group of files using the Process Multiple Files feature located in the Standard editor workspace.

Add labels – Add caption or filename labels to each of the processed files. Also contains an option for watermarking the pictures.

After setting the options for each of the sections in the dialog press the OK button to process the pictures.

Multi-selection editing

Another method of applying automatic changes to several photos at once is to multi-select photos in the Photo Browser workspace then choose an editing option from the right-click pop-up menu. There are a multitude of options available in this menu, with the Rotate, Auto Smart Fix and Auto Red Eye Fix features providing quick editing changes to the selected photos. For best results always apply critical edits and enhancements manually, but this technique is particularly useful if you want to process a bunch of files quickly. The added bonus is that the edited versions of the pictures are not saved over the original file but rather they are kept in a Version Set so that it is always possible to extract the original file if need be. See Figure 14.26.

Keystrokes for fast edits of multi-selected photos

Rotate Photos 90° Left - Ctrl + Left

Auto Smart Fix - Ctrl + Alt + M

Rotate Photos 90° Right – Ctrl + Right

Auto Red Eye Fix - Ctrl + R

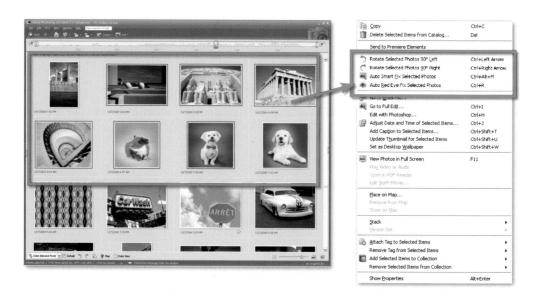

Figure 14.26 The editing and enhancement options located on the menu that is displayed when you right-click a thumbnail in the Organizer workspace can be just as easily applied to several photos that have been multi-selected as to a single picture. This method is a quick and easy means of making automatic changes to a group of photos.

Theory into Practice: Real Life Elements Projects

Projects 1-12

ow that you have an understanding of the program and many of its great features use the following projects to build your skills. You can download all the resources you need to complete the tasks from the book's website (www.guide2elements.com) and once you are feeling confident you can move onto the next step and start to substitute your own pictures for the ones I supplied.

Project 1: Slide shows from your home videos

Skill Level - 1, Version - 5.0, 4.0, 3.0, 2.0

The new range of digital video cameras has made the process of capturing and using frames from your home movies easier than ever. As the data is actually stored in a digital format there is no longer the need to buy expensive capture cards when you want to feature a few moments from your latest cinematic efforts. Elements 5.0 is particularly well suited to this task as you can not only grab the 'Frame From Video' (Editor: File > Import > Frame From Video) but you can also compile the captured still moments in a self-contained slide show created using the Slide Show feature (Organizer: File > Create > Slide Show).

In fact, the Slide Show Creation editor supports adding Windows media player files directly to a show. So in this way you can combine still images with video but there are limitations with output. PDF slide shows, for instance, will only show a still picture where the video would have displayed.

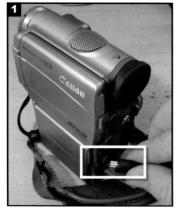

Attach your video camera to your computer and download a few segments of footage to your hard drive using the capture software supplied with the camera.

Select Editor: File > Import > Frame From Video to open the Elements video capture dialog.

Click the Browse button and search for your video files.

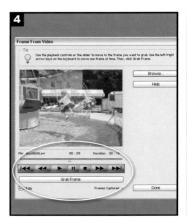

Use the VCR type buttons to navigate the video clip and click the Grab Frame button to capture still images.

The nature of most video capture means that applying a De-interlace filter (Editor: Filter > Video > De-interlace) will help improve the sharpness of the still frames. Apply the filter to the captured pictures.

With all the frames still open in the Elements Editor select the Slide Show feature (Editor: File > Create > Slide Show). Next, use the controls in the Slide Show Preferences dialog to adjust the settings that are applied to the whole presentation.

Your open files should already be included in the Slide Show thumbnail area. To insert more frames use the Add Media button.

Set the duration and transition style and then choose the photo size and quality.

Click Save Project before pressing the Output button to produce the slide show. Here I selected the PDF File option, which is easy to distribute and can be displayed with the Adobe Acrobat reader/viewer available free from www.adobe.com.

Project 2: Stitching big paintings together

Skill Level - 1, Version - 5.0, 4.0, 3.0, 2.0, 1.0

Sometimes it simply isn't possible to get back far enough to capture the whole of a subject in a single shot. A good example of this scenario is when I was trying to make a digital copy of a large painting in a small room. Not being able to move the painting I photographed the artwork four times, moving the camera slightly each time, and then stitched the files together using the Photomerge feature in Elements.

Set up your camera on a tripod in front of the painting. To ensure that the picture is photographed square, check that the back of the camera is parallel to the painting surface.

Shoot several images of the picture, making sure to overlap side as well as top and bottom edges. Be sure to keep the camera-to-subject distance, exposure, zoom and white balance settings consistent.

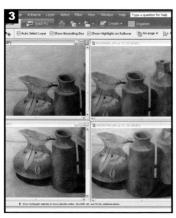

Import all images into Elements. Perform any slight editing alterations such as straightening, brightness and contrast, and color cast removal to each image before saving.

Select Photomerge from the File menu (Editor: File > New > Photomerge Panorama) to start a new panorama. The open images should be automatically listed in the Source Files area of the dialog.

Version 1.0 users only – Set the Image Size Reduction amount to reduce source file sizes. If you are using images greater than 2 megapixels then a setting of 50% or more should be used. To get Elements to lay out the selected images check the Attempt to Automatically Arrange Source Images box; for manual layout control leave the box unchecked. If you are using the Automatic Arrange option then you can also choose to apply perspective correction across the whole of the composition. Do not use this feature for this project.

Select OK to open the Photomerge dialog box. Edit the layout of your source images. Turn the Snap to Image function on so that Photomerge will match the like details of the different images when they are dragged over each other.

As you are stitching a flat picture make sure that you don't tick the Perspective box.

The final panorama file is produced by clicking the OK button. Crop excess wall area to reveal the full picture.

Project 3: Professional folio of images on CD-ROM

Skill Level - 2, Version - 5.0, 4.0, 3.0, 2.0

The picture folio is the photographer's main marketing tool. It wasn't that long ago that all serious image makers owned, and maintained, a black multi-leaf folder of their best prints. With the onset of the digital imaging revolution more and more professionals are converting their weighty and cumbersome image collections to a more easily handled format – the CD-ROM, VCD or DVD.

Now well and truly 'as cheap as chips', the humble CD or DVD has become the preferred transport medium for photographers worldwide. By combining the great pictures that already reside on your hard drive with the Elements Slide Show feature and a handy CD/ DVD burner you can have your own 'virtual' folio produced in no time at all. Don't restrict vourself to just image – use the built-in text abilities of Elements to quickly add biographical and contact details to the presentation.

Consider what images and information you should include and how it should be presented. A few quick sketches will help organize your ideas.

Use the Photo Browser to tag the pictures that are to be included in the presentation. Alternatively, group the images together as a collection so that you can prearrange the order that the folio pictures are presented before adding them to the slide show.

Use Elements to create any textbased heading and biographical slides, tag them and then save them to the Photo Browser.

Display the Tagged or Collection files in the Photo Browser and then select File > Create > Slide Show. Change the settings for the presentation in the Slide Show Preferences dialog and click OK.

Adjust the sequence of source thumbnails to reflect the slide order you want and choose the duration that each picture will be on screen.

Select the transition style from the drop-down list and add an audio/ narration track if you desire.

Click File > Save Slide Project to store your slide show and its settings and then choose File > Output Slide Show that is equipped with VCD/DVD and Burn to Disk to create the disk.

Preview the folio VCD/DVD with a DVD and television or on a computer player software.

Project 4: The school newsletter

Skill Level - 1, Version - 5.0, 4.0, 3.0, 2.0, 1.0

Part of the job of running a busy school is maintaining the communications between staff, students and parents. In recent years many schools have found that producing a regular newsletter helps to keep everyone informed. With the advent of lower priced cameras and scanners the humble single page text document has grown into a publication that is full of photographs of students, staff and school activities.

Wade Haynes, the principal of Wynum North State High School, regularly uses digital images in his school's newsletter. 'It provides the school community with the opportunity to review the week's activities. The students love looking for themselves and their friends in print. Parents also appreciate the extra insight it gives them into school life.' The staff and students at the school source their images either directly from digital cameras or from prints that have been scanned. Next they are imported directly into an image-editing program, where they are cropped, straightened and resized. It is also at this point that the brightness and contrast of the images are improved. From here the pictures are placed into a word processing package containing a template of the magazine. The finished product is then printed out using a high quality inkjet printer before being copied and distributed to school families.

Students and staff shoot images using a digital camera at school activities during the week.

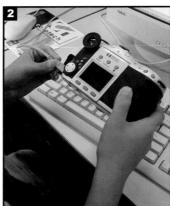

Back in the office or classroom the camera is connected to a computer.

The images are viewed as thumbnails and then downloaded from the camera into image-editing software.

The best photographs are sized, rotated, their contrast and brightness adjusted, and then they are saved to disk.

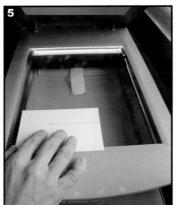

On occasions where the digital cameras are not available traditional film cameras are substituted. The prints from the camera are then converted to digital files using a flatbed scanner.

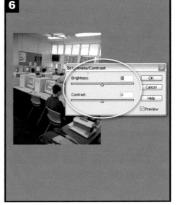

The images from the scanner are then sized, rotated, their contrast and brightness adjusted, and saved to disk.

With the pictures now complete, the A high quality master print of the template for the school's newsletter is opened in a word processing package. The images are imported into the software and positioned in the layout of the page.

completed newsletter is made on an inkjet printer or laser printer.

The school office staff then use a photocopier to duplicate the newsletter ready for distribution.

Project 5: Real estates go digital

Skill Level - 1, Version - 5.0, 4.0, 3.0, 2.0, 1.0

Adam Djordjevic is a busy real estate agent in an inner city firm. A lot of his business is based on communicating ideas and images with his clients. He finds that good photos of properties are crucial for establishing common ground and understanding what style and type of dwelling his customers are looking for.

For this reason taking pictures of houses and apartments is an integral part of the selling process. The images can then be used in a range of marketing activities, including the showcase in the office window, advertisements in local and national papers and on the company's website.

Adam feels that acquiring the images digitally makes it easier to use them in a range of formats. 'We can print them for the window, use them in "open house" literature, send them to the papers for ads and also pop them onto the website. No problems! Before we had to muck around with negatives and prints; the same digital file can be used for all our marketing needs.'

One of the real estate team photographs the property, making sure that all the important features of the house are clearly shown. As there is no film or processing costs involved many pictures can be taken and the best selected for use.

Back at the office the images from the camera are downloaded onto the computer. In this case the camera is connected to the computer using a special cradle.

The brightness, contrast and color of the photographs are adjusted. The image is saved at the full resolution that it was captured. This file will be used for all print applications. A further copy is then saved at a resolution suitable for web and e-mail distribution.

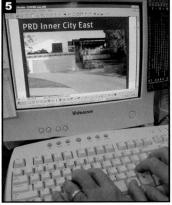

E-mails with attached images and text are sent to the papers, printers and sign makers. Each of these companies will use the digital files for the laying out of advertisements, brochures and signs.

The task of updating the website to include the new listing is handled inhouse. A template of the new page is automatically produced and the images and text are pasted into position. After checking the new page is uploaded to the website.

Meanwhile the sign maker has faxed back a draft of the proposed sign. Adam checks the details and sends any corrections back to be fixed.

The printed window card arrives and is placed in a plastic mount, which is then hung in the display window.

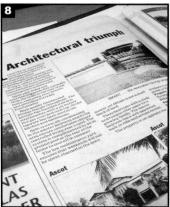

Later that week the local newspaper features an editorial about the property using details and the digital images supplied online by Adam.

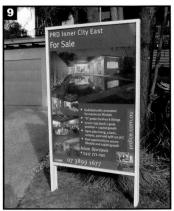

The day the paper is distributed the sign arrives and is hurriedly put in place in front of the property to make the most of the publicity.

Project 6: Photographic print display

Skill Level - 2. Version - 5.0, 4.0, 3.0, 2.0, 1.0

A regular activity undertaken by many photographers, both amateur and professional alike, is the production of a series of images for presentation. This group of photographs might be centered on a single idea or theme or it might represent a summary of skills and techniques. Whatever the case, a lot of time and effort is put into the production of a photographic folio. On the one hand the images must be able to be viewed as a series, each separate piece linked with, and contributing to, the next. But each individual picture must also be strong enough to stand alone.

In the past photographers would spend long hours in the darkroom trying to ensure that all the variables of chemistry, time, exposure and paper were consistent so that each of the prints in the series would 'feel' similar. More recently image makers have started to use the 'digital darkroom' to give their pictures a unified look. Even if the photographs start life as a slide or negative, the enhancing and printing stages are being handled digitally rather than traditionally.

Kathryn Lyndsey is a photographer whose recent images are a good example of this new way of working. When producing a recent series of photographs she chose to shoot the images using a film-based camera and then complete the production process digitally. She says 'Working digitally gives me more freedom to be creative. I can work and rework an image making small adjustments that are not as easy to achieve in the darkroom. I feel less restricted and more in control.'

Despite the growing domination of digital, Kathryn's images are shot using traditional film cameras.

After the film has been processed she searches through the group of negatives to find the most suitable images.

The candidate photographs are then converted to digital using a film scanner.

The unenhanced files are previewed on screen and examined carefully to identify areas that need adjusting.

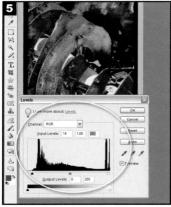

Basic manipulations such as changing orientation and altering brightness and contrast are made first.

Next, parts of the image are darkened and lightened using the Dodge and Burn tools.

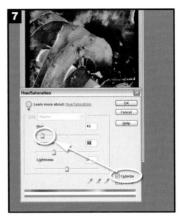

In some images Kathryn adds color and texture to black and white pictures using the Hue/Saturation feature and Texture filters. See Chapter 5 for more details of these techniques.

As a proofing step Kathryn outputs her work to an inkjet printer first to check color and how each of the images appears.

The final step is to burn the files to CD and send them off to a local professional photographic laboratory, who will print the folio images on color photographic paper.

Project 7: Business manager presentation

Skill Level - 2. Version - 5.0, 4.0, 3.0, 2.0, 1.0

Gone are the days when business presentations are made up of a few sheets of columns of dry figures all neatly contained in a plain manila folder. Now managers of all types of companies are expected to deliver their reports with a little more pizazz and certainly more graphical content. Most of these presentations are put together in slide show type packages like Microsoft PowerPoint and consist of a combination of written information and graphical content. Though very sophisticated in themselves, most slide show programs contain no, or very limited, image-editing abilities. Although Elements 5.0 now contains its own slide show maker technology, savvy managers who want a few more controls are using Elements in conjunction with their presentation software to produce interesting and dynamic business reports.

When generating quality business graphics it is important to make sure that the image component supports the business ideas and does not distract from them. For this reason a lot of managers start the process with a few design drawings.

As the presentation process involves the delivery of a series of 'electronic' slides, putting together a story-board similar to those used in the film industry is the next step in the design process.

With the design complete a list of visual elements, or props, that need to be photographed, or scanned, is compiled.

The props are then captured, being sure to take several images from different directions or angles so that there is more choice later in the process.

Next, the images are downloaded to the computer and imported into Elements. Brightness, contrast, color and sharpness are adjusted.

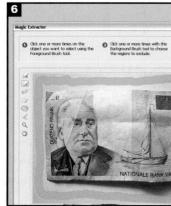

The background is removed from the objects using the Background Eraser tool or the new Magic Extractor feature, and a Cutout filter (Filters > Artistic > Cutout) applied to give the props a more graphic appearance.

The presentation program is started and the background, text and graph components of the slide are composed.

The finished graphic components are then copied in Elements (Select > All, then Edit > Copy) and pasted (Edit > Paste) into the presentation program.

The graphics are then resized and arranged to fit the background and text content. The final slide is saved as part of the full presentation.

Project 8: Restoration of a family heirloom

Skill Level - 3. Version - 5.0, 4.0, 3.0, 2.0, 1.0

Stored away in the lofts of many homes is a collection of family history documents. Usually contained in boxes, or old suitcases, they are a mixture of photographs and letters. One of the first tasks that a family member with a new interest in digital imaging inherits is the restoration of some of these heirlooms to their former glory. Suffering from a mixture of scratches, stains and fading, these images can be improved and repaired using a combination of the techniques introduced in previous chapters.

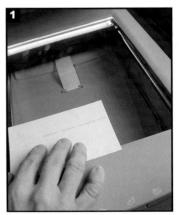

Open up the scanner plug-in either from within Elements or via the Acquire option in the Quick Start screen.

Capturing the photograph to be restored is a critical part of the process. Make sure that the scanner's contrast and brightness settings are adjusted to capture all the highlight and shadow details contained in the original.

With the image imported into Elements rotate and crop the image using the Straighten and Crop Image selection from the Rotate section of the Image menu. For manual control you can use the Crop tool from the toolbox.

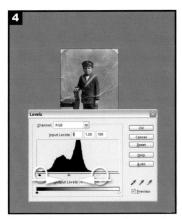

Use the finer tone control of Levels (Enhance > Adjust Lighting > Levels) to peg the white and black points in the image.

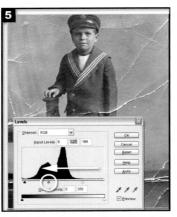

Adjust the midtone value in Levels to darken or lighten middle value tones in the image.

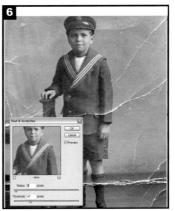

Use the Dust & Scratches filter (Filter > Noise > Dust & Scratches) to eliminate some of the marks on the image surface. For more difficult areas or those sections that need reconstruction use the Clone Stamp or Spot Healing Brush tools to copy and paste new tones and textures.

Darken or lighten selected areas of the picture using the Dodging or Burning tools.

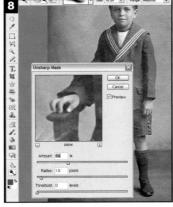

Sharpen the image by using the Unsharp Mask filter (Filter > Sharpen > Unsharp Mask). Ensure that the preview thumbnail is set to 100% to gauge the strength of the filter effect.

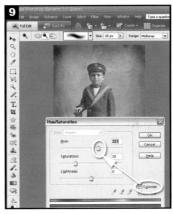

Tone the final image using the Colorize option from within the Hue/Saturation feature (Enhance > Adjust Color > Hue/Saturation).

Project 9: Menu for restaurant

Skill Level - 3. Version - 5.0, 4.0, 3.0, 2.0, 1.0

Updating a restaurant menu to keep track with the seasonal availability of ingredients can be a long-winded and costly affair. Each time a dish is replaced the menu has to be redesigned and printed to account for the changes. However, if the menu is created digitally using a package like Elements and the different dishes and their descriptions stored in different layers, then changing the food list at short notice can be as simple as switching off one layer and turning on another. The new-look menu can then be printed and displayed.

The selection tools and layer techniques we looked at earlier in this book are central to the production of this quick-change menu.

The general design for the menu was sketched roughly on paper, taking into account that the layout would not change but particular menu items might be added or taken away depending on ingredient availability.

The image content was then shot, making sure that each component had similar lighting and angle of view. These settings were noted down so they could be repeated later for new dishes.

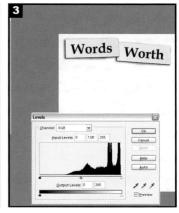

A base Elements document was then created with all the static elements compiled on the background layer.

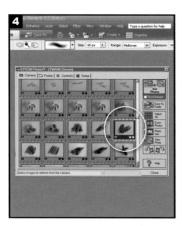

The pictures were then imported as separate documents into Elements.

Each image was adjusted and cut from its background. The new Magic Extractor feature is great for this type of work. The image parts were then copied and pasted as new layers into the base menu file.

The description and pricing for each dish were then added as a text layer. The text layer and its associated image layer were then linked so that they could be moved together.

With the layout complete the menu was printed and was ready for display.

With changing availability of ingredients new dishes were added to the menu. Older items were kept in the stack but were removed from view by clicking their eye icons.

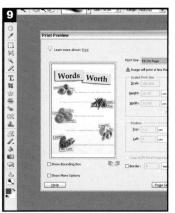

With the changes complete the new version of the menu was printed and displayed.

Project 10: Advertisement optimized for black and white

Skill Level - 2. Version - 5.0, 4.0, 3.0, 2.0, 1.0

Advertising in the local newspaper is a good way to attract new custom to small businesses, but often the task of putting together a design can seem to be a little overwhelming. Using the text features in Elements and a few imaging tricks you can produce a simple but effective advertisement, which can be supplied to the paper's classifieds department on disk for inclusion in the next edition.

Find out from your local newspaper the exact size and resolution that you need to submit to them. These details will usually be supplied in terms of centimeter or inch dimensions together with a figure for resolution in dots per inch or dpi. For our example we will construct an advertisement that is 12 × 8 cm (h × w) at 300 dpi.

Photograph some images that represent your business or the products that you sell. Shoot a range of different photographs so that you have a few to choose from. Keep in mind that the advertisement is in a vertical or portrait format and that horizontal images might need to be cropped to fill the space.

At the same time as shooting, use a word processor to organize and input the text that will be included in the advertisement. At this stage keep the typeface and style simple, as enhancements will be made in Flements.

Open Elements and select the New File option from the Welcome screen. Input the size and resolution values directly into the New Image dialog.

Open and select one of the images that you have photographed using the Select All command from the Select menu. Copy (Edit > Copy) and Paste (Edit > Paste) the picture into the advertisement document. With the new layer selected adjust its size using the Image > Transform > Free Transform command.

Using the Marquee tool make a rectangular selection in the middle section of the image. Feather the selection by 20 pixels (Selection > Feather) and then open the Levels dialog (Enhance > Adjust Lighting > Levels). Move the black output slider to the right to lighten the selection.

Switch to the word processing package and highlight and copy the advertisement text. Switch back to Elements and with the Text tool selected click and drag a text box on the canvas in the lightened area. Paste the copied text here.

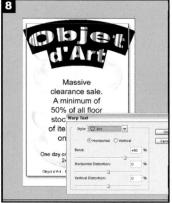

To add a bold heading, insert another text cursor and type directly onto the canvas, altering the size and font to suit. Use the Warp and Layer Styles features to make the type stand out from the background.

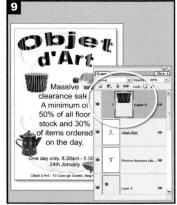

Finally, to add some more interest to the heading open a second image from those photographed earlier. Select and copy the picture. Switch back to the advertisement and paste the picture onto a layer directly above the heading text. Next, insert this new image into the heading text by selecting Group With Previous from the Layer menu.

Project 11: Company logo, letterhead, business card

Skill Level - 3. Version - 5.0, 4.0, 3.0, 2.0, 1.0

The Eastside Community Support Group is a small network of volunteers who regularly give their time to help settle new migrants in their local area. The group runs many orientation activities that require a great deal of organization and communication with the participants, small businesses and the local authorities. Presenting a professional face is an important aspect of reassuring all parties that despite the volunteer nature of the network, the group is committed and organized. They found that 'for some people you have to look the part before they give you a chance'. Part of looking the part is having simple but effective stationery.

The first task was to produce a logo that was not too complex, represented the group's concerns, was easy to understand and was cheap to reproduce. The 'Helping Hands' image met most of these criteria but needed to be simplified so that it could be reproduced using low-cost printers or photocopiers. A basic black and white design seemed to be the solution.

A digital picture of two hands was photographed against a white background and then imported into Elements. The image was then cropped and straightened. The background was erased using the Background Eraser tool, though this step could have been easily handled with the new Magic Extractor feature. Now that the hands had been isolated from the surrounding detail the Threshold feature was applied to the whole image. This converted all picture tones to either black or white, giving a stark graphic image. The edges of the hands were then stroked and any gray areas were either erased or brushed to black. To complete the logo the image was cropped again and some inverted text added to a black rectangle at the bottom. The whole image was then selected and stroked with black. The finished logo was then 'inserted' into word processing software to produce the required stationery.

A piece of white card was used as a background for the photograph.
This simple step helped when it came to isolating the hands from the background later.

The digita from the corp tool.

The digital picture was downloaded from the camera and cropped and straightened in Elements using the Crop tool.

The Background Eraser tool is designed to eliminate unwanted detail from around a subject. The tool was used here to erase the white background so that only the hands were left.

The Threshold feature (Filter > Adjustments > Threshold) was used to convert the image to just black and white. The slider in the dialog controls the point at which image parts are changed to white or black.

The background was selected using the Magic Wand tool and the selection was then inverted (Select > Inverse) so that only the hands were selected. The selection was then stroked (Edit > Stroke) with a black six-pixel line.

With the major manipulations complete the Eraser tool was used to clean up any fuzzy or gray areas. The tool was changed from Block to Paint Brush mode to erase smaller details.

Next, the lines were cleaned up and some areas reshaped using the Paint Brush. To check progress a second view (View > New) of the image was opened. Changes were made on the magnified view and the effects of these changes checked on the full view.

With the retouching complete, the image was cropped and stroked again. A black rectangle was added to the bottom and the name of the group was laid out in white type.

The completed image was then saved as a TIFF file and used in a desktop publishing or word processing package to produce the stationery item masters. As the design is just black and white the items could then be reproduced using photocopy or cheap printing services.

Project 12: Holiday panoramic posters

Skill Level - 2. Version - 5.0, 4.0, 3.0, 2.0, 1.0

Seeing new and different places can be a real 'eye-opening' experience. The culture, people, architecture and clothing can vary so much from country to country that trying to take it all in, or worse, remember it, can be a difficult proposition. Most people prompt their memories with loads of photographs that, for many, spend more time in the drawer in the living room than being admired. Some pictures are framed and make it to the walls but it is only occasionally that these few pictures can sum up all of what the holiday traveler experienced. With stitching programs like Photomerge it is now possible to document a much wider view of the environment and all its differences. Hanging a few of these vistas on the wall will certainly bring back the sights and possibly even the sounds and smells of those distant shores.

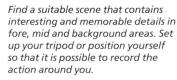

Find a suitable scene that contains Rotate the camera looking through the viewfinder but not taking any interesting and memorable details in images, checking that the horizon is level and the zoom setting you have fore, mid and background areas. Set selected captures the main features of the scene.

Set the aperture of the camera to a high f-stop number to ensure that the sharpness of each picture extends from the foreground right into the distance.

Set the exposure manually on an average between that needed for the brightest part of the scene and what is required for the dark areas.

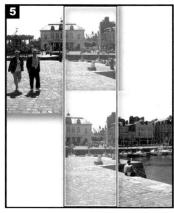

Start to photograph a sequence of images from left to right, overlapping each sequential picture by a minimum of 15% and a maximum of 40%.

Watch and wait for moving details to be positioned in the center of each shot. If this isn't possible take extra reference pictures so that the important details can be cut and pasted into the main composition later.

Back at the hotel download the images onto your laptop and import them into Elements using the Photomerge option in the File menu.

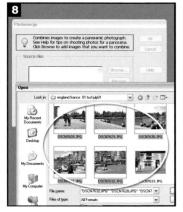

Browse for the panorama images using the Add button in the initial Photomerge dialog. Once found, select all the pictures in the sequence and click the Open and then Add buttons.

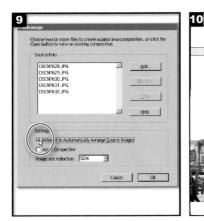

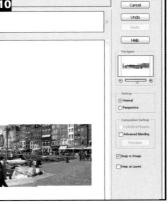

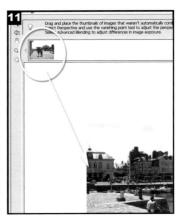

Version 1 users – Tick the Attempt to Automatically Arrange Source Images option and then click the OK button. If Photomerge displays a small dialog that indicates that it has been unable to stitch all images automatically just click OK and move

to the main Photomerge window.

Adjust the view of the image using the Navigator control so that the whole composition can be seen.

Drag and 'Snap to Image' any of the pictures that are still contained in the Light Box section of the dialog.

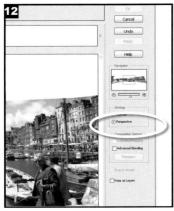

Apply perspective correction to the image if needed by checking the box in the dialog.

Tick the Cylindrical Mapping feature to help compensate for the bow-tie effect that is caused by the perspective corrections. Use the Advanced Blending option to help disguise exposure changes.

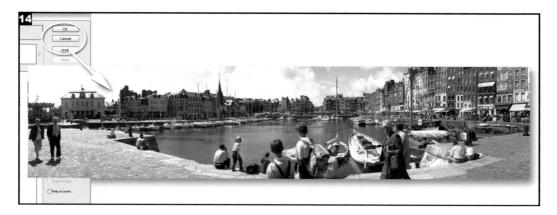

Produce the final panorama by clicking the OK button. Use the Cropping tool if necessary to trim the top and bottom of the image.

Where to From Here?

The differences between Elements and Photoshop

Who can guide me further?

started this book by applauding Adobe for their foresight in releasing Elements, because in doing so they had obviously realized the importance of a huge group of users who wanted the power of Photoshop but didn't need all the features. I hope that the last few chapters have demonstrated that for 95% of your digital imaging needs Elements should be your first port of call.

Most users will find that this package more than covers their entire image-editing requirements, but as you develop your skills and understanding some of you will arrive at a point where you need some of the sophisticated professional features contained in Photoshop. To help you decide when this day has arrived, this chapter will look at the differences between Elements and the Adobe image-editing flagship — Photoshop.

Figure 16.1 Images destined for publication in magazine or book form are separated into Cyan, Magenta, Yellow and Black (or CMYK) components.

The differences between Elements and Photoshop

From the outset it is important to understand that Photoshop is a professional imaging tool. In the current industry climate, this means that not only does the software contain 'bulletproof' editing and enhancement features, but it also must allow users to output files that are customized for high quality offset printing and web production. For this reason, Photoshop contains many features dealing with these areas.

Offset printing

Although Elements is more than sufficient for making prints with most desktop inkjet machines, Photoshop can also create and edit images in the CMYK (Cyan, Magenta, Yellow and Black) press format. See Figure 16.1.

This four-color separation mode is the basis of most offset printing and Photoshop's ability to work with these files is the reason why it has become a favorite software tool of printers all over the world. Unlike Elements, the mode section in Photoshop contains extra options for the conversion of images to CMYK and Duotone, as well as specialist LAB and Multi-channel formats. The options in the Info feature also reflect the different modes available in each package. In addition, Photoshop provides the ability to output the separation images needed to make printing plates directly. See Figures 16.2 and 16.3.

Figure 16.2 Duotone is a special printing mode that colors a monotone image by using two separate printing inks. (1) Ink color 1. (2) Ink color 2. (3) Duotone image combining both ink colors.

Book resources at: www.guide2elements.com

Web-based production

Adobe has deemed quality output to the Net to be so important that a few years ago they created a totally new product called ImageReady. Supplied free with Photoshop, ImageReady is a dedicated image-editing package designed to produce web components such as animations, rollovers, image slices and maps. See Figures 16.4 and 16.5.

Figure 16.4 ImageReady is a stand-alone editing program that is used to optimize and create web images.

Figure 16.5 You can jump between Photoshop and ImageReady by using the extra button located at the bottom of the tool bar.

The animation features extend the basic abilities found in Elements and provide more creative control over how each individual frame fits within a GIF animation. Rollovers are a specialist button type that has gained in popularity over the last few years. ImageReady not only allows the user to set up the pictures that will be used for the button, but the program also writes the special code that is needed to make the button function. See Figure 16.6.

Some advance features in web imaging require an image to be sliced into smaller image segments. Photoshop and ImageReady contain advanced features for editing of web images and their sliced components.

Figure 16.6 The main image in a rollover button changes when the mouse pointer moves over it.

Image maps allow users to allocate different button features and web links to small sections of a large image, and also allow areas of an image that contain more or less detail to be compressed by differing amounts. ImageReady provides a toolset designed to construct, edit and maintain the image maps within a website. Through the use of these special features, users can optimize their existing images for the web or create totally new web elements not possible in Photoshop or Elements alone.

The other main differences revolve around features that allow finer control of images, their tones and hues. In particular, Photoshop contains advanced color management settings, curves functions, extended selection capabilities and special path features.

Color management

It is assumed that most Photoshop users will be professional imaging specialists. As such, the program contains sophisticated color management controls that can be customized to suit a myriad of output scenarios. This level of color organization makes Photoshop the pivot point for digital image creation, manipulation and output. Professionals who are involved at different points in the process can pass image files to each other, being secure in the knowledge that Photoshop will adjust picture data to suit their imaging setup. See Figure 16.7.

Although the color management options in Elements 5.0 include the Covert Color Profile feature and the Color Settings dialog, essentially the system is designed for use with a single digital setup – a camera connected to a computer linked to a printer. It performs this job admirably, but if your business involves inputting and outputting files from a range of sources to a variety of

Figure 16.7 The advanced color management features in Photoshop provide a common base for conversion of color images as they are passed from one person to another along the production line.

destinations with the best color management available, then there is no other choice than to use Photoshop.

Automated functions

A feature that was introduced to Photoshop a few versions ago was the ability to record a series of actions that could be replayed later. For those users whose daily work involves repetitive image changes, this feature was a godsend. To some extent the Layer Styles in Elements is a more basic version of the technology. Here, the repeated actions that would need to take place to make a drop shadow, for instance, have been collated and are performed at the push of a single button. The Actions feature in Photoshop takes this idea further by allowing users to record and organize their own series of steps. See Figure 16.8.

There are now dedicated websites that house thousands of Photoshop actions that are designed to make the professional's day-to-day imaging tasks much simpler. Unlike Elements, the Photoshop batch is able to apply any action to a group of images within a specific folder.

In addition to the actions described above, editing and enhancement activities in Photoshop CS and CS2 can also be automated using scripting (Javascript or Applescript).

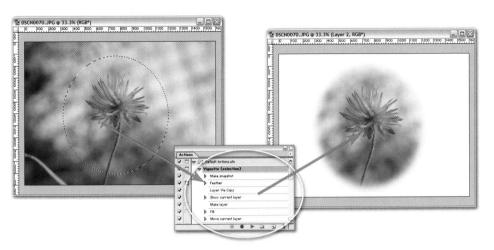

Figure 16.8 Photoshop's Actions feature allows the recording and playback of a series of production steps.

Paths

Photoshop includes a series of tools designed to create and edit paths. Creating a path is similar to making a selection. The Pen is used to make the path outline around image parts. Like the Polygonal Lasso, the Pen lays down anchor points between which a straight line is drawn. When complete, the path can be saved as part of the image file. Anchor points can be added to and removed from the path at any time. The position of any point can be moved and the line that stretches between two points can be adjusted to fit image curves.

And if all these features didn't impress you, a saved path can be converted to an active selection at any time. See Figure 16.9. In addition, because paths are vectors they can be converted to and saved as a custom shapes, or vector masks, ready for later use. See Figure 16.10.

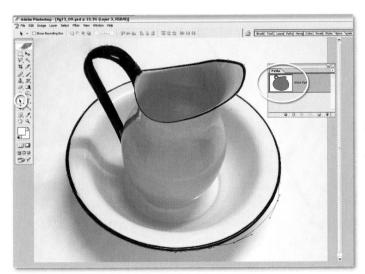

Figure 16.9 Path tools offer a more sophisticated and editable pathway to making selections.

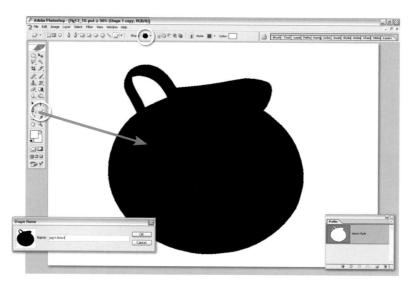

Figure 16.10 Converting paths to custom shapes allows them to be selected from the Shape palette and used later.

The extra editing abilities of paths make this tool a more sophisticated way to select areas within your image than the selection options available in Photoshop Elements.

Curves

The characteristic curve is a familiar sight to many photographers. It is used to describe how the tones in the shadow, highlight and midtone areas are spread throughout an image. In effect, it is another way to represent the information contained in the Levels dialog, with the difference that Curves allows you to interact and change very specific groups of tones. Elements 5.0 is the first version of the program that includes a curves function — Adjust Color Curves. With this new feature Elements users are able to make tonal changes based on manipulating the shape of the curve. That said, the Photoshop Curves feature offers more functionality than what is available in Elements. Specifically, Photoshop users have the ability to adjust the curve shape directly and to apply these changes to the color channels individually and even apply the feature as an adjustment layer. See Figure 16.11.

Color Balance

Many Photoshop users have a background in traditional photography, so Adobe included a Hue control in Photoshop that works in a similar way to the sliders or dials of a color enlarger. The Color Balance feature contains three sliders – yellow/blue, magenta/green and cyan/red. The dominant color of any image can be changed by adjusting the mix of these three spectra. It is also possible to alter the cast of highlights, midtones and shadows independently.

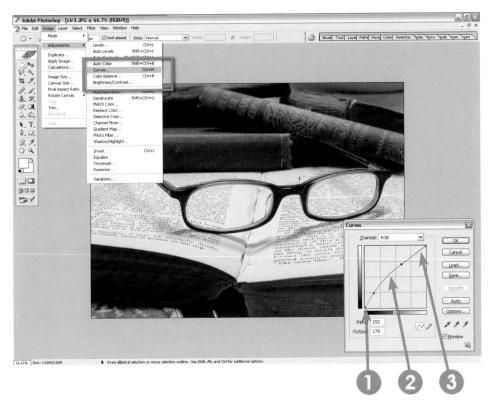

Figure 16.11 Curves provides advanced tonal control of delicate areas such as shadows and highlights. (1) Shadows. (2) Midtones. (3) Highlights.

16-bit support

The 24-bit (8 bits per red, green and blue channel) mode provides a color gamut that is suitable for most imaging needs but, occasionally, when the highest quality pictures are required, the image files need to be captured at a higher bit depth. Many professional cameras and good quality scanners can now capture images in 16 bits per channel (48-bit mode) as either a TIFF or RAW file. Even though Photoshop Elements 5.0 can now open and, in a very limited way, enhance 16-bit files, with Photoshop you have a much larger range of tools and features available for the manipulation of these files. Features like adjustment layers, adding text, Paint Brush, advanced selection options, Clone Stamp, Healing Brushes and layers are all available in 16-bit mode in Photoshop.

High Dynamic Range photos

In addition to these 16-bit options, the latest release of Photoshop has introduced limited 32-bit support with its High Dynamic Range feature providing an incredible number of colors and tones for photographers to play with. Photoshop CS2 is the first version of the program that has the ability to create and apply basic edits to 32 bits per channel digital photos. Most digital camera sensors are capable of capturing a brightness range of between 6 and 8 f-stops between deepest shadow and brightest highlights. With this new technology it is possible to create photos that contain up to 14 f-stops brightness range.

Vanishing Point

The Vanishing Point filter is a new addition to Photoshop's specialist filter line-up that includes Extract, Lens Blur and Liquify. Like the others, the feature has its own dialog complete with preview image, toolbox and options bar. The filter allows the user to copy and paste and even Clone Stamp portions of a picture whilst maintaining the perspective of the original scene. Photoshop Elements does not contain any features that can manipulate images in three-dimensional space.

Who can guide me further?

If you are wanting to switch over to Photoshop and need a text that will give you a good grounding in the basic skills and techniques then *Photoshop CS2: Essential Skills* is a great place to start. Written by myself and Mark Galer, the text provides the same highly visual approach as this book uses and contains plenty of terrific examples of how to improve your pictures using Photoshop.

Wanting something a little more substantial? Well, with the previous versions of this book never straying from the top 10 digital imaging publications for photographers at www.amazon.com, Martin Evening's *Adobe Photoshop CS2 for Photographers* is the book to introduce you to the sophistication of this powerful program. The current edition is updated to include the new features and functions contained in the latest release of the industry-leading image-editing software. Evening's style is ever practical, as he provides step-by-step guides and tutorials loaded with real life examples and pragmatic advice.

Ctrl + S Ctrl + ZCtrl + Y Ctrl + T Shift + Ctrl + L Alt + Shift + Ctrl + L Shift + Ctrl + B Ctrl + U Ctrl + L

Appendices

Jargon buster

Keyboard shortcuts

Elements/Photoshop feature equivalents

Jargon buster

A >>

Aliasing The jaggy edges that appear in bitmap images with curves or lines at any angle other than multiples of 90° . The anti-aliasing function in Elements softens around the edges of images to help make the problem less noticeable. See Figure A.1.

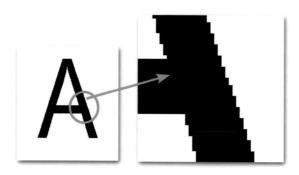

Figure A.1 Aliasing is most noticeable on the edges of text and objects with diagonal or curving edges.

Aspect ratio This is usually found in dialog boxes concerned with changes of image size and refers to the relationship between width and height of a picture. The maintaining of an image's aspect ratio means that this relationship will remain the same even when the image is enlarged or reduced. See Figure A.2.

Figure A.2 Maintaining the aspect ratio of your photograph when you enlarge or reduce sizes will help guarantee that all your picture elements remain in proportion.

B>>

Background printing Is a printing method that allows the user to continue working whilst an image or document is being printed.

Batch processing or **Process Multiple Files** as it is known in Elements 5.0. Refers to a function or a series of commands being applied to several files at one time. This function is useful for making the same changes to a folder full of images. In Elements this function is found under the File menu and is useful for converting groups of image files from one format to another. See Figure A.3.

Figure A.3 The batch or Process Multiple Files feature applies a set of changes to a group of files automatically.

Bit Stands for 'binary digit' and refers to the smallest part of information that makes up a digital file. It has a value of only 0 or 1. Eight of these bits make up one byte of data.

Bitmap or 'raster' Is the form in which digital photographs are stored and is made up of a matrix of pixels. Many people confuse this term with Bitmap mode, which refers to a pure black and white picture that contains no colors or gray tones.

Blend mode The way in which a color or a layer interacts with others below it. The most important after Normal are probably Multiply, which darkens everything, Screen, which adds to the colors to make everything lighter, Lighten, which lightens only colors darker than itself, and Darken, which darkens only colors lighter than itself. Both the latter therefore flatten contrast. Color maintains the shading of a color but alters the color to itself. Glows therefore are achieved using Screen mode, and Shadows using Multiply.

Brightness range The range of brightnesses between shadow and highlight areas of an image.

Burn tool To darken an image, can be targeted to affect just the Shadows, Midtones or Highlights. Opposite to Dodge. Part of the toning trio, which also includes the Sponge.

Byte This is the standard unit of digital storage. One byte is made up of 8 bits and can have any value between 0 and 255. 1024 bytes are equal to 1 kilobyte. 1024 kilobytes are equal to 1 megabyte. 1024 megabytes are equal to 1 gigabyte.

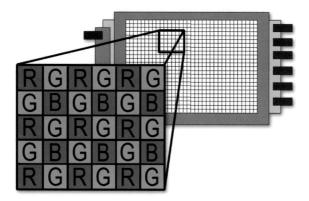

Figure A.4 The CCD sensor is the digital equivalent of film and is used to record the photograph.

C>>

CCD or **Charge Coupled Device** Many of these devices placed in a grid format comprise the sensor of most modern digital cameras. See Figure A.4.

Clone Stamp or **Rubber Stamp tool** Allows a user to copy a part of an image to somewhere else. It is therefore ideal for repair work, e.g. unwanted spots or blemishes. Equivalent to Copy and Paste in a brush.

Color mode The way that an image represents the colors that it contains. Different color modes include Bitmap, RGB and Grayscale. See Figure A.5.

Compression A process where digital files are made smaller to save on storage space or transmission time. Compression is available in two types – lossy, where parts of the original image are lost at the compression stage, and lossless, where the integrity of the file is maintained during the compression process. JPEG and GIF use lossy compression whereas TIFF is a lossless format.

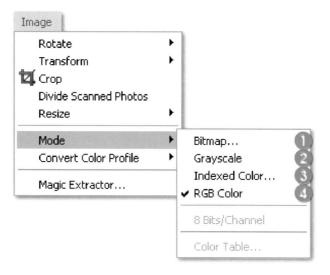

Figure A.5 The mode of a picture determines the number of colors that can be used in the photo.

- (1) Bitmap uses just black and white tones.
- (2) Grayscale consists of up to 256 levels of gray.
- (3) The Index color format is restricted to 256 colors in total.
- (4) RGB contains up to 16.7 million colors.

D>>

Digitize This is the process by which analog images or signals are sampled and changed into digital form.

Dodge tool Used for lightening areas in an image. See also Burn.

DPI or **Dots per inch** A term used to indicate the resolution of a printed photo. PPI or Pixels Per Inch refers to the resolution of a digital picture. Generally the higher the DPI or PPI the better quality the photo. See Figure A.6.

Dynamic range The measure of the range of brightness levels that can be recorded by a sensor.

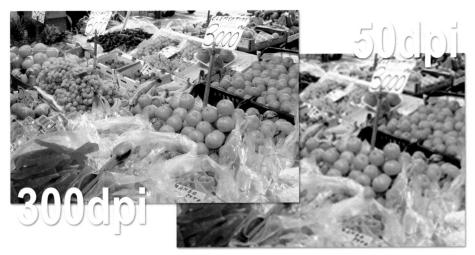

Figure A.6 The dpi or dots per inch term is used as a measurement of the resolution of a printed picture. The higher the dpi value the higher the image's resolution will be.

E>>

Enhancement A term that refers to changes in brightness, color and contrast which are designed to improve the overall look of an image.

F>>

File format The way that a digital image is stored. Different formats have different characteristics. Some are cross-platform, others have inbuilt compression capabilities.

Filter In digital terms a filter is a way of applying a set of image characteristics to the whole or part of an image. Most image-editing programs contain a range of filters that can be used for creating special effects. See Figure A.7.

Front page Sometimes called the home or index page, refers to the initial screen that the viewer sees when logging onto a website. Often the name and spelling of this page file are critical if it is to work on the web server. Consult your ISP staff for the precise name to be used with your site.

Figure A.7 Elements contains a host of filters that can change the look of your digital photographs. See the complete collection by displaying the Filter section of the Artwork and Effects palette.

G>>

Gamma The contrast of the midtone areas of a digital image.

Gamut The range of colors or hues that can be printed or displayed by particular devices.

Gaussian Blur When applied to an image or a selection, this filter softens or blurs the image.

GIF or **Graphic Interchange Format** An indexed color mode that contains a maximum of 256 colors that can be mapped to any palette of actual colors. It is extensively used for web graphics, buttons and logos, and small animated images.

Grayscale A monochrome image containing just monochrome tones ranging from white through a range of grays to black.

Figure A.8 The histogram is a visual representation of the pixels that make up your digital photograph.

Book resources at: www.guide2elements.com

H>>

Histogram A graph that represents the tonal distribution of pixels within a digital image. In version 3.0 of Elements the histogram can be found under the Windows menu. See Figure A.8.

History Adobe's form of Multiple Undo.

Hot linked A piece of text, graphic or picture that has been designed to act as a button on a web page. When the viewer clicks the hot linked item they are usually transported to another page or part of a website.

HTML The Hyper Text Mark Up Language is the code used to create web pages. The characteristics of pages are stored in this language and when a page file is downloaded to your computer the machine lays out and displays the text, image and graphics according to what is stated in the HTML file.

Hue Refers to the color of the light and is separate from how light or dark it is.

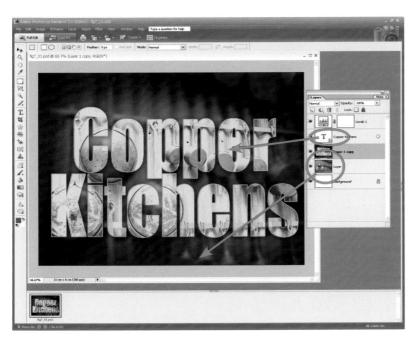

Figure A.9 Layers help keep different parts of a complex image separate. This makes editing and enhancement steps easier.

1>>

Image layers Images in Elements can be made up of many layers. Each layer will contain part of the picture. When viewed together all layers appear to make up a single continuous image. Special effects and filters can be applied to layers individually. See Figure A.9.

Interpolation This is the process used by image-editing programs to increase the resolution of a digital image. Using fuzzy logic the program makes up the extra pixels that are placed between the original ones that were generated at the time of scanning.

ISP The Internet Service Provider is the company that hosts or stores web pages. If you access the web via a dial-up account then you will usually have a portion of free space allocated for use for your own site; others can obtain free (with a small banner advert attached) space from companies like www.tripod.com.

J>>

JPEG A file format designed by the Joint Photographic Experts Group that has inbuilt lossy compression that enables a massive reduction in file sizes for digital images. Used extensively on the web and by press professionals for transmitting images back to newsdesks worldwide. See Figure A.10.

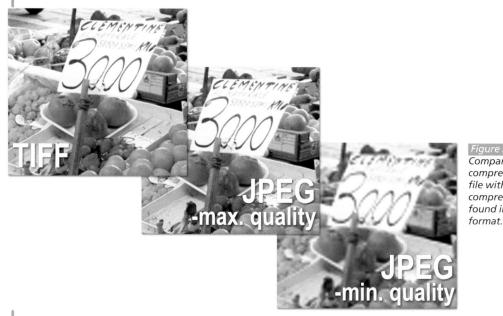

Comparing the lossless compression of a TIFF file with the lossy compression version found in the JPEG file

L>>

Layer opacity The opacity or transparency of each layer can be changed independently. Depending on the level of opacity the parts of the layer beneath will become visible. You can change the opacity of each layer by moving the Opacity slider in the Layers palette.

LCD or **Liquid Crystal Display** A display screen type used in preview screens on the back of digital cameras, in laptop computers and more and more as replacement desktop screens.

Liquify A tool that uses brushes to perform distortions upon selections or the whole of an image.

M>>

Marquee A rectangular selection made by clicking and dragging to an opposite corner.

Megapixel One million pixels. Used to describe the resolution of digital camera sensors.

Book resources at: www.guide2elements.com

N >>

Navigator In Elements, a small scalable palette showing the entire image with the possibility of displaying a box representing the current image window frame. The frame's color can be altered; a new frame can be drawn (scaling the image window with it) by holding the Command/Ctrl keys and making a new marquee. The frame can be dragged around the entire image with the Hand tool. The Zoom tools (mountain icons) can be clicked, the slider can be dragged, or a figure can be entered as a percentage.

0>>

Optical resolution The resolution that a scanner uses to sample the original image. This is often different from the highest resolution quoted for the scanner as this is scaled up by interpolating the optically scanned file.

Options bar Long bar beneath the menu bar, which immediately displays the various settings for whichever tool is currently selected.

P>>

Palette A window that is used for the alteration of image characteristics: Properties palette, Layers palette, Styles palette, Hints palette, file browser, History, etc. These can be docked together vertically around the main image window or if used less frequently can be docked in the Palette Bin to the right of the main workspace or in the Palette Well (for earlier versions of Elements) at the top right of the screen (dark gray area). See Figure A.11.

Pixel Short for 'picture element', refers to the smallest image part of a digital photograph. See Figure A.12.

Figure A.11 Palettes are a good way for image-editing software to provide users with a range of options for a particular tool or feature.

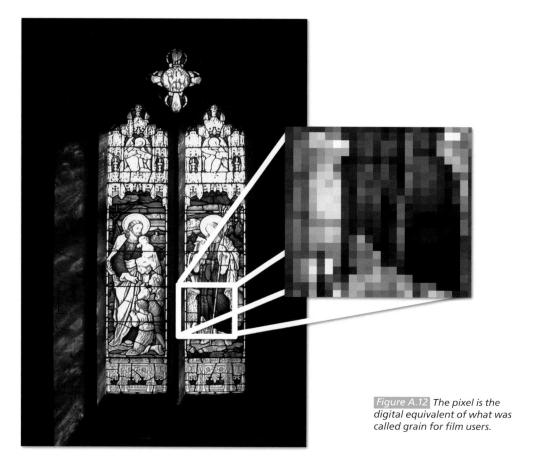

R>>

RGB All colors in the image are made up of a mixture of Red, Green and Blue colors. This is the typical mode used for desktop scanners, painting programs and digital cameras. See Figure A.13.

5>>

Sponge tool Used for saturating or desaturating part of an image that is exaggerating or lessening the color component as opposed to the lightness or darkness.

Status bar Attached to the base of the window (Mac) or beneath the window (PC). Can be altered to display a series of items from Scratch Disc usage and file size to the time it took to carry out the last action or the name of the current tool.

Stock A printing term referring to the type of paper or card that the image or text is to be printed on.

Swatches In Elements, refers to a palette that can display and store specific individual colors for immediate or repeated use.

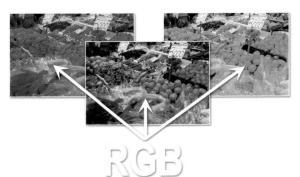

Figure A.13 Digital photographs are typically made of three components – one for the red parts of the image, one for green and one for blue. When combined these three parts form a full color picture.

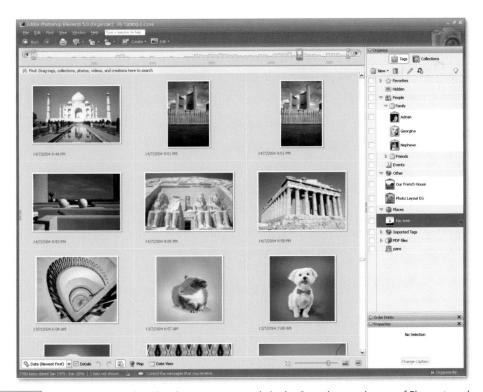

Figure A.14 Browsing software like the Photo Browser mode in the Organizer workspace of Elements makes use of smaller copies of the pictures contained on your hard drive as a way of previewing the contents of the full file quickly and easily.

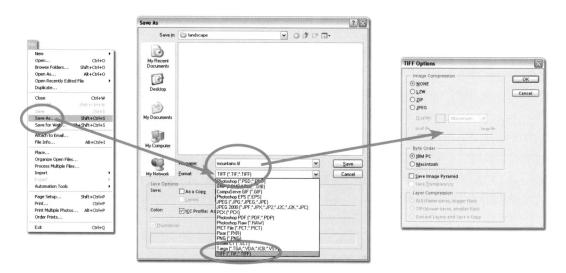

Figure A.15 The TIFF file format uses lossless compression and can be read by both Macintosh- and Windows-based machines. This means that this format is a good choice for storing high-quality photos that need to be available on both platforms.

T>>

Thumbnail A low-resolution preview version of larger image files used to check before opening the full version. See Figure A.14 on page 401.

TIFF or **Tagged Image File Format** A file format that is widely used by imaging professionals. The format can be used across both Macintosh and PC platforms and has a lossless compression system built in. See Figure A.15.

W >>

Warp Text feature A means of creating differing distortions to pieces of text such as arcs and flag ripples.

Keyboard shortcuts

General >>

Jeneral >>		
Action	Windows (ver. 5.0)	Macintosh (ver. 4.0)
Open a file	Ctrl + O	Command + O
Open file browser	-	Shift + Command + O
Close a file	Ctrl + W	Command + W
Save a file	Ctrl + S	Command + S
Step backward	Ctrl + Z	Command + Z
Step forward	Ctrl + Y	Command + Y
Free Transform	Ctrl + T	Command + T
Auto levels	Shift + Ctrl + L	Shift + Command + L
Auto contrast	Alt + Shift + Ctrl + L	Option + Shift + Command + L
Auto Color Correction	Shift + Ctrl + B	Shift + Command + B
Convert to Black and White	Alt + Ctrl + B	
Hue/Saturation	Ctrl + U	Command + U
Levels	Ctrl + L	Command + L
Select All	Ctrl + A	Command + A
Apply last filter	Ctrl + F	Command + F
Show/Hide rulers	Shft + Ctrl + R	Command + R
Show/Hide selection	Ctrl + H	Command + H
Help	F1	Command + ?
Print Preview	Ctrl + P	Command + P
Exit Elements	Ctrl + Q	Command + Q
Deselect	Ctrl + D	Command + D
Feather a selection	Alt + Ctrl + D	Option + Command + D

Viewing >>

Action	Windows	Macintosh
Fit image on screen	Ctrl + 0	Command + 0
100% magnification	Alt + Ctrl + 0	Option + Command + 0
Zoom in	Ctrl + +	Command + +
Zoom out	Ctrl + -	Command + -
Scroll image with hand tool	Spacebar + drag mouse pointer	Spacebar + drag mouse pointer
Scroll up or down 1 screen	Page Up or Page Down	Page Up or Page Down

Selection/Drawing tools >>

Action	Windows	Macintosh
Add to an existing selection	Shift + selection tool	Shift + selection tool
Subtract from an existing selection	Alt + selection tool	Command + selection tool
Constrain marquee to square or circle	Shift + drag selection tool	Shift + drag selection tool
Draw marquee from center	Alt + drag selection tool	Option + drag selection tool
Constrain shape tool to square or circle	Shift + drag shape tool	Shift + drag shape tool
Draw shape tool from center	Alt + drag shape tool	Option + drag shape tool
Exit cropping tool	Esc	Esc
Enter cropping tool selection	Enter	Return
Switch magnetic lasso to lasso	Alt + drag tool	Option + drag tool
Switch magnetic lasso to polygonal lasso	Alt + drag tool	Option + drag tool
Switch from selection to move tool	Ctrl (except hand tool is selected)	Command

Painting >>

Action	Windows	Macintosh
Change to eyedropper	Alt + painting or shape tool	Option + painting or shape tool
Cycle through blending modes	Shift + + or -	Shift + + or -
Set exposure or opacity for painting	Painting tool + Number key (%= number key × 10)	Painting tool + Number key (%= number key × 10)
Display Fill dialog box	Shift + Backspace	Shift + Delete
Perform Fill with background color	Ctrl + Backspace	Command + Delete
Change Brush tip size	[to decrease size] to increase size	[to decrease size] to increase size
Change Brush tip hardness	Shift + [to decrease hardness Shift +] to increase hardness	Shift + [to decrease hardness Shift +] to increase hardness

Type editing >>

Action	Windows	Macintosh
Select word	Double-click	Double-click
Select line	Triple-click	Triple-click
Decrease font size by 2 points/pixels	Selected text + Shift + <	Selected text + Shift + <
Increase font size by 2 points/pixels	Selected text + Shift + >	Selected text + Shift + >

Elements/Photoshop feature equivalents

Lighten shadow	5'11.51 1.6 (4.0.10.0)	
	Fill Flash feature (ver. 1.0/2.0), Shadows/Highlights (ver. 3.0/4.0/5.0) Adjust Color Curves (ver. 5.0)	Curves and Shadowl Highlight feature
areas in an image	Backlighting feature (ver. 1.0/2.0), Shadows/Highlights (ver. 3.0/4.0/5.0) Adjust Color Curves (ver. 5.0)	Curves and Shadowl Highlight feature
Transformation	Image > Transform	Edit > Transform
Rotate Layer	Image > Rotate > Layer 90 deg left	Edit > Transform > Rotate 90 deg CCW
Rotate Canvas	Image > Rotate > 90 deg left	Image > Rotate Canvas > 90 deg CW
Resize image	Image > Resize > Image Size	Image > Image Size
Resize canvas	Image > Resize > Canvas Size	Image > Canvas Size
	File > Batch Processing or File > Process Multiple Files	File > Automate > Batch
VVED PROTO GALIERV	File > Create Web Photo Gallery or Create>HTML Photo Gallery	File > Automate > Web Photo Gallery
	File > Print Layouts > Contact Sheet or File > Process Multiple Files	File > Automate > Contact Sheet II
	File > Print Layouts > Picture Package or File > Process multiple Files	File > Automate > Picture Package
Auto Levels	Enhance > Auto Levels	Image > Adjustments > Auto Levels
Auto Contrast	Enhance > Auto Contrast	Image > Adjustments > Auto Contrast
Auto Color Correction	Enhance > Auto Color Correction	Image > Adjustments > Auto Color
nue/Saluration	Enhance > Adjust Color > Hue/ Saturation	Image > Adjustments > Hue/Saturation
	Enhance > Adjust Color > Color Variations	Image > Adjustments > Variations
	Enhance > Adjust Brightness/Contrast > Brightness/Contrast	Image > Adjustment > Brightness/Contrast
	Enhance > Adjust Brightness/Contrast > Levels	Image > Adjustments > Levels

Index

Index

Note: For ease of use: > symbol indicates onscreen instructions

3D filters, 103 8 bits per channel, 125–6 16-bit color, 128, 129–30, 134–5 16-bit support (Photoshop/Elements differences), 389 24-bit color, 126 48-bit color, 126

Add Blank Page command, 243 Add graphics, slide shows, 287 Add labels option, 355 Add noise filter, 157-8 Add Page Using Current Layout command, 243 Addition: new photos, 240-1 pages, 243 Additional Options in Photos layout, 236 Adjust Color Curves command, 19, 140-1 Adjust options in Photos layout, 236 Adjust Sharpness command, 19, 148 Adjust Skin Tone command, 98 Adjust Smart Fix command, 87 Adjustment layers, 191-2 Adobe Photo Downloader, 338-9 image rotation, 61 Advanced Mode workflow, 40-1 Advanced options, color curves, 141 Advertisement optimized for black and white project, 373-4 Airbrush tool, 219 Album Pages option, 318-19 Alignment of text, 214

Amount: adjust Sharpness command, 148 Unsharp Mask command, 146–7 adjust Sharpness command, 148 more Options palette, 218 Animated option for multi-select pictures, 275 Animations: flipbooks, 285-6 web, 283-5 Artificial depth of field, 185 Artwork and Effects command, 100-4 Artwork and Effects palette, 231, 245-8 Attachment, e-mail dialog, 281-2 Auto Color Correction command, 94, 136 Auto Contrast command, 84-5, 132 Auto Levels command, 86, 132 Auto Red Eye Fix command, 66, 78 Auto sharpen command, 145

Auto Smart Fix command, 66, 78, 86

Auto Stacks in picture organization, 75

Auto Stacking command, 353-4

Autofix option, 65-6

Automated editing tasks, 355–6
Automated functions (Elements/Photoshop differences), 386
Automatic corrections, 65–8
Automatic editing, 78, 287
Automatically Fix Red Eyes, 40
Automatically Stack command, 20
Automatically Suggest Photo Stacks, 40

Backups: backing up, 76 Backup command, 76 first, 345 frequency, 350 multi-disk, 346 Online, 20 security, 350 Banding, printing, 311 Bas relief filter, 102 Benefits of Photoshop Elements 5.0, 9 Big paintings project, 359-60 Bit depth see color Black and white optimization for advertisements project, 373-4 Black and white photos (coloring), 227-8 Black/white points, 133-4 Blank File command, 52-3 Blend modes for layers, 195-6 Blur tool, 149-50 Brightness, 83-90, 120 Brightness/Contrast command, 84-5 Bring to Front/Bring Forward option, 239 Burn tools, 90-3 Burning selections, 183-4 Business card project 375-6 Business manager presentation project, 368-9

Calibration of monitors, 81–2
Camera data for raw files, 115
Camera position in Photomerge images, 252
Camera source, 38–40
Candle light, 93
Canvas size command, 167–8
Capture in digital imaging process, 8, 10
Card reader source, 38–40
CCDs (charge-coupled devices), 5
CD-ROM professional folio images project, 361–2
CDs:
artwork, 3

jackets project, 322–3 labels project, 324–5 Chalk & Charcoal filter, 105 Charge-coupled devices (CCDs), 5 Clear Frame option, 238 Clear Photo option, 238 Clipboard source, 53–4 Clone Stamp command, 152–3 CMOS sensor see charge coupled devices

burning gallery, 276

Collections, 16, 74-5, 341, 343-4 addition to black and white photos, 227-8 balance, 388-9 black and white photos, 227-8 cast, 94-5 control, 135 depth, 125-7 depth/space, 123 digital image, 5-6, 7 management, 385-6 monitors, 81-3 paint, 222 printing, 309-10 replacement tool, 223-4 selection tools, 170, 176 strength adjustments, 121-2 Color corrections, 93-4 automated, 136 gray point eyedropper, 134 Color Curves command, 140-1 Color Variations command, 95-6, 139-40 Color-based selections, 177-8 Colored Pencil filter, 102 Company Logo, Letterhead and Business Card project, 375–6 Compare Photos Side by Side command, 58–9 Comparison of Elements and Photoshop, 14–15 Computer/TV, slide shows, 326-7 Contact sheets, printing, 299-301 Contiguous option, 177 Continuous tone images, 4 Contrast: high, 131 image changes, 83-90 levels, 135 tonal control, 120 Convert to Black and White command, 20 Cookie cutter tool, 217, 230-1 Correct Camera Distortion command, 19 Craquelure filter, 102 Create command, 54, 316-17 Creation in Photos layout, 237 Cropping: Crop to remove Background command, 63 Crop to remove Original Size command, 63 Crop tool in canvas size, 168 photos, 62-4 tools, 26-7

Date View, 16, 56
Daylight, 93
Deletion of pages, 244
Depth/space, color, 123
Digital image:
photos, 3-4
process, 8-9
quality, 5-7

Curves, Elements/Photoshop, 387-8

Distort command in picture adjustment, 240 Divide Scanned Photos command, 44 DNG file type, 73 Do Not Share option, 276 Document size, 164

Document stitches, 260-1 Dodge tools, 90-3 Dodging of selections, 183-4

Downloading of files, 338-40 Downsizing of images, 44

Drawing:

selection tools, 170-5 tools, 25, 216, 228-32 Drawn selections, 177-8 Dust & scratches command, 150-1

jackets project, 322-3 labels project, 324-5

with menu option, 328-9

E-mail attachment dialog, 281-2 Edge bleeding in printing, 311 Edges in Photomerge images, 255 Editing:

Edit photos, 37

Edit text in Photo Layout designs, 239

Editor command, 44, 52-6 panoramas, 257-9

Photo Layout designs, 238-40 simple image changes, 78-80

Versioning command, 351-2 Effects, 98-109

Elements features, 14-15 Elements file type, 73 Elements/Photoshop: comparison, 14-15 differences, 383-90 feature equivalents, 406 Emboss filter, 108

Enhance menu, 22 Enhance Photos, 37 Enhancement tools, 25 Erasing, 224-5

Existing photos replacement, 241-2

Exposure, 83-4, 254 Fade in More Options palette, 218

Families of fonts, 213-14 Family heirloom project, 370–1 Favorites in Artworks and Effects palette, 245-6,

File/folder source for Organizer command, 46 Files:

destination option, 355 features of each type, 73 format type option, 355 format for web use, 273 management, 337-56 naming option, 355

size for web use, 266 source option, 355 Fill layers, 192 Film scanners, 6

Filter Gallery command, 99-101 Filter gallery texturizer filter, 163

Filters:

Artwork and Effects palette browser, 101

controls, 99 image changes, 98-109

menu, 22, 98-9 selections, 186

'ten commandments' of usage, 109

thumbnail preview, 99 Find All Stacks command, 19 Find by Details option, 346

Find menu in Organizer workspace, 344

First backups, 345 Fit command, 63

Fit Frame to Photo option, 238 Flash file format for internet, 269 Flash Galleries command, 19

Flat images, 131 Flatbed scanners, 6

Flipbook: animation, 285-6 command, 20

feature, 332-3 Fluorescent light, 93

Focal length in Photomerge images, 253 Fonts, family and style, 213-14

'Formats I Use', 72-3 Frame layers, 192-4 Frame from Video command, 56

Framed prints, 3

Free Rotate Layer in picture adjustment, 240 Free Transform in picture adjustment, 240

FTP site option, 276-7 Full edit interface, 18

Full Screen Photo in image rotation, 61

Gamma utility, 82 Get Photos feature, 16, 50-2

GIF files: features, 73 internet, 267

Global enhancement, 128 Glowing edges filter, 102 Going live with web images, 276-9

Gradient Map filter, 103 Grain filter, 159-60

Graphic Pen filter, 107 Graphics in Artwork and Effects palette, 231-2

Gray point eyedropper, 134 Greeting card project, 320-1 'Group Custom Name', 41 Grow canvas to Fit command, 63

Hard mix blend mode, 193 Hardness in more Options palette, 218 Healing brush tool, 154-5 Help system, 111-12 High dynamic range photos, Photoshop/ Elements differences, 390 High-bit misconceptions, 128-30 Highlights command for dodging and burning, 92

Hints function, 110 Histogram palette, 131-2 History command, 67-8

Holiday panoramic posters project, 377-8 Horizontal option (grain filter), 160

Household bulb light, 93 How To palette, 110-11

Hue Jitter, 218

Hue/saturation adjustment, 137-9

Hybrid scanners, 6

Image from Clipboard command, 53-4 Image-editing program, 9

Images: downsizing, 44 e-mail attachments, 281 internet, 267-70 layers, 190 menu, 22

outcomes from scanners, 43-4 overlap in Photomerge images, 252

printing, 291-314 quality, 266 raw files, 115-16 resolution, 43 rotation, 61 section printing, 298 size, 123, 164-8, 306, 355

size/quality balance, 306 size/resolution, 123 sizing option, 355

stacks, 352-3 web. 265-90 window, 18 Import Settings, 38-40

Importing pictures, 38 Impressionist Brush tool, 222 In-camera files, 338 Individual prints, 304-5

Inkjet printers, 292

Inputting photos in Organizer and Get Photos feature, 50–2 Interactive gallery, 275

Internet images, 267-70 Invert command, 143-4 IPTC keywords, 21

'Jaggies', 206-7 Jargon buster, 392-402 JPEG 2000 files: compression, 271-2 internet, 268, 269-70 compression, 271-2 features, 73 internet, 268 Justification, text, 214

Keyboard shortcuts, 403-5 Keyword tags, 16

Labels for pictures, 303-4

Lasso tools, 171-3, 175 Lavers: blend modes, 195-6 menu, 22 organization, 199-200 origins, 188 palette, 189 shortcuts, 200 styles, 20, 197-8 transparency, 194 types, 190-1 Layout, photos, 233-48 Lens Flare filter, 103 Lens pivoting, 253 Letterhead project, 375-6 Levels dialog, lighting, 132-5 Lighting: effects, 93, 103 filter, 103 manual tonal control, 132-5 Liquify filter, 106 Local enhancement, 128

Locating files, 344-5

Magic Extractor command, 21 Magic Extractor tool, 170, 181-2 Magic Selection Brush, 21, 170, 179-80 Magic Wand tool, 176 Magnetic Lasso tool, 171-3, 175 Make Photo Creations, 37 Manipulation of digital image process, 8, 10 Manual editing, 79-80 Manual tonal control, 130 Manual white balance adjustment, 118-9 Map references, 347 Marquee tools, 171-2, 175 Measurement units for type size, 212-13 Megapixels, 5 Menu for restaurant project, 371–2 Menus, 18, 22-3 Metadata: author and copyright, 41

file management, 346

Middle values for levels, 135 Midtones for dodging and burning, 92 Mobile phone source for Organizer command, Monitors calibration, 81-3 More Options palette, 218-19 More Refined option in Adjust Sharpness command, 148–9 Motion Blur filter, 104 Move tools, 26 Moving pages, 243-4 Multi-disk backups, 76, 346 Multi-page documents, 20 Multi-page Photo Creation, 242 Multi-select pictures, web usage, 275 Multi-selection editing, 356 Multi-session backups, 346 Multiple Disks, 20 Multiple prints, 298-9 My FTP site option, 276-7

Navigator command, 60 New documents, 52-6 New Face tagging technology, 343 New Photo Layout dialog, 236-7 New photos addition, 240-1 New Tag option, 341-2 New tools, 12-13 Noise reduction, 122-3 Non-detrimental size changes, 165

Ocean Ripple filter, 102 Offset printing Elements/Photoshop differences, Online backups, 349-50 Online sharing service, Organizer command, 48 Open As command, 50, 51 Open command for inputting photos, 50 Open Recently Edited File command, 50 Opening: processed file, 123-4 raw files, 117-18 Optimize command, 82 Options bar, 18, 27 Order Prints command, 314 Organization: layers, 199-200 pictures, 74-5 Organize bins, 19 Organize Open Files command, 51 Organizer command: file/folder source, 46

Organize Photos command, 37, 38-42 inputting photos, 50-2 mobile phone source, 47-8 online sharing service source, 48 scanner source, 41–2 searching source, 48

Organizer workspace, 16, 30-1, 340-1 Find menu, 344 printing, 295 Output, digital image process, 8, 10 Overexposure, 131 simple image changes, 84-9

Pages: addition, 243 deletion, 244 moving, 243-4 viewing, 244 Paint Brush, 217 Paint bucket tool, 220-1 Paint colors, 222 Painting tools, 25, 216, 217-27 Palettes, 27-8

Packages of pictures, 301-2

Pan and zone, slide shows, 287–8 Panoramas: creation, 250-64 editing, 257-9 posters project, 377-80 problems, 263-4 spin, 262 Paper type and quality, 295-6

Paragraph text, 204-5 Paths (Elements/Photoshop differences), 387-8 Pencil tool, 220

Perspective in picture adjustment, 240 Photo bins, 18-19 Photo Book Pages option, 318-19

Photo Browser: image rotation, 61 Photomerge, 259-60 raw file, 118 view, 56 workspace, 30-1

Photo Calendar project, 334-5 Photo Creations: options, 17, 32-4, 54

projects, 316-17 Photo Downloader command, 20, 21 Photo Filter command, 144

Photo Galleries: alternative creation for sharing online, 280 creation, 277-9

wizard, 274 Photo Gallery feature, 330-1 Photo Layouts: command, 20 creation, 236-7

designs editing, 238-40 option, 318-19 Photo Stamps project, 336 Photographic print display, 366-7

Photomerge:	Problems, panoramas, 263–4	Saving:
dialog, 257–8	Product Overview, 37	images, 71–4
images, 252–5	Professional folio images project, CD-ROM,	Photos layout, 237
Panorama command, 55–6, 256–60	361–2	processed raw file, 124–5
Photo browser, 259–60	Protection, pictures, 347–8	Scale, picture adjustment, 240
		Scanners:
Photos:	Quality:	driver dialog, 42
importing, auto Stacking, 353	digital image, 5–7	3.
Layout, 233–48	paper, 295–6	scanning summary, 45
in Organizer, auto Stacking, 353	Quick Fix editor:	type, 6, 41–5
removal, 242		Scatter in more Options palette, 218
tagging, 341–2	automatic corrections, 65–8	School newsletter project, 362–4
Photoshop features, 14–15	cropping, 62	Screen setting up, 80–3
Photoshop file type, 73	editing control, 78	Searching source for Organizer command, 48
Photoshop/Elements differences, 383-90	image rotation, 61	Section of image printing, 298
Pictures:	interface, 18, 28–30	Select:
adjustment, 239-40	'quick change central', 87–8	menu, 22
importing, 38	summary, 17, 28–30	Photos layout, 236
labels, 303–4	Quick fix enhancement, 355	Selection Brush tool, 172–4, 175
organization, 74–5	Quickly Fix Photos, 37	Selection tools, 24–5
9		Selections:
packages, 301–2	Radius:	dodging and burning, 183–4
protection, 347–8	adjust Sharpness command, 148	features, 170–6
viewing, 57–60	Unsharp Mask command, 146–7	
Pixels:	Raw files:	saturation changes, 186–7
color depth, 130	conversion settings, 125	Semi-automatic editing, 78–9
color selection, 176–7		Send to Back/Send Backward option, 238
digital images, 4, 5, 7	features, 114–29	Set Vanishing tool, 258
dimensions, 164	Format, 72	Settings dialog for style, 210
lighting, 132–5	processed file, opening and saving, 123–4	Shadow/Highlights command, 89–90
quantity, 43–4	Real estates project, 364–5	Shadows:
upsizing and downsizing, 166	Red Eye Removal tool, 97	dodge and burn, 92
Plastic Wrap filter, 102	Reduce noise filter, 155–6	tonal control, 120
PNG files:	Removal of photos, 242	Shape:
compression, 271–2	Remove in adjust Sharpness command, 148	Artwork and Effects palette, 231–2
features, 73	Remove Color Cast command, 94–5	layers, 191
	Replace Photo option, 238	tool, 228–9
internet, 268	Replacement of existing photos, 241–2	Share Photo Gallery option, 2760
Polygonal lasso tool, 171–3, 175	Resample image option, 166	Sharing online, Photo Galleries alternative
Popularity of digital imaging, 81	Resolution:	creation, 280
Position Photo in frame option, 238	change, 165	Sharpen tool, 149–50
Posterize command, 142–3	image, 43	Sharpness controls, 17, 19, 145–9
Premiere Elements, 21	testing, 308	Sharpness/Smoothness, 122–3
Presentation folders, 3		Shortcuts:
Preset changes for white balance, 118–19	Restoration of a family heirloom project, 370–1	
Preset sizes, 52	Retouching techniques, 150–6	bar, 18, 28
Printing, 68–70	Revert command, 67–8	keyboard, 403–5
banding, 311	Rotation:	Simple type, 204
contact sheets, 299–301	90° option, 238	Size:
edge bleeding, 311	controls, 64	fonts, 213
individual prints, 304–5	images, 61	images, 164–8
multiple prints, 293, 298–9	raw files, 118	Photos layout, 236
Organizer workspace, 295	Roundness in more Options palette, 218	Preset, 52
Print command, 296–8		Size/quality balance, images, 306
	Saturation:	Size/resolution, image, 123
Print Multiple Photos command, 293	control, 122	Skew in picture adjustment, 240
Print Preview dialog, 293–4, 297	selections changes, 186–7	Skin tone, 98
Print scanners, 6	sponge tool, 142	Slide show:
Print Selected Photos dialog, 69–70	Saturation/hue adjustment, 137–9	computer/TV, 326–7
Printing/drawing tools, 25	W. 3C. W. 100 100 100 100 100 100 100 100 100 10	from home video project, 358–9
section of image, 298	Save command, 71, 72	monthiome video project, 330-3
surface pudding (pooling), 310-11	'Save for Web' feature, 270–1	

web based, 311–14

Slide Show command, 286-90 Smart erasing, 226 Smart Fix option, 87 Smudge tool, 149-50 Spacing in more Options palette, 218 Spatter filter, 102 Special Effects in Artworks and Effects palette, 245–6, 247–8 Speckle option (grain filter), 160 Speed of web images, 276 Spin of panoramas, 262 Sponge tool, 91, 142 Spot Healing brush, 153-4 Stacks: images, 352-3 organization of pictures, 75 Stained Glass filter, 102 Standard Editor: cropping, 62 image changes, 78 image rotation, 61 interface, 18 summary, 17 toolbox, 23 Standard Mode workflow, 38-40 Start from Scratch (not version 5.0), 37 Start-up, 16 Stippled option (grain filter), 160 Stitching big paintings together project, 359-60 Straightening tools, 26-7, 63-4 Style: fonts, 213-14 layers, 197-8 settings dialog, 210 text for slide shows, 287 type layers, 207-10 Surface pudding (pooling), 310-11 Sync Pan command, 59 Tablet usage, 226 Tagging photos, 74, 341-2, 345 Talbot, Fox, 2 Temperature settings, 119 'Ten commandments' filter usage, 109

alignment and justification, 214

section for Artworks and Effects palette, 245-

alternatives, 211-12

changes, 205

tools, 26 Texture, 157–63 filter, 161–3

Artworks and Effects palette, 245-7 Photos layout, 236 Third party filters, 109 Threshold in Unsharp Mask command, 146–7 Thumbnails, 20 TIFF Format, 72-3 Tolerance setting for pixels, 177 brightness/contrast, 83 control, 120-1, 130 exposure, 88-9 levels, 135 redistribution, 127 testing, 306-7 Tool bar interface, 18 Toolbox for Standard Editor, 23 Tools, 24-8 Transitions in slide shows, 287-8 Transparency of layers, 194 Tutorials, 37 TV/computer slide shows, 326-7 Type: layers, 191 layers style, 207-10 masks, 205-6 measurement units, 212-13 paper, 295-6 warping, 207-8 Underexposure, 84, 131 Undo command, 67-8 Unsharp Mask command, 146 Use Perspective option, 258

Themes:

Vanishing point, Photoshop/Elements differences, 390
VCD with menu option, 328–9
Version sets, 20, 66–7
Versioning edits, 351–2
Vertical stitches for photomerge, 260
View Photos:
in Full Screen command, 58
Welcome screen, 37
View tools, 26

Viewing:

pages, 244

pictures, 57-60

Warping type, 207-8 Web: animations, 283-5 Compression format, 271-3 file formats, 273 gallery, 273-4, 275 images, 265-90 pages, 3 printing, 311-12 Web-based production, Elements/Photoshop differences, 384–5 Website, 2 Welcome Screen, 16, 36-7 White areas, tonal control, 120 White balance: Photomerge images, 255 raw files, 118-19 tool, 119 Workflow, Photoshop Elements 5.0, 13 World wide web see web WYSIWYG font previews, 202-3 Yahoo map, 20

Zoom tool, 59-60

nts

More great titles by Philip Andrews...

Do you need more information on Photoshop Elements, Photoshop or general photography? Do you crave extra tips and techniques?

Do you want all these things presented in a no nonsense understandable format?

Well, Philip Andrews is one of the world's most published photography and imaging authors and with the following titles he can extend your skills and understanding even further.

Adobe[®] Photoshop[®] Elements 5.0 A–Z Tools and features illustrated ready reference

"...with Adobe Photoshop Elements A–Z at your side you will be up to speed in no time." Don Day, Photoshop Elements QE, Adobe Systems Inc.

- Discover and master the tools and features in Photoshop Elements 5.0 with this comprehensive, beautifully illustrated full color guide
- Save valuable time when trying to understand a function or tool simply dip in and find the listing in this easy-to-use A–Z format
- Learn tool and feature tips and best practice from a professional photographer and Elements guru!
- Dedicated website full of resources and video tutorials www.elementsa-z.com ISBN: 0 240 520610 – \$29.95/ £17.99 – Paperback – 256pp

Advanced Photoshop® Elements 5.0 for Digital Photographers

"...a beautifully rendered and compellingly written exploration of the advanced features and techniques that can be accomplished with Photoshop Elements." Mike Leavy, Engineering Manager for Photoshop Elements, Adobe Systems, Inc.

- Provides tips from a pro to advance your Elements skills beyond the basics
- Step-by-step color illustrated tutorials show you what can be achieved
- Full workflow coverage, includes digital cameras and web work
- Dedicated website full of resources and video tutorials www.adv-elements.com

ISBN: 0 2405 20572 - \$34.95/ £19.99 - Paperback - 416pp

RAW Workflow from Capture to Archives A complete digital photographer's guide to raw imaging

'Raw Workflow from Capture to Archives' provides specific practical explanations and how-to instructions for the digital photographer mastering this process. The most comprehensive book devoted to simplifying raw workflow, this guide will demystify raw functions in the camera, raw converter, image processing and enhancement software, and digital asset management programs.

- Straightforward example workflow solutions for Adobe Photoshop CS2, Adobe Photoshop Elements 4.0, Aperture and Lightroom and other software innovations for raw imaging
- Demystifies raw functions in the camera, computer, during download, and conversion, and finally during image processing

ISBN: 0-240-80752-9 - \$39.95 / £24.99 - Paperback - 304pp

Photoshop® CS2: Essential Skills

A guide to creative image editing

"...excellent coverage of Photoshop as a digital darkroom tool as well as covering a truly amazing amount of background information."

Mark Lewis, Director of Technology Training, Mount Saint Mary College, USA

- Put theoretical knowledge into a creative context with this comprehensive text packed with original student assignments and a supporting CD-ROM
- Discover the fundamental skills vital for quality image manipulation and benefit from the highly structured learning approach!
- CD-ROM and dedicated website www.photoshopessentialskills.com

ISBN: 0 240 52000 9 - \$32.95 / £21.99 - Paperback - 384pp

Langford's Starting Photography A guide to better pictures for film and digital camera users

"....full of information to help beginners become more familiar with their cameras and improve their technique." What Digital Camera magazine, UK

- Completely revised and extended by Philip Andrews for the new era of digital photography
- Practical and user-friendly guide to get you started fast whether using film or digital photography for your image making
- Lavishly illustrated each step of the way with beautiful color images to show what you can achieve and to inspire your imagination

ISBN: 0 240 51967 1 - \$21.95 / £14.99 - Paperback - 304pp